CHICAGO FROM THE SKY
A REGION TRANSFORMED

Lawrence Okrent

CHICAGO'S BOOKS PRESS

Photo of Mies van der Rohe's Glass Tower project on page
75 © 2011 Artists Rights Society (ARS), New York / VG Bild-
Kunst, Bonn. Used with permission.

All other photography by Lawrence Okrent.
Text by Lawrence Okrent.

The images on the historic postcards in this book are in the
public domain. Every reasonable effort has been made to
identify the owners of the photographic copyrights of those
that could not be verified as such. Errors or omissions will
be corrected in subsequent editions.

Produced by Lawrence Okrent and Neal Samors.
Graphic Design by Sharon Maloy, Okrent Associates, Inc.
Design and Production Consulting by Sam Silvio,
Silvio Design, Inc.

Printed in Canada by Friesens Corporation.

For further information about this book visit
www.chicagosbooks.com.

For inquiries about the photographic content of this
book visit www.okrentassociates.com or email
info@okrentassociates.com

ISBN: 978-0-9788663-8-9

This book is dedicated
to the memory of
my son, David L Okrent
(1977-1998). The purity of
his heart continues
to inspire.

TABLE OF CONTENTS

ACKNOWLEDGEMENTS

Special thanks to **John A. Buck**, whose timely sponsorship gave this project the momentum it needed; **Sharon Maloy**, who transformed a disparate photo collection into a working layout; and **Gary DeWindt** of Embry-Riddle Aeronautical University, a peerless pilot who became a valued friend.

Supporters
Joseph Antunovich, Antunovich Associates
Brian Bernardoni, Chicago Association of Realtors
J. Leonard Caldeira, Jones Lang LaSalle Americas
Susanne Cannon, The Real Estate Center, DePaul University
Robert Chodos, Colliers International
Paul Fisher, CenterPoint Properties
James Goettsch, Goettsch Partners, Inc.
Richard Hanson, Mesa Development, LLC
Richard Horwood, Horwood Marcus & Berk Chtd.
Angelo Kokkino, Ghafari Associates, LLC
Anthony Licata, in honor of Jack Guthman,
 Shefsky & Froelich, Ltd.
Dirk Lohan, Lohan Anderson, LLC
Jack McKinney and Charlie Portis, JF McKinney & Associates
J. Marshall Peck, InterPark
The Partners of Skidmore, Owings & Merrill, LLP
The Partners of Solomon Cordwell Buenz, Architects
Mike Haney and Pete Tortorello, Newcastle, Limited

Editorial advisors
Eric Bronsky
Jennifer Ebeling
Jonathan Laing, Senior Editor, *Barron's*
Gail Lissner, Appraisal Research Counselors
Daniel Okrent
Joan Pomaranc, American Institute of Architects

The Staff, present and past, of Okrent Associates, Inc.
George Kisiel
Sharon Maloy
Jason Jarrett
Michal Galas

Pete Benitez
Roberto Diaz
Emily Iverson
James Lee
Tom Longhi
Kevin Putz
Paul Sorensen
Tom Steenhuysen

Pilots
The certified flight instructors of Windy City Flyers, Chicago Executive Airport, especially Stephen Lane, Jeff Conrad, Pat McCarte, Dan Kopelow, Anthony Conte, Hanna Packouz, Mark Nightengale, Eric Marando and Jake Dorman; and Ken Phlamm, Travel Express Aviation, DuPage County Airport

Finally, I would like to thank Neal Samors, who encouraged me to commit to this effort, and Sam Silvio, whose design inspiration made it sparkle.

The period covered in this book (1985-2010) almost exactly coincides with the mayoral administration of **Richard M. Daley** (served 1989-2011). The most significant public works of the era, including such iconic projects as the restoration of Navy Pier, the construction of Millennium Park, the creation of the Museum Campus, as well as numerous other projects, large and small, occurred on Daley's watch. Many private sector risk-takers, too numerous to mention, also left their mark on this extraordinary era of growth and transformation. Many are identified in the pages of this book. Were all deserving contributors to be included, this would be a far larger work.

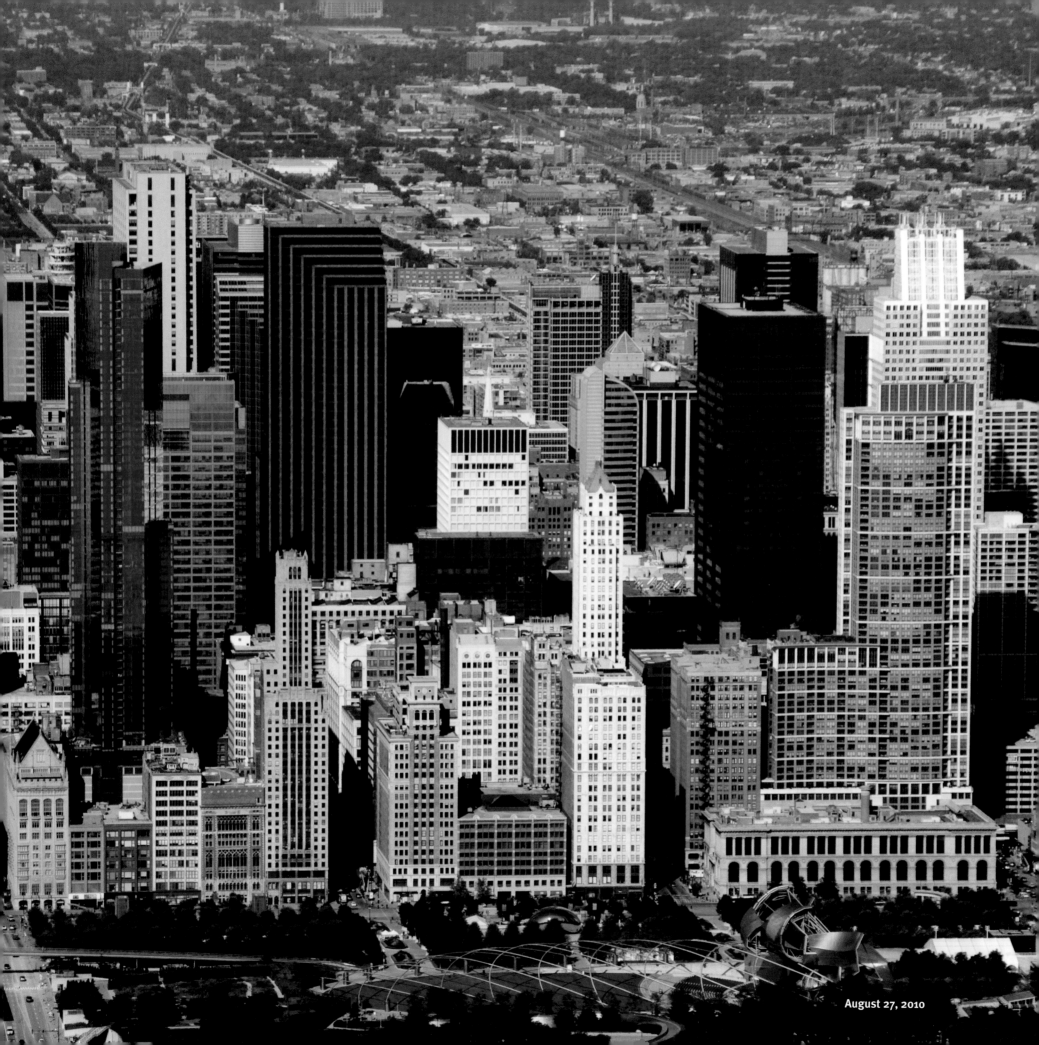

August 27, 2010

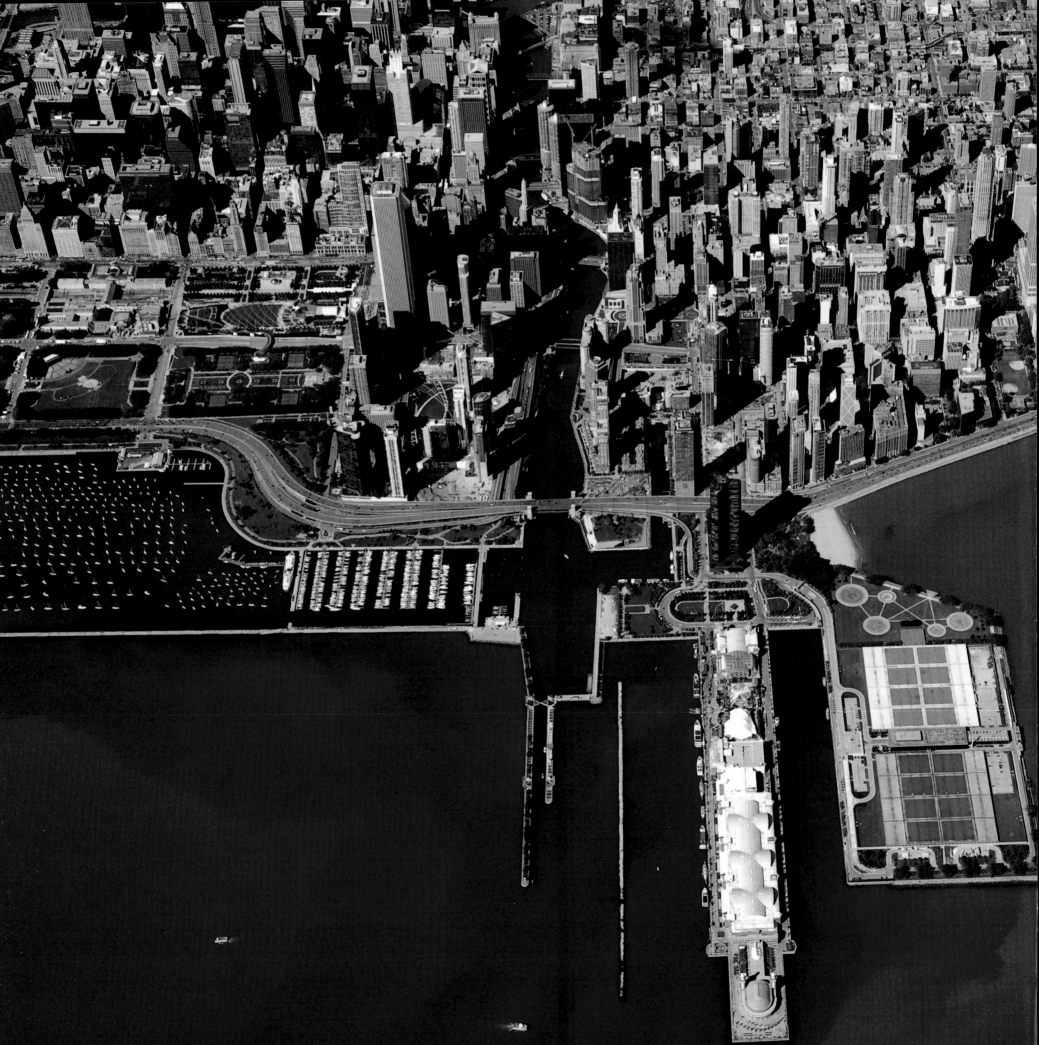

INTRODUCTION

I arrived in Chicago in 1966, enrolling as a graduate student at Northwestern University. It took a while for me to become comfortable with my new city, with my transition to adulthood, and with my emerging sense of the innumerable factors that make this city such an interesting place. Having spent a career in the field of urban planning, the creative challenge has always been "How can we make it even more interesting?"

An outsider arriving in a new city has a distinct advantage over its natives: Every place is new and interesting. His geographical perception is not constrained by his childhood experience. He has no reliable preconceived notions of any aspect of his adopted hometown. Everything is new. He is new.

A lifetime passes quickly by. The city of my young adulthood is but a memory, but I feel very fortunate that I was able to capture some of it on film. Photography is a great abettor of memory. I look back at it all now with a sense of having witnessed a transformation unlike any other. The city has changed in countless, consequential ways. The best example is perhaps the downtown, which just a generation ago was drained of people and life at the end of the workday. Today it contains a vast, vibrant residential community, thousands of college students and all the collateral attributes of urban life needed to sustain a genuine 24-hour city.

Yet, in spite of all that has been accomplished, the city has not reached its final form, because, especially in Chicago, there can never be one. Every generation of Chicagoans, whether native or not, has made its contribution, as will current and future generations. There is little doubt that Chicago will be a much different city 25 years hence and that—at least the historically inclined—will recall the current era as a point of beginning for an entirely new era of transformation. The past is enshrined in memory; the future will be the vibrant offspring of the city's boundless creativity and imagination.

September 15, 2007
Navy Pier, looking west

ASK ANY CHICAGOAN in Millennium Park what used to be there, say in 1999, and you are almost certain to encounter an expression of utter bewilderment. Things change without fanfare or notice. Experience informs us that the steel, stone, brick, and glass that are the bones, flesh, and skin of this extraordinary city are no more permanent than the weather, gracefully segueing into novel and even uplifting forms as we go about our daily lives. The urban artifact that used to be is forgotten as soon as the final touches are put on its successor. What once was the future to past generations becomes familiar, but only briefly, for the future remains a powerful draw. In Chicago, permanent only applies to the eternal prairie, to a vast lake that reaches to the horizon—and to the inevitability of change.

Mark Twain fully understood Chicago's incomparable dynamic. In 1863, he wrote, "It is hopeless for the occasional visitor to try to keep up with Chicago—she outgrows her prophecies faster than she can make them. She is always a novelty; for she is never the Chicago you saw when you passed through the last time."

Grant Park, a human creation reclaimed from the lake and 100 years in the making, is at last defined on three sides by architectural works of a scale commensurate with its impressive horizontal dimensions. Universities proliferate in and near the Loop as ever-higher towers rise above it. The fading office buildings of diminished stature in relation to their newer neighbors have become thoroughly refreshed havens for older adults drawn to the city's numerous cultural attractions.

Yet growth and change are not concentrated at the city's picture postcard center. Change has spread relentlessly outward with an energy that more resembles storm-driven waves than the gentle ripples emanating from a pebble dropped in a pond. The immigrant portal of yesteryear becomes a re-imagined destination for the privileged. The city of neighborhoods is restored. Schools, parks and countless other civic spaces, recently of the past, are again of the future. In Chicago, it is always about the future.

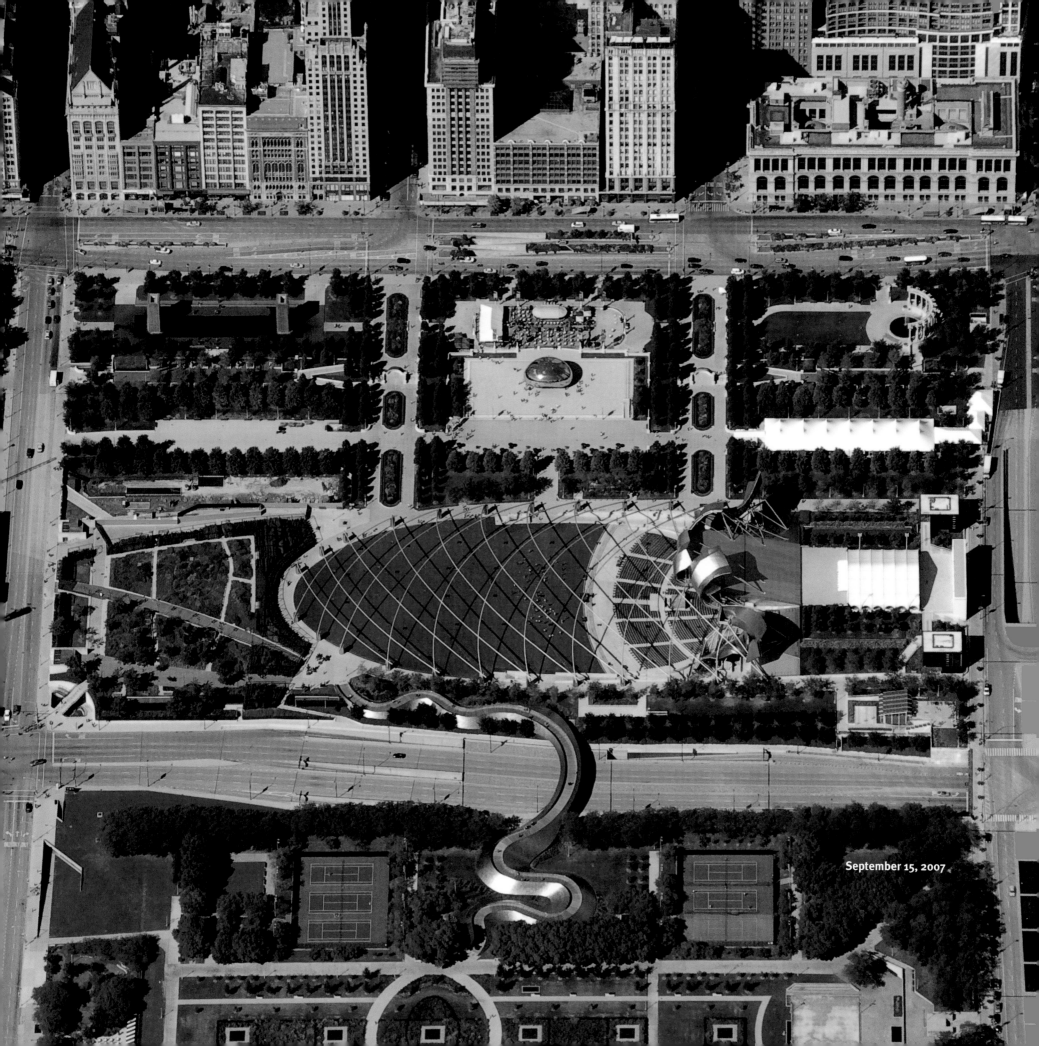

September 15, 2007

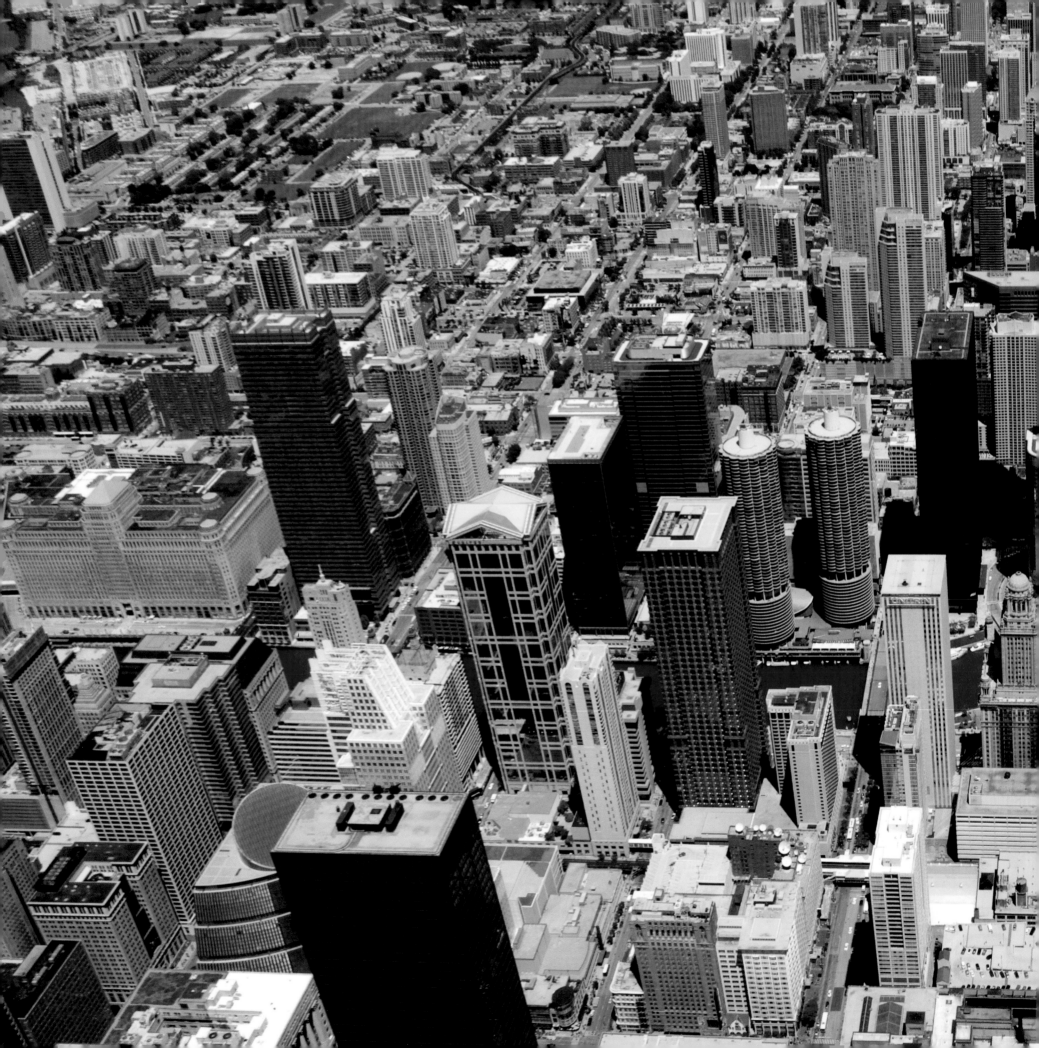

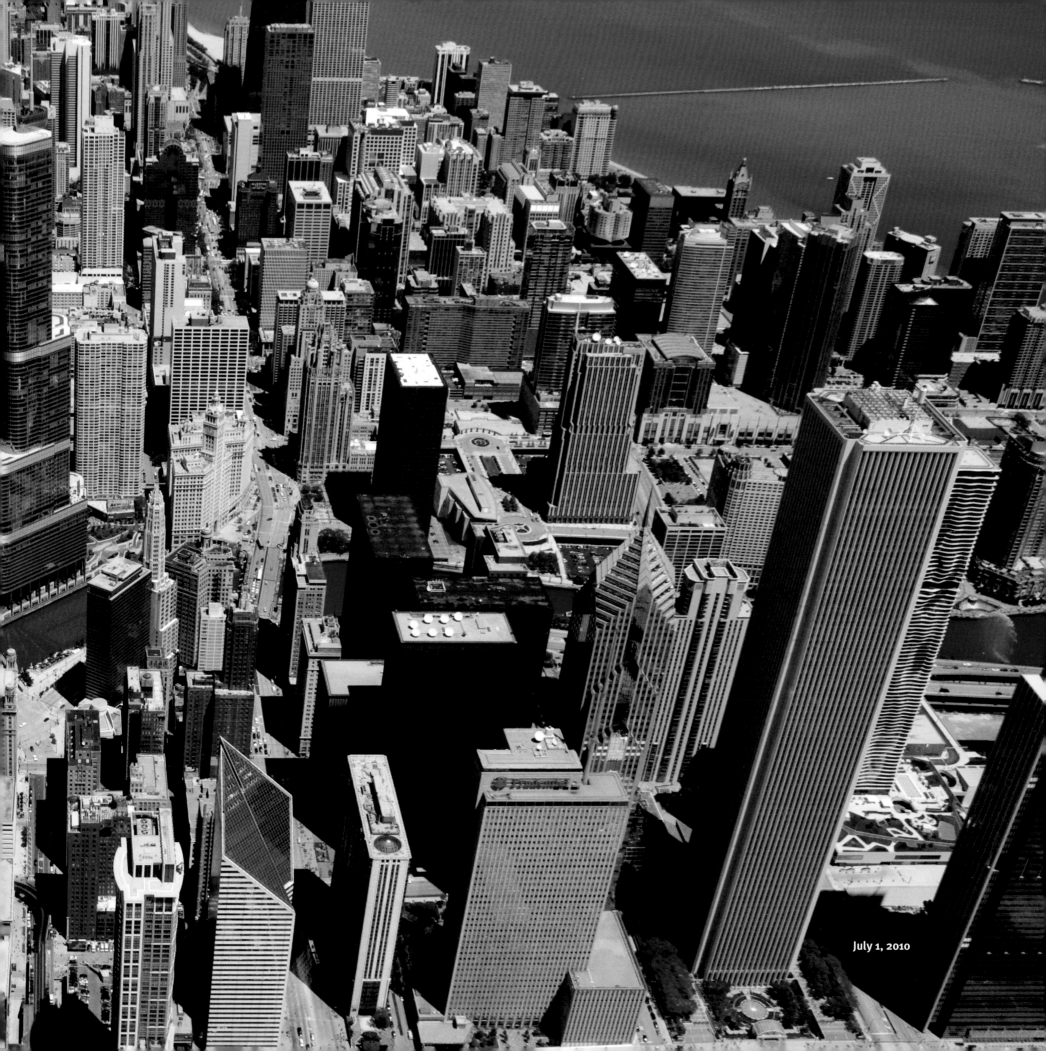

July 1, 2010

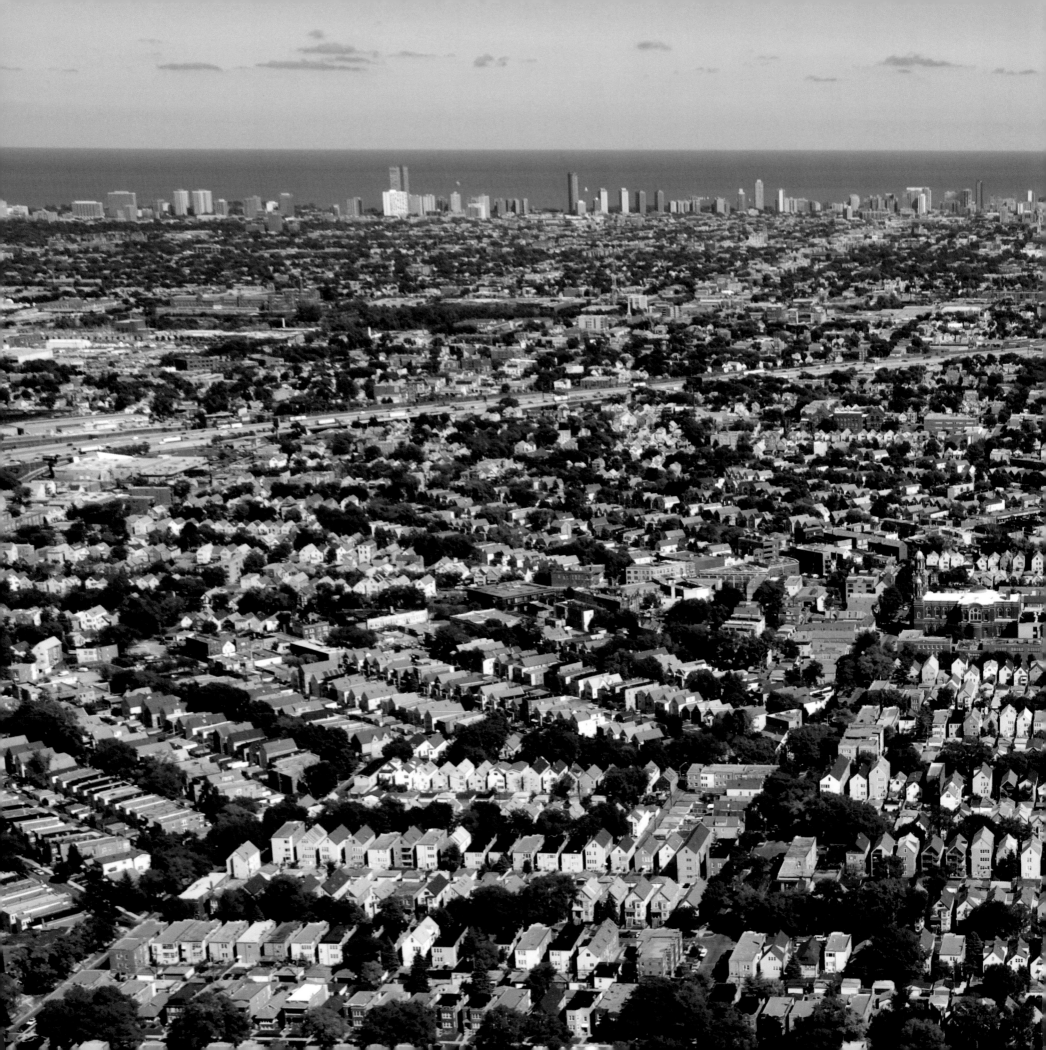

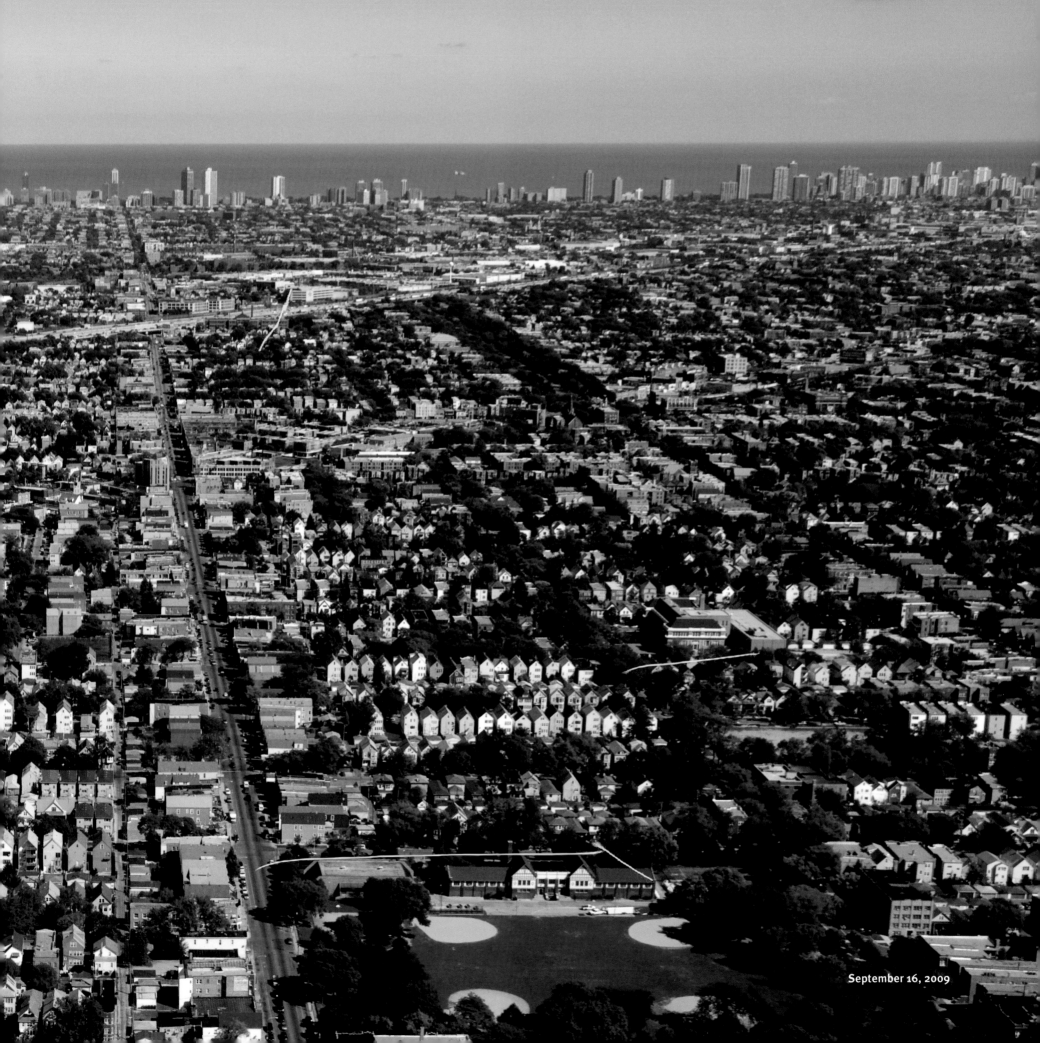

September 16, 2009

September 17, 2010

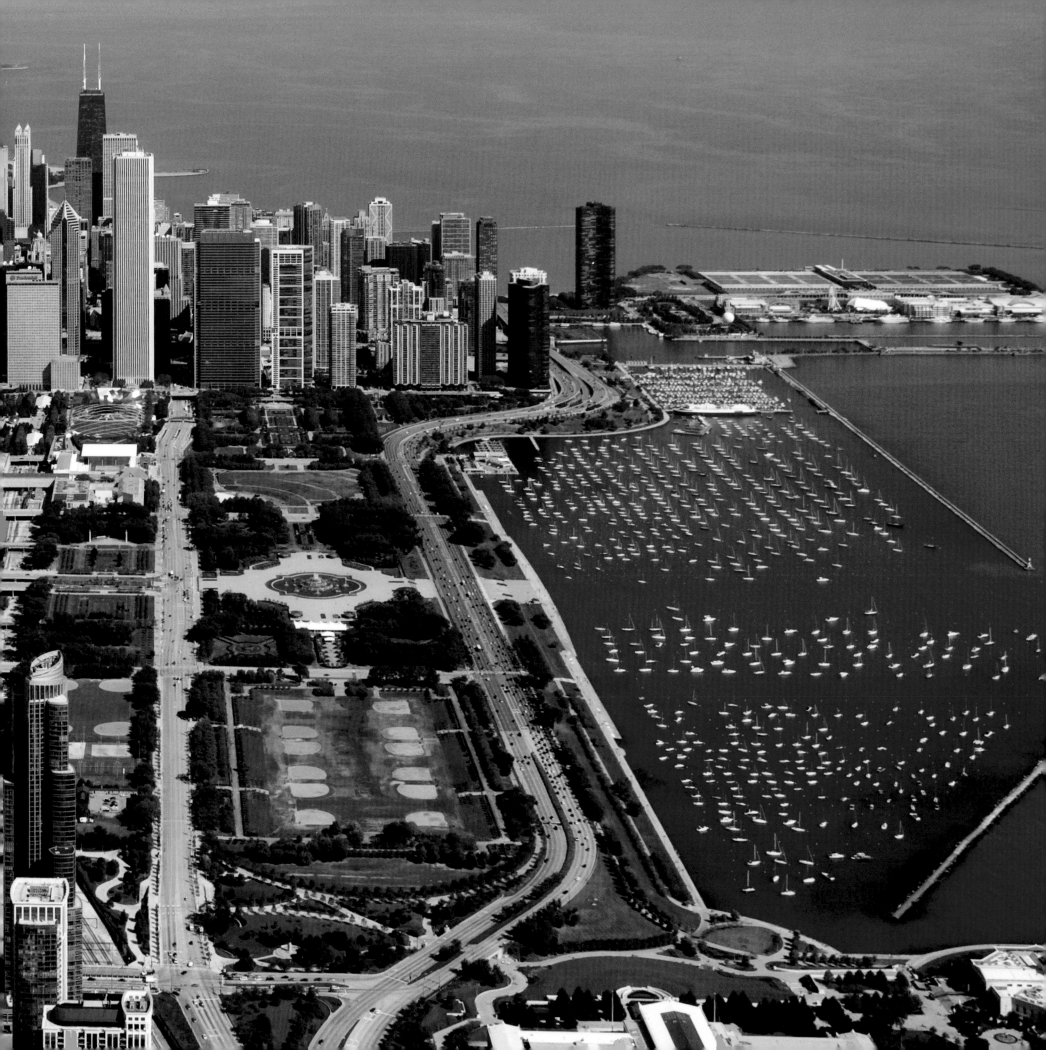

THE HEART OF THE CITY

June 7, 1992

From an altitude above 10,000 feet, the small plane in the center of this photo appears to be on a collision course with the then recently-completed Chicago Title & Trust Center (Kohn Pederson Fox, Architects). For a brief period, New York-based KPF was very active in the city. The firm also designed the buildings at 225 and 333 W. Wacker Drive, and the multi-use complex at 900 N. Michigan Avenue.

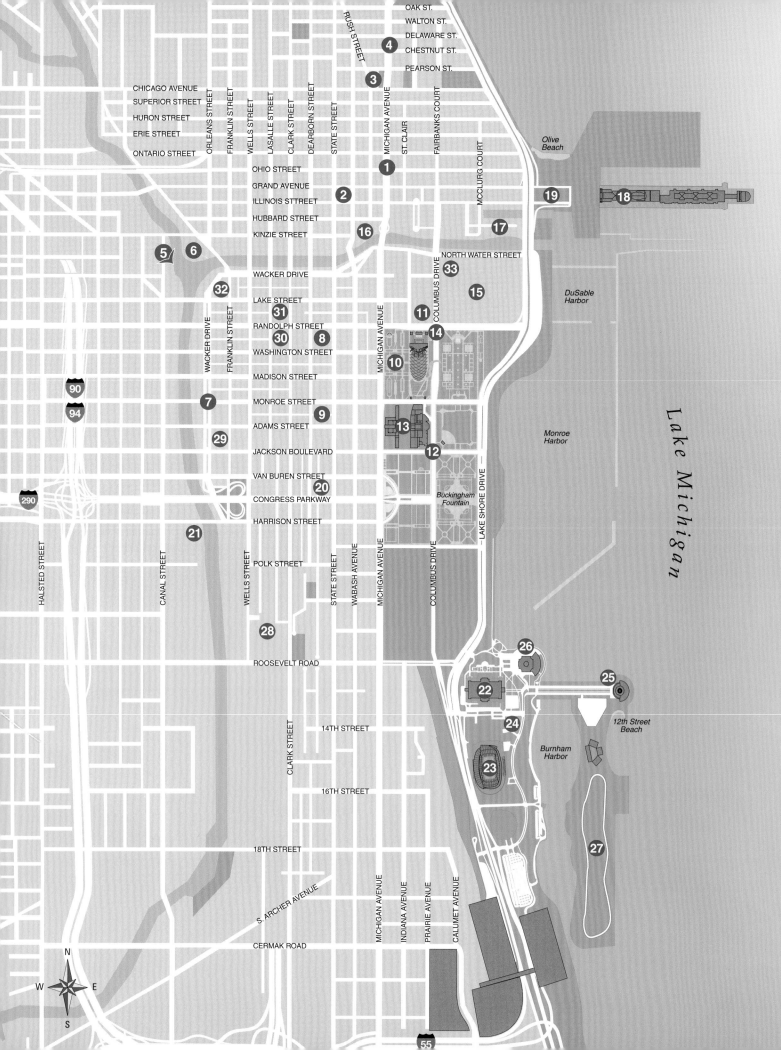

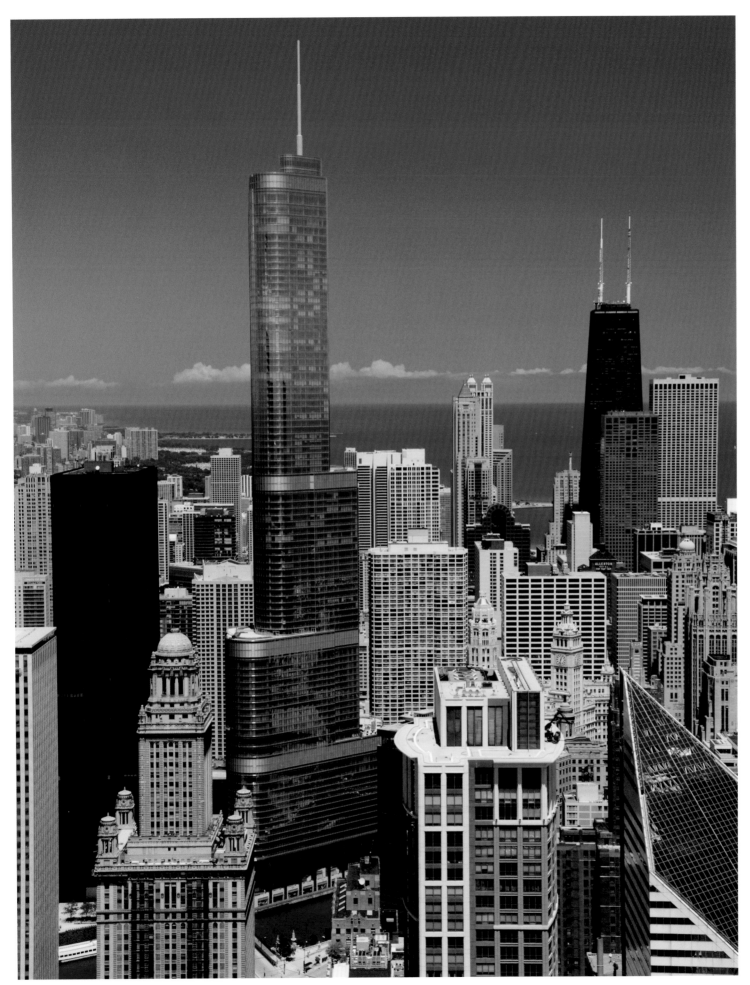

June 13, 2010
As with all of its iconic
buildings, it is difficult
to recall the city as it was
before the completion of
Trump Tower in 2009.

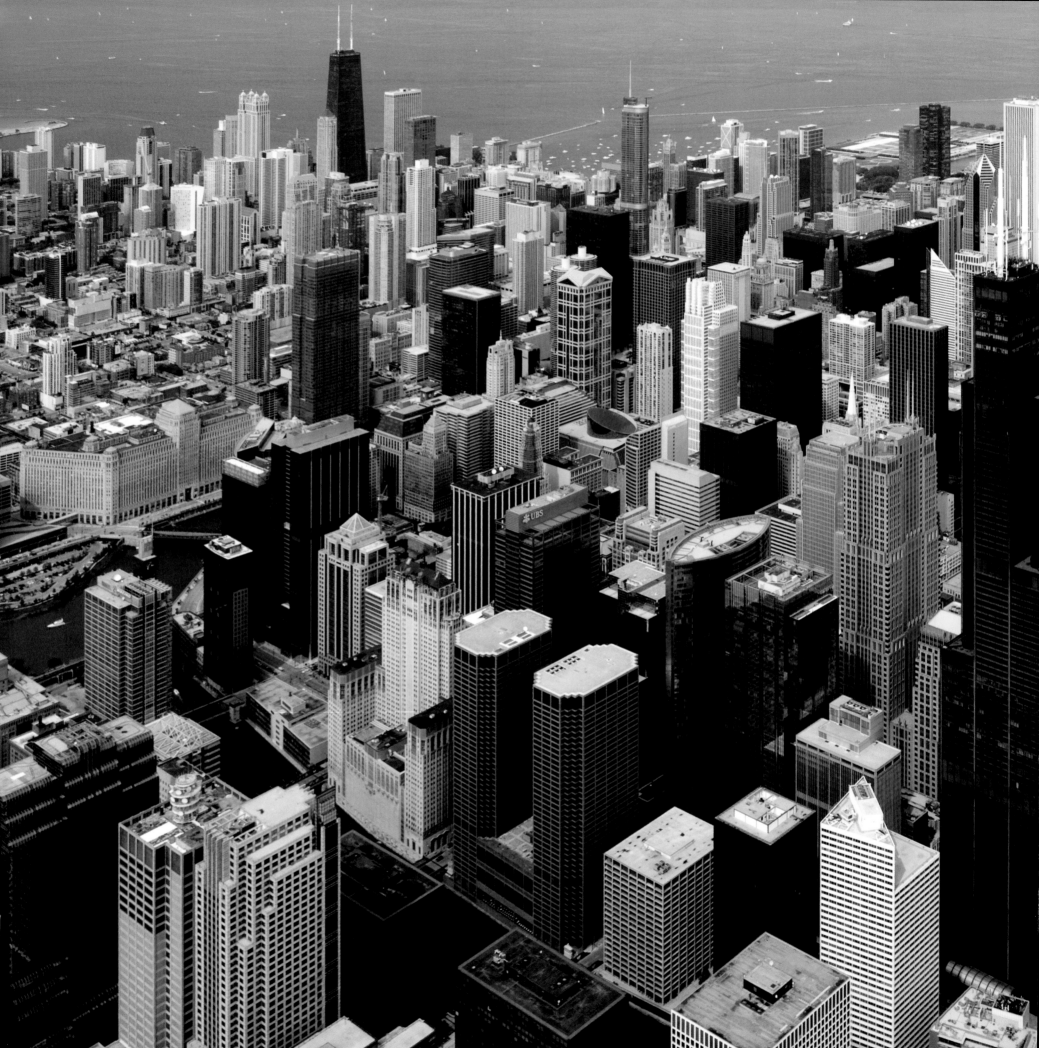

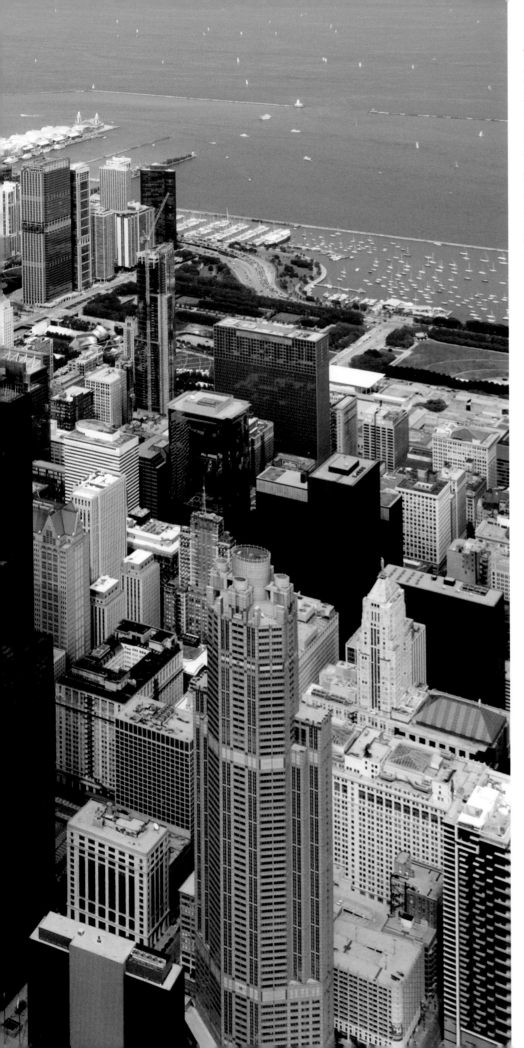

Wacker Drive

From the completion of the Chicago Civic Opera Building in 1929, to the arrival of Sears (now Willis) Tower in 1974, the north-south segment of Wacker Drive was well removed from the locus of business activity within the Loop. Today, it is the city's leading corporate business address, with almost 16 million square feet of Class A office space—and ever more limited opportunities for new development. Between 2001 and 2009, five architecturally sophisticated office towers with a combined floor area of 5.7 million square feet have been added to the Wacker Drive streetscape.

July 11, 2009

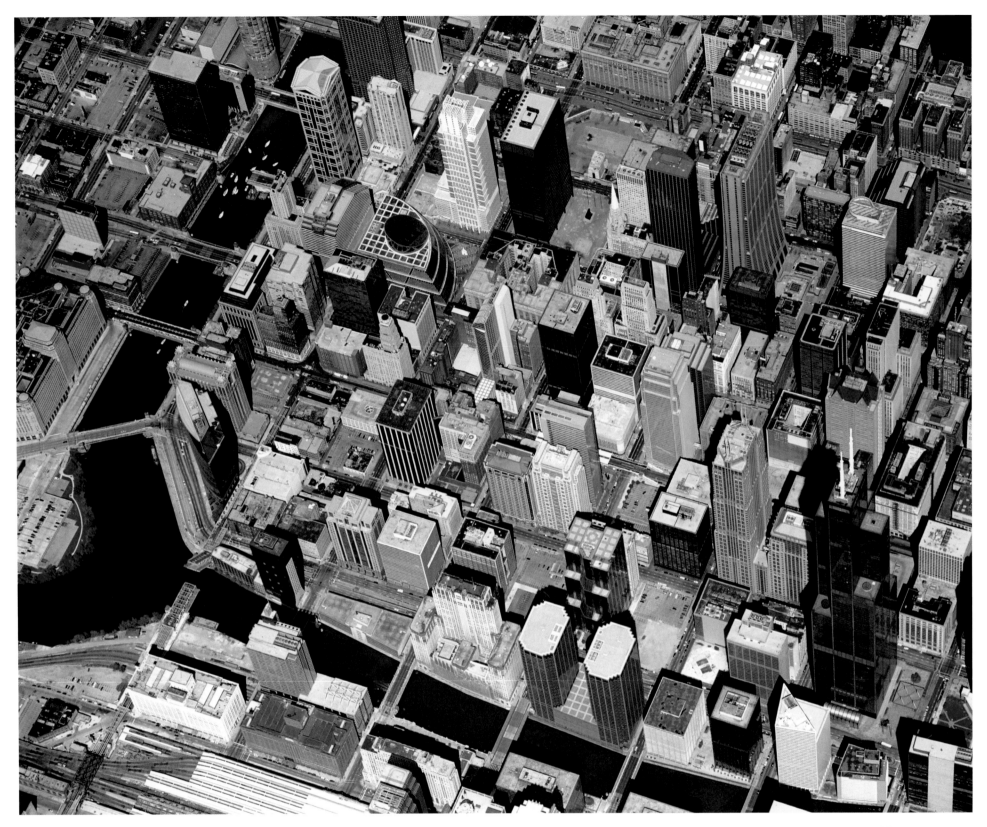

May 21, 1995
View to northeast. Still a work in progress when this picture was taken, open parking lots and aging loft buildings occupied several future Wacker Drive development sites.

2010 Conditions
The emergence of the Wacker Drive office market.

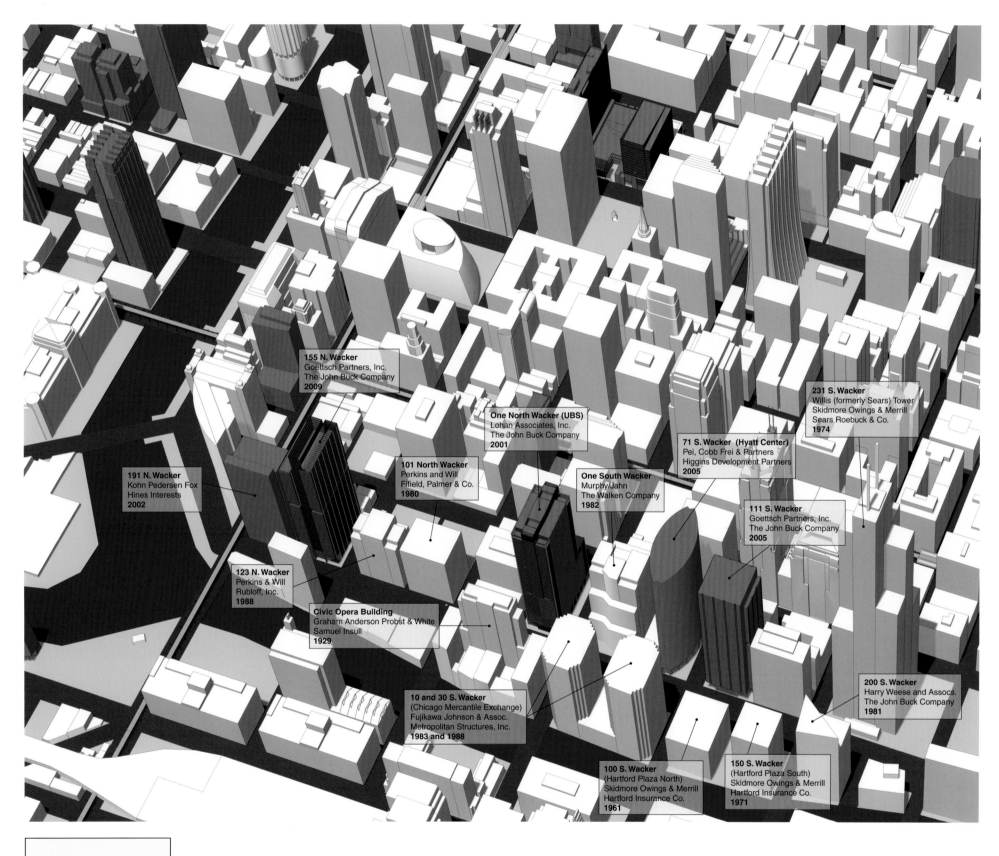

155 N. Wacker
Goettsch Partners, Inc.
The John Buck Company
2009

One North Wacker (UBS)
Lohan Associates, Inc.
The John Buck Company
2001

231 S. Wacker
Willis (formerly Sears) Tower
Skidmore Owings & Merrill
Sears Roebuck & Co.
1974

101 North Wacker
Perkins and Will
Fifield, Palmer & Co.
1980

71 S. Wacker (Hyatt Center)
Pei, Cobb Frei & Partners
Higgins Development Partners
2005

191 N. Wacker
Kohn Pedersen Fox
Hines Interests
2002

One South Wacker
Murphy/Jahn
The Walken Company
1982

111 S. Wacker
Goettsch Partners, Inc.
The John Buck Company
2005

123 N. Wacker
Perkins & Will
Rubloff, Inc.
1988

Civic Opera Building
Graham Anderson Probst & White
Samuel Insull
1929

200 S. Wacker
Harry Weese and Assocs.
The John Buck Company
1981

10 and 30 S. Wacker
(Chicago Mercantile Exchange)
Fujikawa Johnson & Assoc.
Metropolitan Structures, Inc.
1983 and 1988

100 S. Wacker
(Hartford Plaza North)
Skidmore Owings & Merrill
Hartford Insurance Co.
1961

150 S. Wacker
(Hartford Plaza South)
Skidmore Owings & Merrill
Hartford Insurance Co.
1971

KEY

Building Address
Architect
Developer
Date of Completion

= built since
1995

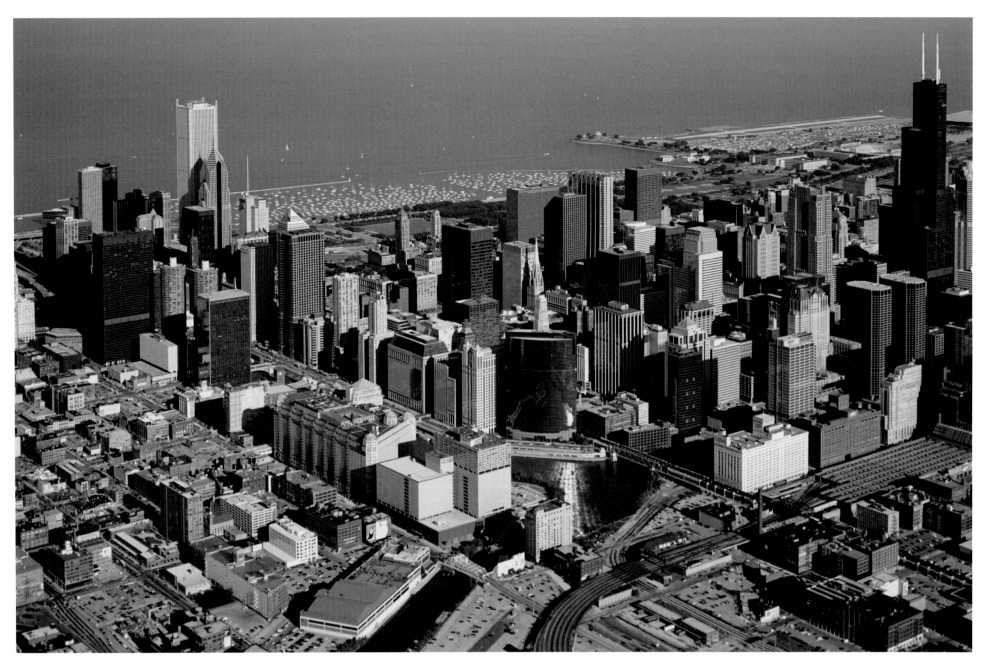

Central Business District

At the end of the 1980's, the northwest corner of the city's central business district was largely defined by the Main Channel and South Branch of the Chicago River. Recent development (photo at right) has resulted in many new office buildings north of the Main Channel and significant new apartment and condominium projects west of Wolf Point, where the North Branch joins the Main Channel.

July 31, 1990
The boundaries of the central business district were evident in the abrupt change in building scale at its perimeter.

July 11, 2009
High-rise residential buildings and loft conversions beyond the traditional core reflect the emergence of a thriving market for center city living.

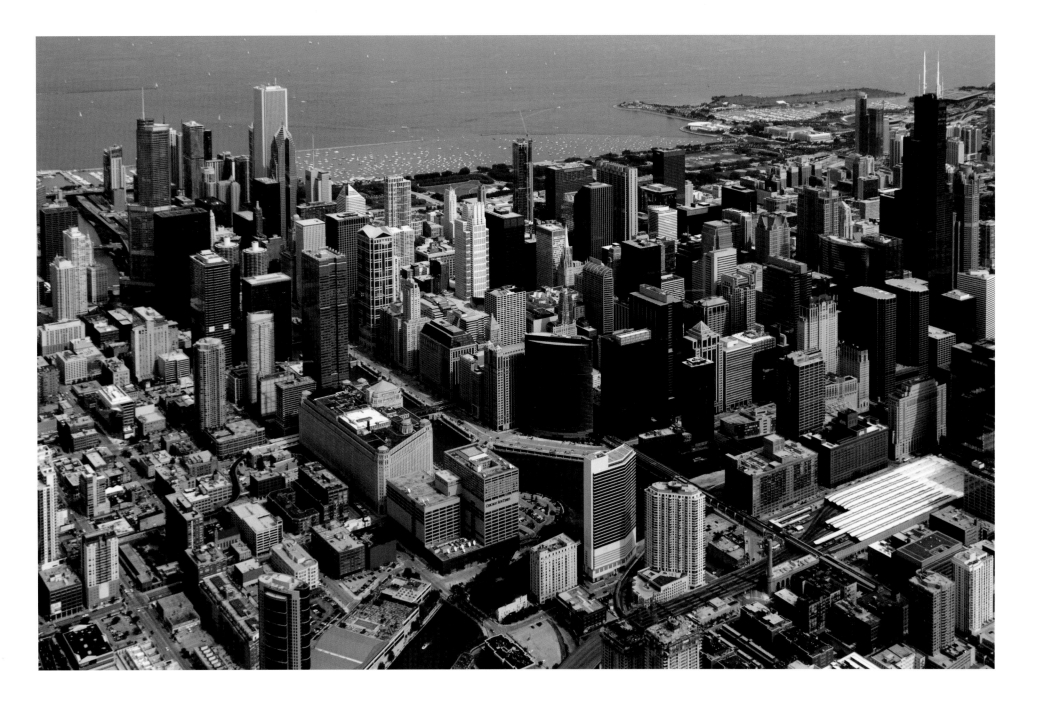

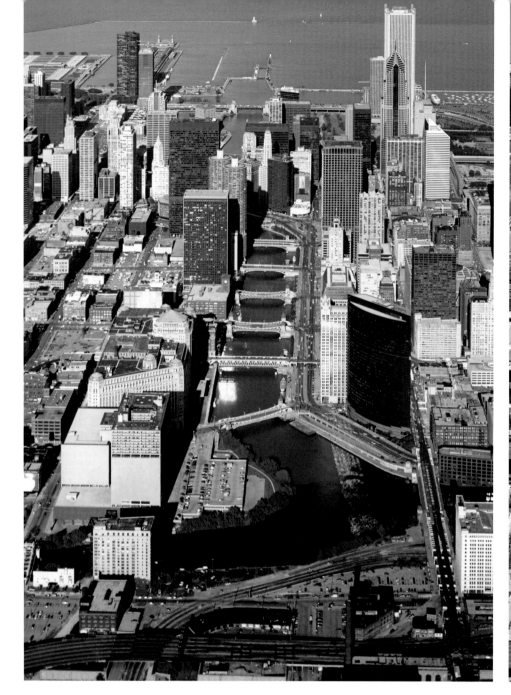

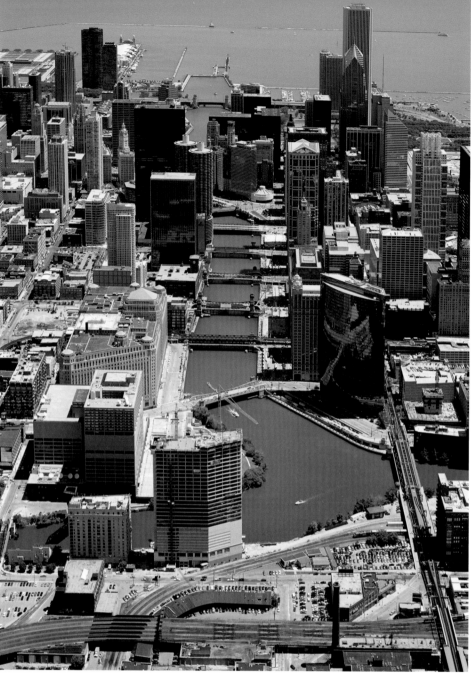

Wolf Point

Wolf Point is the small peninsula formed by the convergence of the North Branch and Main Channel of the Chicago River. But for the parking deck visible in the 1990 image, it has not been the site of an active use since 1834. The construction of the 28-mile-long Sanitary and Ship Canal (1894-1899) between the South Branch of the river at Damen Avenue and the town of Lockport succeeded in reversing the flow of the Main Channel and South Branch away from the lake and into the canal. Locks at the mouth of the river east of Lake Shore Drive control the release of lake water into the river.

July 31, 1990
The curving dark green glass façade of 333 West Wacker Drive (right center) makes the most of its triangular riverfront site. Designed by Kohn Pederson Fox and completed in 1983, it is regarded as Chicago's first post-modern office tower.

July 5, 2001
High-rise development north of the river has begun to appear west of Michigan Avenue and north of the parcels directly fronting on the river. The narrow site of the Residences at River Bend condominium, under construction in the foreground (DeStefano+ Partners, architects), is based on a floor plan that imparts to all its 152 units unobstructed views to the east.

September 16, 2009
The tall glass tower (center left) at 300 N. LaSalle Street, designed by Pickard Chilton Architects of New Haven CT effectively extends the LaSalle Street financial/legal district to the north side of the river—long a barrier to such expansion—for the first time.

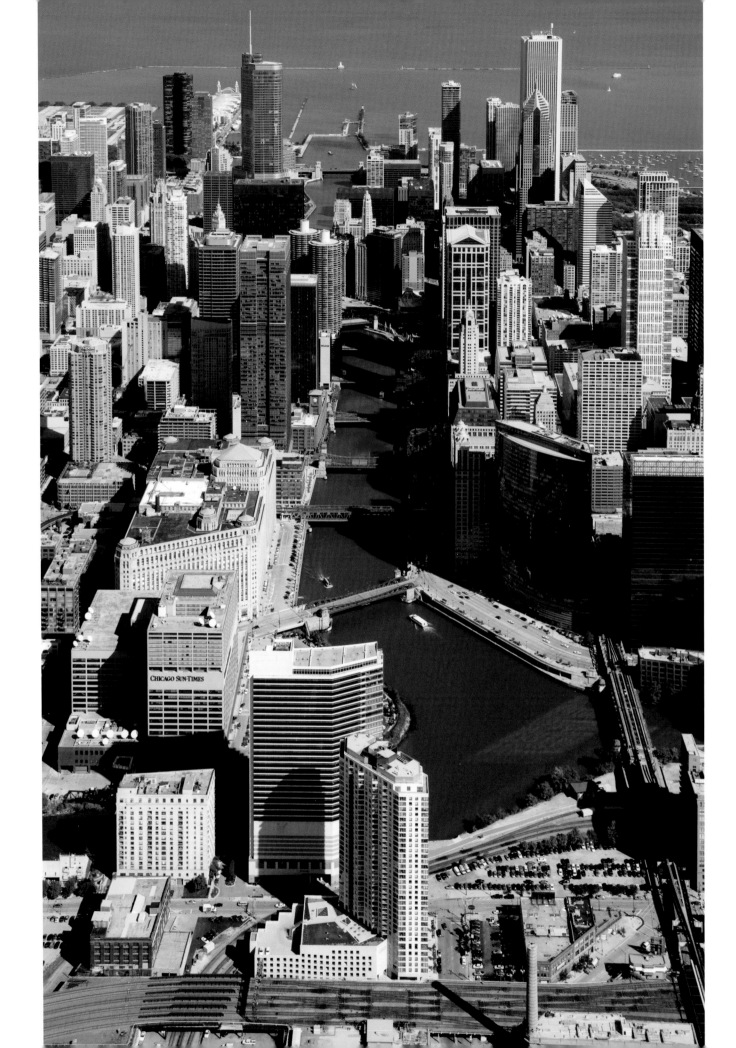

North Michigan Avenue

Since the completion of Water Tower Place (just south of the John Hancock Center) in 1976, North Michigan Avenue, one of the city's signature civic spaces, has been defined by its flanking architectural masses. Nearly all of the smaller buildings of that era have since been replaced by much larger ones. The transformation of the areas east and west of the avenue has been even more dramatic, with acres of open parking lots and aging low-rise buildings replaced by office, residential and retail projects of exceptional scale, value and architectural diversity.

June 9, 1988
Clearing land for parking as a temporary hold strategy enabled property owners to generate revenue while limiting real estate tax exposure. The trapezoidal Mandel Building, on the riverbank (lower right) temporarily housed the Chicago Public Library, from 1975 until 1988.

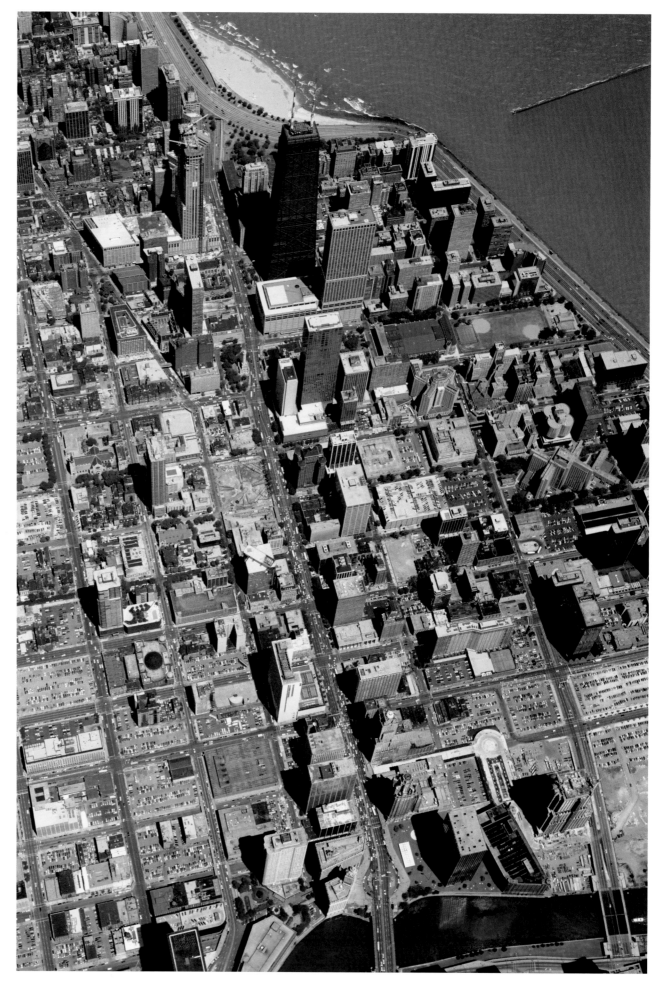

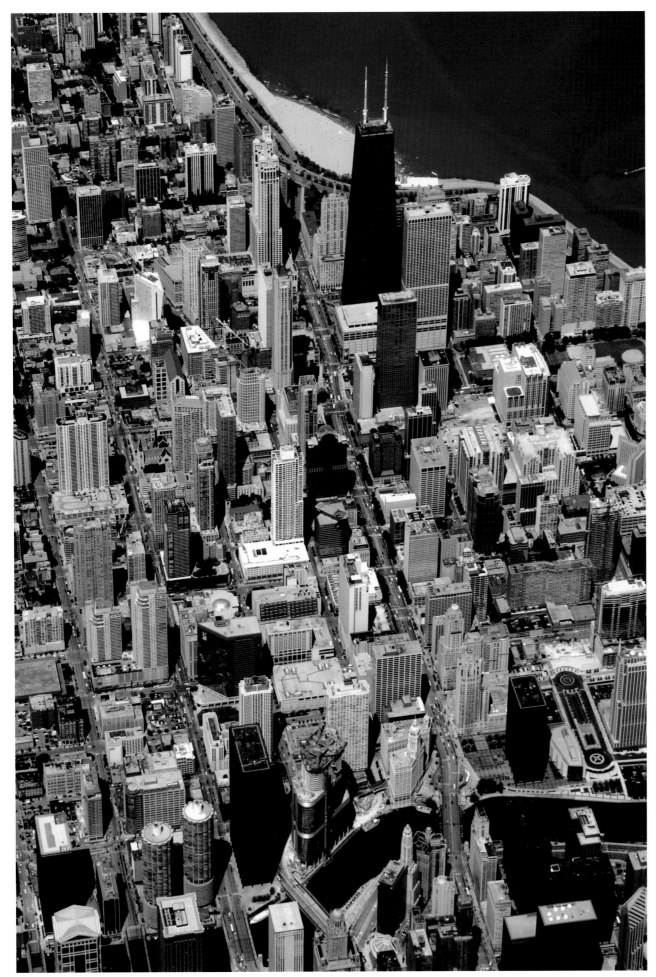

August 13, 2007
Land values near the avenue were at a premium in 2007, with several significant projects still in the pipeline. Trump Tower, west of the Michigan Avenue Bridge, had not yet risen above the neighboring IBM building.

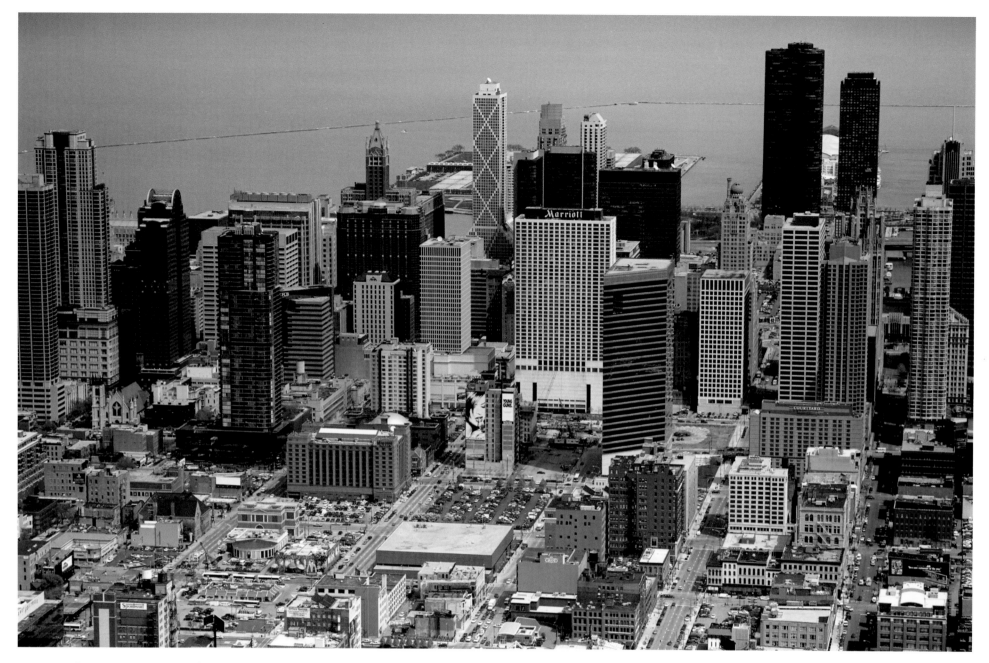

Ft. Dearborn Post Office/AMA

Only seven years separate the development patterns depicted in these two images. The single-story full block building in the center foreground of each is the Ft. Dearborn Post Office. When completed in 1979, the post office was largely surrounded by parking lots. Given the scale and intensity of subsequent development in the area, the post office site has often been suggested for redevelopment as a much needed public park.

April 27, 1998

The angular American Medical Association (AMA) Building, to the right of the Marriott Hotel, was one of the first Class A office towers to be constructed west of Michigan Avenue and north of property fronting on the Chicago River when completed in 1990. Developer John A. Buck awarded the architectural commission to the noted Japanese architect Kenzo Tange (1913-2005).

August 22, 2005

Loewenberg Associates designed Grand Plaza, the paired towers in the center of this image. Millennium Center, the 58-story building at left, was designed by Solomon, Cordwell, Buenz, architects.

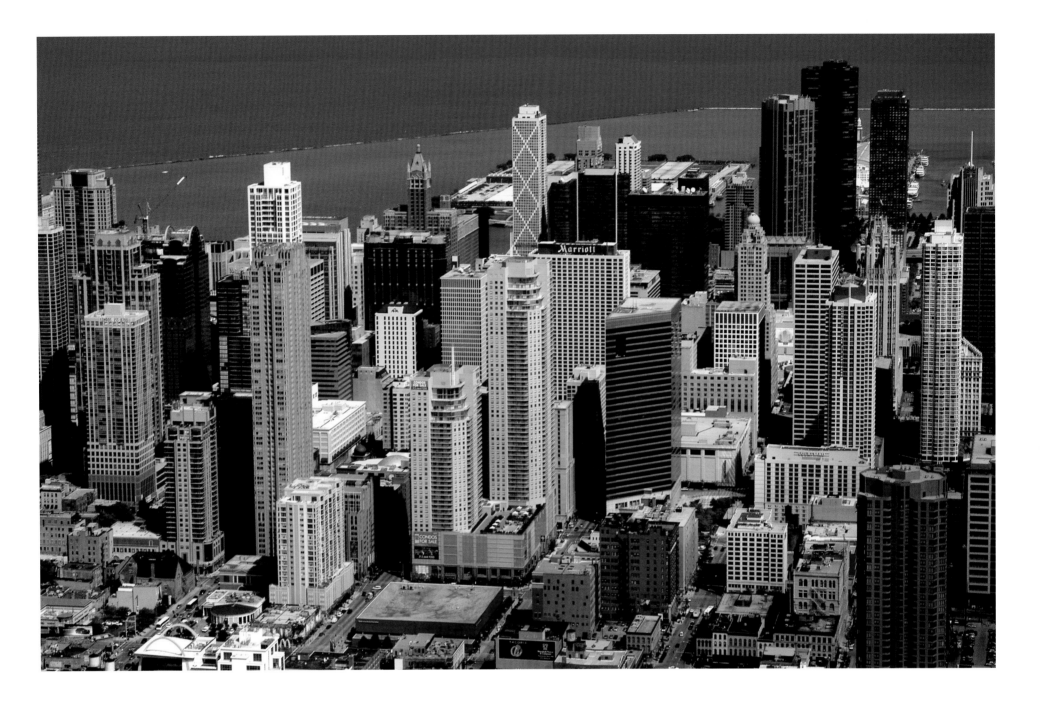

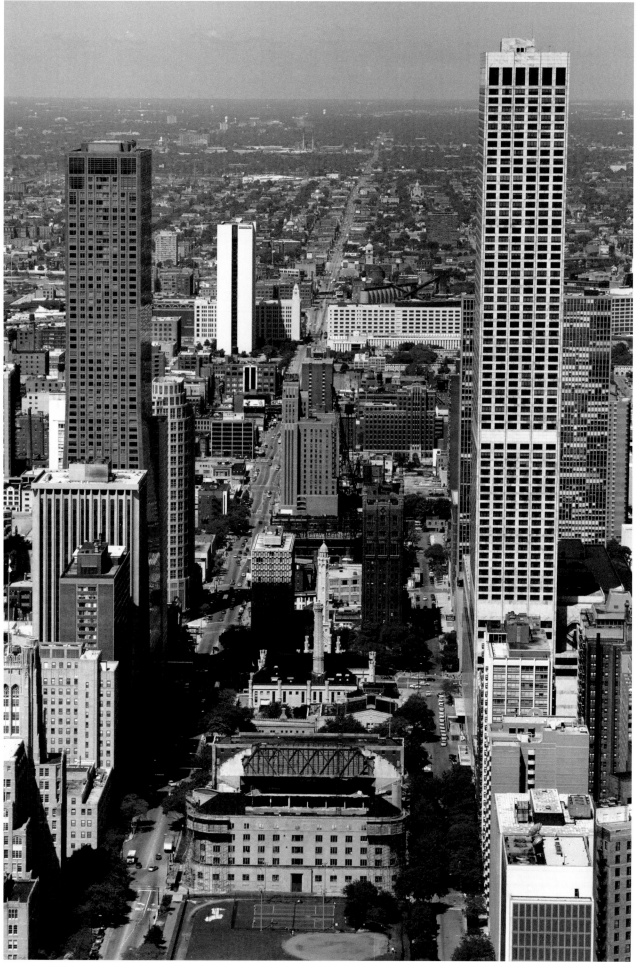

Park Tower/MCA

The Illinois National Guard Armory (1923-1993) at the western end of Lake Shore Park was demolished to make way for the Museum of Contemporary Art (MCA), designed by Josef Paul Kleihues of Berlin and completed in 1996. The 67-story Park Tower, just west of the historic water tower, provides a powerful visual terminus to the open park space. French-born, Chicago-based architect Lucien LaGrange designed Park Tower (completed in 2000).

June 5, 1993
The hulking mass of the National Guard Armory is as expressive of its military roots as the MCA (opposite) is of its aesthetic mission. The museum's lake-facing gardens increase neighborhood green space.

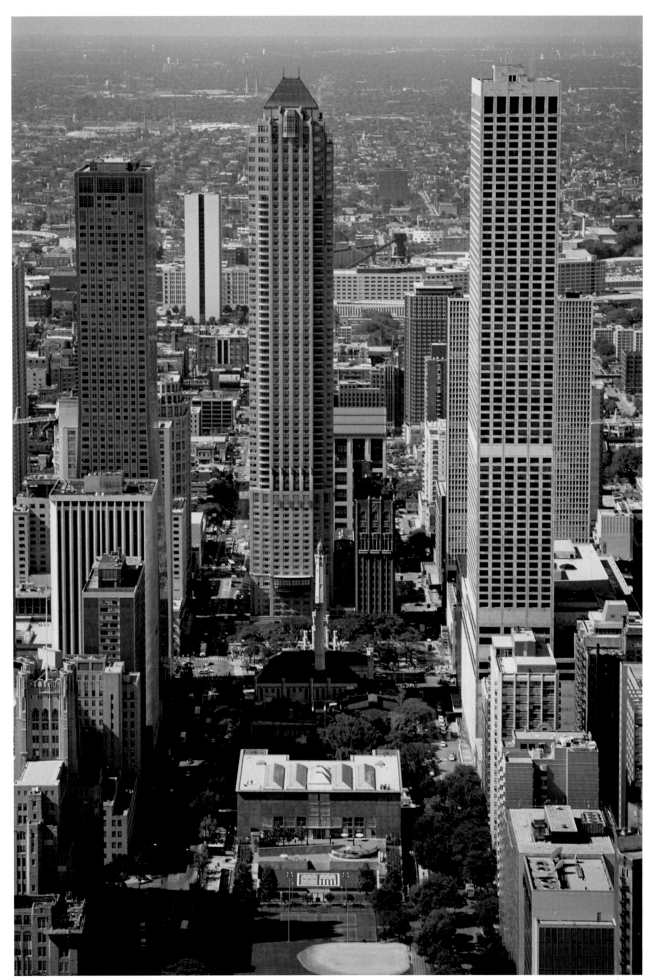

September 28, 2000
Park Tower's pitched copper roof has both ornamental and functional attributes. Its contrasting form and color enhance the project's identity; within it is a utilitarian 300-ton tuned mass damper, which serves to offset wind-induced lateral movement.

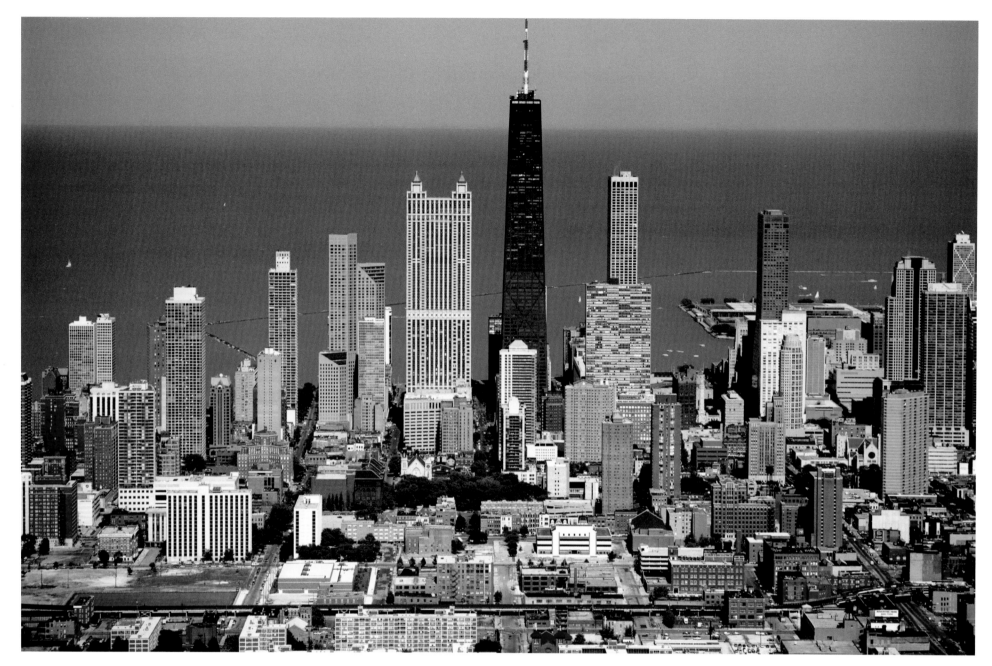

John Hancock District

For a few short years, before the completion of Sears (now Willis) Tower in 1974, the John Hancock Center (Skidmore, Owings & Merrill, completed 1968) held the honor of being Chicago's tallest building. The project also attracted substantial new real estate investment to upper Michigan Avenue. Water Tower Place (1976), One Magnificent Mile (1983), Olympia Center (1986), 900 N. Michigan (1989), Chicago Place (1990), 730-750 N. Michigan (1998), and Park Tower (2000) are among the largest. The historic Palmolive Building of 1929 became a residential condominium in 2005. Six new nearby condominium projects added 502 units between 2007 and 2010.

June 23, 1991
The segment of Michigan Avenue between the Old Water Tower (center right) and Oak Street Beach (to the left of the John Hancock Center) had largely reached maturity by 1991. The last significant addition, Park Tower, was completed in 2000.

August 16, 2010
As Michigan Avenue development opportunities diminished, developers' attention was drawn to the area immediately west of the avenue, which experienced a profusion of new development between 2000 and 2010. The bright white building in the center of the image, the Sofitel Hotel, was designed by French architect Jean-Paul Viguier.

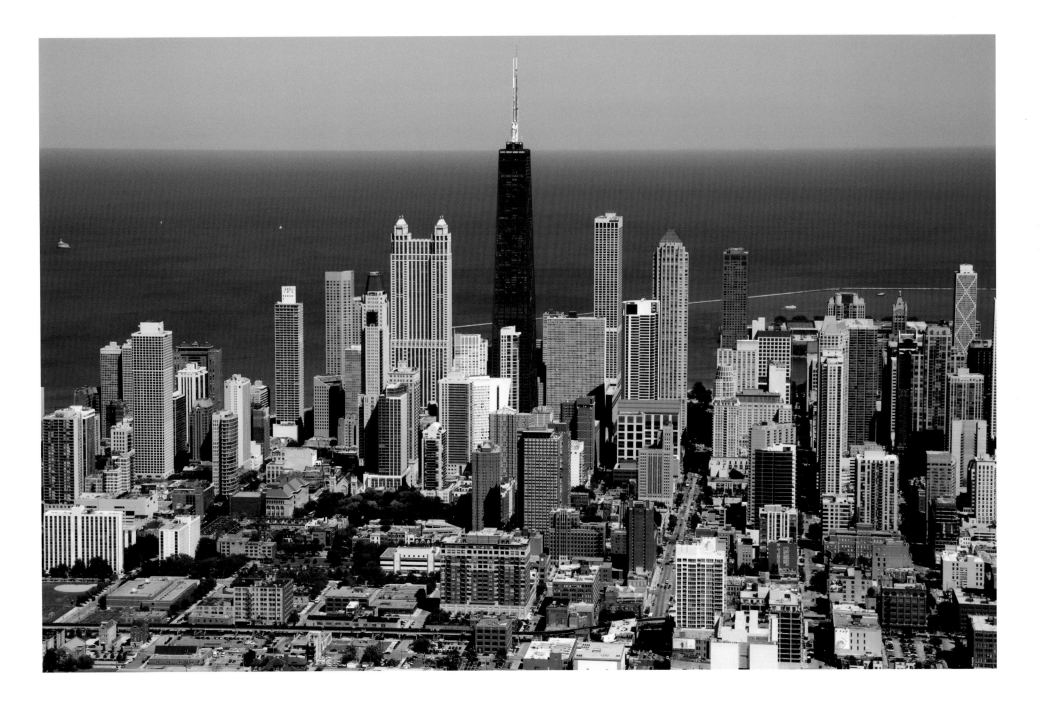

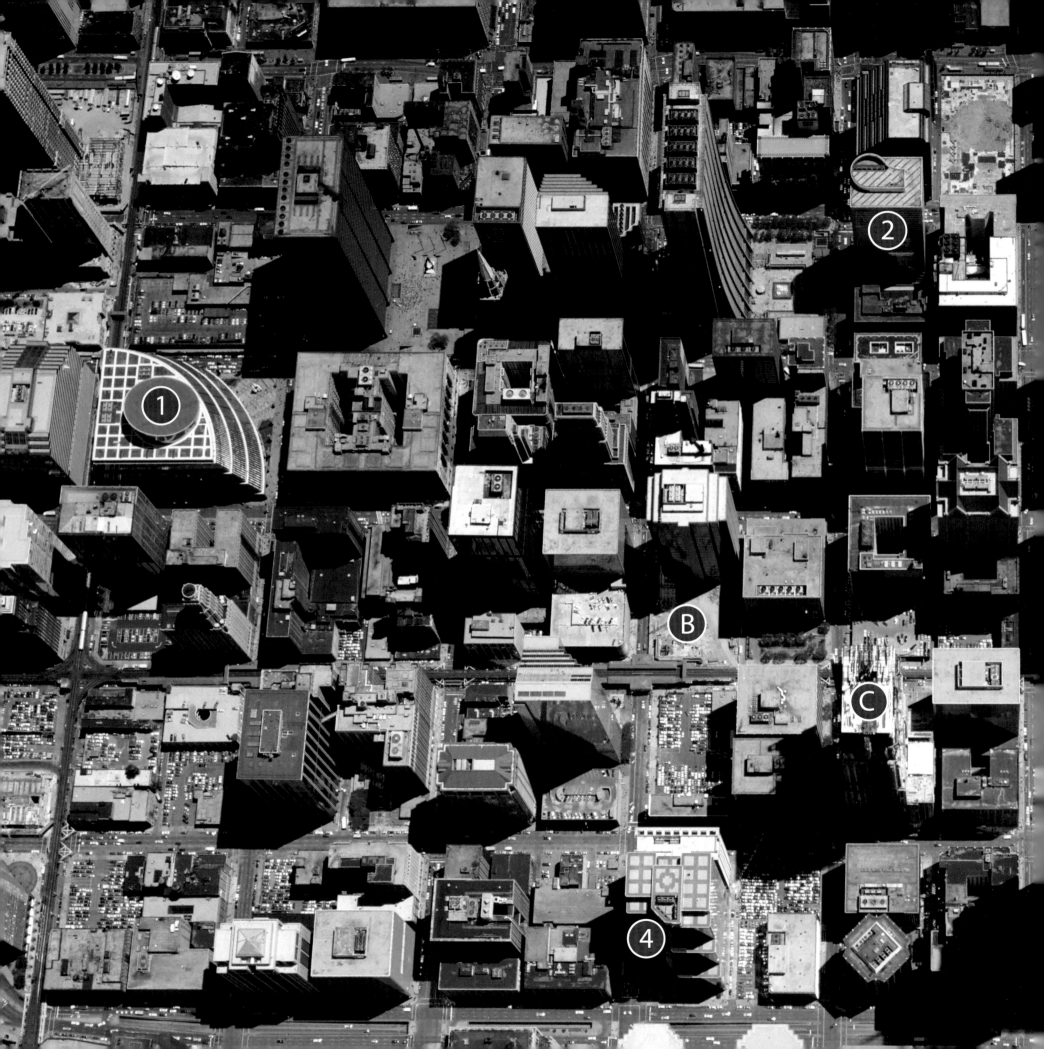

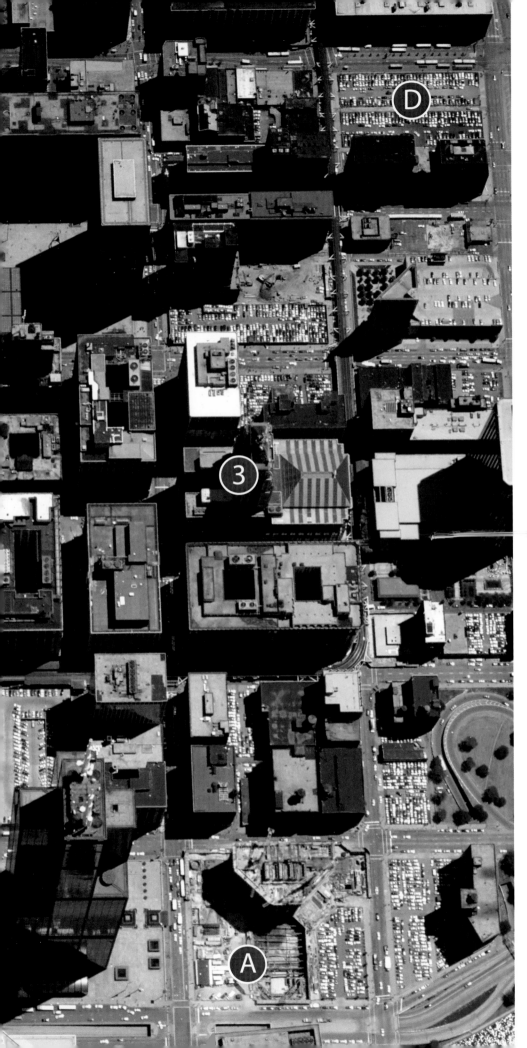

Helmut Jahn's Rooftops

Unseen by pedestrians and largely unknown to workers in nearby office towers, the rooftops designed by Helmut Jahn (Murphy/Jahn Architects) could clearly be seen from the sky. Until covered over in a subsequent resurfacing, the most prominent was the roof of the James R. Thompson Center ❶, completed in 1985. Jahn's other rooftops communicate enhanced identity through similar treatment of a frequently neglected detail. These include 55 W. Monroe ❷ and the Board of Trade addition ❸, both built in 1980, and One S. Wacker Drive ❹, completed in 1982.

June 9, 1988
The decade of the 1980's brought many prominent additions to the Chicago skyline. In the image at left, active construction continues at 311 S. Wacker Drive Ⓐ, Kohn Pederson Fox, architects and Harwood K. Smith Inc.; 181 W. Madison Ⓑ, Cesar Pelli & Assoc., architects; and AT&T Corporate Center Ⓒ, Skidmore Owings & Merrill, architects. The future site of Harold Washington Library Center Ⓓ, like so many others to be developed in the coming decade, is in temporary use as a surface parking lot.

August 13, 2007
The Thompson Center's roof after resurfacing. Chicago's City Hall displays its new green roof.

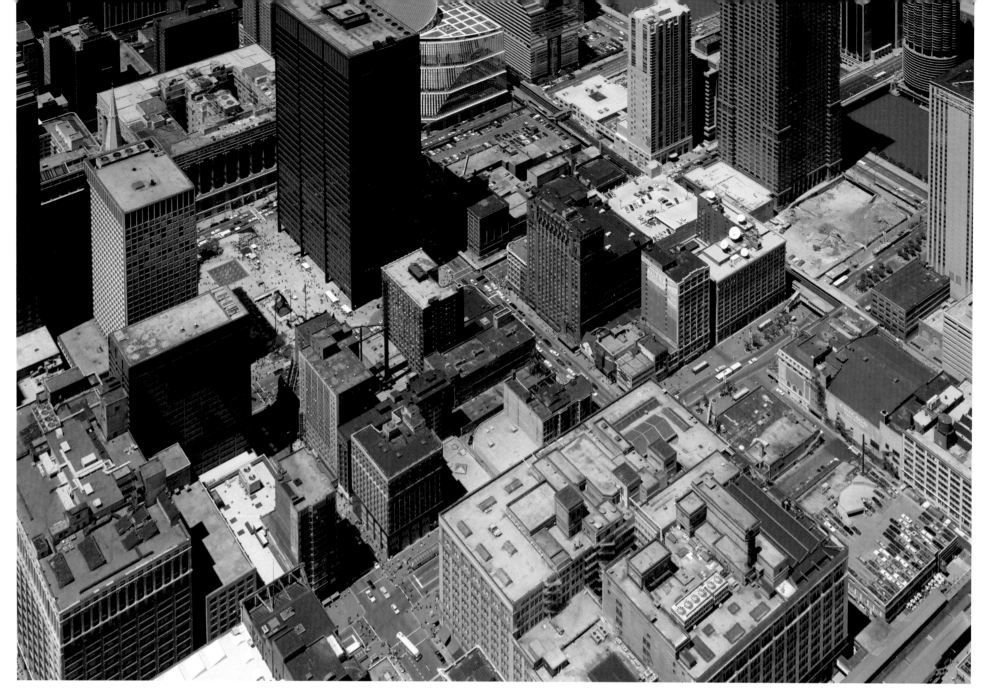

Block 37

Block 37 is identified as such in accordance with James R.
Thompson's 1830 city survey, and is one of 58 numbered blocks
in the historic center of the city. Declared as blighted in 1979
during the administration of Mayor Jane Byrne, and cleared in
1989, twenty more years would pass before its redevelopment as
a substantial real estate asset. Block 37 may be the only one in
Chicago to have a published biography: *Here's the Deal: The Buying
and Selling of a Great American City,* by Ross Miller (pub. 1996).

June 29, 1989
Block 37 lies between
the Daley Center (center-
left, top) and the former
Marshall Field's (now
Macy's) department store
(center-right, bottom).
Demolition would occur
later that year.

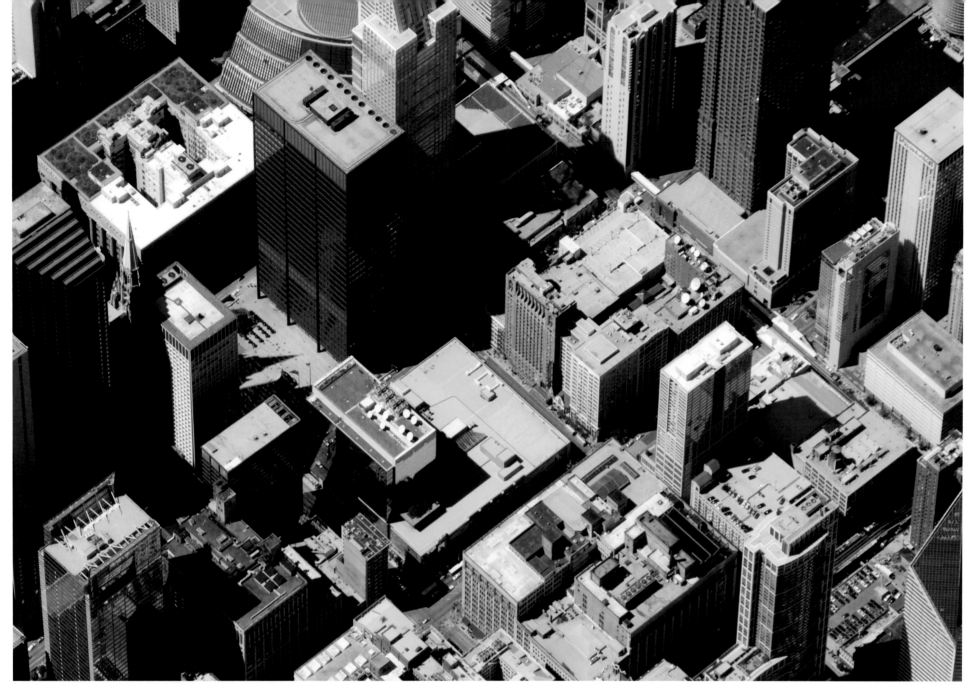

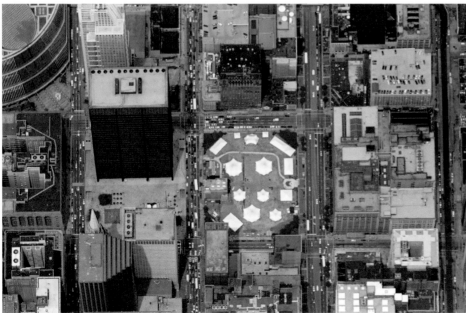

June 22, 1998
For nearly two decades, Block 37 supported a number of temporary civic events, from student art exhibits in the summer to ice skating in the winter. The site is bounded by Randolph Street on the north, State Street on the east, Washington Street on the south and Dearborn Street on the west.

August 16, 2010
Several developers attempted, without success, to see the redevelopment project through to completion. In late 2009, the project depicted above fell into foreclosure. A planned rapid transit terminal below Block 37, which would have facilitated commuter service to O'Hare International Airport, was deferred for lack of construction funds.

Construction of 131 S. Dearborn Street

A J. Paul Beitler development completed in 2003, Citadel
Center stands on a site that had been vacant since 1984. The
building rests upon the foundations of its predecessor, The Fair
department store of 1897. Montgomery Ward & Co. acquired The
Fair in 1957 and placed its own name on it in 1964. Chicago-based
DeStefano+Partners is the architect of record for the new building.

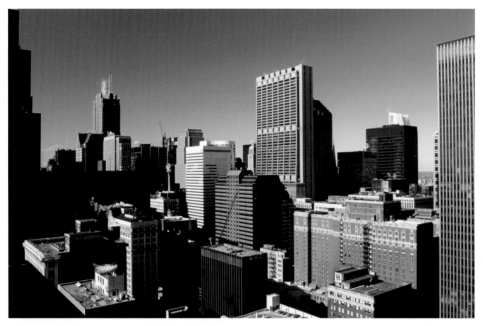
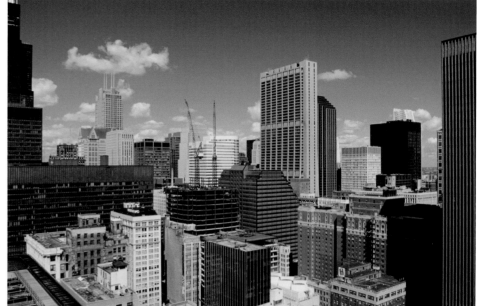
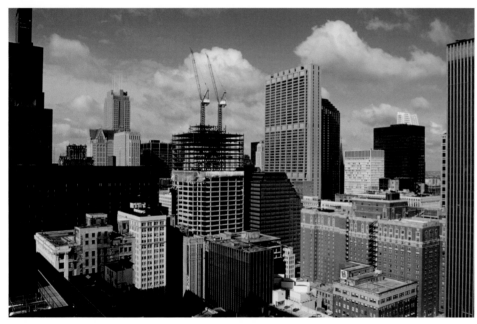
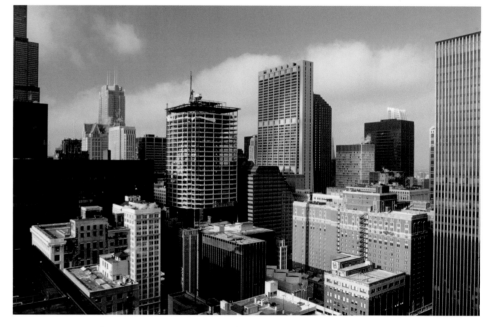
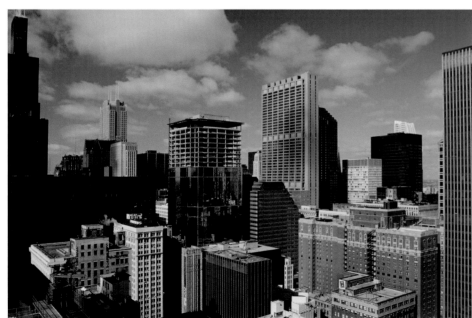
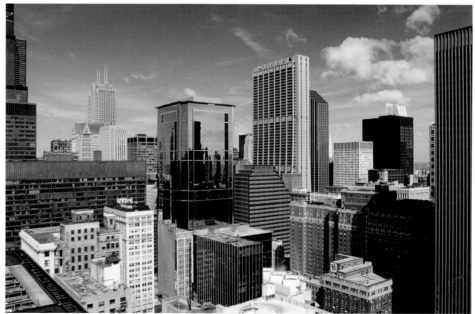

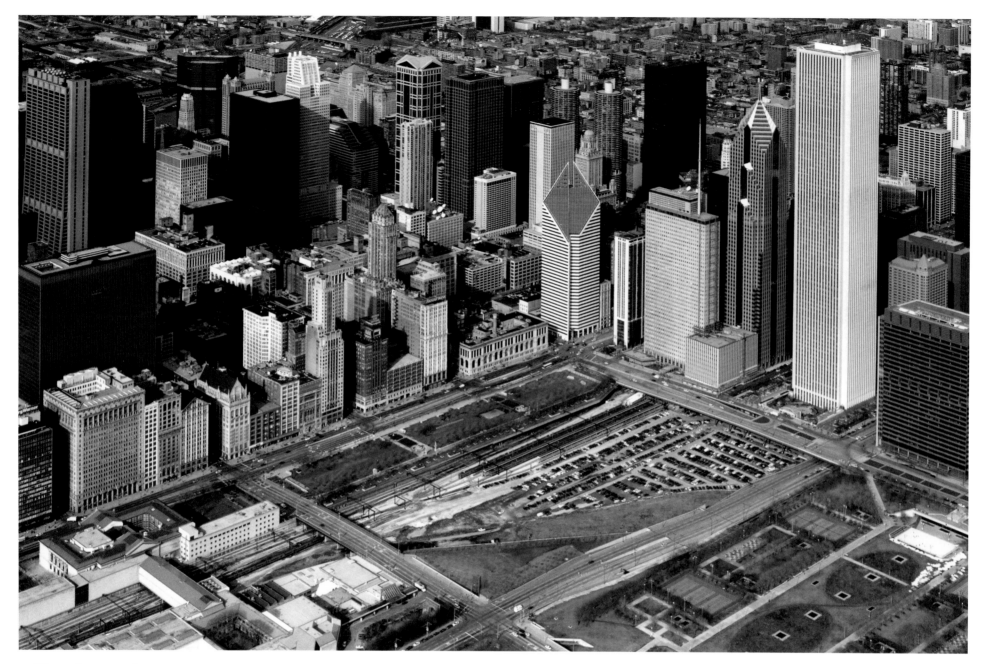

Millennium Park

In a few short years, Millennium Park has become one of the city's signature features, attracting worldwide attention for the sophistication of its architectural and sculptural components, the elegance of its overall design—and its impact (overwhelmingly positive) on surrounding property values. Private donors underwrote more than $200 million of its nearly $486 million construction cost. The largest green roof in the world, more than 24.5 acres, the park sits atop a three-level parking garage.

February 3, 1998
The last remaining vestige of a visible railroad presence north of Monroe Street can be seen in the center of this image. The rail line continues in operation today, below the surface of Millennium Park.

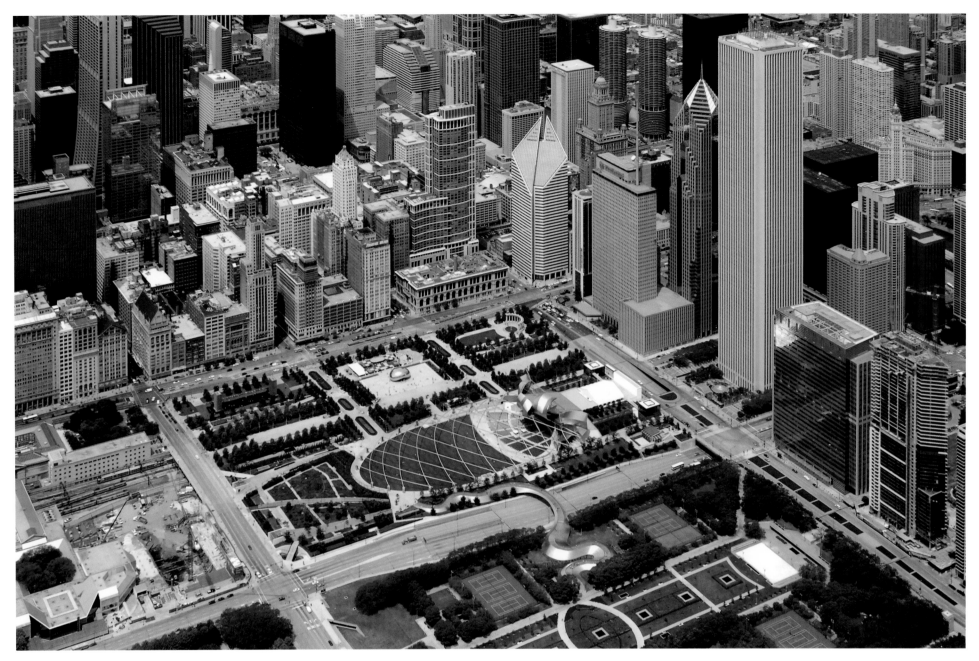

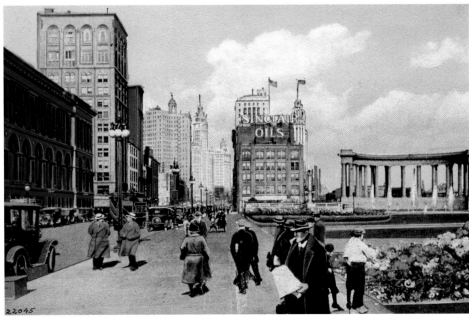

Grant Park Peristyle, circa 1920
View north on Michigan Avenue. The peristyle, at right, was completed in 1917 and demolished in 1953 to make way for the Grant Park North underground garage. Its replacement, the Millennium Monument, is located in the northwest corner of Millennium Park.

June 26, 2006
By the time of its completion, the park had attracted considerable new private sector investment. The Heritage Condominiums (Solomon, Cordwell, Buenz, architects) just behind the three-story Chicago Cultural Center on Michigan Avenue, was completed in 2005. 340-on-the-Park (lower right; also by Solomon, Cordwell Buenz) would be completed in 2007.

August 31, 2007 (overleaf)
Millennium Park, view to the north from Monroe Street. The Jay Pritzker Pavilion and the serpentine BP Bridge were both designed by Gehry Associates of Los Angeles.

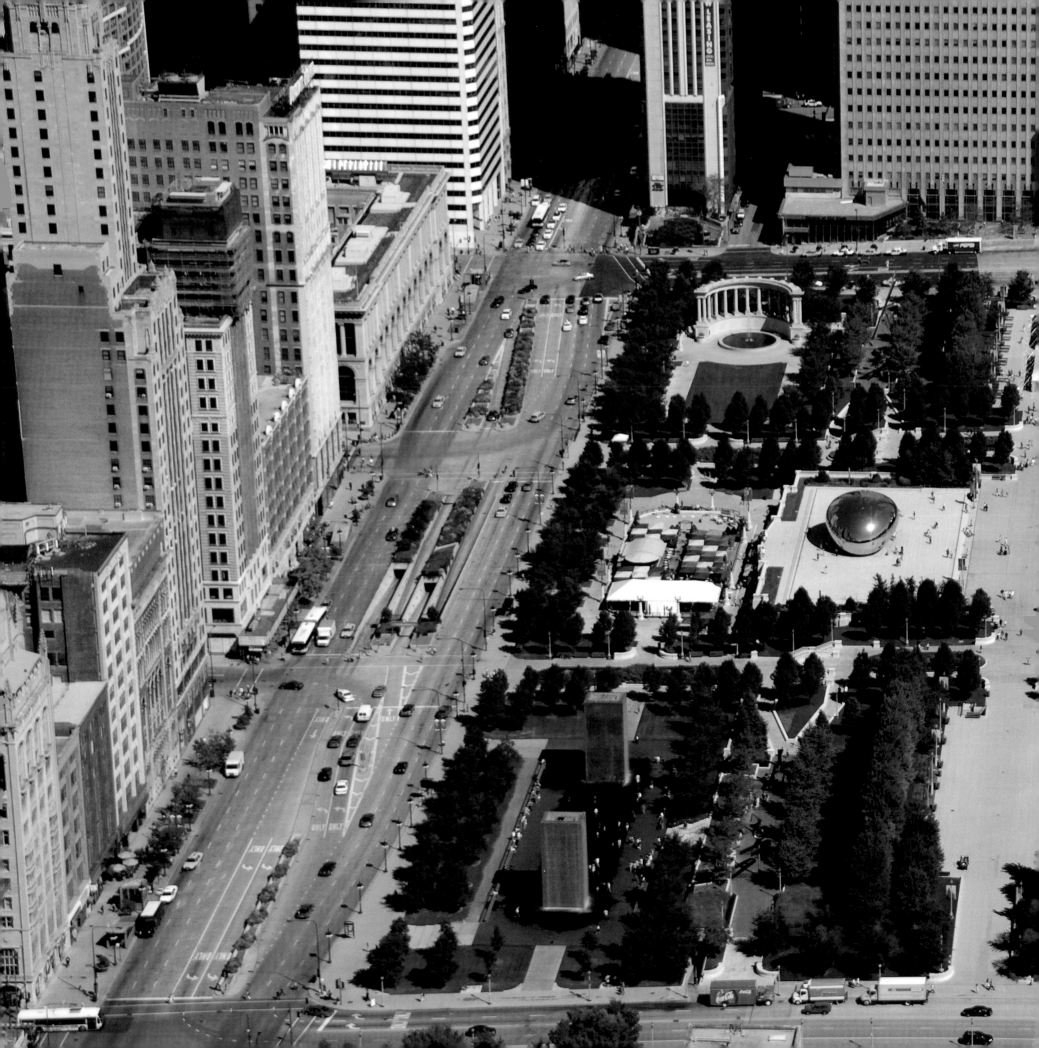

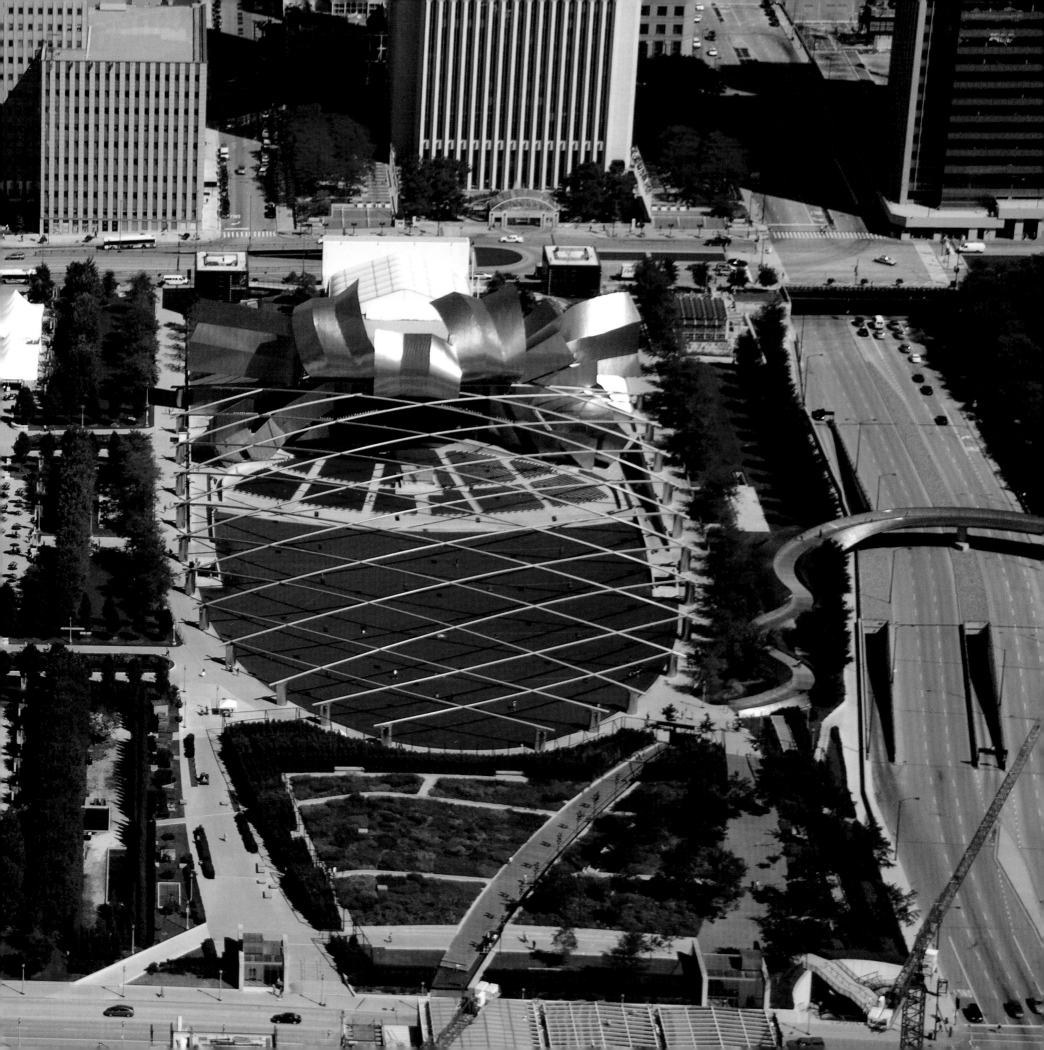

November 1998

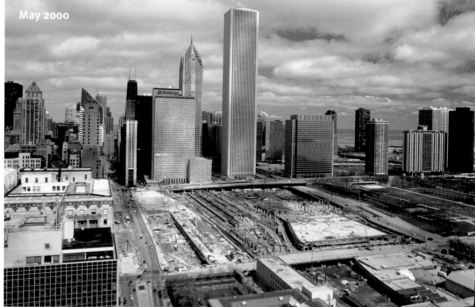

May 2000

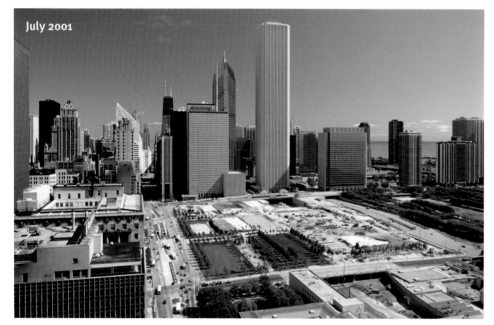

July 2001

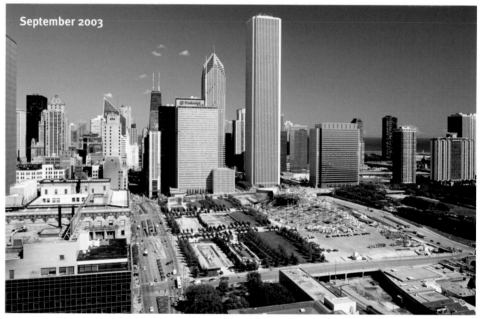

September 2003

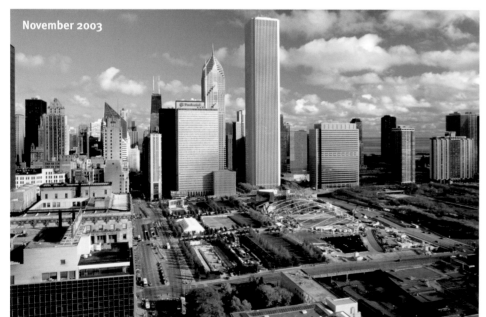

November 2003

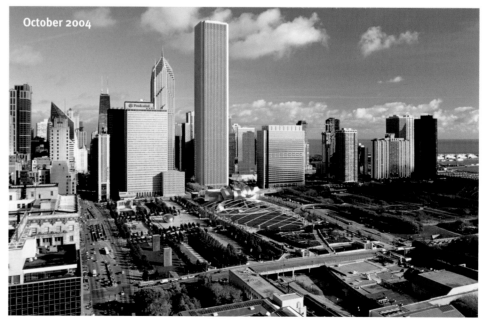

October 2004

(left)
The construction of the park commenced in October 1998 and concluded in 2004. The Public Building Commission of Chicago served as the developer and program manager.

August 23, 2004
Cloud Gate, affectionately known as "the bean," is the work of Indian-born, British sculptor Anish Kapoor. Soon after this picture was taken, the still-visible linear seams were filled and polished.

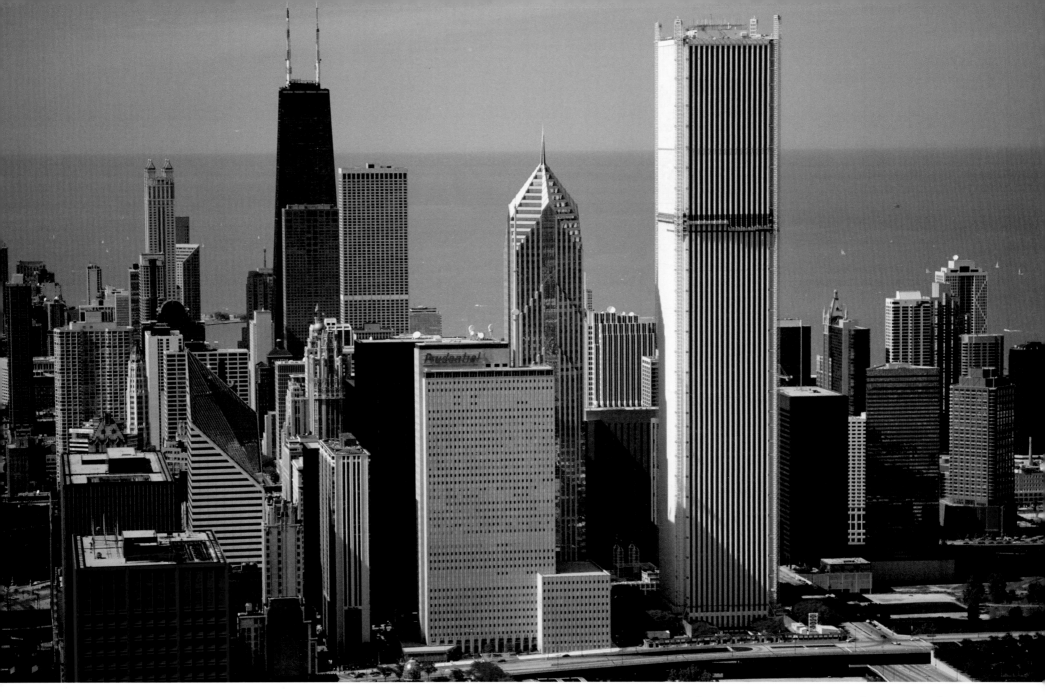

Aon Center

Renamed the Aon Center in 2001, the 1136-ft. tower, when completed in 1974, was known as the Standard Oil (of Indiana) Building, or "Big Stan." It was originally clad in the same white Carrera marble Michelangelo used to carve his famous *David*. The marble fared poorly in Chicago's harsh climate and had to be removed in 1990-92 and replaced by more durable white granite. The scaffolding demarcates the boundary between the two materials. It has been suggested that the cost of the recladding equaled two-thirds of the original construction cost of the entire building. New York-based architect Edward Durell Stone (1902-1978) is credited with the design.

June 23, 1991
The stone cladding was replaced from the bottom up. Although the marble appears to be darker than the granite, by the time it was removed it had been exposed to the elements for more than 15 years.

August 31, 2006
The Aon Center contains more than 80 acres of floor space. The plaza at the base of the building was renovated in 1994 according to the design of Highland Park (Illinois) architect Voy Madeyski.

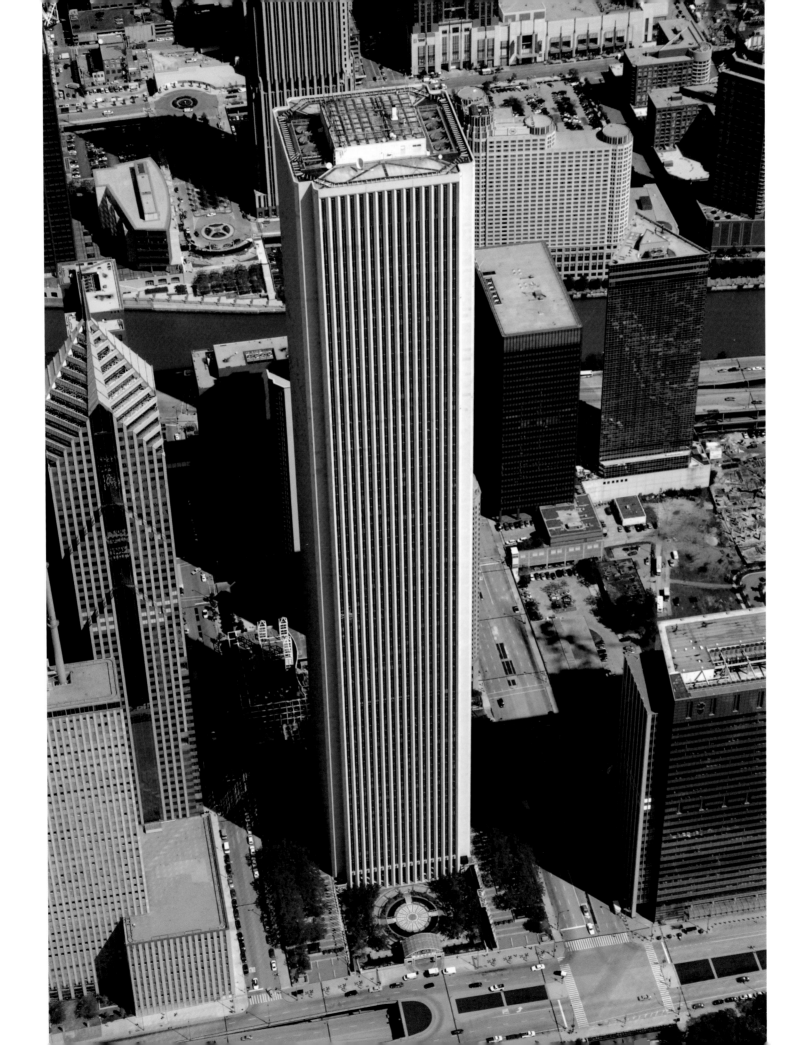

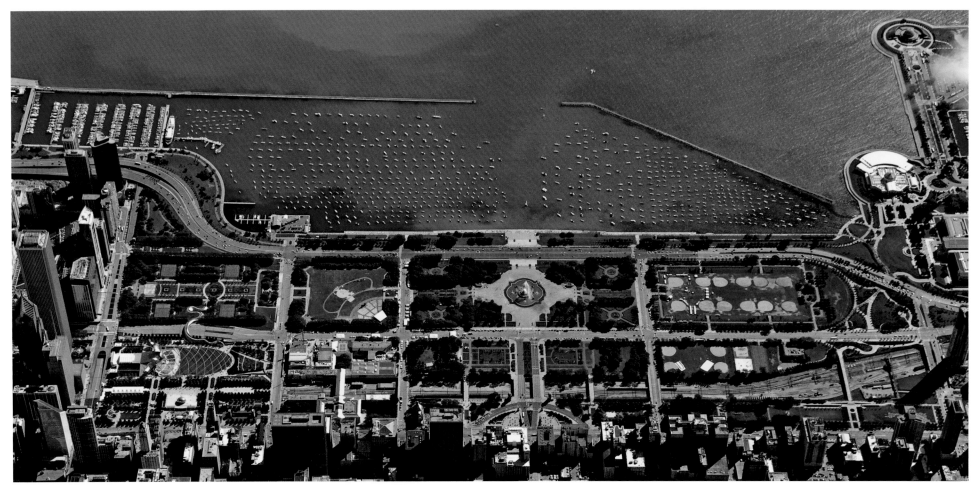

Grant Park

Generally regarded as the city's front yard throughout its history, Grant Park is mostly a 20th century construction. The landfill that extended it to the current shoreline dates from 1909. Buckingham Fountain was completed in 1927. Landscaping began after 1910, much of it is attributable to the New Deal public works programs of the 1930s.

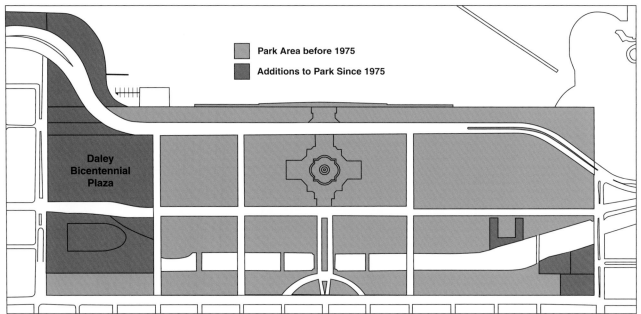

Park Area before 1975

Additions to Park Since 1975

Daley Bicentennial Plaza

September 15, 2007 (top)
For most of its history, the Michigan Avenue street wall defined the park's western boundary. Recent development on Randolph Street (left) and Roosevelt Road (right) now provide architectural definition on the north and south as well.

Growth of Grant Park
Change is not often easily perceived, but Grant Park has expanded by nearly 60 acres since the completion of Daley Bicentennial Plaza in 1976, to a current area of about 320 acres.

October 12, 2003 (right)
While the overall course changes from year to year, the Chicago Marathon always begins and ends in Grant Park. In 2003, 32,395 competitors crossed the finish line.

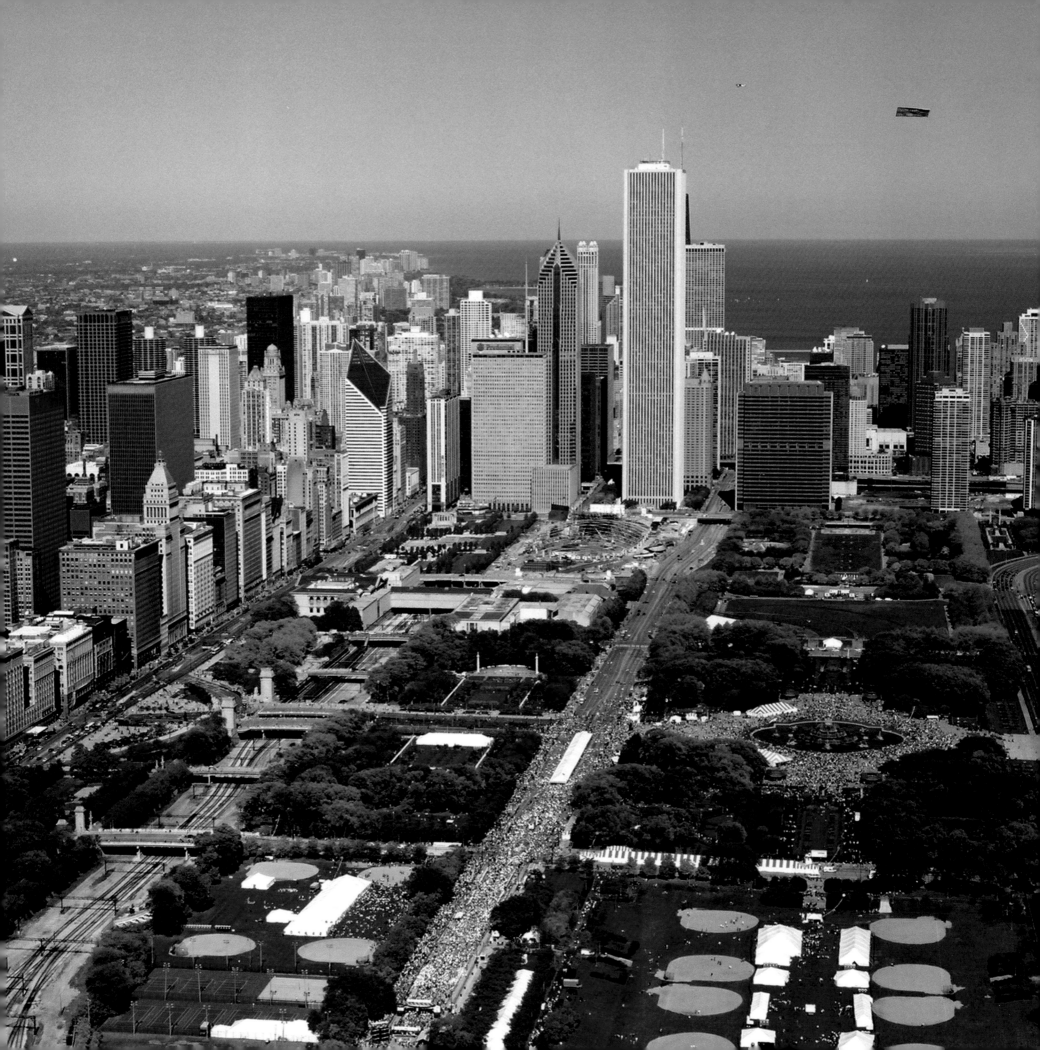

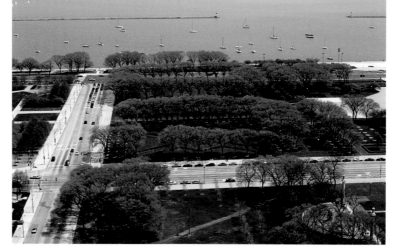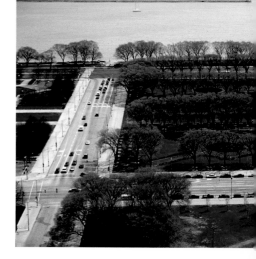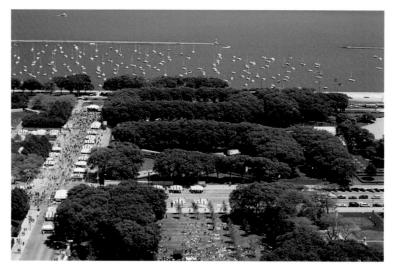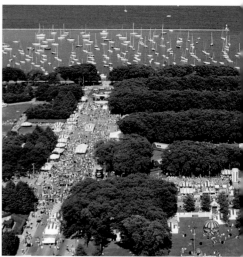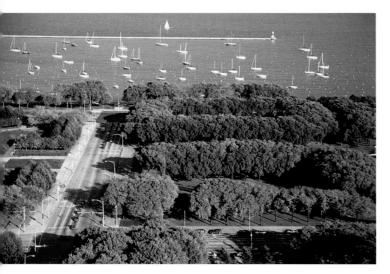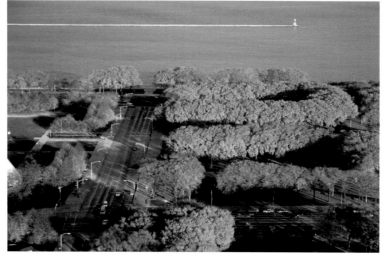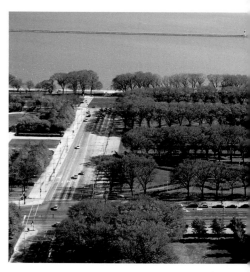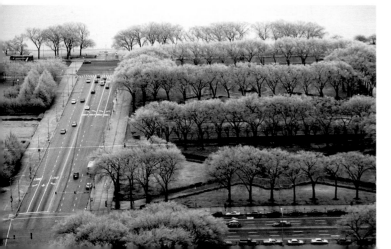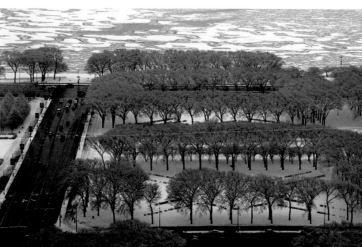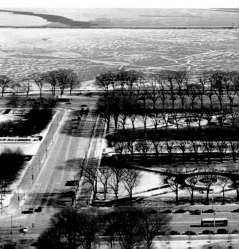

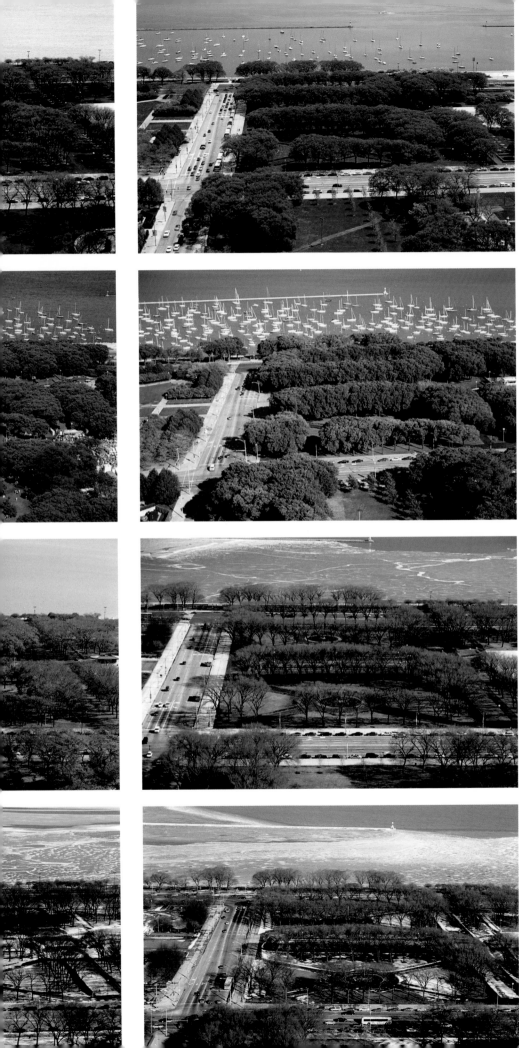

Grant Park Through the Seasons

Four seasons are insufficient to categorize Grant Park's ever-changing visual characteristics. Change can come gradually or suddenly. The trees, the ground, the lake and the weather seemingly conspire to produce imagery of unexpected natural beauty.

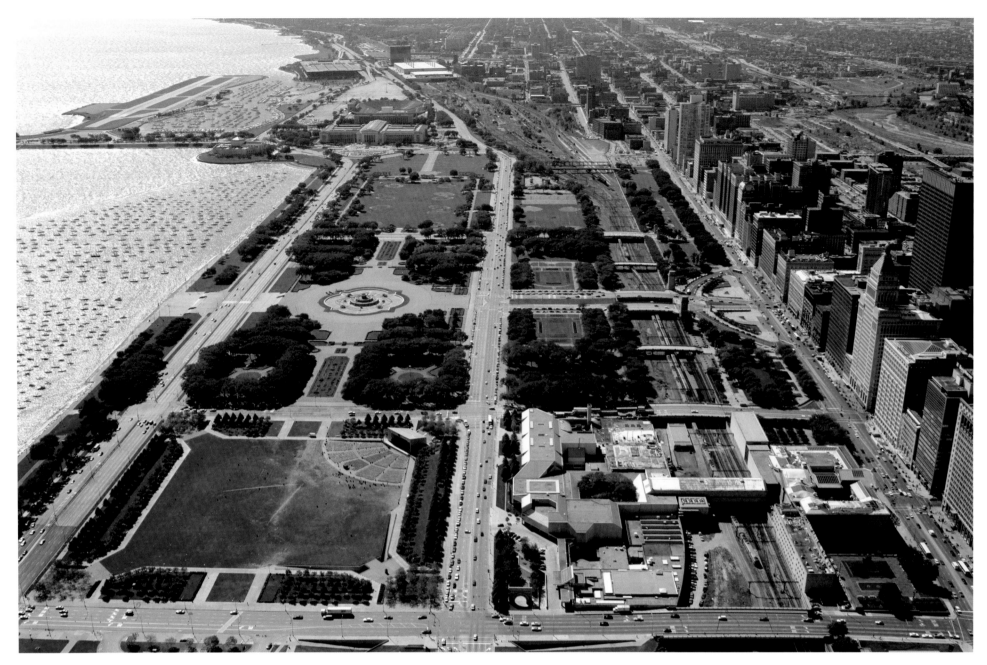

The Art Institute of Chicago

One of the world's great museums of art moved into its Michigan Avenue building (Shepley, Rutan & Coolidge, Boston, architects) in 1893 after the property owners along the east side of Michigan Avenue gave their consent to a building with 400 feet of street frontage. The Modern Wing, at the northeast corner of the complex, opened to critical praise in 2009. Designed by Renzo Piano, the 264,000 square-foot addition increased the museum's exhibit space by thirty percent. The Art Institute is now the second largest art museum in the United States.

September 16, 1986
View to the south, with Monroe Street in the foreground. The rectangular Ferguson (1957-1959) and Morton (1961-1962) wings adjoining the original Michigan Avenue building are clearly visible along the west side of the Illinois Central tracks. Construction continues at the School of the Art Institute on the north side of Jackson Blvd., and east of the tracks. The Goodman Theater was situated on the future site of the Modern Wing at the southwest corner of Columbus Drive and Monroe Street. Directly to its south is the Columbus Drive addition, completed in 1977, following the design of Walter Netsch, Jr., of Skidmore, Owings & Merrill.

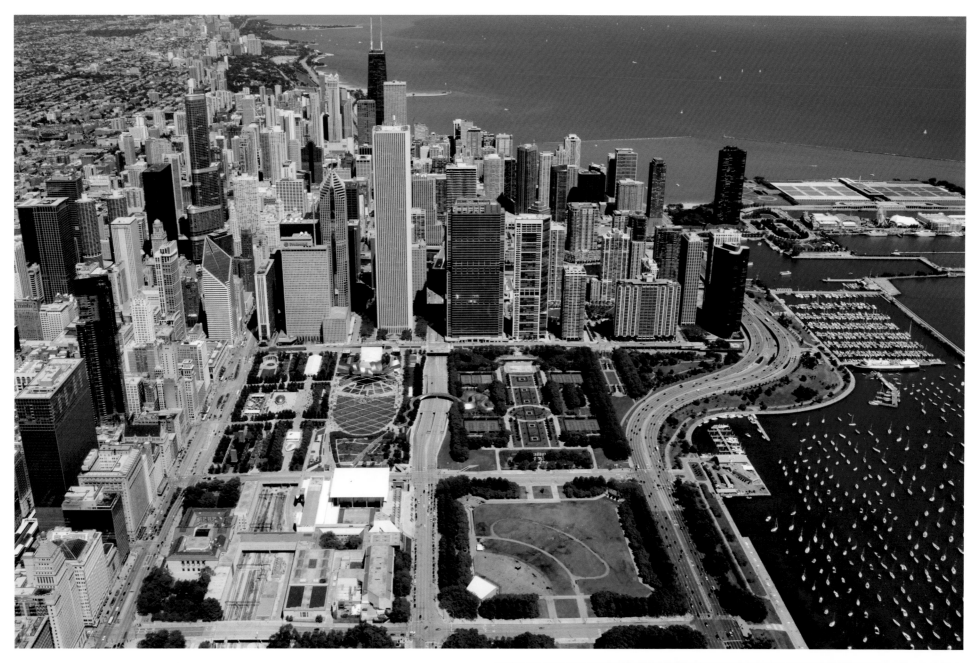

August 23, 2009
View to the north, Jackson Blvd. in foreground. The white-roofed Modern Wing has become the most distinctive architectural component of the museum complex. The Nichols Bridgeway, crossing Monroe Street and providing a dramatic pedestrian link between the third floor of the Modern Wing and Millennium Park, brings the park and museum together in a unified work of urban design.

August 28, 2007
The Art Institute's Michigan Avenue frontage was limited to 400 feet under an 1891 consent agreement with the property owners on the west side of the avenue.

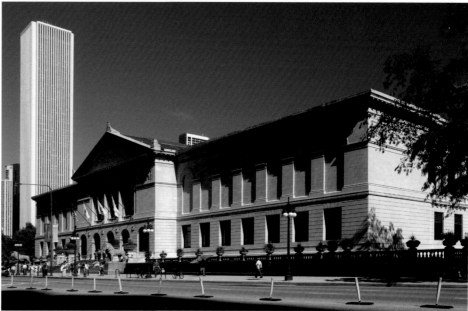

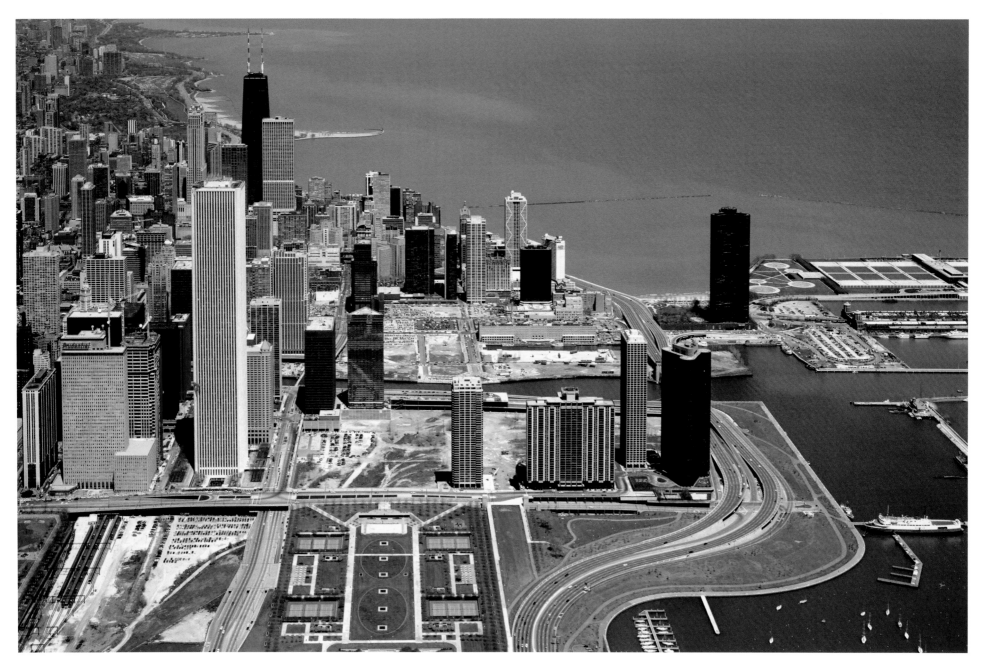

Randolph Street

The sector of Randolph Street east of Michigan Avenue has always been an elevated roadway. Originally constructed on a viaduct to provide lakefront access across the Illinois Central Railroad classification yards, the elevated configuration has survived to the present day as an essential component of the three-level road system serving the immediate area. Development along Randolph Street's frontage did not reach maturity until the 2009 completion of the 22-floor addition to Blue Cross/Blue Shield building, which arrived on the site in 1997.

May 11, 1989
Not only did Grant Park lack an architecturally-defined northern boundary, but Millennium Park (lower left corner) had hardly been imagined.

September 16, 2009
At least 29 of the multi-story buildings east of Columbus Drive (lower left) have been built since 1989. Stacked on end, they would rise more than 2.5 miles into the sky.

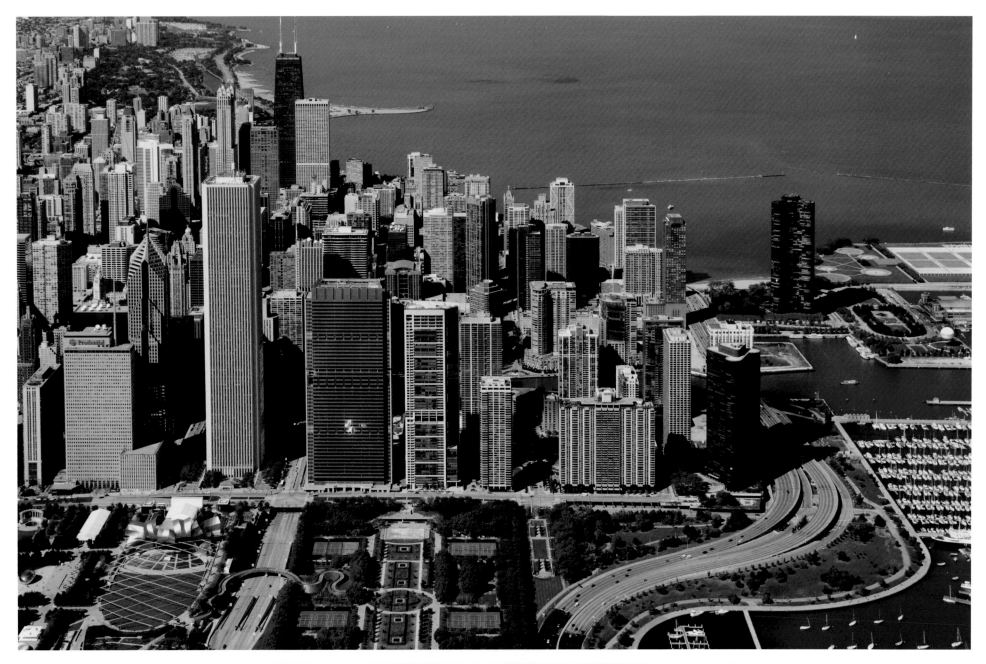

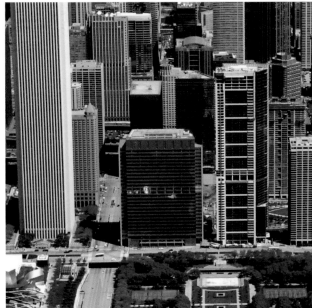

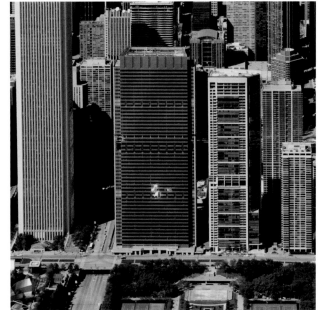

May 5, 2007 (far left)
The Blue Cross/Blue Shield Building as it had appeared since initially occupied in 1997 (Lohan Caprile Goettsch, Architects).

Sept. 16, 2009 (left)
By design, the construction of the 22-story addition did not interfere with ongoing office operations on the lower floors.

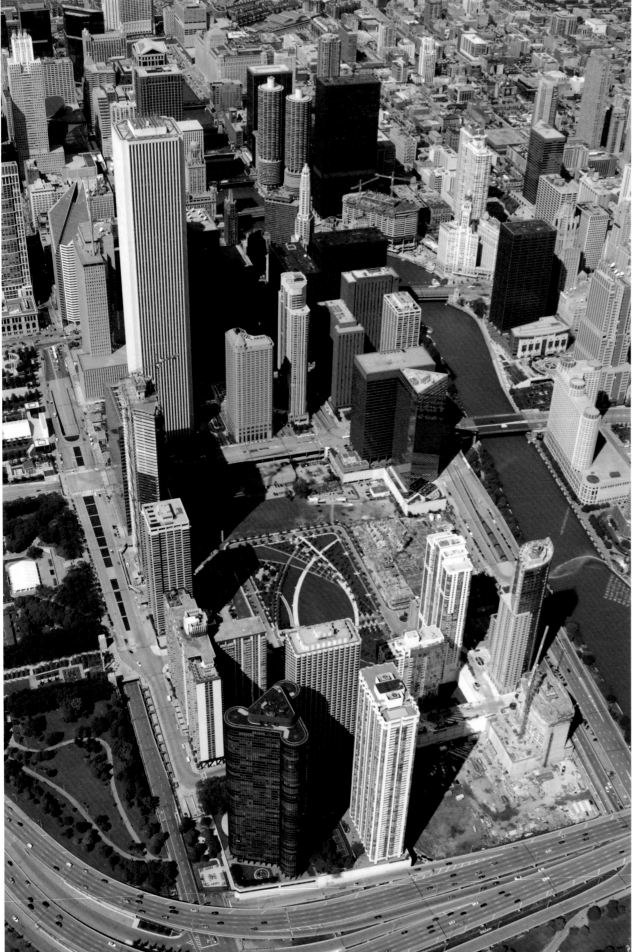

Lakeshore East

Change in Chicago can occur with stunning rapidity. In these two photos, taken almost exactly three years apart, at least six consequential new building projects can be identified, including the Aqua ❶ (Studio Gang Architect), Trump Tower ❷ (Skidmore, Owings & Merrill), a 24-story addition to the Blue Cross Building ❸ (Lohan Caprile Goettsch) and three additional high-rise apartment buildings in Lakeshore East: the Chandler ❹ (DeStefano+Partners), the Shoreham ❺ (Loewenberg Associates) and 340 E. Randolph ❻ (Solomon, Cordwell, Buenz).

August 31, 2006
The six-acre park in the center of Lakeshore East was a requirement of the original planned development approved for the former Illinois Central site in 1969.

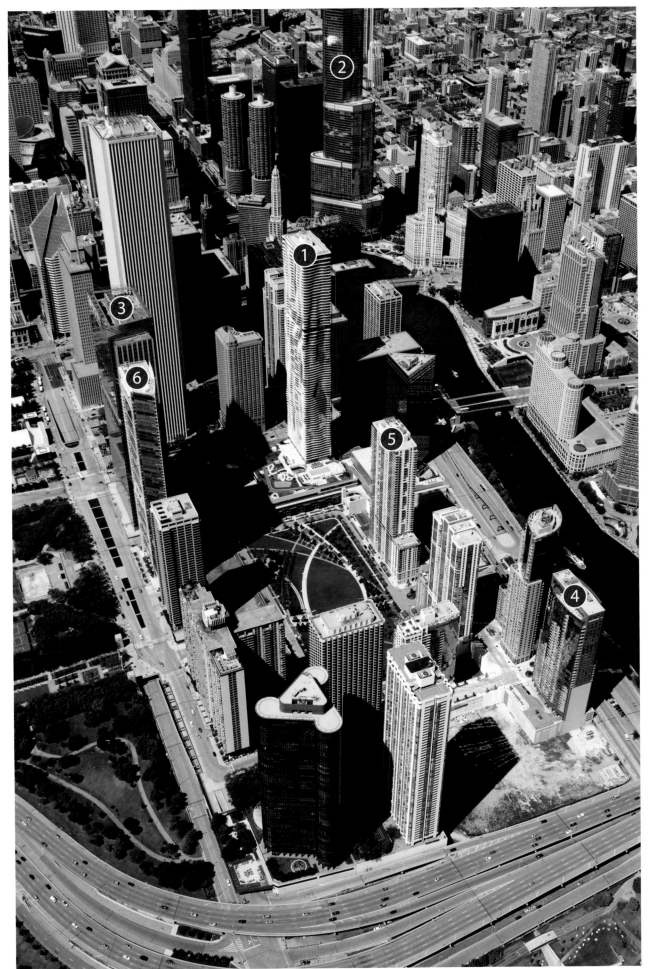

August 23, 2009
A continuous row of tall buildings provides physical definition to the north boundary of Grant Park.

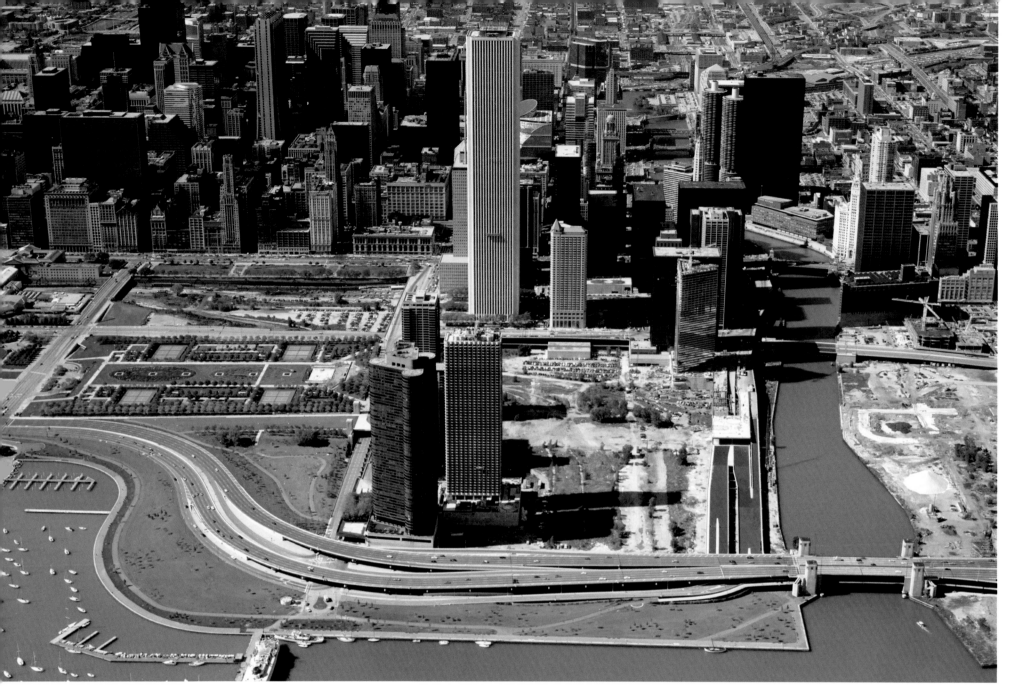

Lakeshore East occupies the onetime site of the Illinois Central Railroad classification yards, where grain harvested on the Illinois prairie was stored in giant elevators at the river's edge before being transferred onto Great Lakes vessels. The City approved a very ambitious development plan in 1969, but most of the site remained vacant until 2005, when it was acquired by Magellan Development Company. Since then, seven new high-rise residential buildings containing nearly 3,800 units have been completed. Six additional parcels on the periphery of the 28.5-acre site await future development.

October 1, 1987
The 1985-1986 relocation of Lake Shore Drive from its old right-of-way (the horizontal gravel strip south of the river, center of photo) to the water's edge, created fourteen acres of new lakefront parkland. The ground floors of the buildings fronting on Lake Shore Drive, sitting atop "underground" parking garages, are higher than the elevated roadway.

August 23, 2009
All Lakeshore East buildings have park and/or water views. Skidmore, Owings & Merrill prepared the master plan.

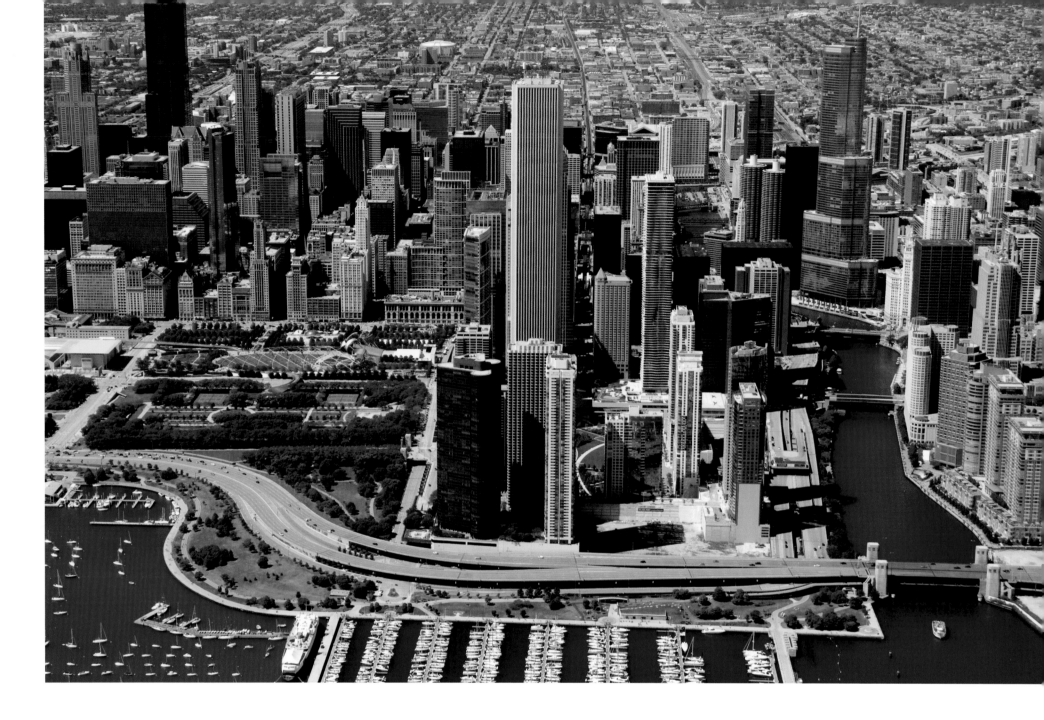

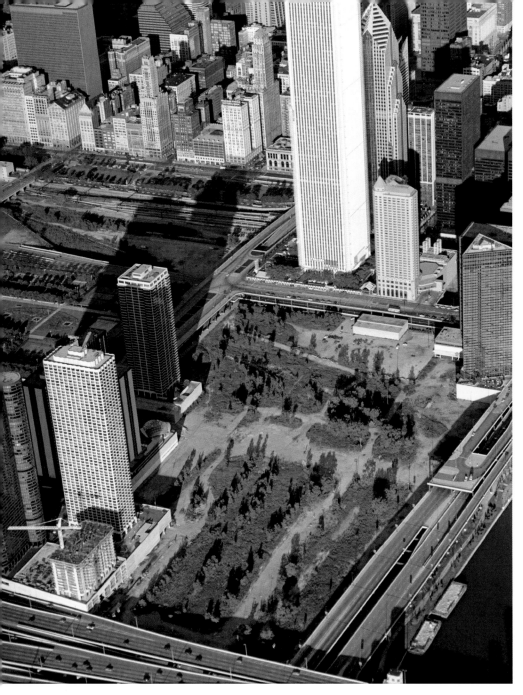

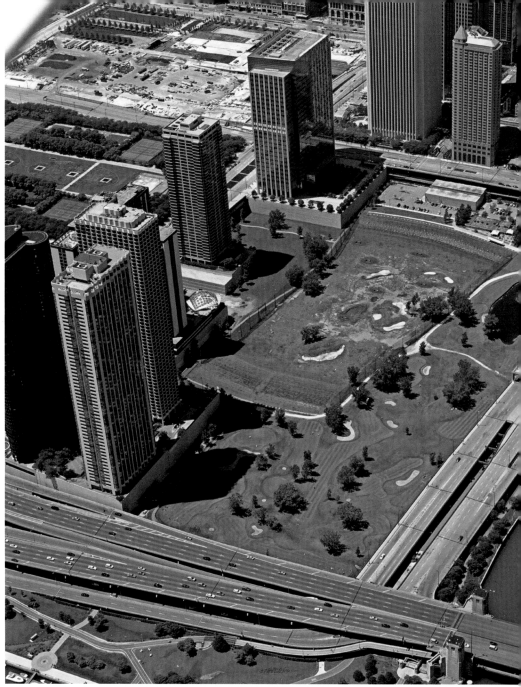

June 19, 1990
The former right-of-way of Lake Shore Drive (horizontal gravel strip, center) bisected the site. The three-level road system, which places all parking and loading below finished grade, is clearly visible.

June 17, 2001
From 1995 until 2002, a chip-shot golf course occupied most of the site. The trees on the course had previously emerged naturally among the rail spurs.

October 24, 2007
Construction activity is evident throughout the Lakeshore East site. The yellow crane at right sits atop the lower floors of the Aqua, which would be completed in 2009.

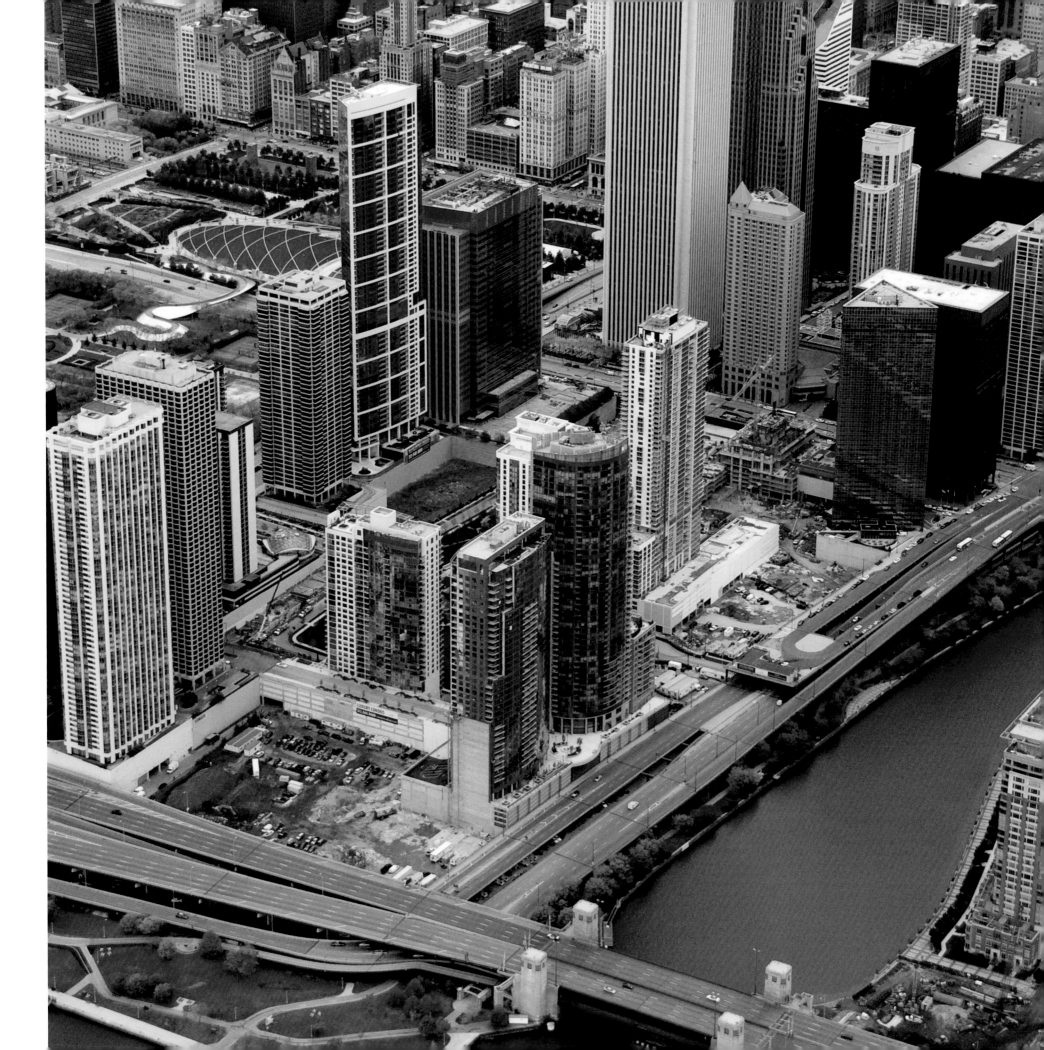

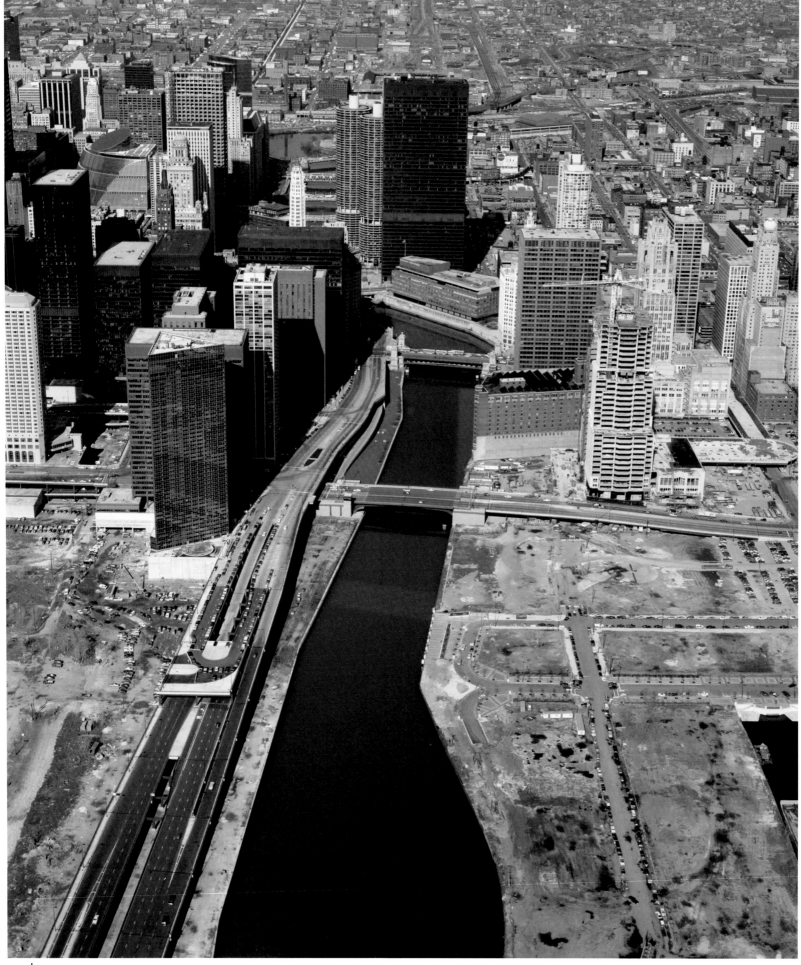

Trump Tower

At 1388 feet, Trump Tower is now the second tallest building in Chicago—and the United States. The 92-story structure has 2.6 million square feet of floor space. Sears (now Willis) Tower (1451 feet, completed 1974) and the John Hancock Center (1127 feet, completed 1969) were, like Trump, designed by Skidmore, Owings & Merrill.

April 29, 1988
Naess & Murphy designed the old Sun-Times building (the low-rise structure at the bend in the river). With a construction budget of $15 million, it opened in 1958. The Trump venture paid $73 million to acquire the property. Exposed railroad tracks had previously occupied the riverfront site.

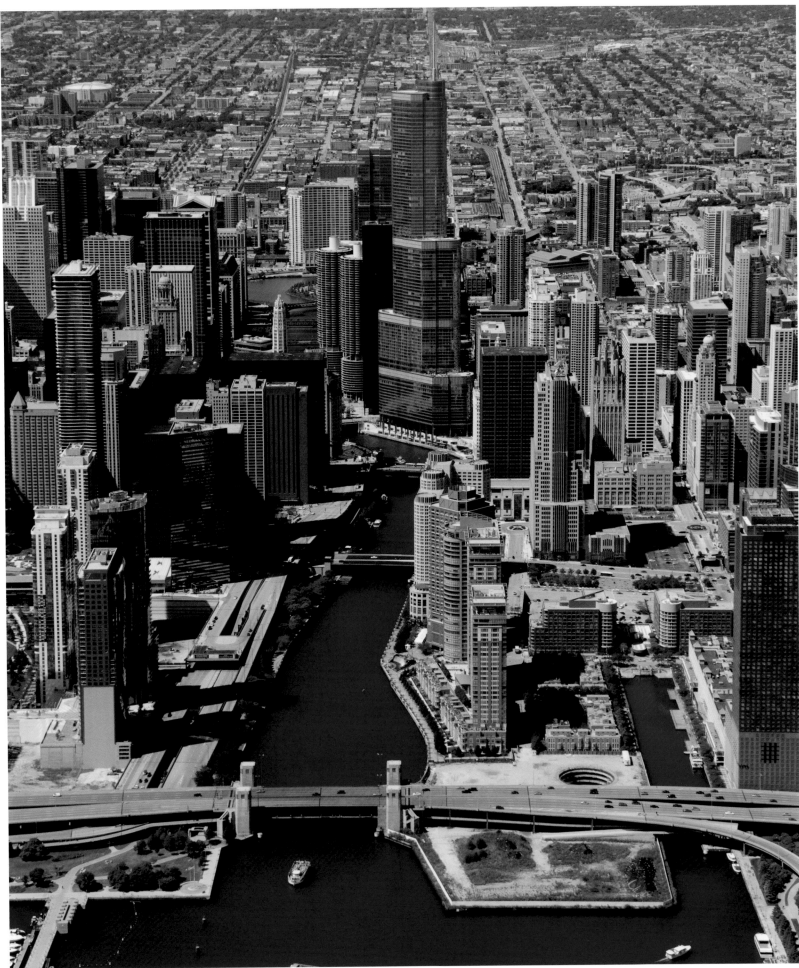

August 23, 2009
Its commanding presence at a bend on the main channel of the Chicago River provides the tower with unobstructed lake views from every floor.

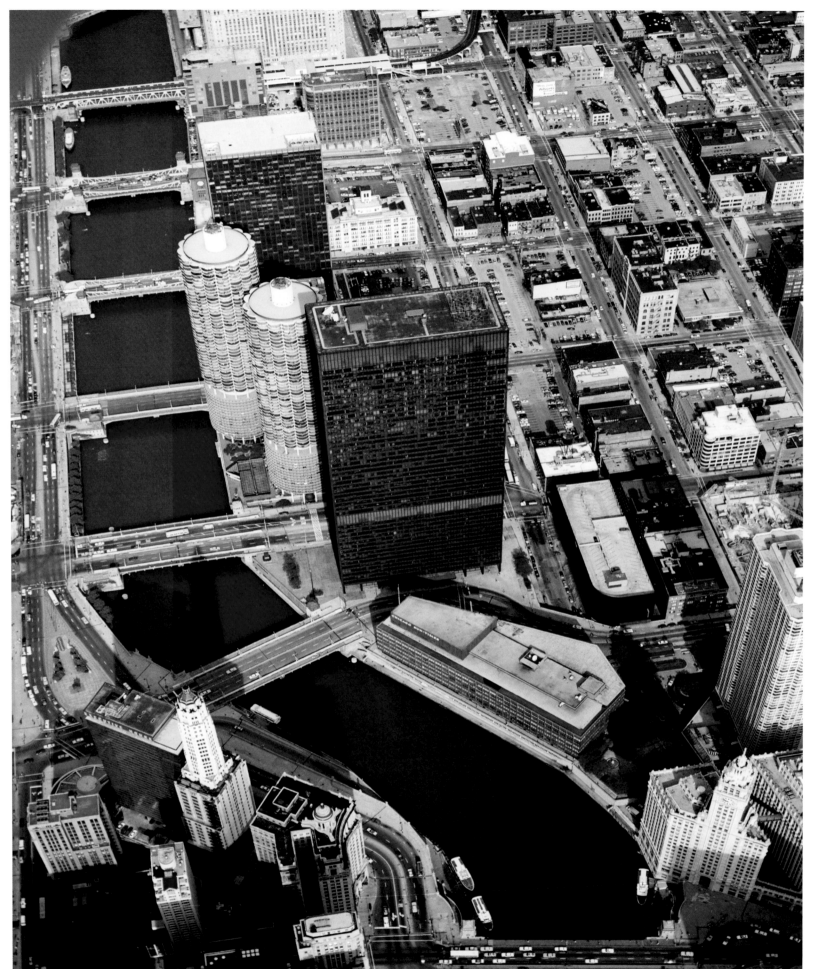

June 19, 1990
Marina City, left (Bertrand Goldberg Associates, 1967), and the neighboring IBM Building, center (Ludwig Mies van der Rohe, completed 1971) established a dramatic high-rise presence on the north side of the river's Main Channel.

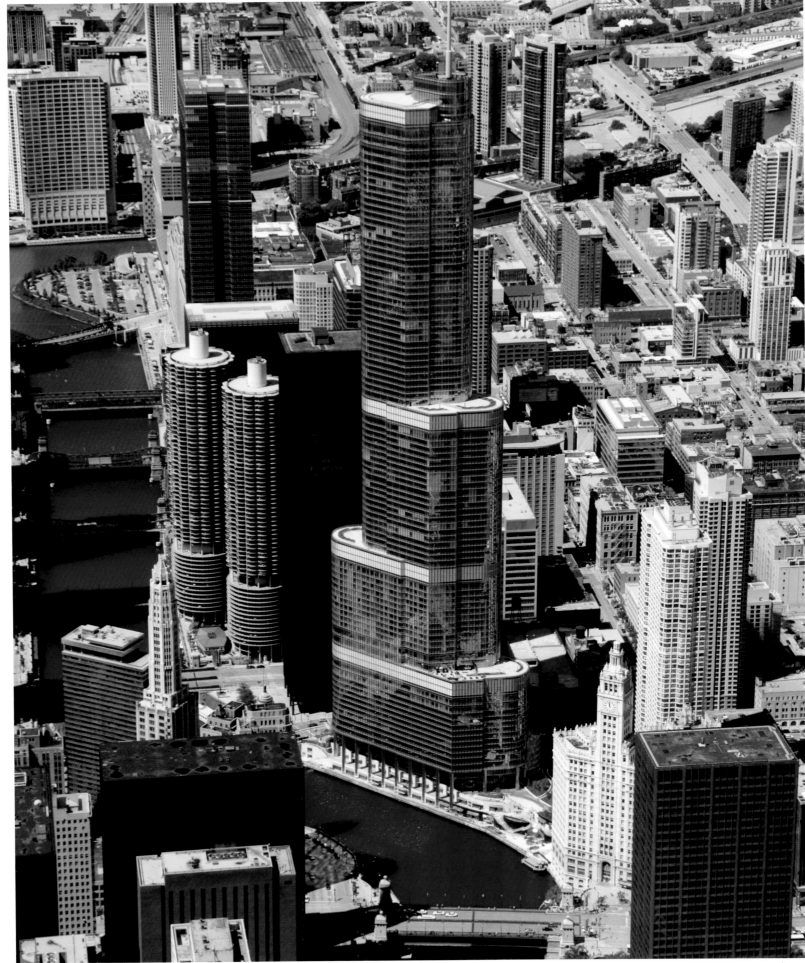

August 23, 2009
Adrian Smith, the
Skidmore, Owings
& Merrill architect
responsible for the Trump
design, is also the architect
of the current world's
tallest building, Burj
Khalifa in Dubai.

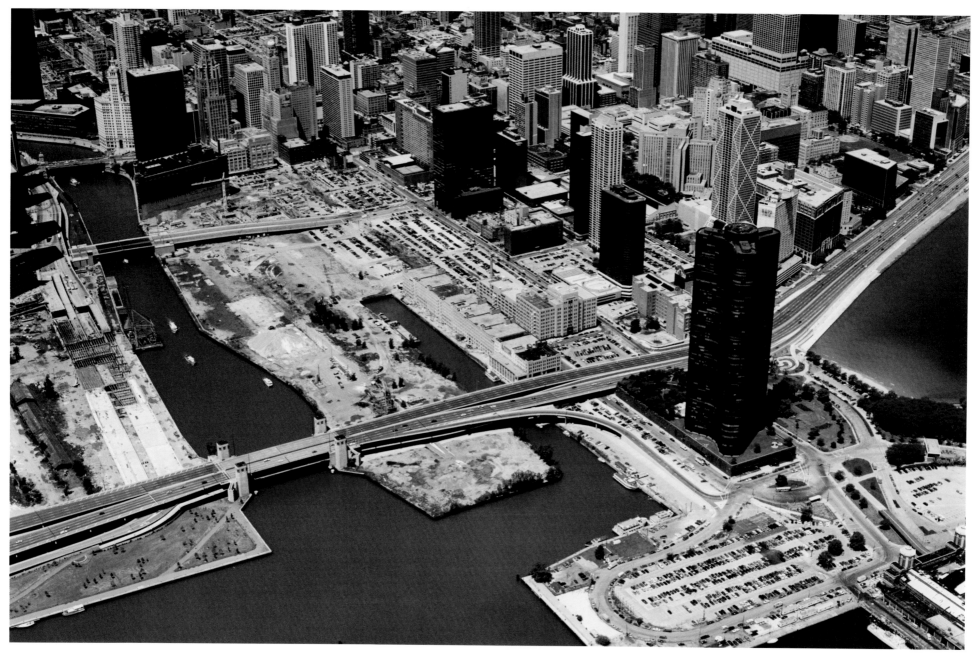

Ogden Slip/River East

The dead-end canal in the center of this image, known as Ogden Slip, is a remnant of the shipping industry that once flourished at the mouth of the Chicago River. Originally owned by the Chicago Dock and Canal Trust, the 52-acre site was sold for $180 million in 1997 to an investment group led by developer Dan McLean. The subsequent development plan for the property transformed the banks of the Chicago River into a pedestrian amenity, thereby altering long-held attitudes about the river's value as a feature of the urban environment.

167—Outer Drive Link Bridge and Skyline, Chicago

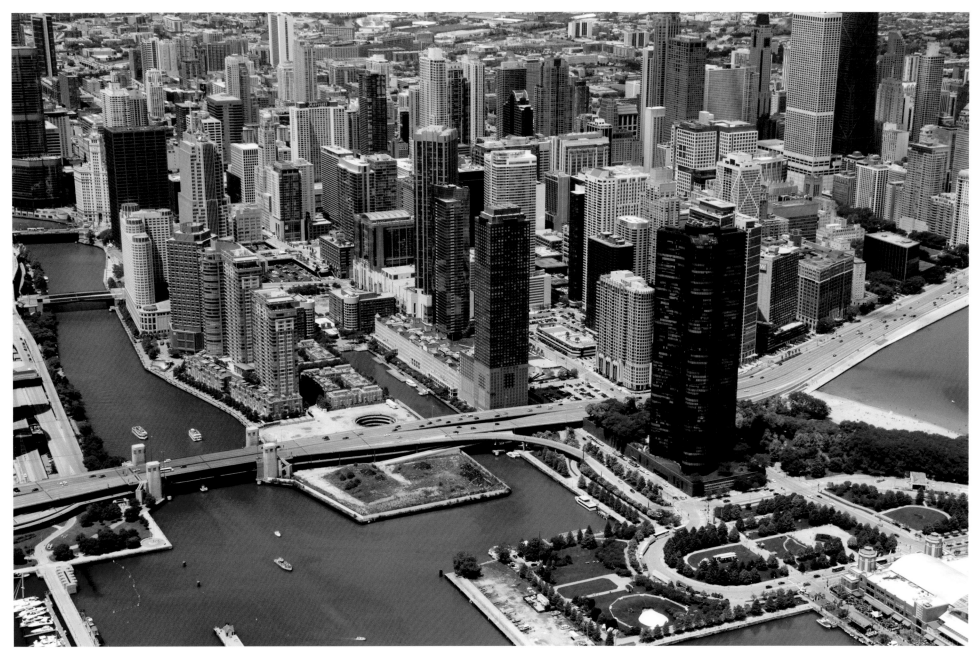

June 4, 1987
The completion in 1983 of the Columbus Drive Bridge (the second longest bascule bridge in the world) greatly facilitated the development of the riverfront property and the land adjoining Ogden Slip.

The "S-Curve," circa 1941
The infamous "S-curve" of Lake Shore Drive supported an elevated roadway traversing the industrial uses at the mouth of the Chicago River. It would not be replaced with the current configuration until 1985-6.

June 16, 2010
The circular substructure of the stalled "Spire" project is on the south side of Ogden Slip just west of Lake Shore Drive. The peninsula east of Lake Shore Drive is the site of the future DuSable Park.

Navy Pier

Chicago Municipal Pier opened in 1916, largely as a terminal for lake-borne freight and passenger service, although the head house at the easternmost end has from the start been a place of public gathering and recreation. Renamed Navy Pier in 1927, it served as a training facility for the US Navy during World War II. The University of Illinois at Chicago occupied the Pier from 1946 until 1965, when the new Circle Campus opened on the Near West Side. The Pier subsequently fell into disrepair, until its revival in the 1990s.

August 1, 1990
On the eve of its rebirth, the active area of Navy Pier had been reduced to the historic head house.

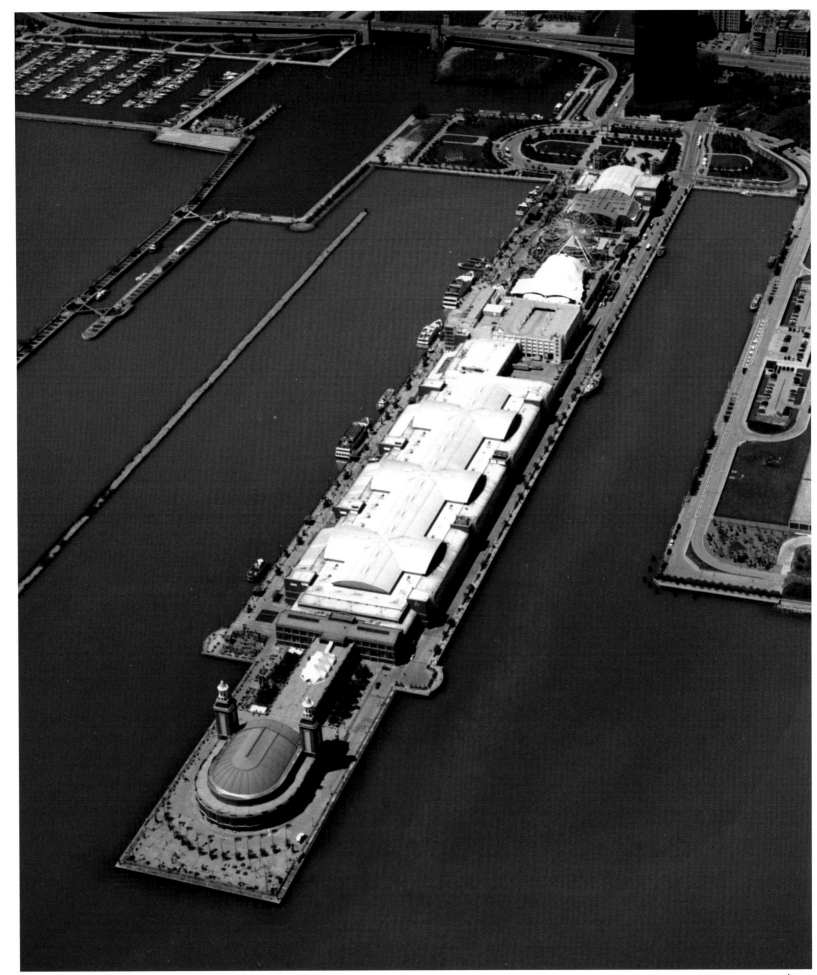

May 21, 2002
The pier complex, including the park adjoining its main entrance, encompasses more than 50 acres. It extends 3300 feet from shoreline into the lake.

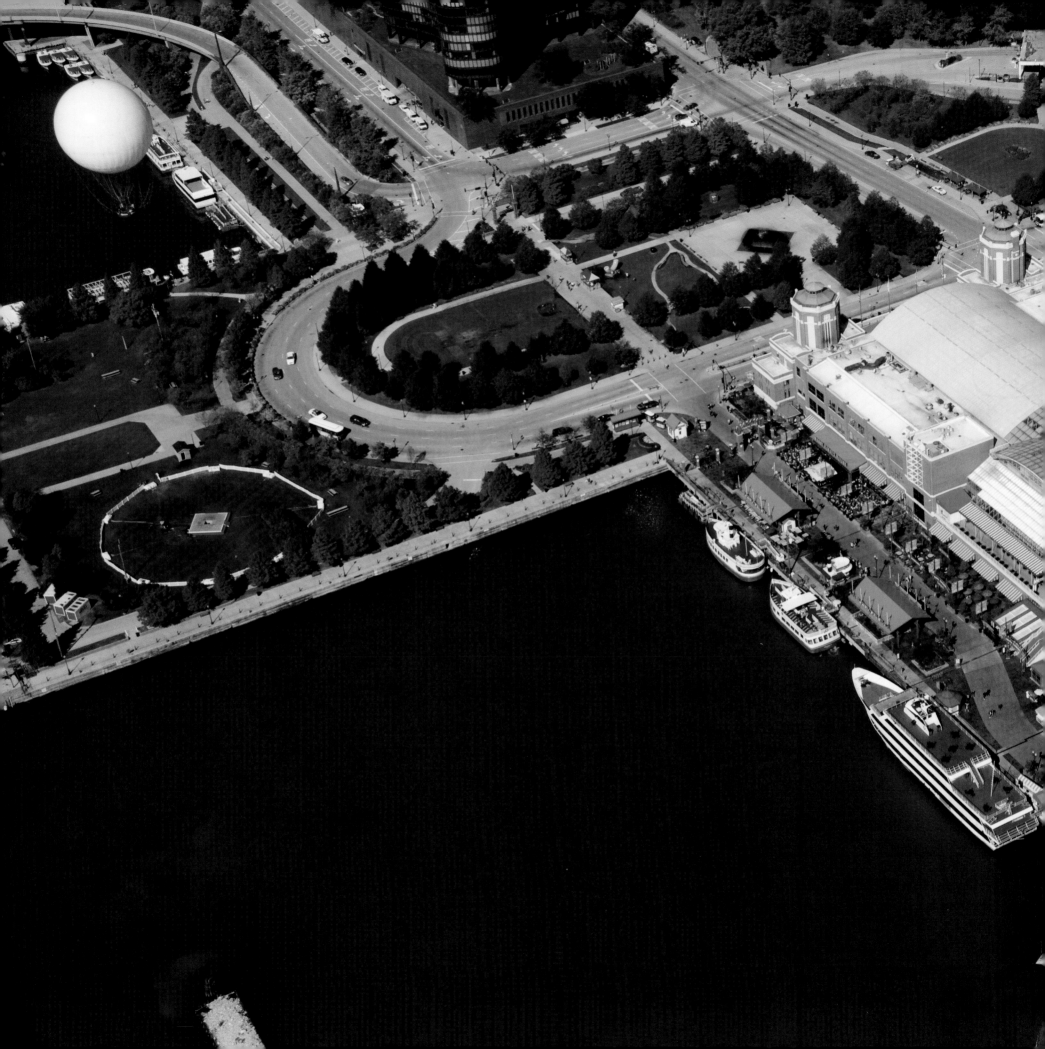

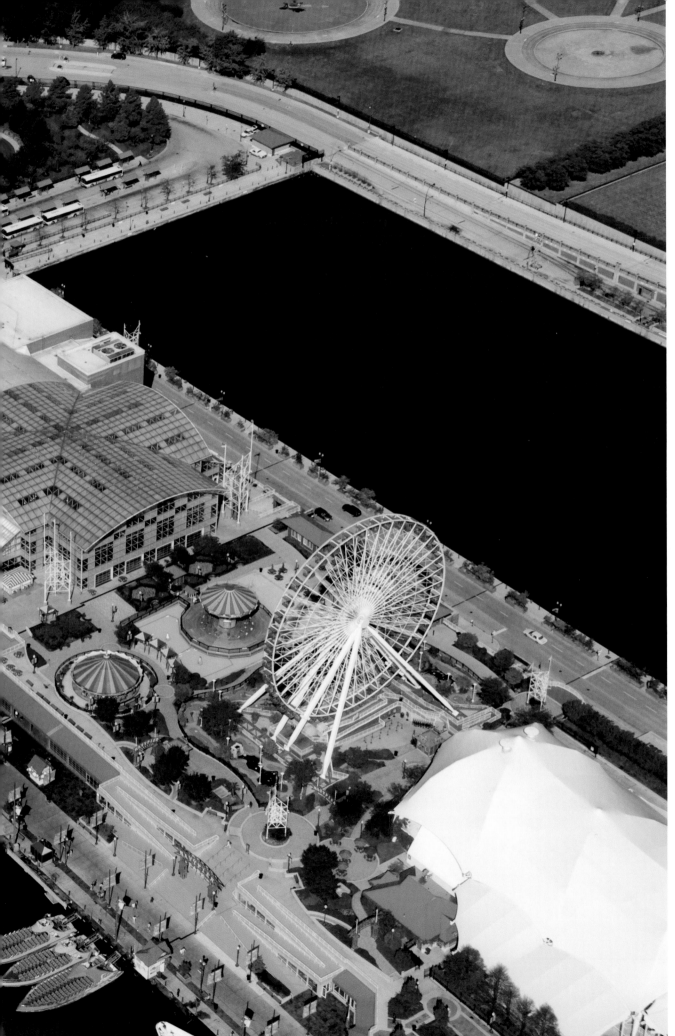

August 4, 2006
Some of the special attractions located in the west end of the Pier include the 150-foot diameter Ferris Wheel, the Chicago Children's Museum, the Chicago Shakespeare Theater, and the IMAX Theater. The south side of the Pier (left) is an exhilarating pedestrian promenade with numerous attractions on one side and outstanding views of the central city skyline on the other.

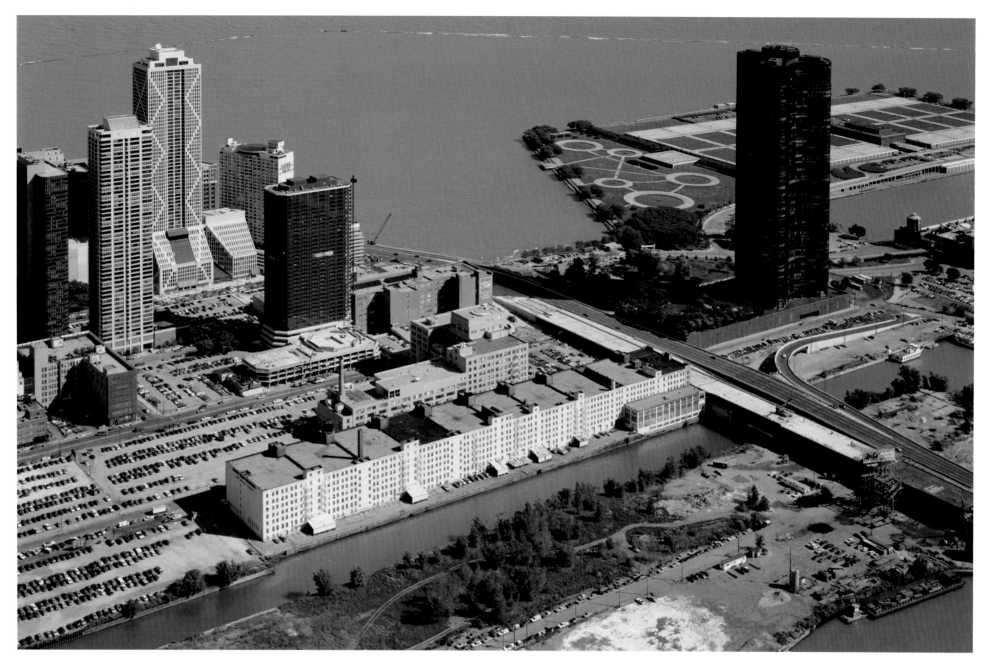

Lake Point Tower

Isolated between a declining industrial area and a deteriorating Navy Pier when completed in 1968, Lake Point Tower would become the last private development east of Lake Shore Drive. The Lakefront Protection Ordinance of 1972 expressly banned further such development.

September 16, 1986
The sliver of land between Ogden Slip and the main channel of the Chicago River has since been transformed. The site of the unrealized Spire project designed by the architect Santiago Calatrava, is just west (left) of Lake Shore Drive. Lake Shore Drive was realigned and reconstructed in the vicinity of the mouth of the Chicago River in 1985-6.

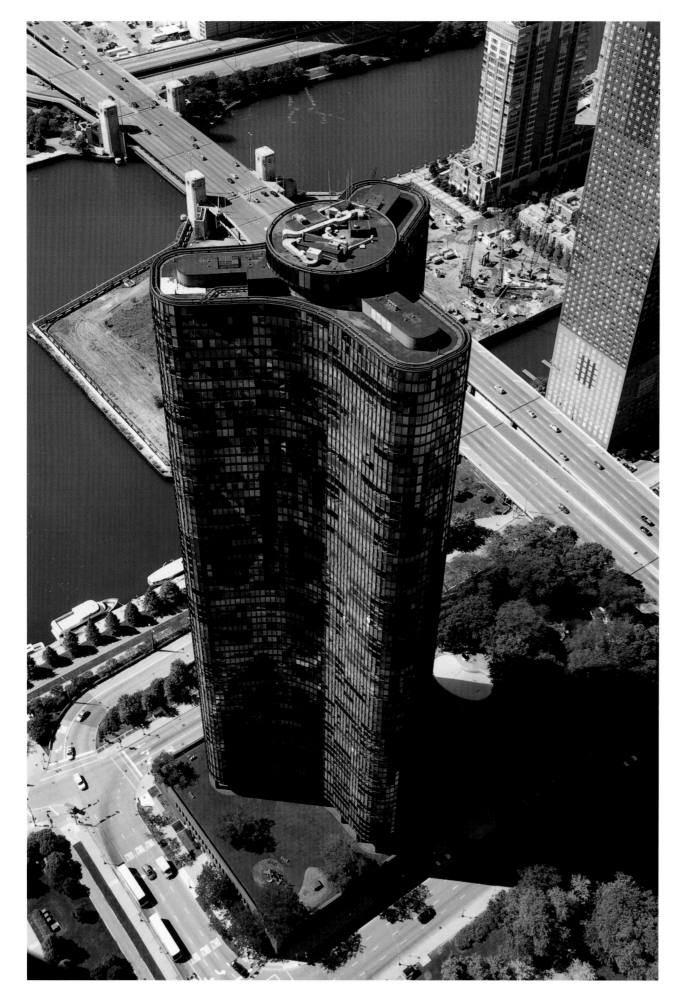

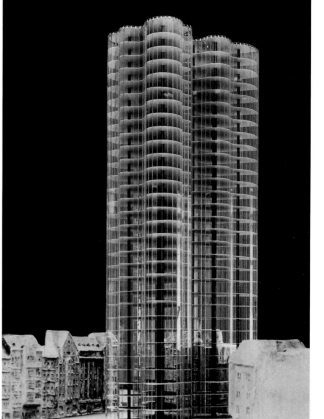

August 31, 2007
The concept for Lake Point Tower (at left, Schipporeit & Heinrich, Architects) is generally regarded as derivative of Ludwig Mies van der Rohe's unrealized "Glass Skyscraper" project of 1922 (above). Mies directed the architecture school at the Illinois Institute of Technology during Schipporeit and Heinrich's student days.

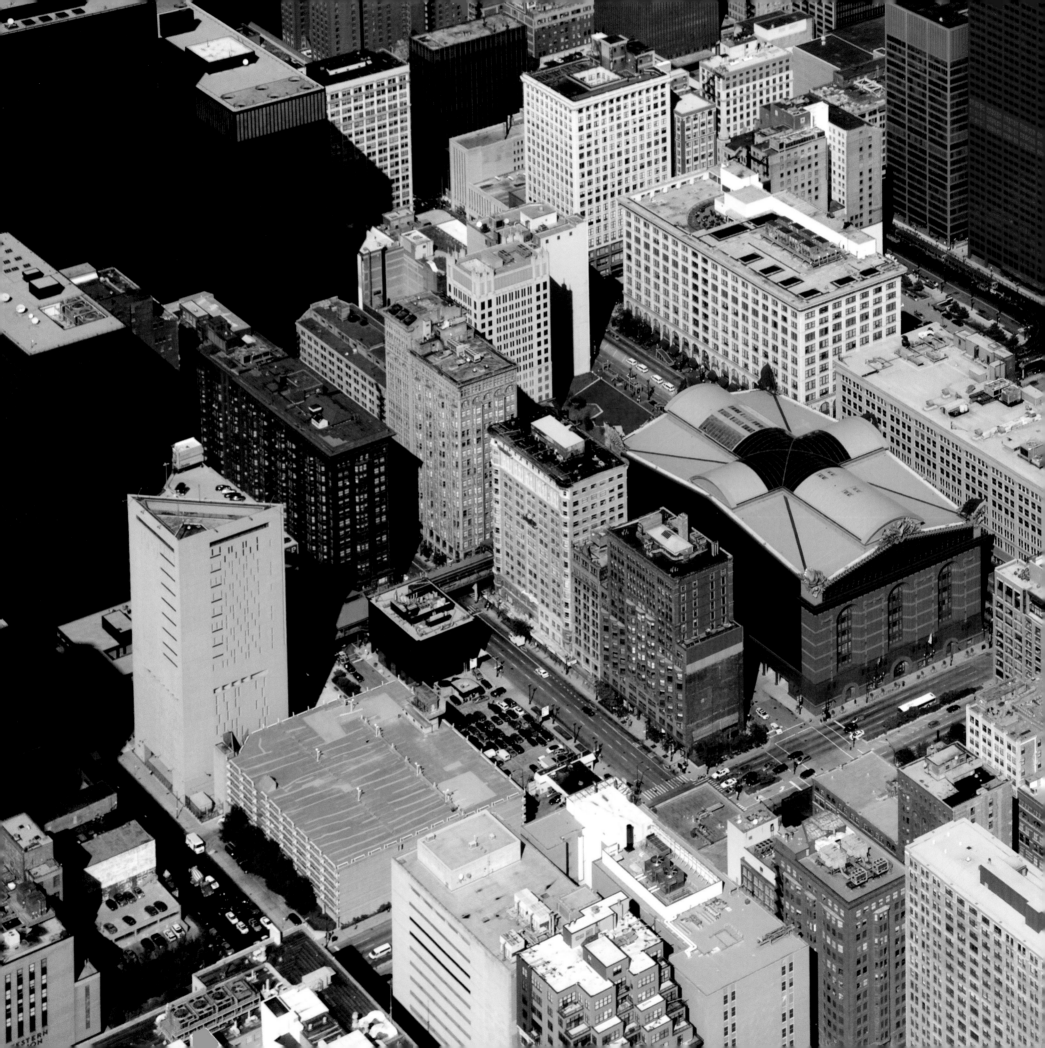

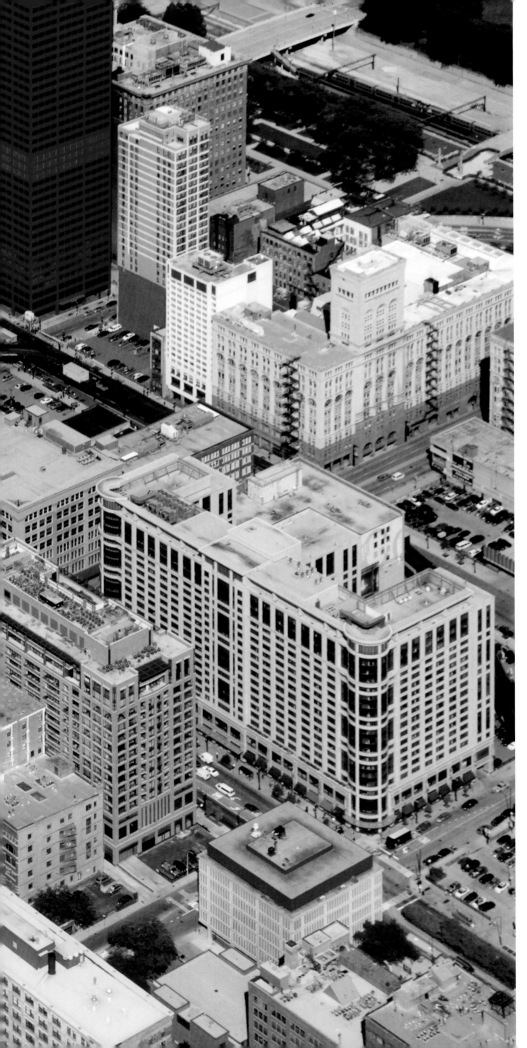

Harold Washington Library Center

Architect Thomas Beeby won the commission to design the new Harold Washington Library Center in a 1987 competition. The library is named in honor of Chicago's first African-American mayor (1922-1987) who died in office. Prior to being cleared, the library site was State Street's last surviving block of seedy pawn shops, bars and SRO's.

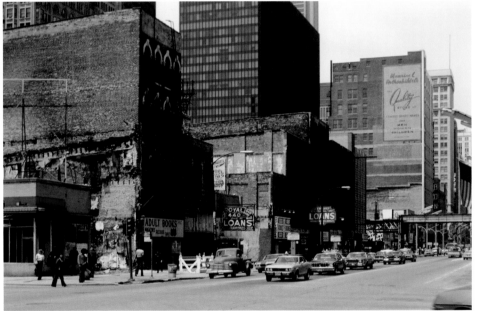

September 16, 2009
The library site is at what was the southern end of the historic State Street retail district. Since its arrival, the immediate vicinity has been transformed. Nearby University Center (with the cylindrical corners), opened in 2004 (Antunovich Associates, architect) at the southeast corner of State and Congress. It provides housing for students from Roosevelt University, DePaul University, and Columbia College.

July, 1978
Future site of Harold Washington Library Center at the northwest corner of State Street and Congress Parkway, looking north on State Street.

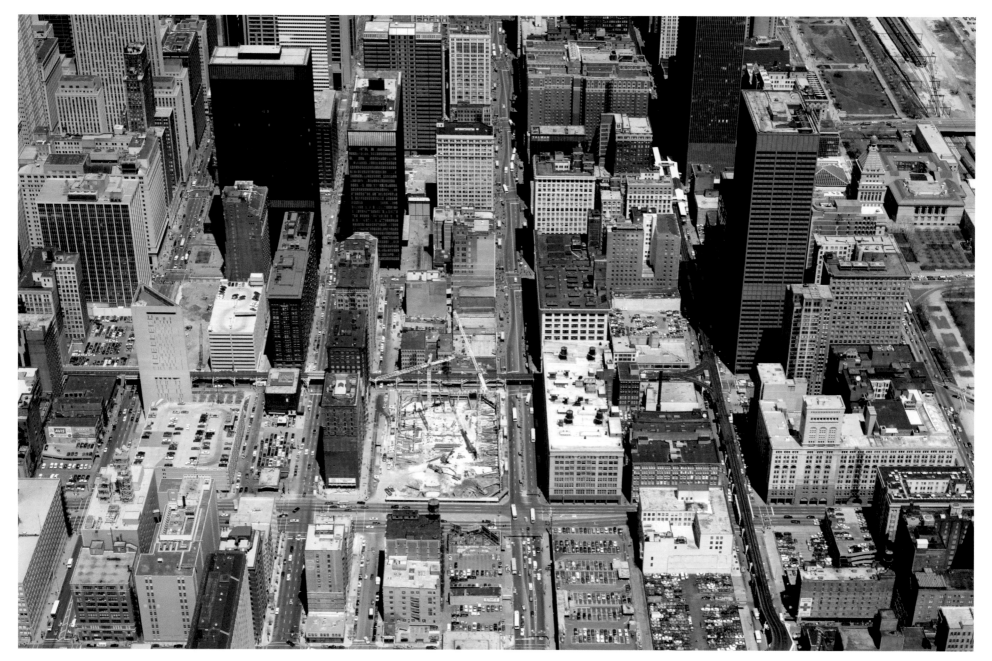

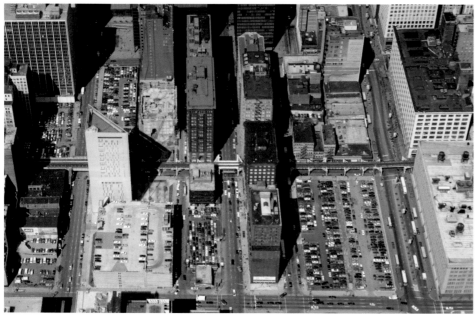

May 11, 1989
Commencement of construction. The bulk of the library's collection of 4.7 million items was in storage at the time.

March 30, 1988
The site briefly served as an open parking lot, a common generator of short-term revenue.

July 15, 2001
US Equities Realty of Chicago, designated as project developer at the conclusion of the design competition, oversaw the development of the $144 million project. According to the *Guinness Book of Records*, the 760,000 square-foot building is the largest public library in the world. It opened to the public on October 7, 1991.

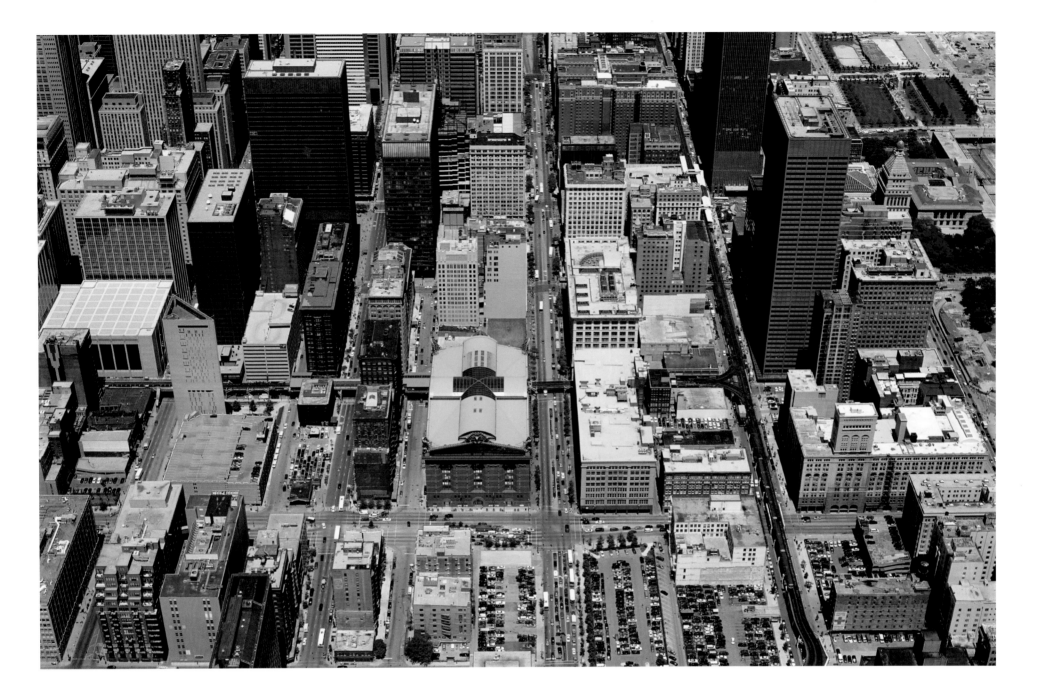

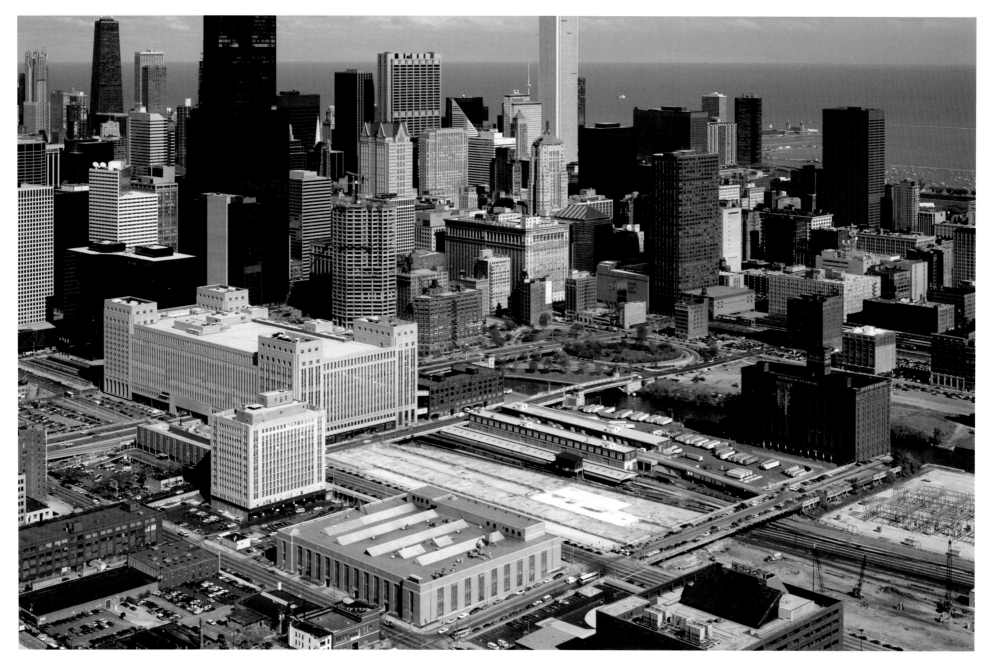

The New Main Post Office

Completed in 1996 and renamed the Cardiss Collins Processing and Distribution Center in 1999, the new postal facility machine sorts an average of 5 million pieces of mail per day. The sorted mail is then dispatched to local stations for delivery.

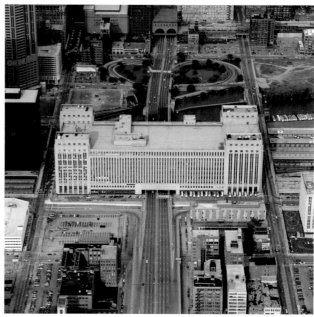

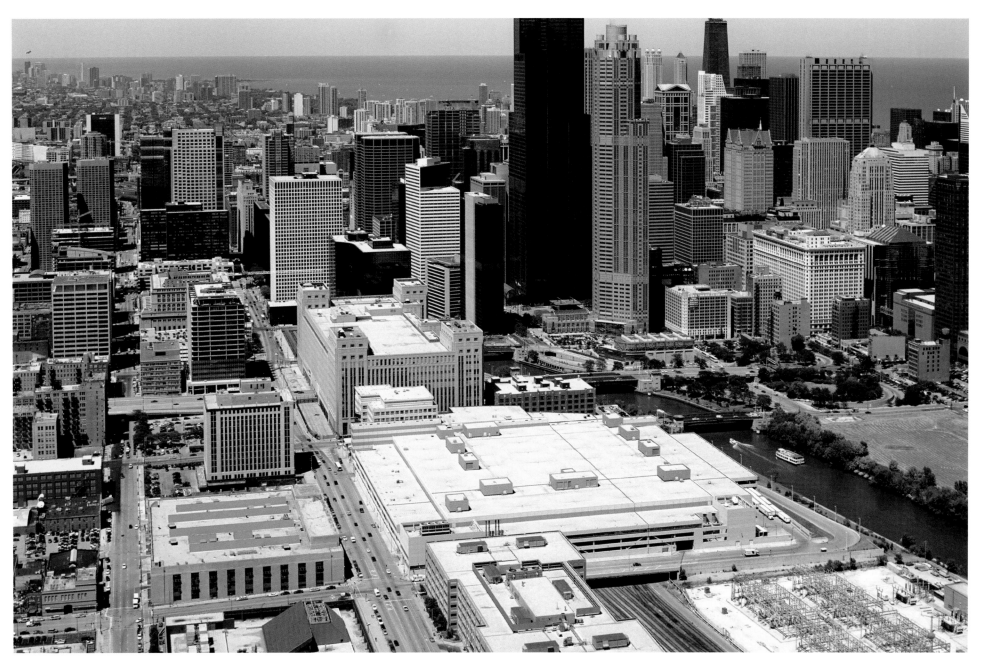

October 12, 1988
The operating rail lines, open storage of truck trailers, multi-story warehouse and surviving remnant of the Polk Street Bridge on the South Branch of the Chicago River, reflect the site's history as a transportation hub.

July 1, 1990 (below left)
The old Central US Post Office, view to east. When the 1921 building was expanded to 2.5 million square feet in 1932, an opening below it was left for a future roadway, which would not be built for more than 20 years. Listed on the National Register of Historic Places in 2001, the building has been vacant since 2005.

July 13, 2001
Initially, the Postal Service wanted to develop its new facility at a Clark Street site, but the City preferred the river site. As a result of the complications of building over active railroad tracks, the construction budget ballooned from $199.7 million to $332.9 million. Architectural services were provided by Knight Architects.

Field Museum of Natural History and Soldier Field

The unusual juxtaposition of the highly respected Field Museum of Natural History and the home of a professional football team did not seem as incongruous when the headquarters of the Chicago Park District (the rectangular structure adjacent to the north end of the stadium) stood between the two. The Field Museum opened in 1920. Originally known as Grant Park Stadium, Soldier Field opened in 1925. The Jack Dempsey-Gene Tunney fight of 1927 attracted more than 100,000 spectators. The new Soldier Field hosted its first Chicago Bears home game on September 29, 2003.

September 18, 1994
Ribbons of highway isolated both the Field Museum and Soldier Field, and constrained pedestrian access to the lakefront. The parking lot east of the stadium would ultimately be converted to park space and the northbound traffic lanes relocated to the west side of the new stadium.

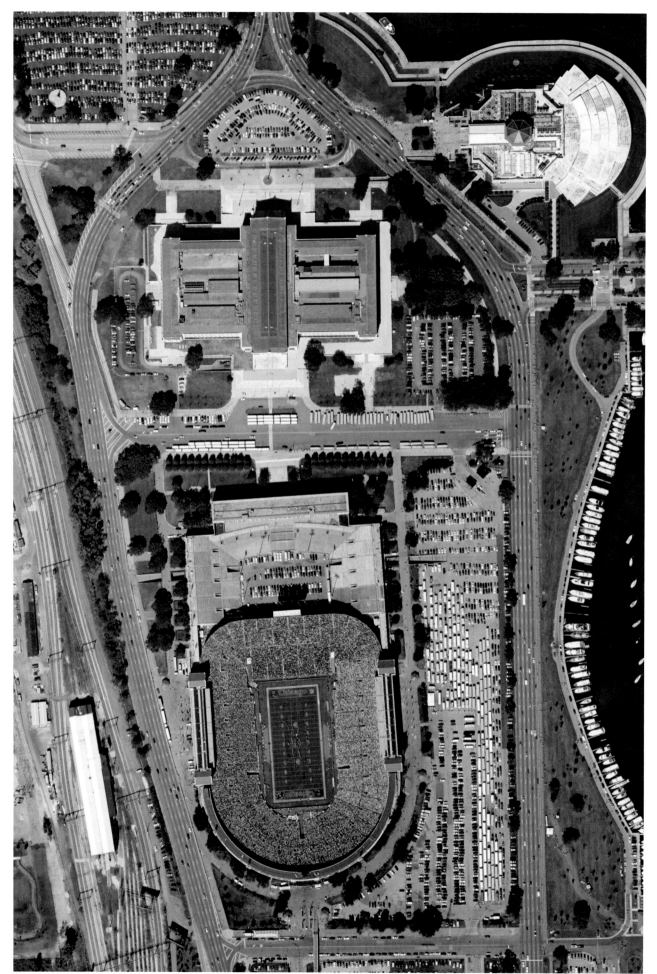

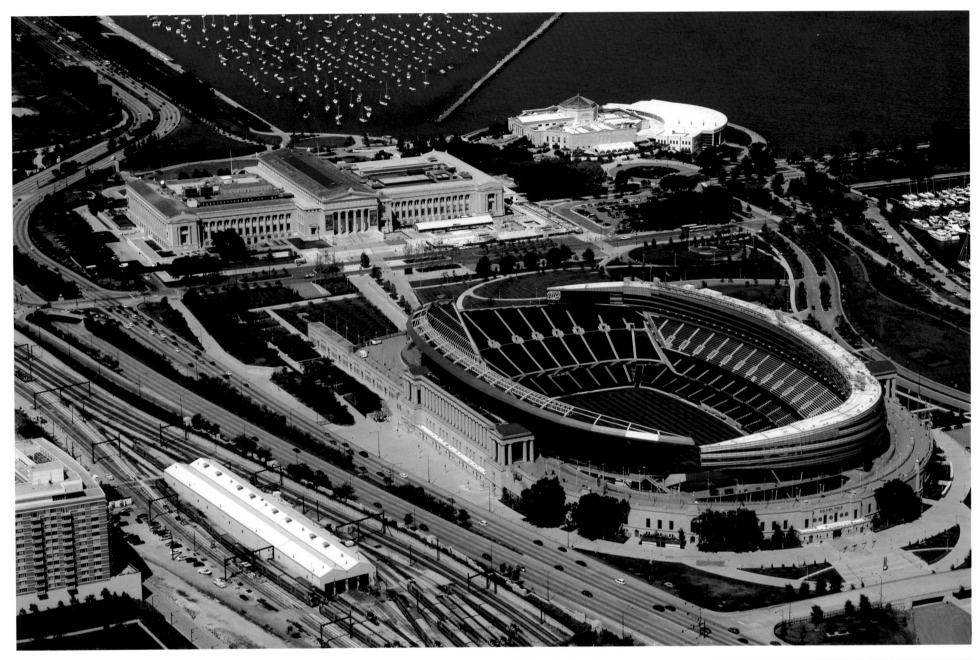

June 4, 1987
The Chicago Park District leased Soldier Field to the Chicago Bears in 1971 as their home stadium. From 1921 to 1970, the Bears had played their home games at Wrigley Field.

August 22, 2005
Two architectural firms are credited with the $630 million project: Lohan Caprile Goettsch of Chicago and Wood + Zapata of Boston.

Soldier Field concept, circa 1920
The original architectural concept called for a far more grandiose memorial to the soldiers of the US Army.

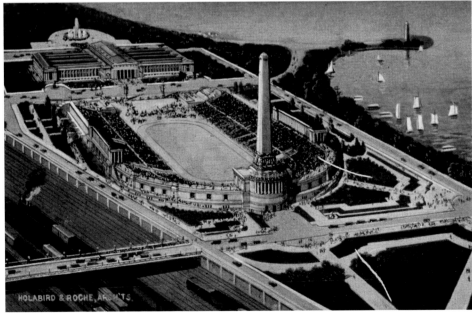

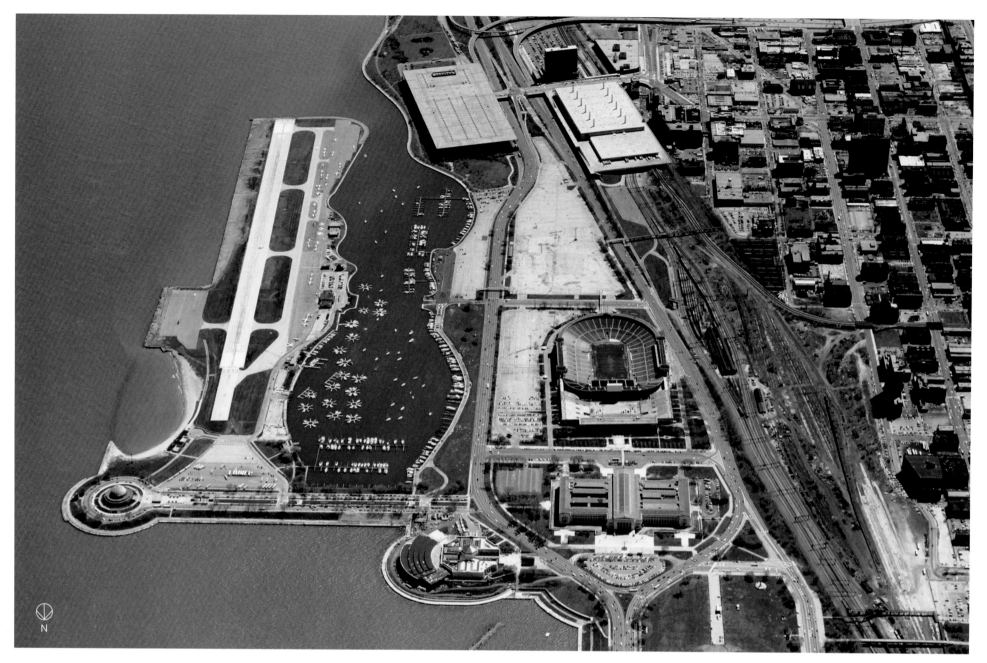

Museum Campus

The idea of creating a Museum Campus by relocating the northbound lanes of Lake Shore Drive—which were formerly located between the Field Museum of Natural History and the John G. Shedd Aquarium, from McCormick Place to Roosevelt Road—to the west of the Field Museum, was first set forth in the *Chicago Central Area Plan* of 1983. Since its inception in 1920, the Field Museum, as well as the neighboring John G. Shedd Aquarium (1929) and Adler Planetarium (1930), had been cut off from the rest of the city by the eight traffic lanes of Lake Shore Drive and a broad swath of railroad tracks. Pedestrian access from the central area was extremely difficult, disorienting, and for the handicapped, virtually impossible. The campus improvement opened to the public in 1998. Lohan Associates prepared the master plan.

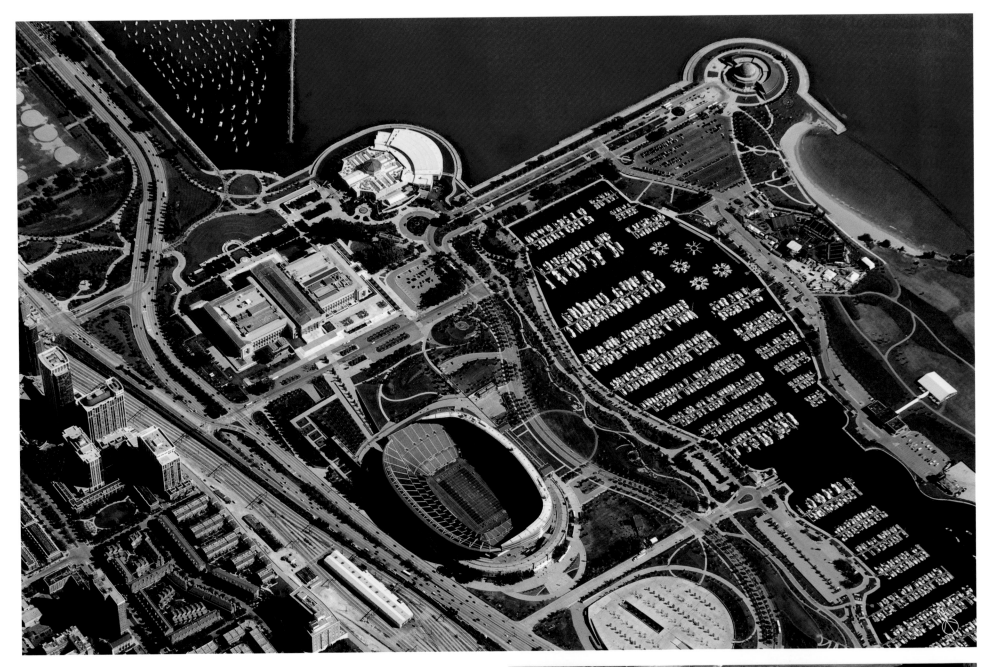

May 11, 1989
View to south. The isolation of the Adler Planetarium, the Shedd Aquarium and the Field Museum—and the absence of convenient pedestrian linkages among them—is evident in this image. At the time, Roosevelt Road did not yet cross over the Illinois Central tracks. Soldier Field is at center.

September 15, 2007
Pedestrian circulation among the three museums can now be accommodated without any street crossings. A wide, shallow tunnel beneath the northbound lanes of Lake Shore Drive northwest of the Field Museum provides a welcoming gateway for pedestrians approaching the campus from Grant Park.

September 29, 2004
The Children's Garden, southeast of the Field Museum, is situated in an enclosing man-made landform. The park is centered on play apparatus representing the earth, the unifying theme of the three institutions. Hoerr-Schaudt Landscape Architects designed the Children's Garden.

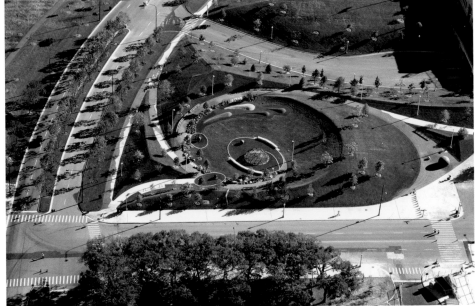

Field Museum of Natural History

The original Field Columbian Museum was housed in the old Palace of Fine Arts, constructed for the 1893 Columbian Exposition in Jackson Park. It took more than two years to move its collections to the new building south of Grant Park, which opened in 1920. By 1968, the collection had grown to 9.5 million objects. In an effort to keep pace with growing storage and display needs, the six interior light courts were filled in over the years. Completed in 2005, the Collection Resources Center, below the finished grade of the elevated plaza in front of the main entry, and located at the southeast corner of the building, greatly alleviated the space crunch. The museum's collection now numbers more than 25 million items.

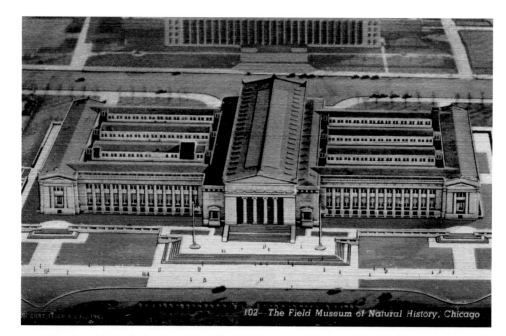

102— The Field Museum of Natural History, Chicago

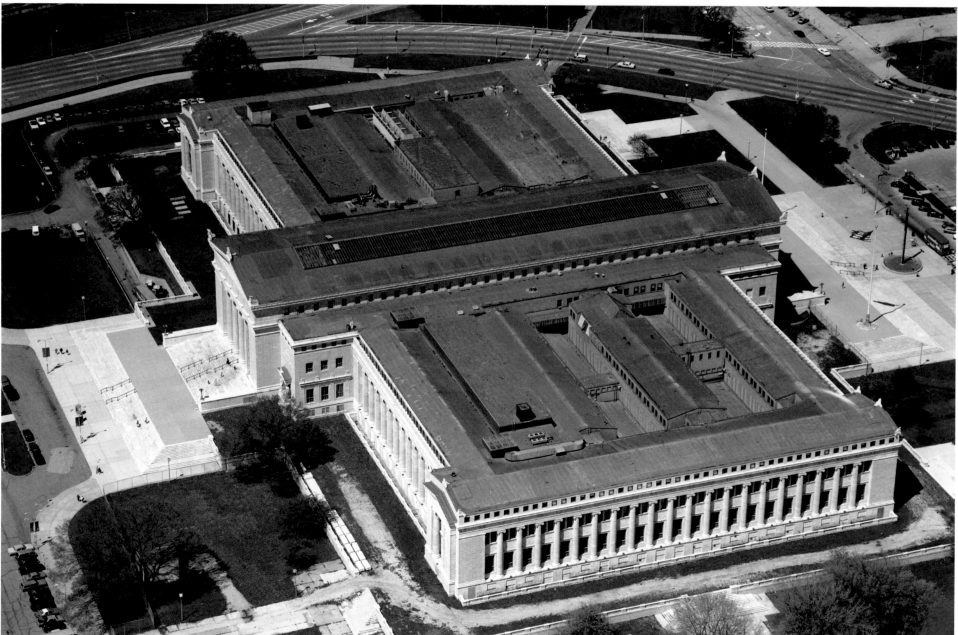

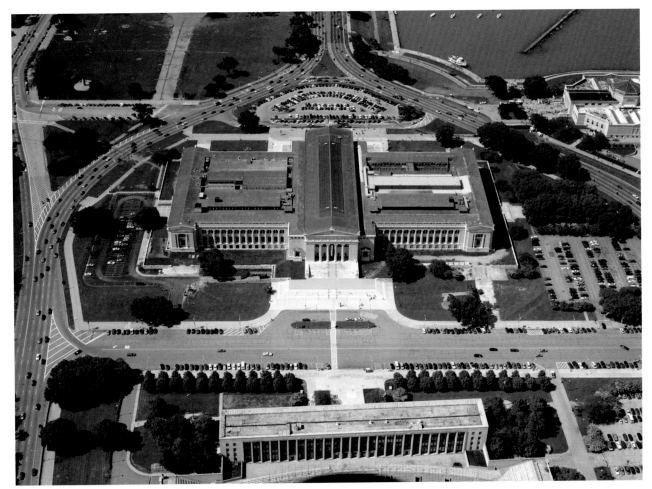

Circa 1942 (opposite, top)
In its original configuration, six light courts introduced natural illumination into enclosed museum spaces.

April 24, 1991 (opposite)
By 1991, only two light courts remained.

May 30, 1993
A fifth light court has recently been filled in. The divided configuration of Lake Shore Drive would be unified on the west side of the new Museum Campus by 1996.

July 11, 2009
The latest addition, the Collection Resources Center, beneath the plaza at right, contains 185,000 square feet of storage space. Its placement defers to the symmetry of the building's classical architectural profile. The sixth light court has been enclosed.

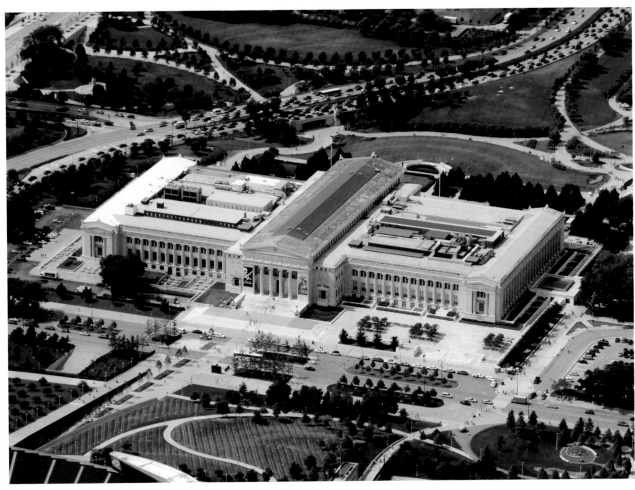

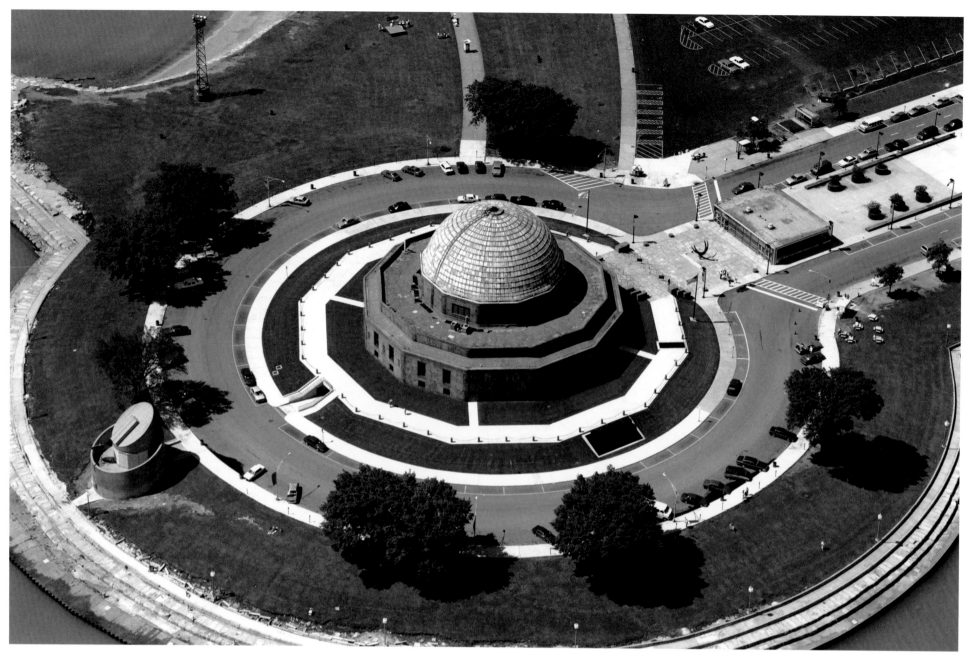

The Adler Planetarium and Astronomical Museum

The Adler Planetarium opened in 1930. Its principal benefactor was Max Adler (1866-1952), a Sears Roebuck & Co. executive, one-time concert musician, and brother-in-law of Julius Rosenwald (who transformed Sears into the largest retail enterprise of the 20th century).

June 5, 1993
The first planetarium in the United States, the Adler was designed by the architect Ernest Grunsfeld, Jr. (1897-1970). Decorative plaques by sculptor Alfonso Ianelli, depicting the signs of the zodiac, adorn the twelve corners of the building.

May 4, 2008
The Chicago-based architectural firm, Lohan Associates, designed the semi-circular glazed addition, completed in 1999. It supports an ambitious expansion program, including three technologically sophisticated full-size theaters. The removal of the circular drive allowed the building to re-engage the lake and restored the main entrance to its original function.

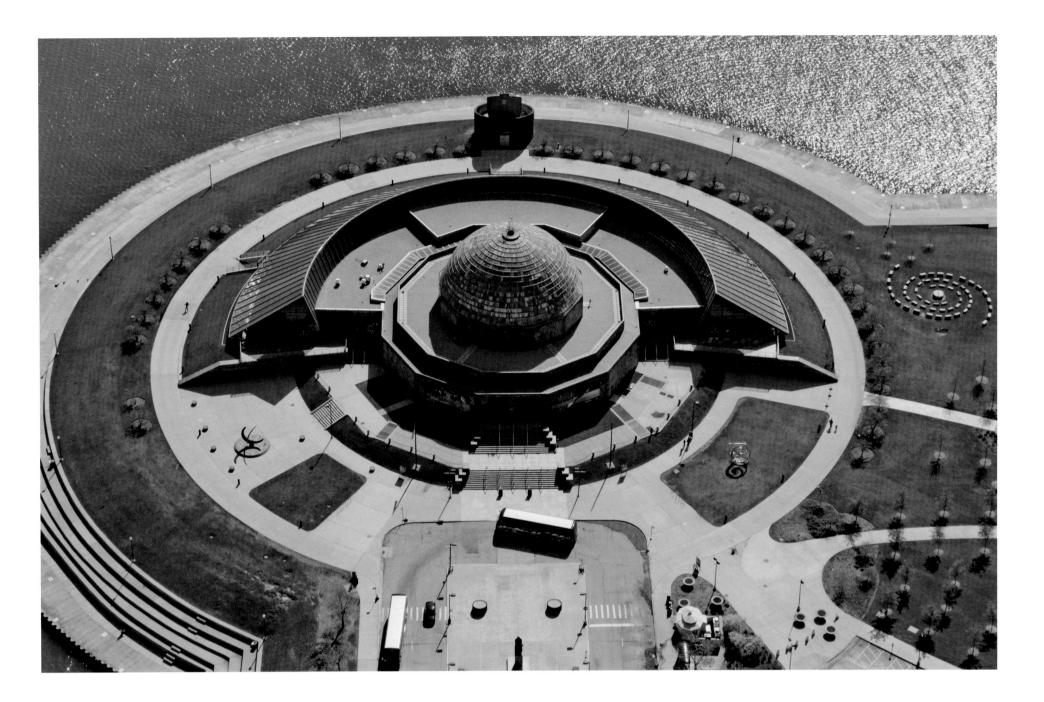

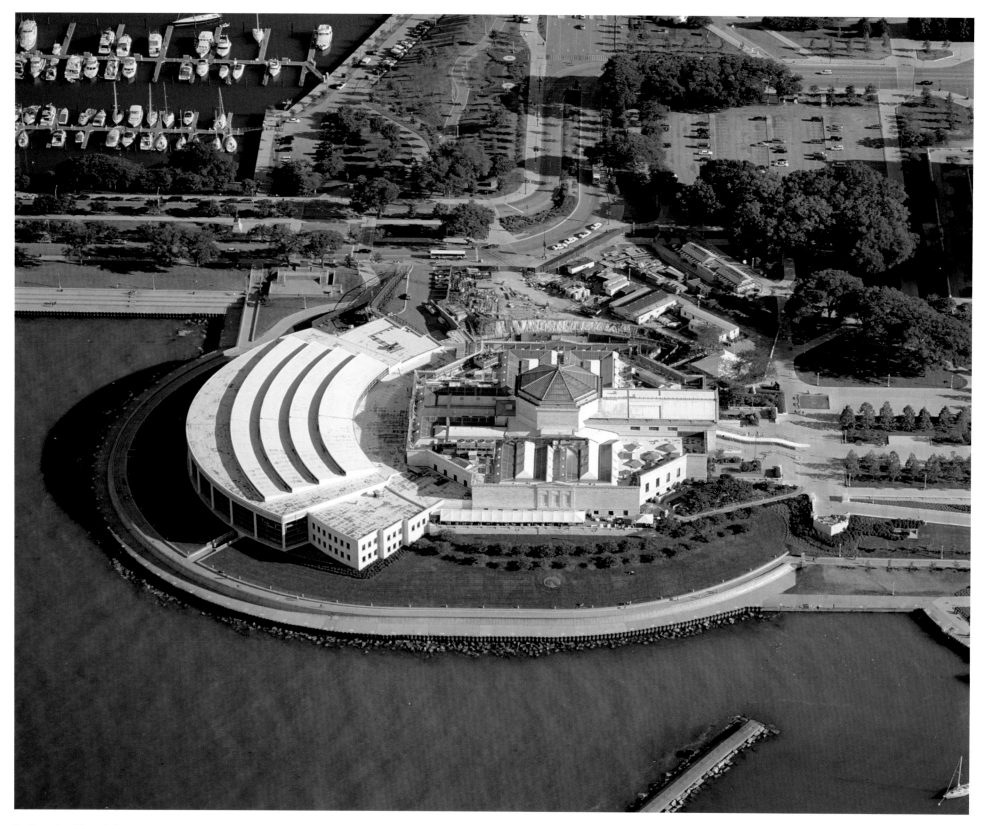

John G. Shedd Aquarium

John G. Shedd (1850-1926), who succeeded Marshall Field (1834-1906) as president of Marshall Field & Co., left a bequest of $3 million for the construction of the aquarium, which opened to the public in 1930. The Shedd was the first inland aquarium with a permanent marine fish collection. In its early days, seawater was transported on railroad tank cars from Key West.

July 5, 2001
Further expansion, ongoing as of the date of this photo, concluded with the opening in 2003 of the Wild Reef exhibit, two levels below the main hall.

June 4, 1987 (right)
The prolific Chicago architectural firm of Graham, Anderson, Probst & White (a descendant firm of Daniel Burnham & Co.), designed the Shedd. Distinctive features include an octagonal plan, classical details, and a steel structural frame sheathed in white Georgia marble.

April 29, 1988 (below, right)
The construction of the Oceanarium (Lohan Associates, architects; opened 1991) involved a modest shoreline landfill, both to accommodate the program and to defer to the integrity of the original Graham Anderson design.

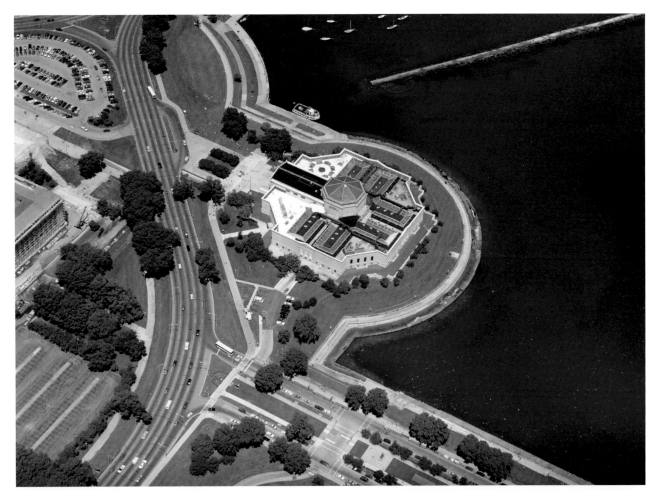

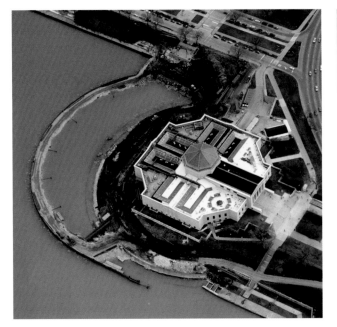

December 13, 1987
Construction of the cofferdam

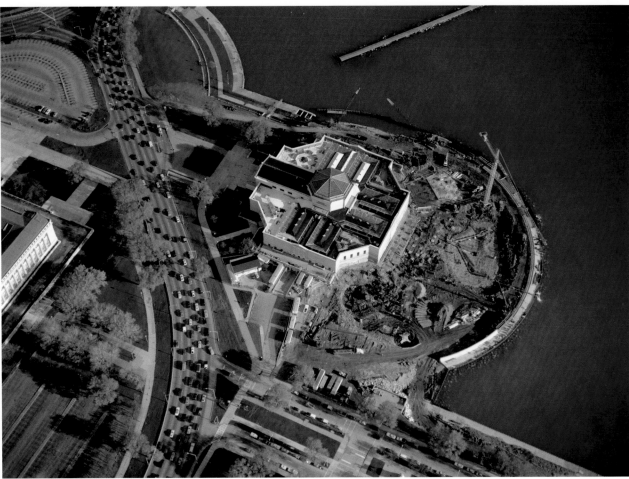

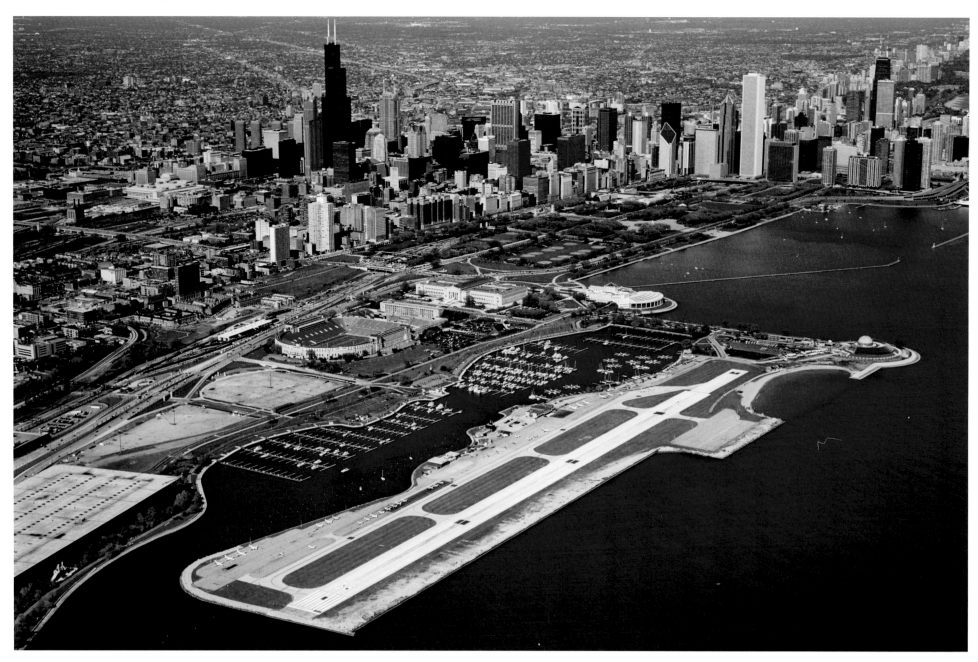

Meigs Field/Northerly Island

Located on the lakefront just east of Soldier Field, Meigs Field opened in 1948 on Northerly Island, the first of what was to have been a string of man-made recreational islands, as envisioned in the 1909 *Plan of Chicago*. In 1933, it was the site of the Century of Progress Fair and Exposition, celebrating Chicago's centennial. Although Meigs closed briefly in the winter of 1996-1997, the unannounced destruction of the runways by a city crew on the night of March 30, 2003, sealed its fate. The aviation community was incensed over the closure of the field, but to those with no personal contact with the airport, the news was greeted with little more than a shrug.

October 20, 1998
Operations on a single north-south runway could be affected by cross-winds, but the airport had a better safety record than is commonly believed.

September 15, 2007
Nearly 100 years after Daniel Burnham first proposed the creation of a string of man-made recreational islands, the first one, at least, has been realized largely as imagined.

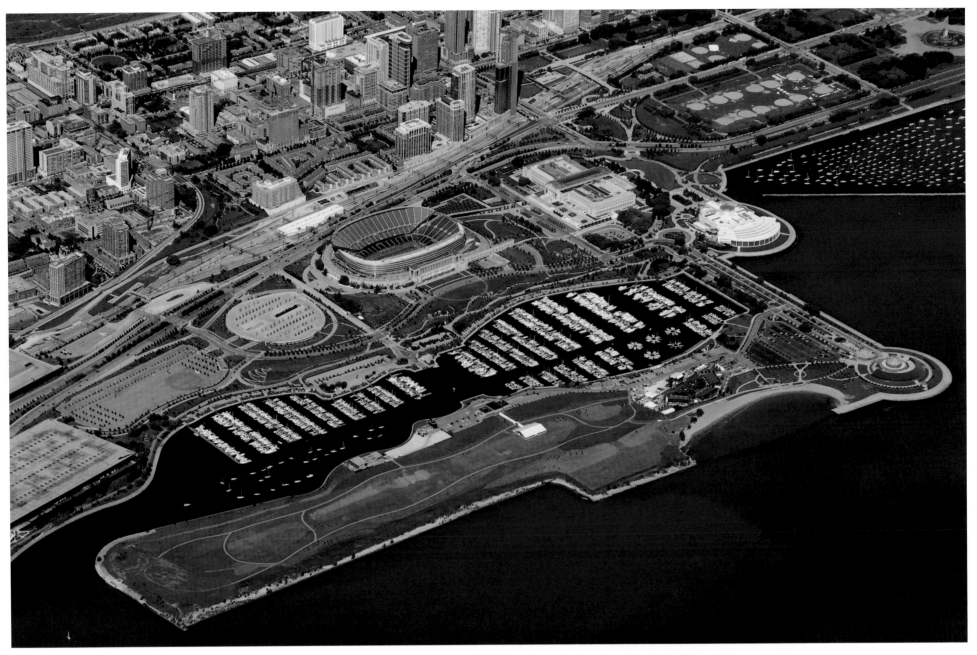

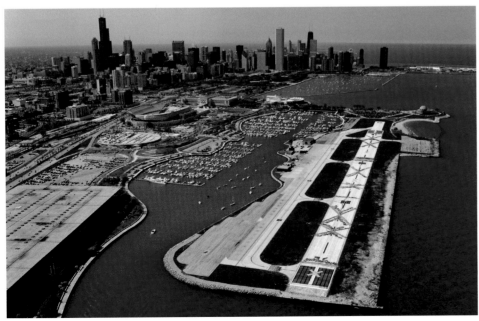

May 21, 2003
After the runway was gouged with deep X-shaped trenches, the planes remaining on the airfield had to take off from the taxiway.

May 28, 2004
The geometry of the old aviation surfaces is still evident.

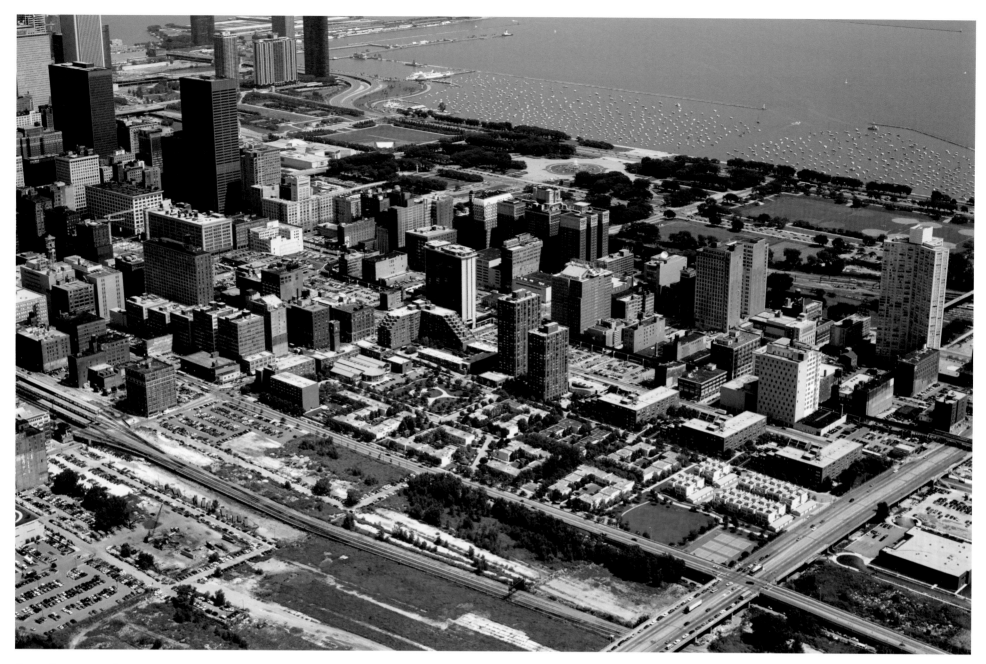

Dearborn Park

Constructed on the old rail yards south of the Dearborn Street Station, Dearborn Park, initiated in 1978, planted the seed that ultimately transformed the entire periphery of the central area. Developed by the limited-profit Dearborn Park Corporation, led by prominent real estate developers Philip Klutznick (1907-1999) and Ferd Kramer (1902-2002) and Commonwealth Edison president Thomas Ayers (1915-2007), Dearborn Park was the first of dozens of residential projects that have since emerged in the Near South Side, Near West Side, and River North.

August 17, 1989
The fascinating history of the creation of Dearborn Park is the subject of Lois Wille's 1997 book, *At Home in the Loop: How Clout and Community Built Chicago's Dearborn Park.*

July 11, 2009
The success of Dearborn Park attracted substantial new investment to the State Street-Wabash Avenue corridor directly to the east, and to the abandoned rail yards to the west. The white-roofed building, lower edge left of center, is a Target department store, an institution ordinarily found in outlying suburban locations.

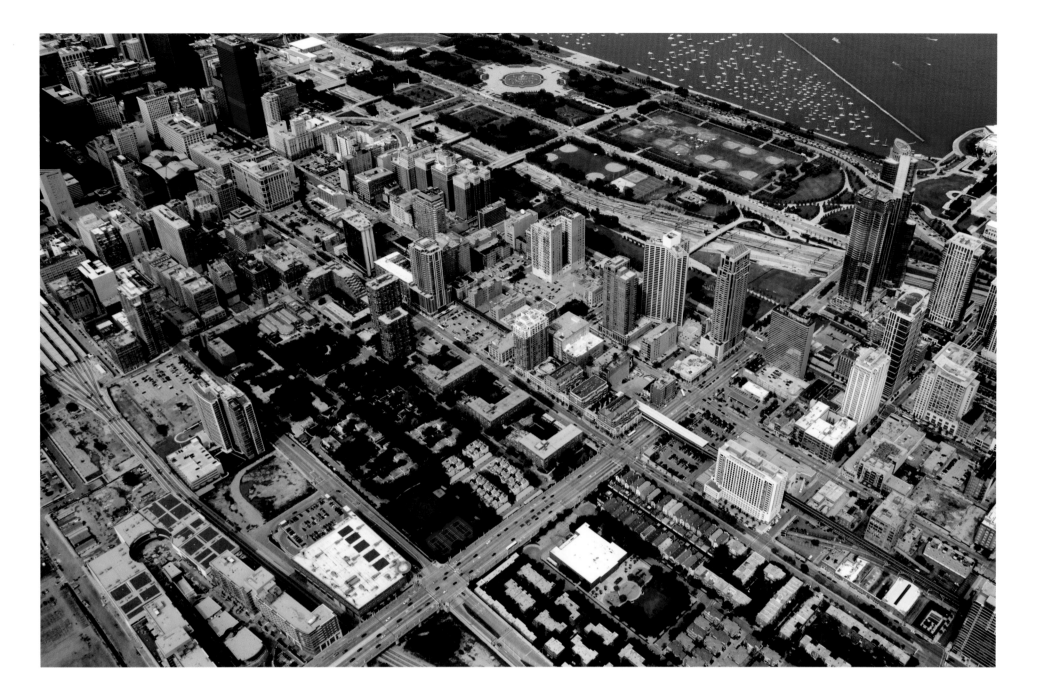

BEYOND THE CENTER

August 23, 2009
Jesse Owens Park, view
to west from S. Clyde
Avenue, with 87th Street
at right.

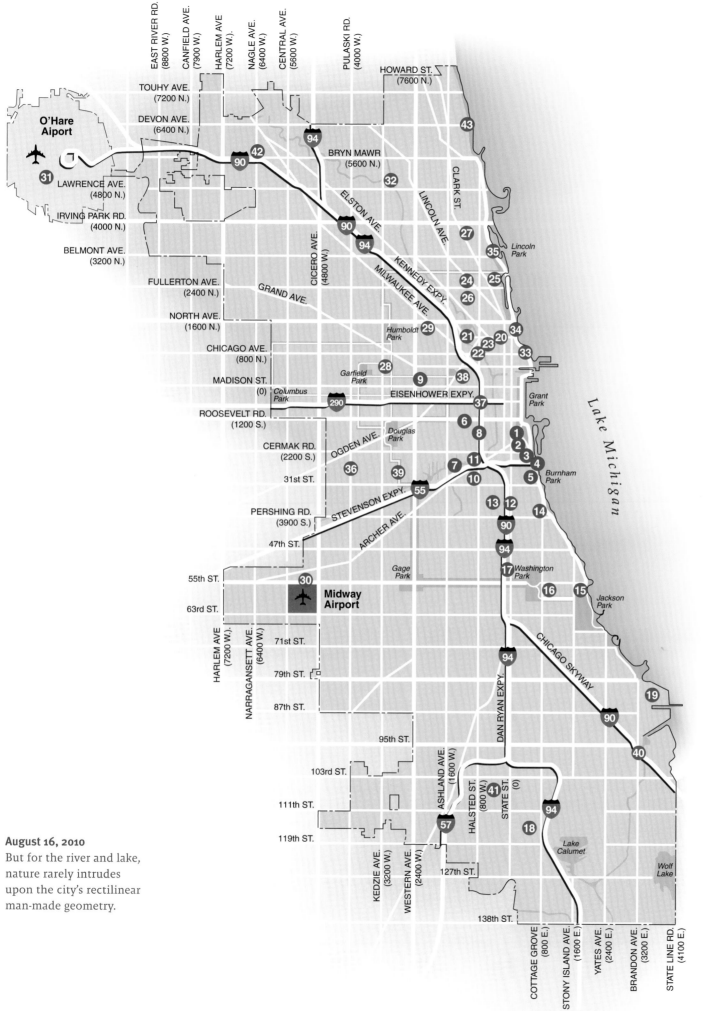

August 16, 2010

But for the river and lake, nature rarely intrudes upon the city's rectilinear man-made geometry.

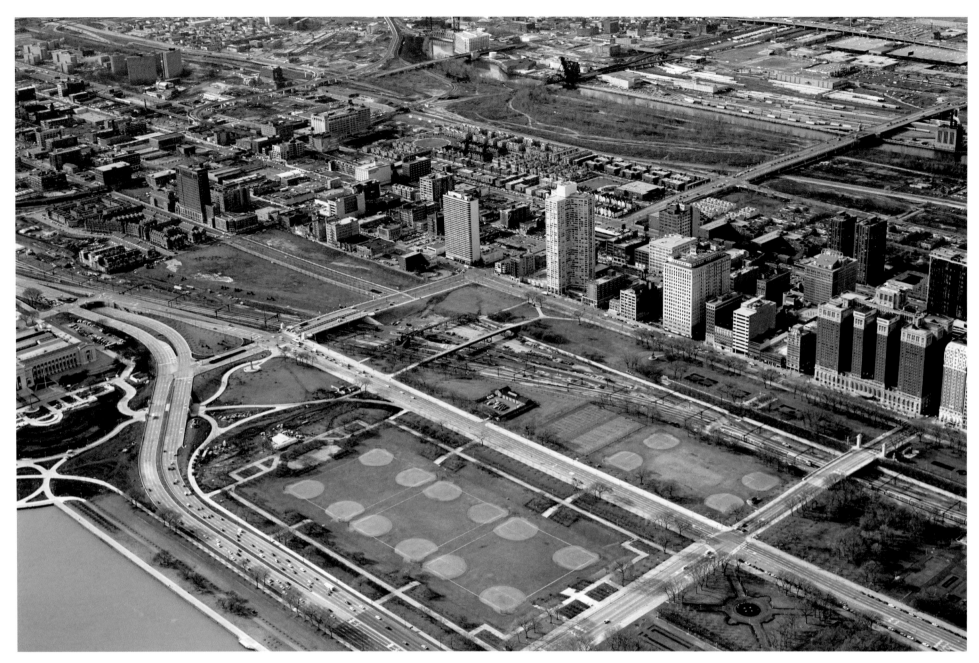

Central Station

Central Station has arisen on (or above) land once used exclusively for railroad purposes. Fogelson Properties acquired 69 acres of air rights from the Illinois Central Railroad in 1988 and deeded it to the Central Station Limited Partnership. It is one of the largest mixed-use urban developments in the United States. If fully realized as anticipated, 7,500 new dwelling units and associated retail space will occupy the site.

February 3, 1998
For years, Grant Park lacked a well-defined southern boundary. The creation of the Museum Campus and the eastward extension of Roosevelt Road to Lake Shore Drive in 1995-6 not only imparted physical definition to Grant Park's southern boundary, but created significant new development opportunity, particularly for the property on the south side of the new street.

July 1, 2010
Pappageorge/Haymes of Chicago is the architect of record for both the 62-story One Museum Park and the 54-story One Museum Park West, opposite the southern boundary of Grant Park. Two additional towers are planned for Central Station's remaining Roosevelt Road frontage. These projects will enhance the park boundary in much the same way the street wall along the west side of Michigan Avenue defines the western boundary of the park space.

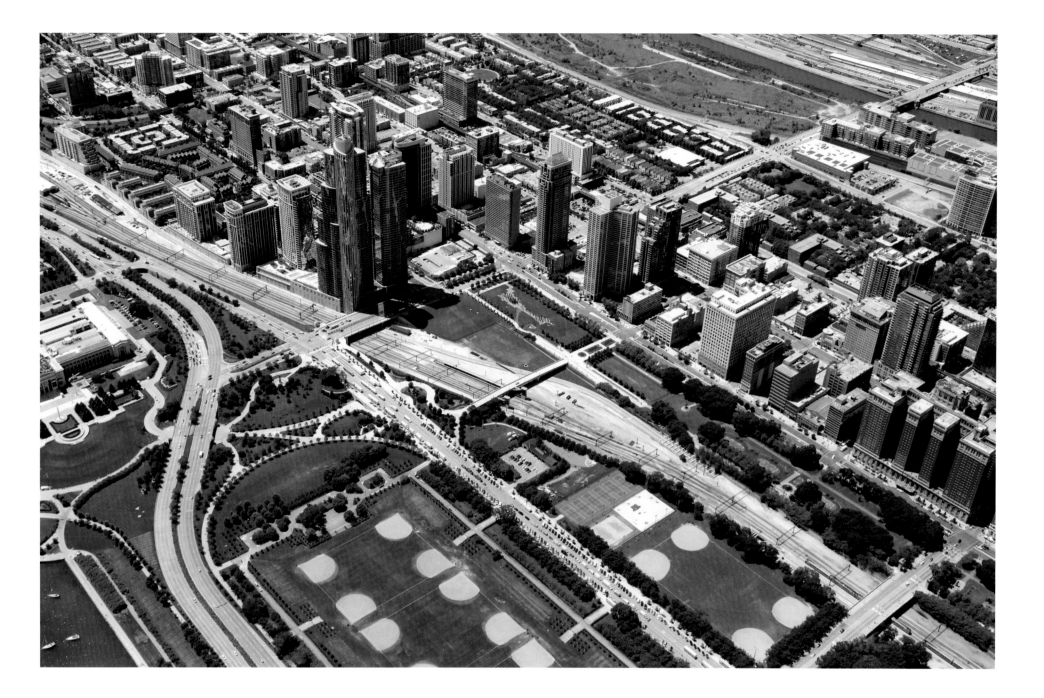

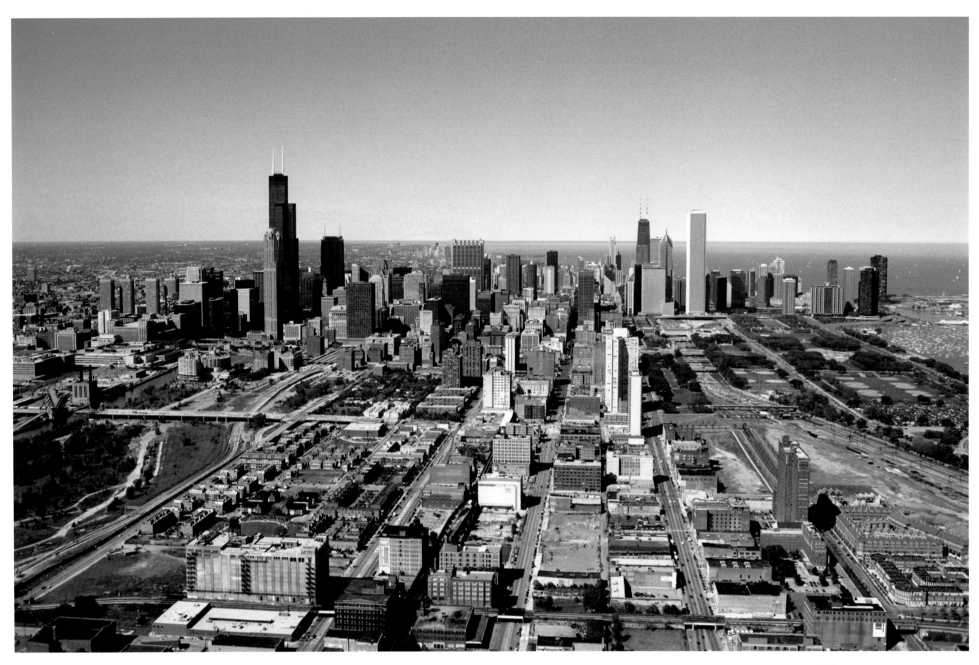

The Near South Side

A long-neglected part of the city, the area between Congress Parkway and the Stevenson Expressway only recently emerged as the largest of the residential markets on the periphery of the central business district. Of the nearly 22,000 dwelling units in place as of 2010, approximately 16,500 were added since 1990. A number of previously approved projects have been put on hold as demand began to lag behind supply, during the recession that began in 2008.

September 18, 1994
View to north. The development of Dearborn Park II, at left, drew increased attention to the corridor between State Street and Michigan Avenue as a venue of development opportunity.

July 1, 2010
The construction of multi-story condominium buildings on smaller sites within the State-Michigan corridor is reflective of the influence of both Dearborn Park and the Central Station development, at right, between Michigan Avenue and the Field Museum. The 10-story former Beatrice Foods Warehouse (lower left) was transformed into Dearborn Tower, a 16-story residential condominium of 317 units.

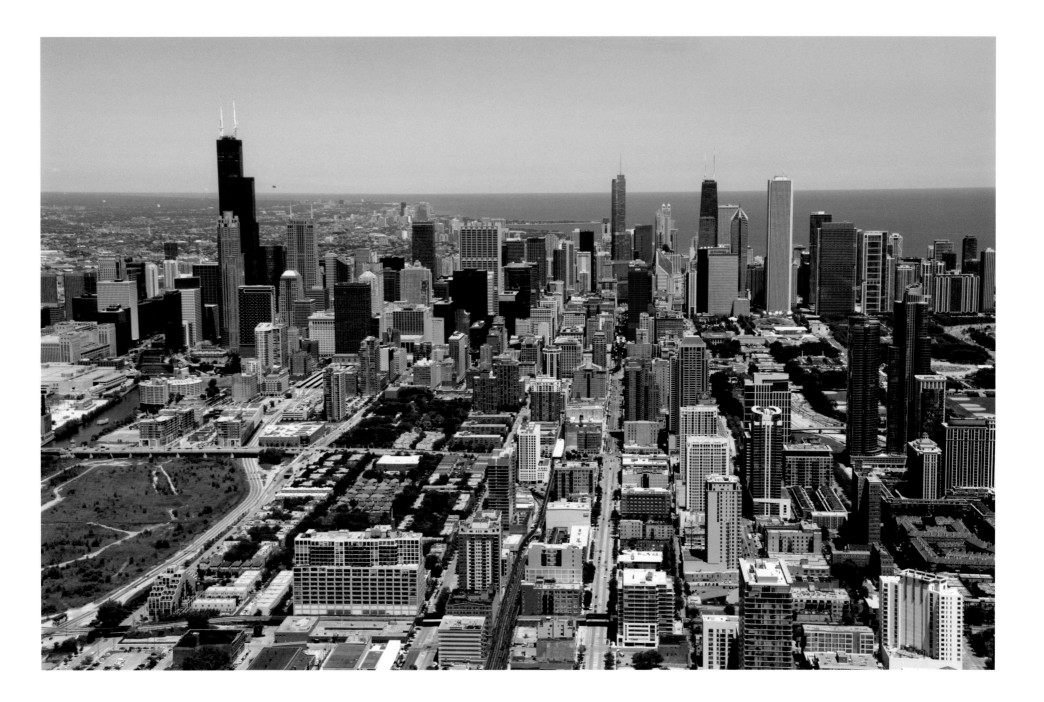

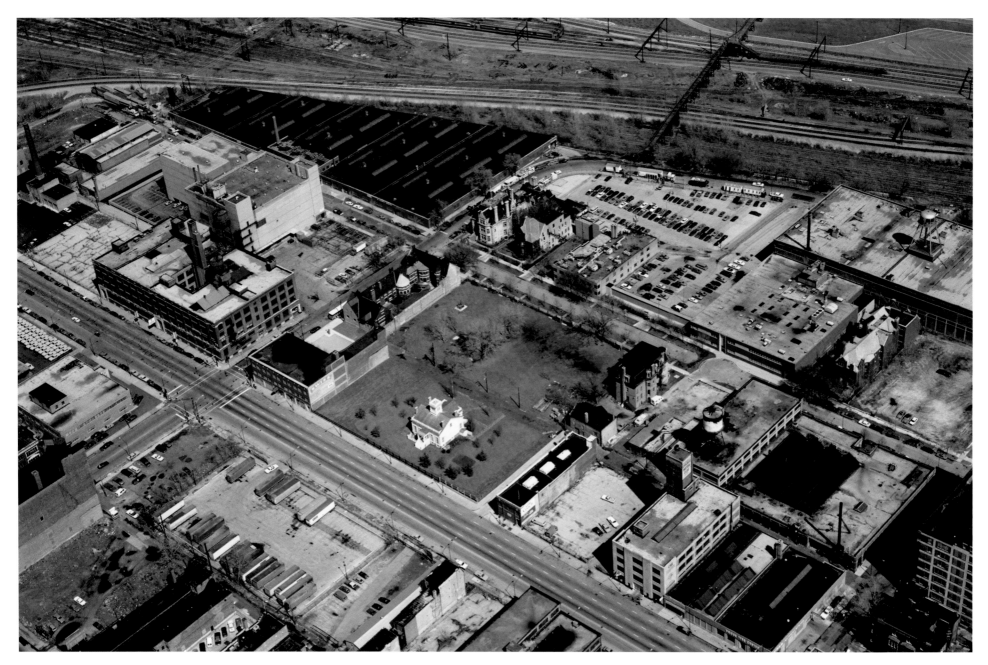

Widow Clarke House

Constructed in 1836, the Henry B. Clarke house, also known as the Widow Clarke House, is the city's oldest. It was moved to its current—and third—location at 1827 S. Indiana Avenue in 1977. Prairie Avenue, one block to the east, was home to Chicago's 19th century elite, immortalized in Arthur Meeker's 1949 novel, *Prairie Avenue*. The nearby John J. Glessner house at 1800 S. Prairie Avenue, with its cone-capped turret, was designed by H.H. Richardson of Boston, and constructed in 1885-87. The most celebrated survivor of that era, it is now a museum, as is the Clarke House.

March 30, 1988
View to northeast from Indiana Avenue. In 1988, it would have been difficult to imagine that this fading industrial area would eventually re-emerge as an elite residential neighborhood, despite the presence of the Clarke House (center).

August 16, 2010
The portico to the Widow Clarke house has been fully restored (as has been the red-roofed Glessner house). The surrounding park has reached maturity. Townhomes on the east side of Prairie Avenue were brought to market with sale prices in excess of $1,000,000.

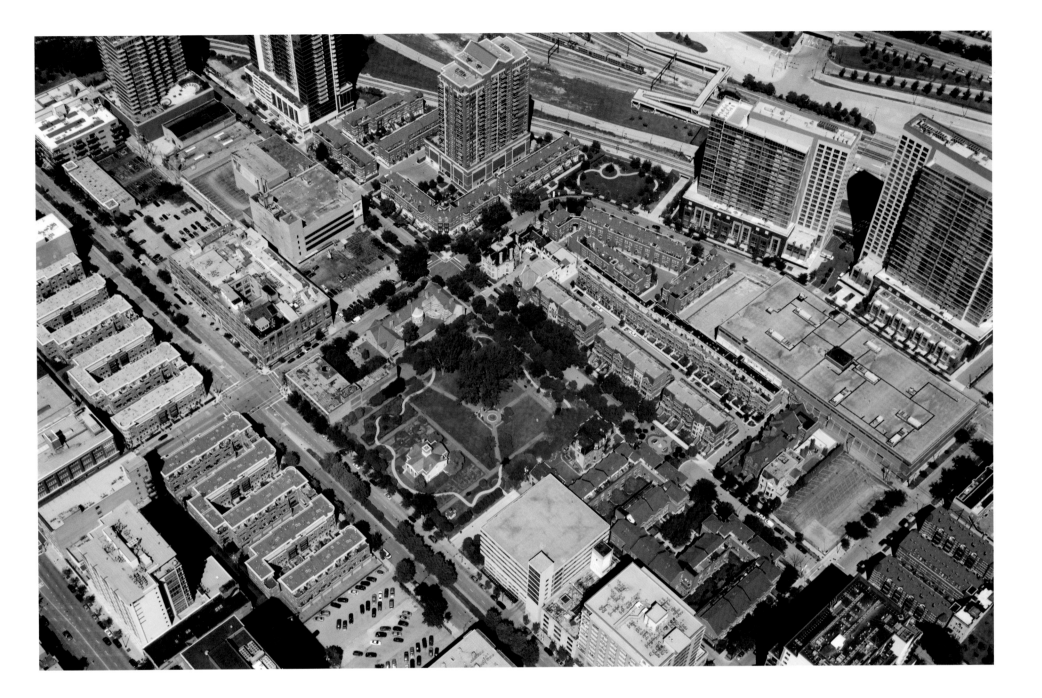

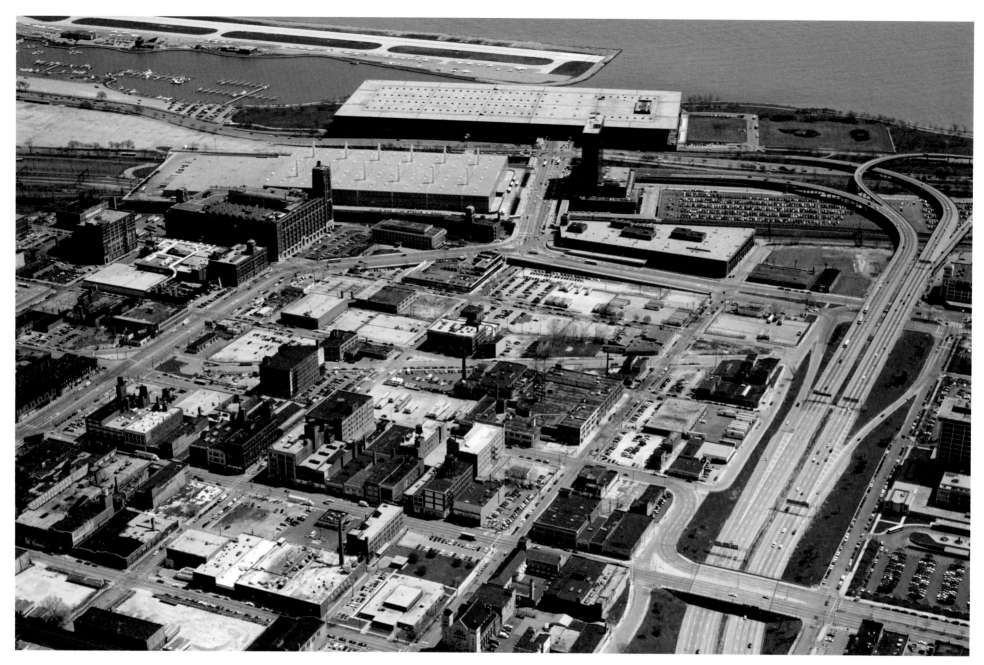

McCormick Place

Constructed in four phases between 1971 and 2006, the McCormick Place complex, with 2.67 million square feet (61.3 acres) of exhibition space and 173 meeting rooms encompassing 600,000 square feet (13.8 acres) of additional floor area, is the world's largest convention center. The east building, completed in 1971, replaced the original McCormick Place, destroyed by a calamitous fire in 1967 after only seven years of service.

May 5, 1992
McCormick Place phase II (the building with the cable-stayed roof) designed by Skidmore, Owings & Merrill had only been open for six years when this picture was taken. The old McCormick Inn, (black glass box, center), would be demolished in 1993 and replaced by the 800-room Hyatt Regency McCormick Place. Subsequent expansion projects would result in the elimination of the Cermak Road overpass/interchange at Lake Shore Drive and its replacement by an enclosed pedestrian concourse.

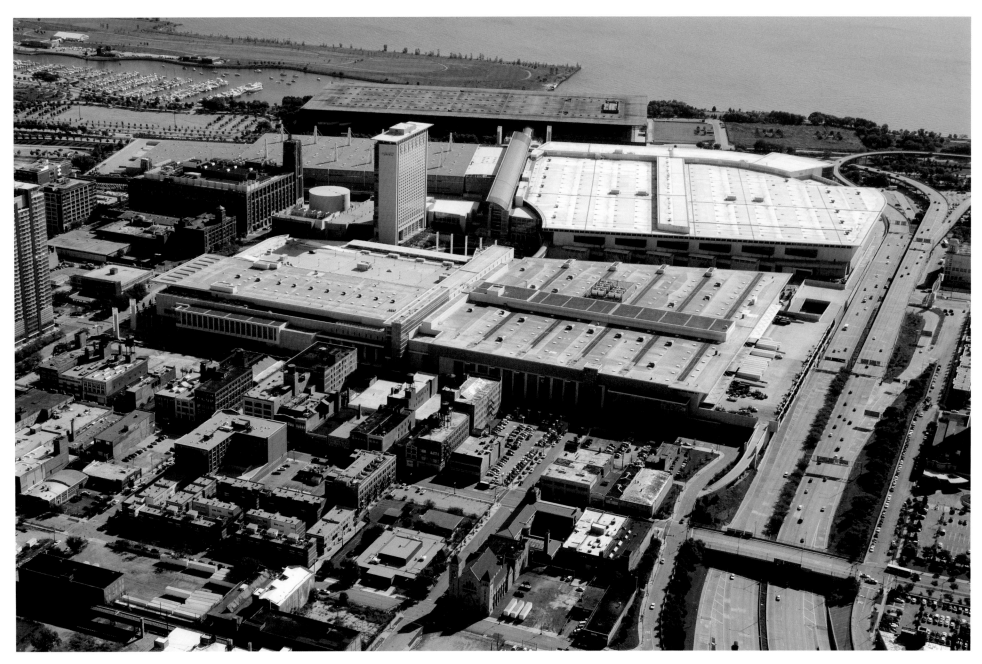

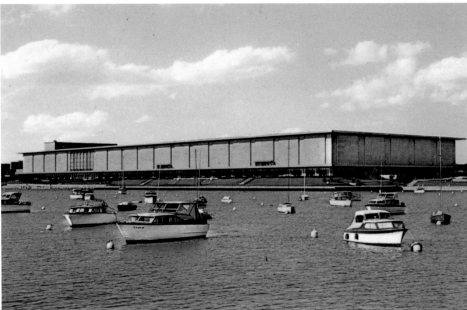

August 27, 2010
With more than one million square feet of floor area, the south building, at upper right, designed by Atlanta-based TVS Design and completed in 1997, has almost twice the total floor area of the east building (now know as Lakeside Center). Lakeside Center is a sophisticated work of modern architecture designed by Gene Summers of CF Murphy Associates. The most recent expansion project, phase IV, is in the foreground. It too was designed by TVS Design. It opened in 2007.

McCormick Place, circa 1965
The original McCormick Place measured 340 x 1050 feet in plan, more than 8 acres. Its site has been occupied by Lakeside Center since 1971.

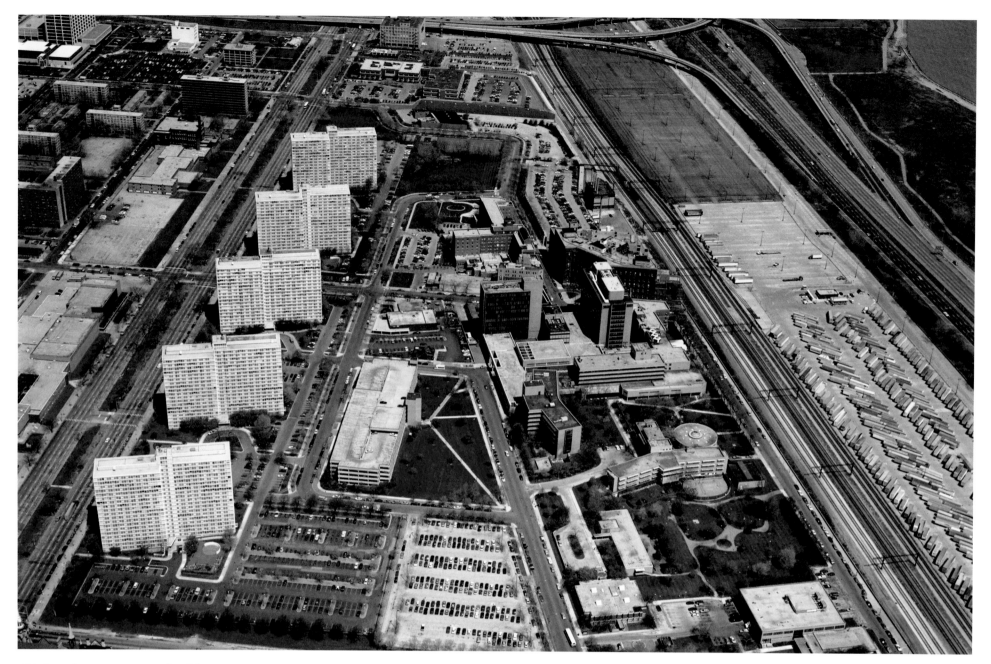

Michael Reese Hospital/Prairie Shores

Originally established on its lakefront site in 1881, Michael Reese Hospital ultimately grew into a 37-acre campus with 29 buildings. The surrounding neighborhood had become seriously blighted by the 1950's, and extensive urban renewal projects were initiated on the periphery of the site, including the Prairie Shores apartment complex to the west. After several changes of ownership, Michael Reese closed for good in September 2008. The hospital site is currently owned by the City of Chicago. Demolition of hospital structures was underway as of June 2010, despite preservationists' efforts to save some architecturally important buildings, including several credited to the modernist Walter Gropius.

May 5, 1992
Designed by Loebl, Schlossman & Bennett and constructed between 1958 and 1962, the five-building Prairie Shores apartment complex includes 1,677 dwelling units. In deference to the staffing needs of Michael Reese Hospital, the original lease application required that at least one member of each household have a college degree.

July 1, 2010
Before Chicago failed in its effort to secure the 2016 Olympic Games in October of 2009, the then abandoned, city-owned hospital site had been designated for redevelopment as the Olympic Village. Its future remains uncertain.

Michael Reese Hospital, circa 1950
The Main building, completed in 1907, was designed by Richard E. Schmidt.

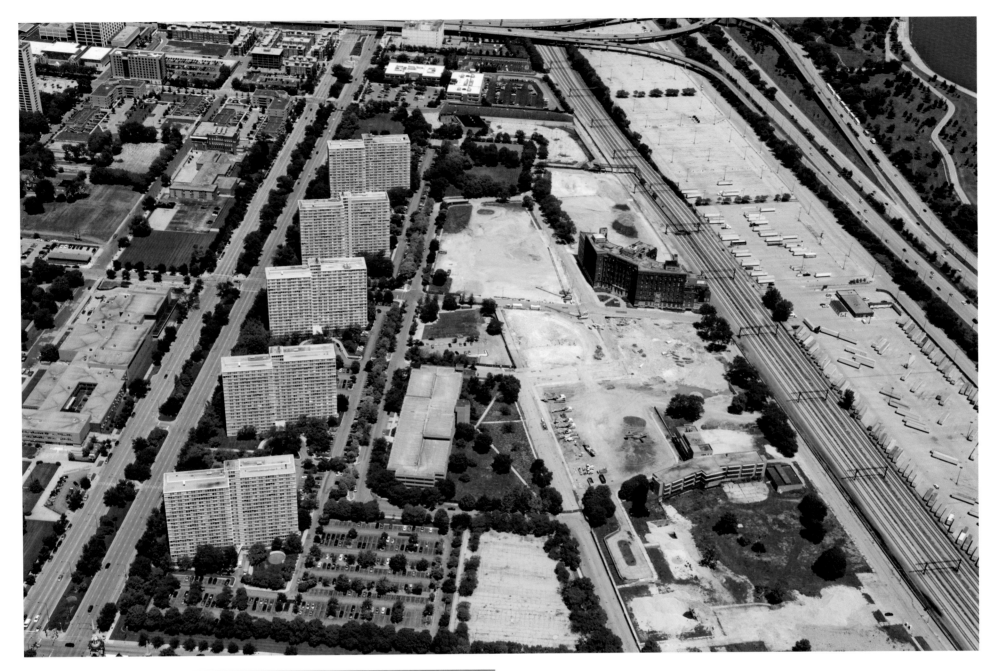

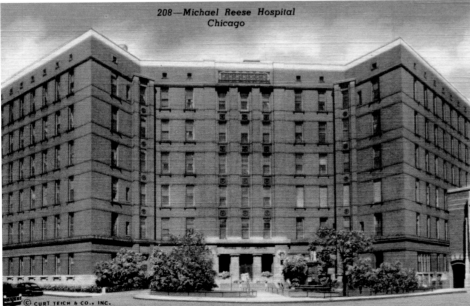

208—Michael Reese Hospital
Chicago

© CURT TEICH & CO., INC.

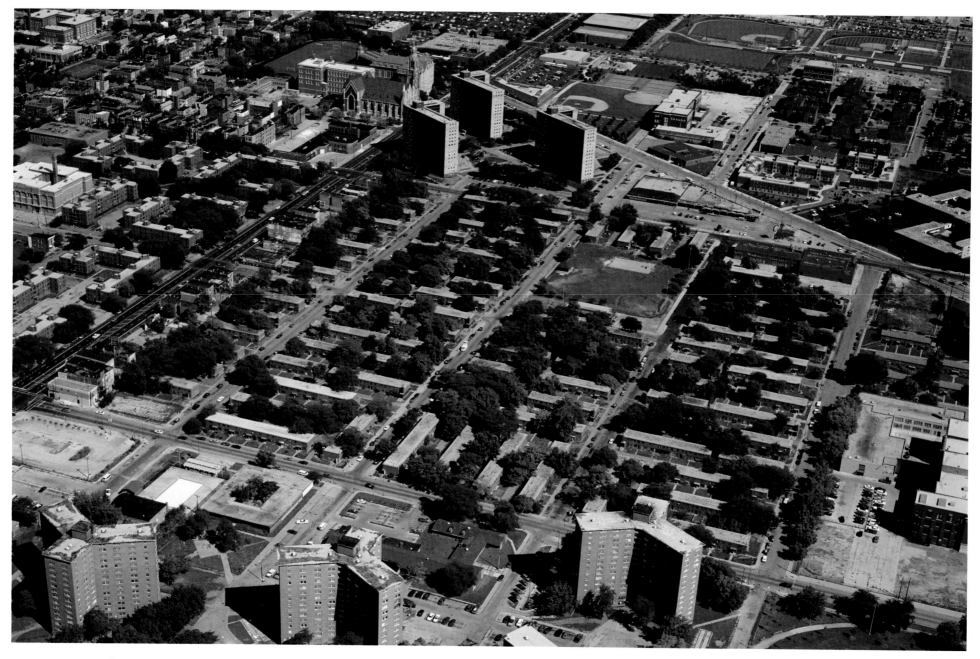

ABLA Homes/Roosevelt Square

ABLA is an acronym for four former public housing projects on the Near Southwest Side: Jane Addams Homes, Robert Brooks Homes, Loomis Courts, and Grace Abbott Homes. Once the second-largest public housing complex in the city, with an estimated 12,000 residents, most of ABLA has been demolished in recent years under the Department of Housing and Urban Development Hope VI program, and a mixed-income community known as Roosevelt Square has emerged in its place.

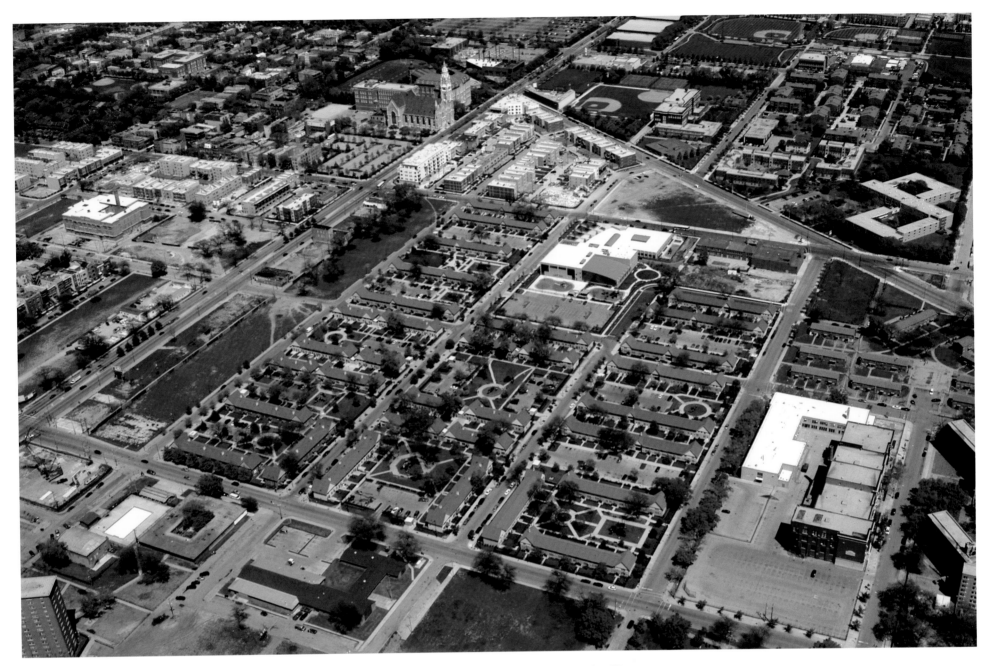

September 19, 1996
View to northeast. The steeple (top center) identifies Holy Family Church of 1857, one of the city's oldest. The tri-lobed towers of Grace Abbot Homes in the foreground were demolished between 2005 and 2007.

Holy Family Church, circa 1919
Holy Family Church, view to west on Roosevelt Road. To the right (east) of the church is St. Ignatius College Prep, still one of the city's elite private high schools.

May 6, 2006
View to northeast., The first phase of Roosevelt Square appears in the triangle south of Holy Family Church on the site where the three 16-story towers of the Robert Brooks Extension (demolished 1998-2001) previously stood. The $45 million Chicago Housing Authority (CHA)-funded redevelopment of the low rise Robert Brooks Homes (center) reduced the number of dwelling units from 800 to 330, and increased the average unit size. Selective demolition of numerous row houses significantly expanded community open space. The large new building in the center of the image is the 52,000-square foot Fosco Park Community Center, a project of the Public Building Commission of Chicago, completed in 2005.

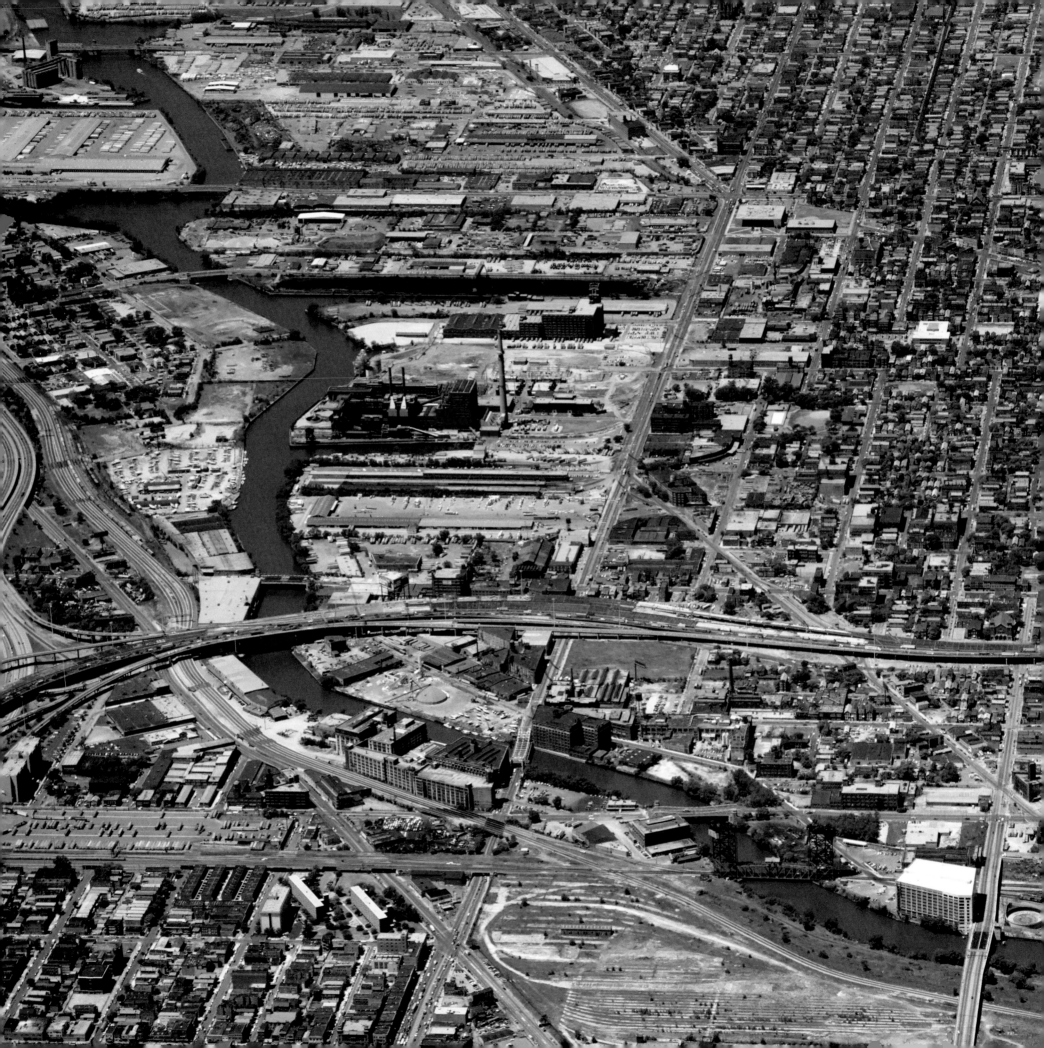

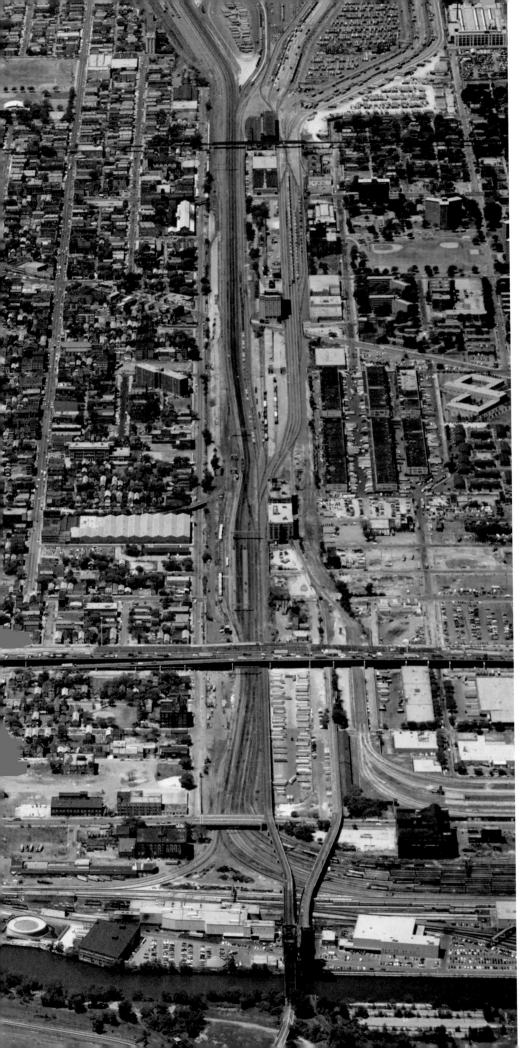

Chicago River South Branch

June 9, 1988
View to the west. Since
the city's earliest years,
the South Branch of the
Chicago River has traversed
a largely industrial district.
The lateral linear canals,
dating from the 19th
century, provided points
of off-loading for river-
borne freight, such as coal,
lumber or, more recently,
newsprint.

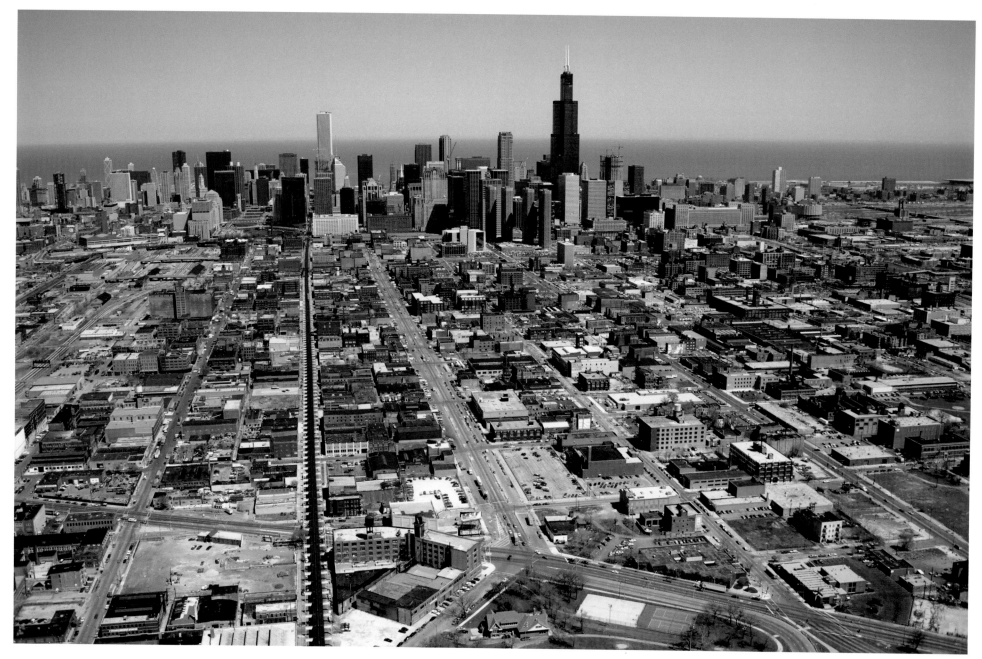

The Near West Side

Prior to its rebirth as a highly-desirable residential community, the Near West Side was the home of numerous industrial loft buildings that had become too outdated to support contemporary industrial uses, but so solidly built that there was no economic justification for their demolition. Most were converted to apartments, condominiums, and offices. For many years, Madison Street between the Chicago River and Ogden Park served as the main artery of Chicago's skid row.

May 11, 1989
Ogden Park (foreground), the Lake Street elevated tracks (left), and the broad right-of-way of Randolph Street were the most prominent physical features of the neighborhood, otherwise characterized by aging loft buildings and open parking lots. The white concrete and black glass Social Security Administration Building (upper center) marked the western limit of the central business district.

June 8, 2006
The beautification of Randolph Street is consistent with the explosive residential growth of the area. The Chicago Police Department's 9-1-1 call center on Madison Street (curving building, lower right) was completed in 1995. No longer skid row, Madison Street is largely characterized by small neighborhood retailers at street level, with apartments above.

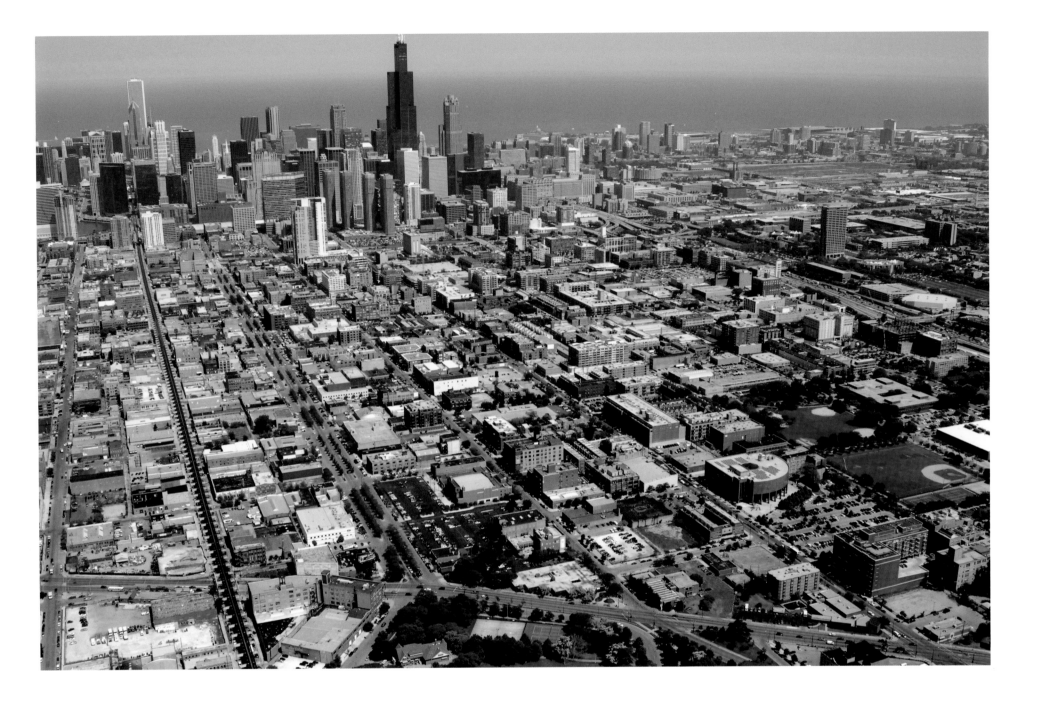

Chicago Stadium and United Center

Both the Chicago Stadium and the United Center have served as the home venue of the Chicago Blackhawks and the Chicago Bulls, in addition to hosting occasional musical events. Upon its completion in 1929, the Stadium became the world's largest indoor arena. It also hosted the Democratic National Conventions of 1932, 1940 and 1944, and the Republican National Conventions of 1932 and 1944.

August 5, 1994 (top)
The new United Center is just nearing completion in this image. The surrounding Near West Side would undergo significant change during the ensuing years.

October 12, 1988 (center)
The Stadium had a clear span of 266 feet. It was designed by Westcott Engineering Company, a leading structural engineer of the era of its construction.

May 12, 1994 (opposite)
Although the United Center appears much larger than the Stadium, its seating configuration for hockey can accommodate 19,717 fans (and 23,500 for concert events). The Stadium seated 17,317 for hockey.

Chicago Stadium, circa 1940 (bottom)
The acoustics of the "Madhouse on Madison" were once likened to those of a shower stall.

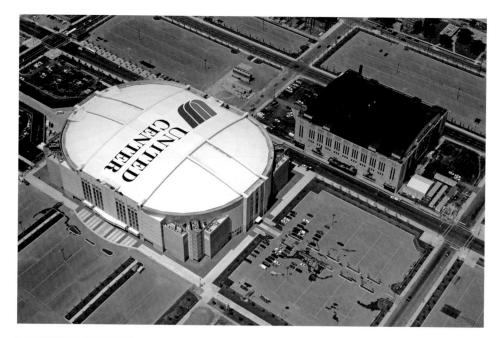

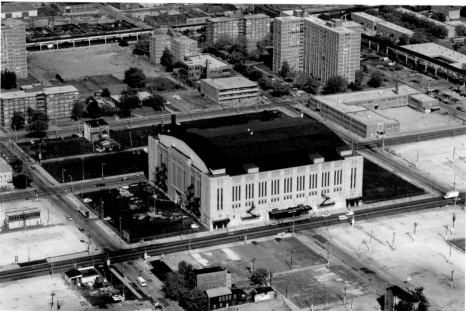

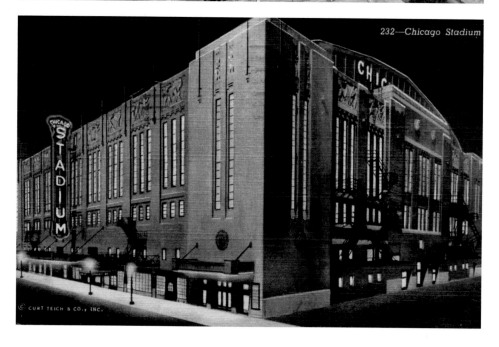

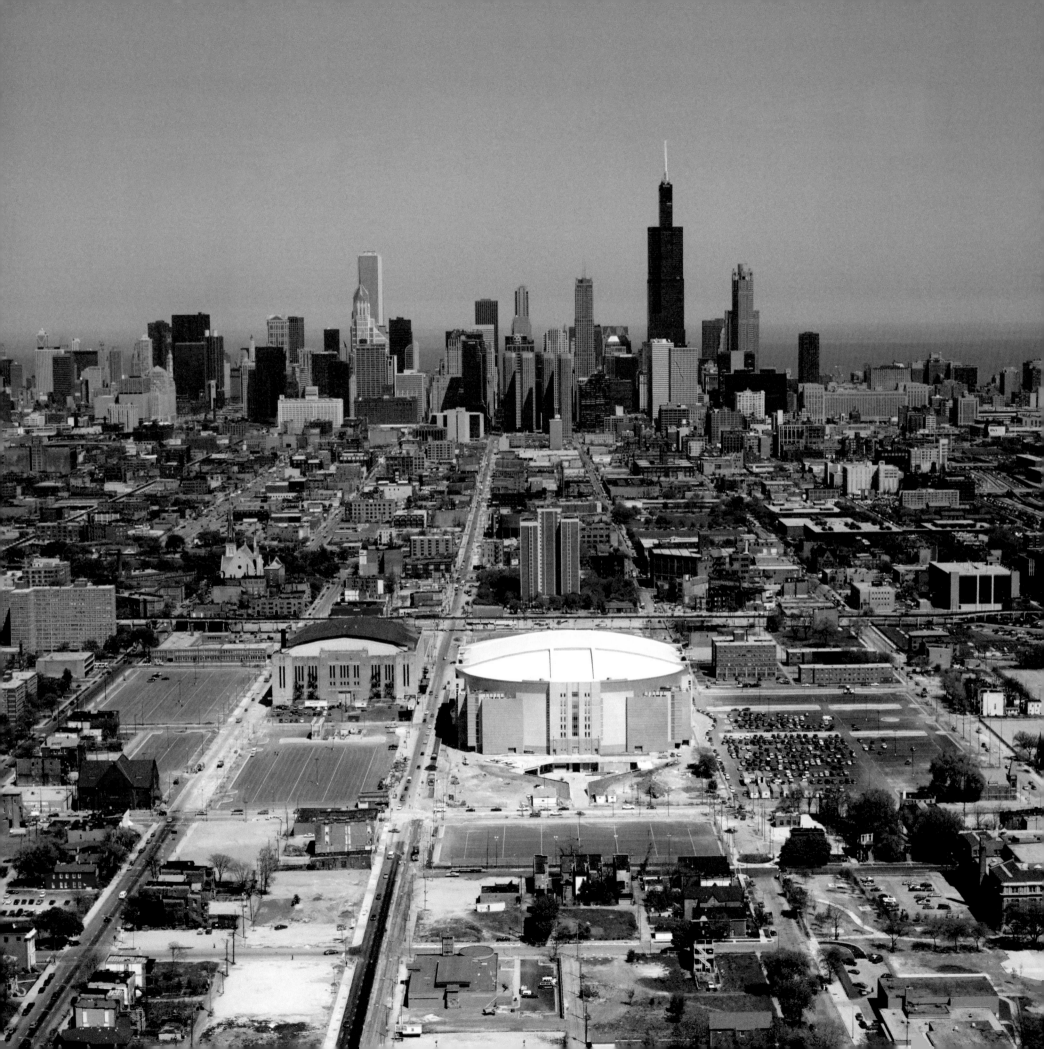

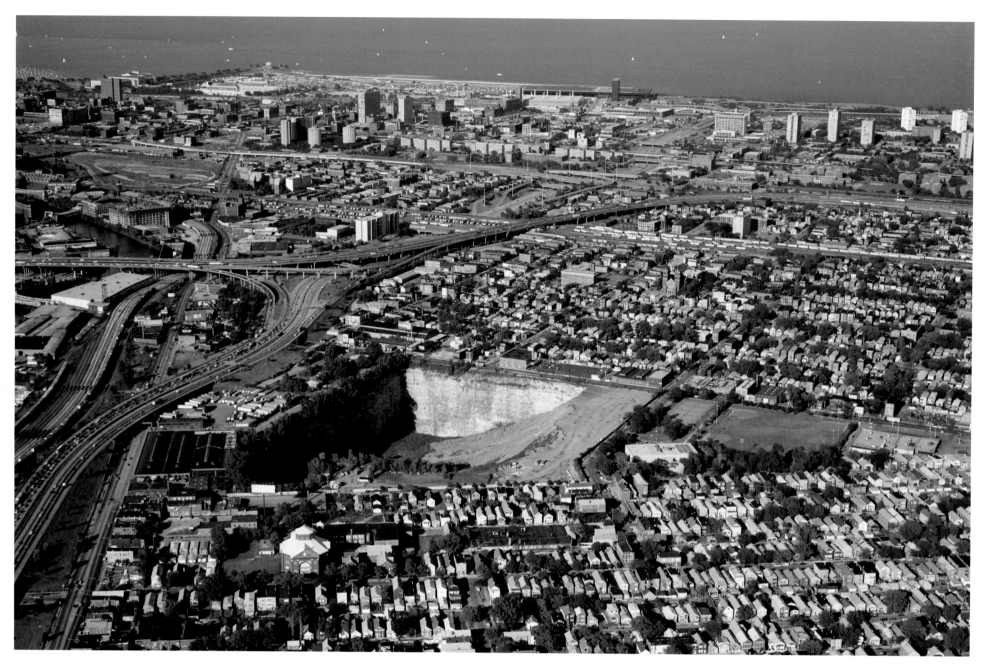

Stearns Quarry/Palmisano Park

Between 1833 and 1969, so much limestone was extracted from Stearns Quarry that the pit ultimately reached a depth of 380 feet. The City of Chicago acquired the 27-acre site in 1970 at a cost of $9 million. Years of backfilling with incinerator ash and construction and demolition debris—and installation of environmentally-sensitive surface materials—culminated in the creation of a new park for the Bridgeport neighborhood. The 35-foot sledding hill in its center offers expansive views of the surrounding city.

August 12, 1986
The vertical enclosing walls of the quarry were South Halsted Street on the east (in sunlight) and West 27th Street on the north. McGuane Park is to the south (at right). Meigs Field and McCormick Place occupy the central portion of the lakeshore in this view.

August 23, 2009
The novel features of Palmisano Park include a fishing pond partly bounded by the old quarry wall (at lower left), and a wetland habitat that drains into the pond. The park was designed by Site Design Group, Ltd. (Ernest C. Wong).

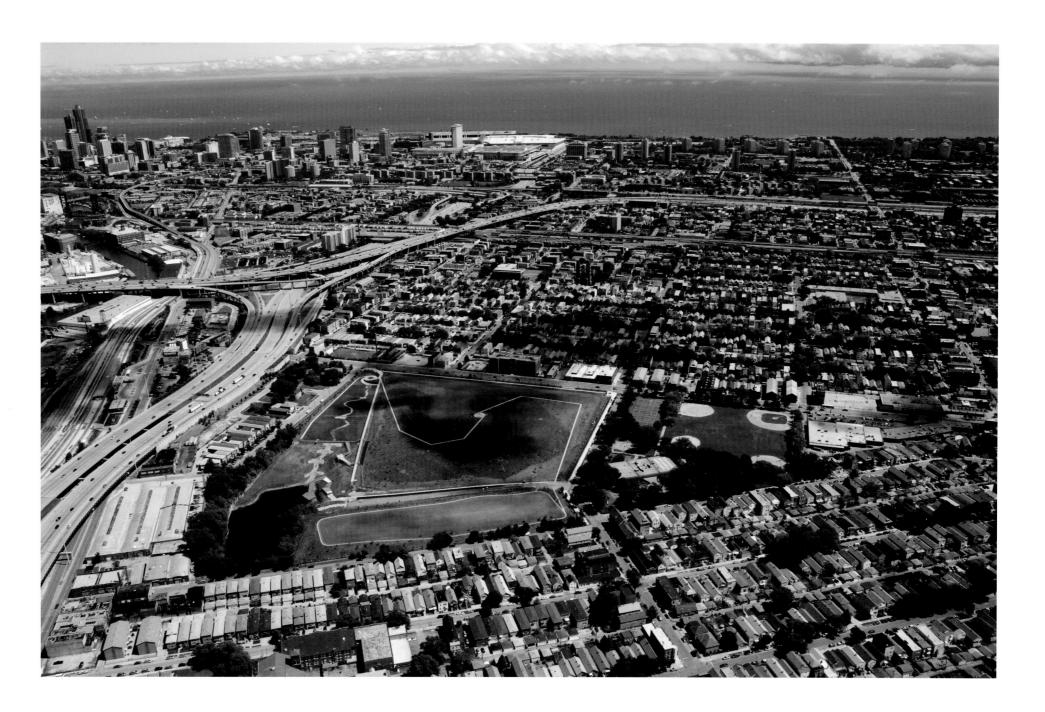

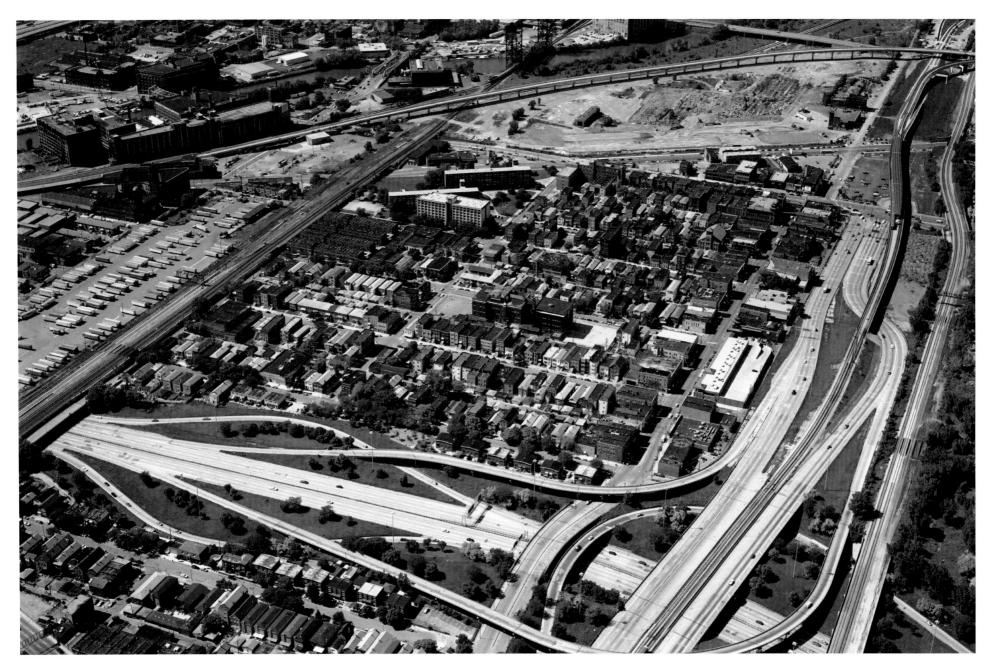

Chinatown

Chinatown experienced considerable new growth in the 1990s when it expanded into the old Santa Fe railroad yards north of Archer Avenue. Along with the two-story Chinatown Square retail and office complex and more than 600 new residential units (Santa Fe Gardens), the expansion created a Chinatown waterfront on the South Branch of the Chicago River with the completion of 17-acre Ping Tom Park in 1999. The local public school, John C. Haines Elementary, a project of the Public Building Commission of Chicago, was replaced in 1994. Its predecessor had served the community for 100 years.

June 5, 1991
Tightly encircled by expressways and railroads, Chinatown had little room for expansion before the Santa Fe yards became available. The old John C. Haines School is the large rectangular building in the center of the photograph.

July 1, 2010 (opposite top)
A shared commitment to the maintenance of Chinatown's older building stock is evident in the widespread replacement of its preferred roofing material, from black tar to energy-efficient reflective finishes.

June 16, 2010 (opposite)
View to southeast. Ping Tom Memorial Park is named in honor of a lifelong Chinatown resident and founder of the Chinese-American Development Corporation. Ernest C. Wong of Site Design Group designed the award-winning riverfront park.

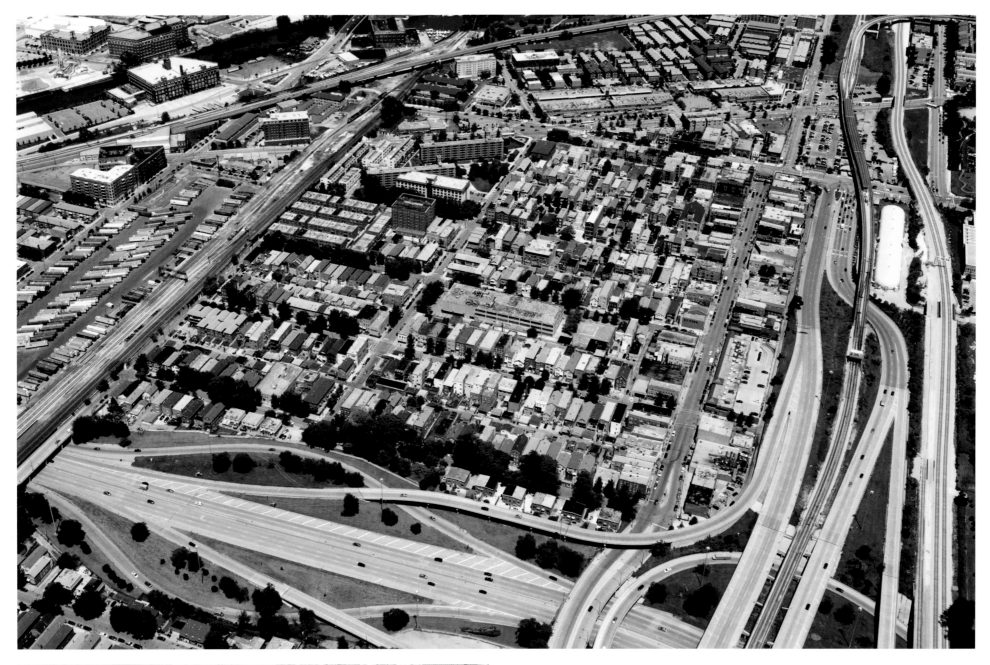

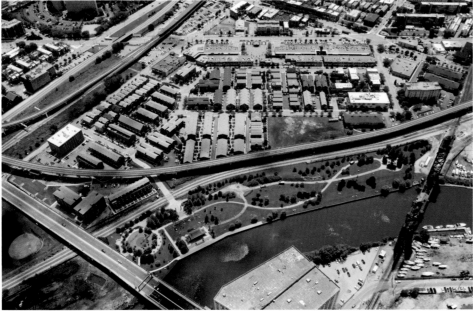

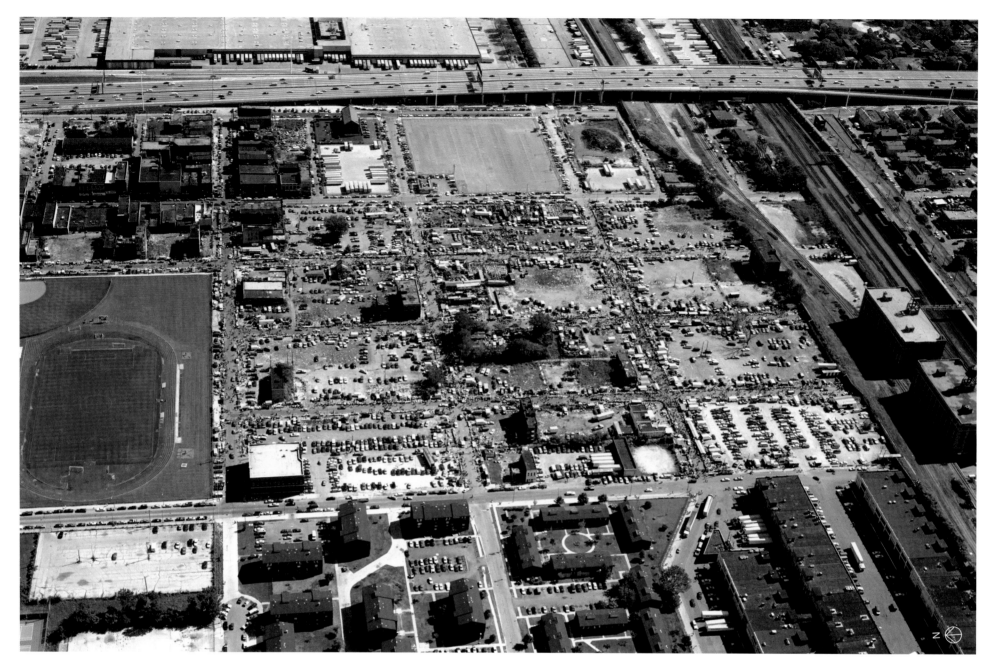

Maxwell Street/University Village

For generations, Maxwell Street served as a destination for impoverished immigrants: from the shtetls of Eastern Europe early in the 20th century, African-Americans from the south at mid-century, and Mexicans in its closing decades. Before its relocation to Canal Street in 1994, the famous Maxwell Street market had become increasingly confined, particularly by the construction of the Dan Ryan Expressway in the 1950's, and later by the expansion of the University of Illinois Chicago campus. In 2008, the market was relocated for a second time, to Desplaines Street, between Harrison Street and Roosevelt Road.

September 30, 1990
Even long after most of the buildings in the area had been demolished, market activity continued almost exclusively in the street spaces, just as it had in the market's earliest days, when it was enveloped by a dense urban neighborhood.

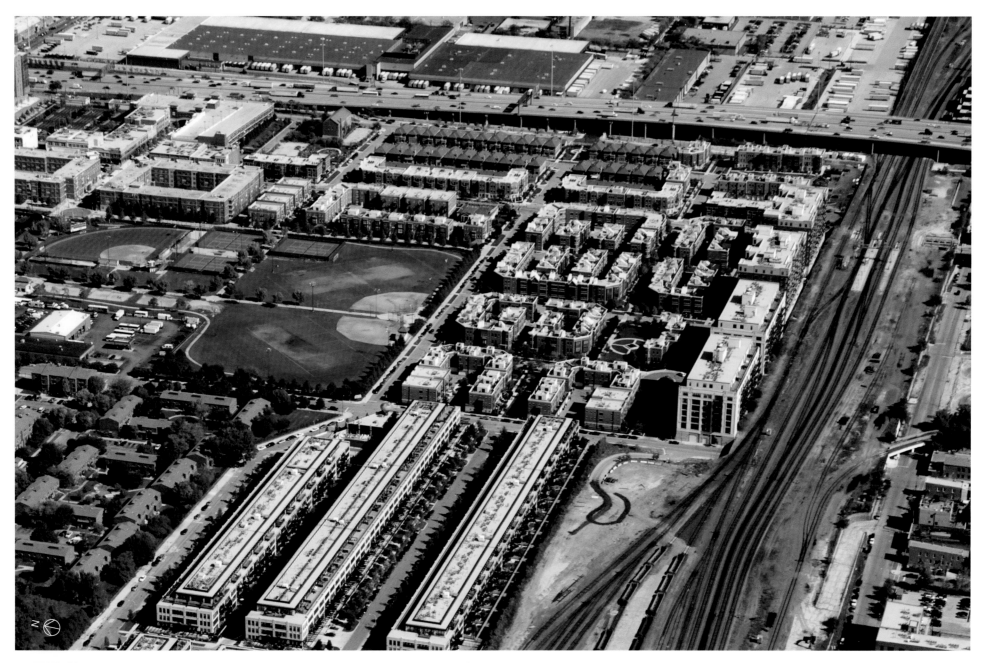

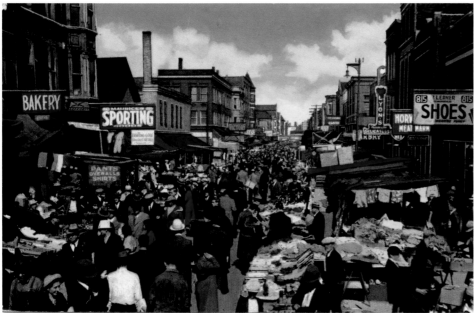

October 9, 2008

By the beginning of the new century, nine blocks of the old market, covering 58 acres, had been redeveloped as a new urban neighborhood known as University Village. It includes 930 townhouses and condominiums, 36 single-family homes, and two quadrangles of student housing with ground floor retail space, fronting on Halsted Street. The old South Water Street produce market (the three long buildings in the foreground) has been converted to residential condominiums as well.

Maxwell Street Market, Circa 1950

View to east.

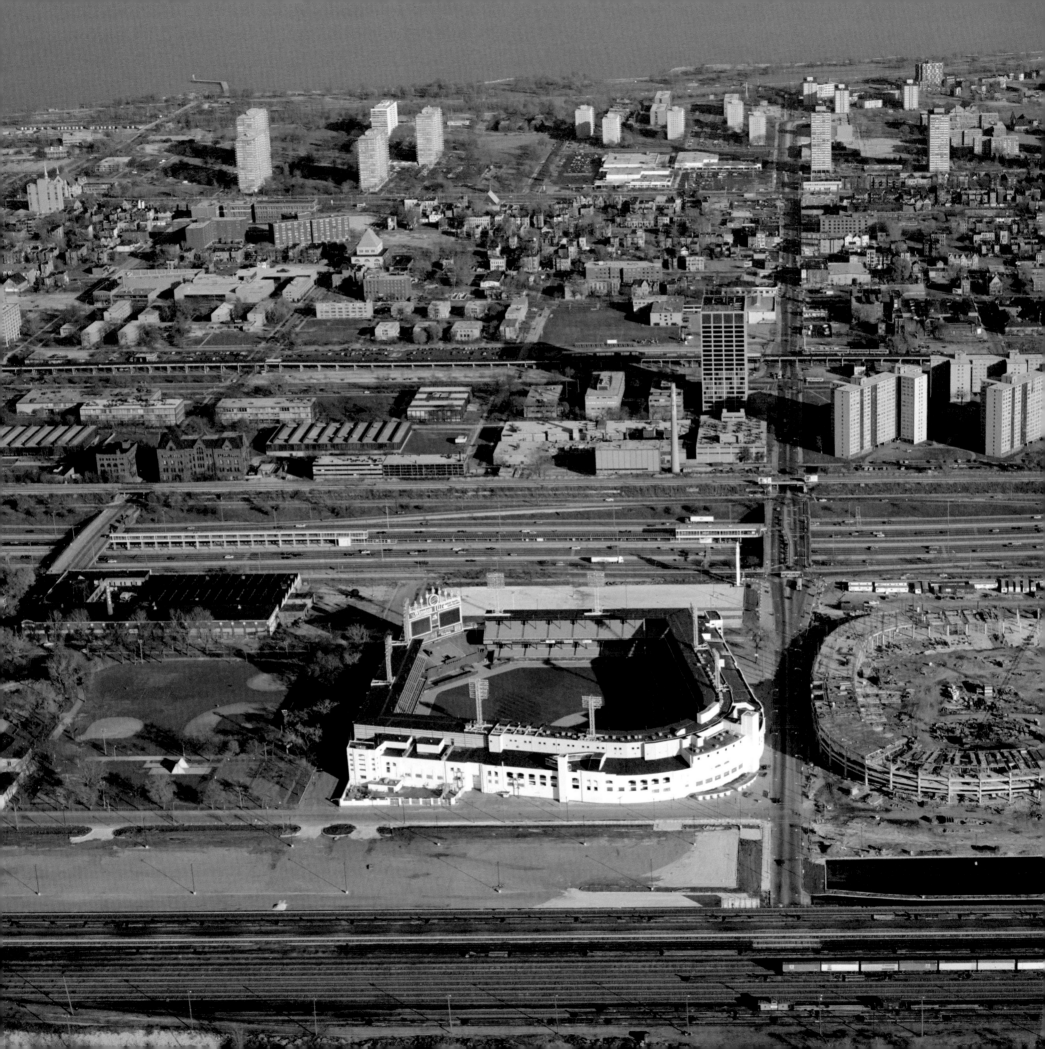

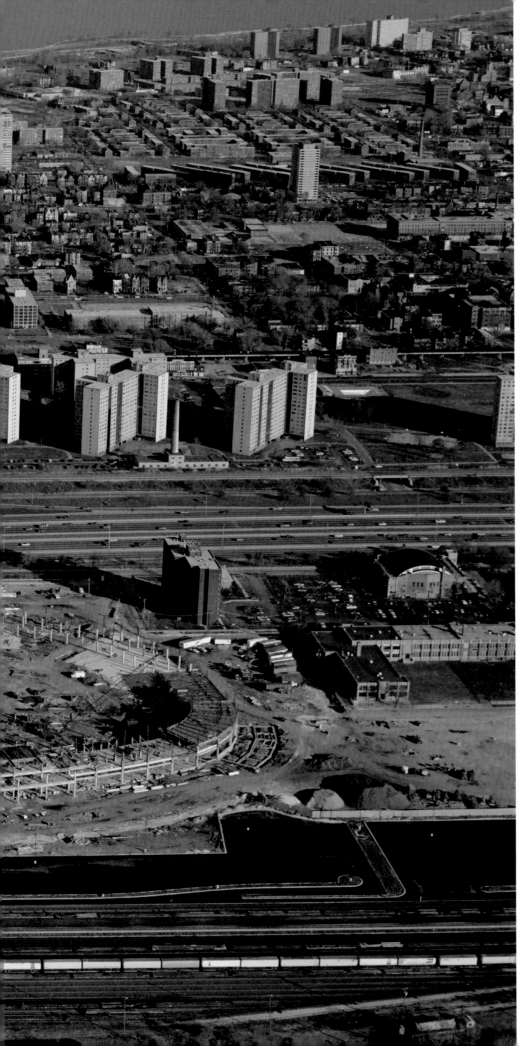

US Cellular Field/Comiskey Park

The White Sox, under owner Charles Comiskey, won the very first American League pennant, in 1901. The team relocated to Comiskey Park in 1910. US Cellular Field, developed and owned by the Illinois Sports Facilities Authority, opened for the 1991 season. The authority had been created by the state legislature in 1987 to induce the White Sox to remain in Chicago.

November 12, 1989
Construction of the future US Cellular Field. The White Sox played their last game in old Comiskey Park on September 30, 1990.

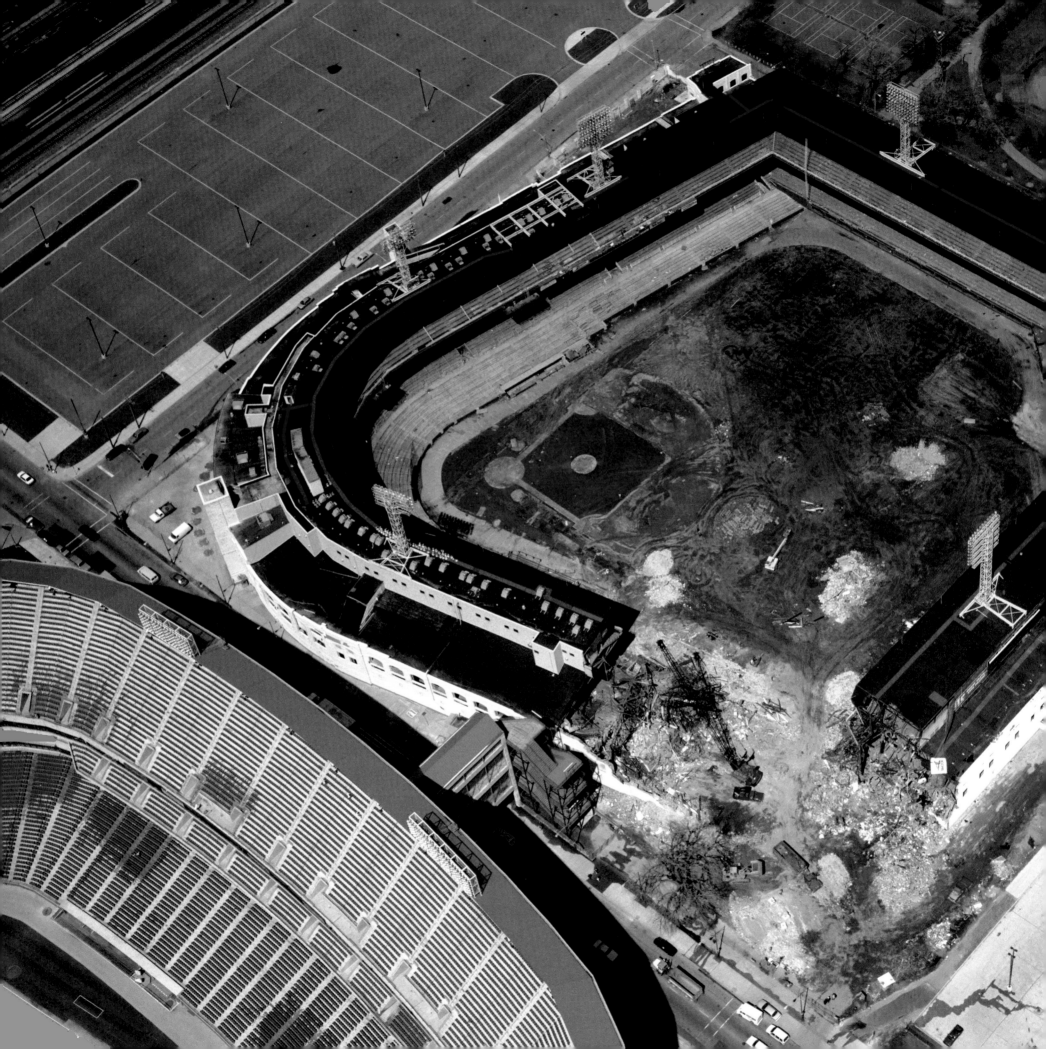

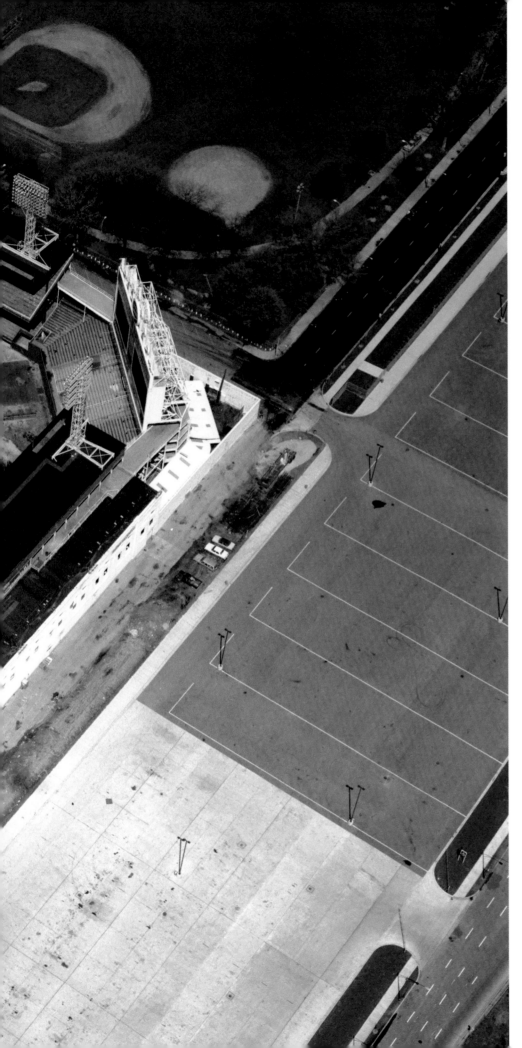

236—Comiskey Park, Chicago

© CURT TEICH & CO., INC.

April 29, 1991
Demolition of Comiskey
Park. The oldest ballpark
still in use at the close of
the 1990 season, Comiskey
had been the home field
of only one World Series
champion, the 1917
White Sox.

Night game at
Comiskey Park, circa 1950
Comiskey hosted its first
night game August 14,
1939. It also served as the
site of the first Major
League All-Star game, on
June 22, 1937.

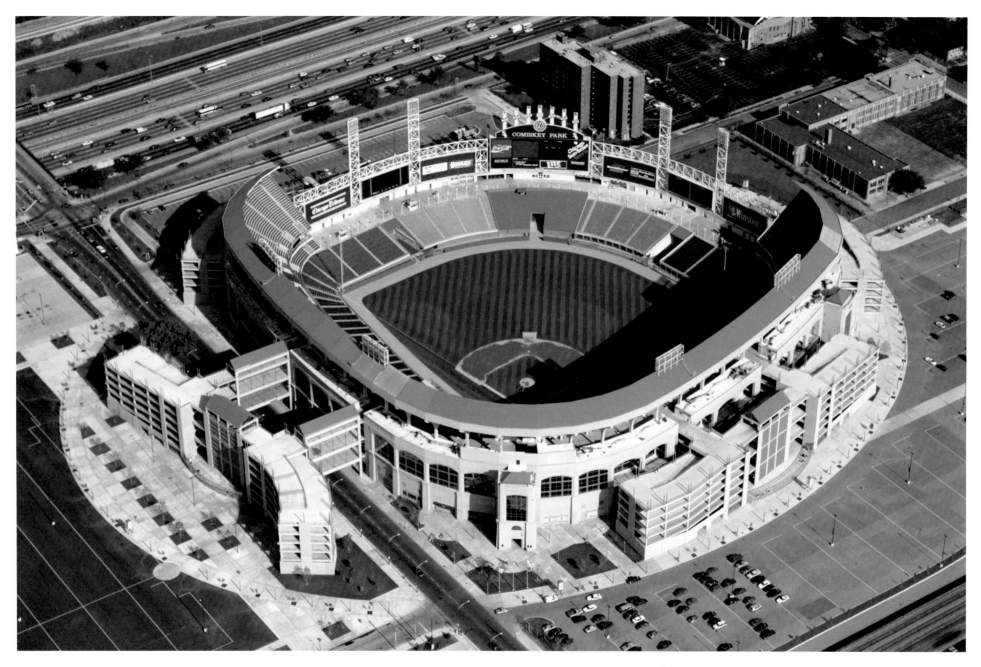

July 15, 1992
Since its inaugural season in 1991 as the last of the "modern" ballparks that dominated baseball in the last half of the 20th century, US Cellular Field has been transformed through an ambitious series of subsequent renovation projects into a member of the expanding community of retro ballparks.

August 31, 2007
In 2004, 6,000 upper deck seats were removed to make way for the truss-supported canopy, and the original blue stadium seats were replaced by green ones. In 2003, US Cellular company paid $68 million for 20 years of naming rights.

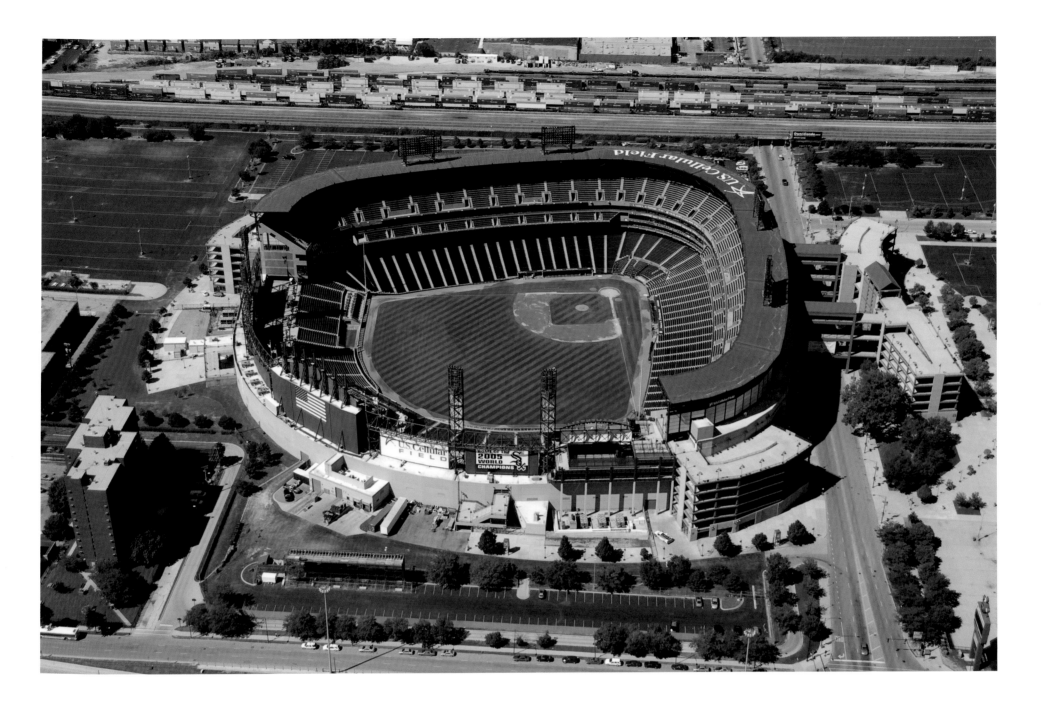

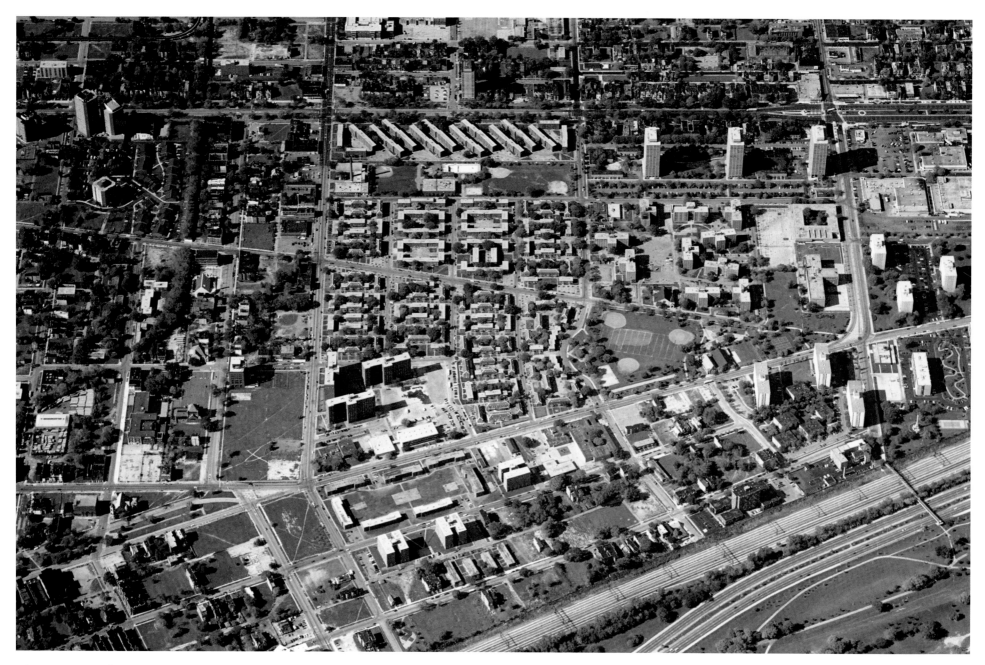

Ida B. Wells/Oakwood Shores

Four former public housing projects, Ida B. Wells, Wells
Extension, Clarence Darrow Homes, and Madden Park Homes
were transformed into the community of Oakwood Shores, as the
result of a grant from the US Department of Housing and Urban
Development. The new project includes 3,000 new dwellings,
with 1,000 set aside as public housing, and the remainder market
rate and affordable housing.

October 14, 1996
View to west from the
lakefront. The regimented,
institutional look of
public housing remained
pronounced in the four
projects' waning days. The
future site of Mandrake
Park is at lower left.

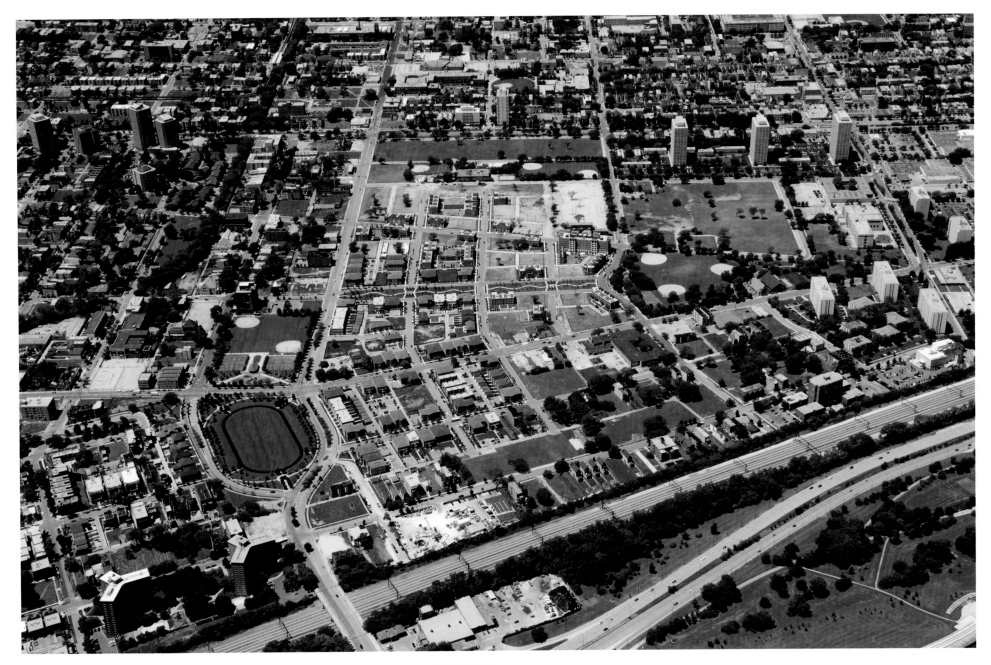

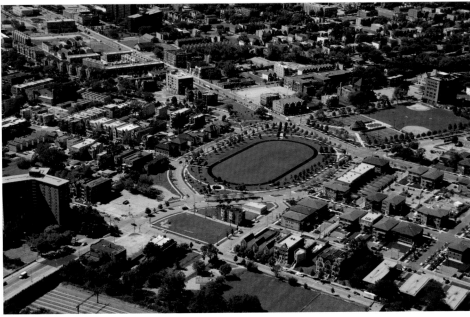

July 1, 2010
For hundreds of households, the emergence of Oakwood Shores embodies the beginning of the end of social, as well as architectural, isolation.

August 31, 2007
View to southwest, Mandrake Park at center. A new neighborhood has emerged on the city's Near South Side. Surviving historic homes blend seamlessly with the new.

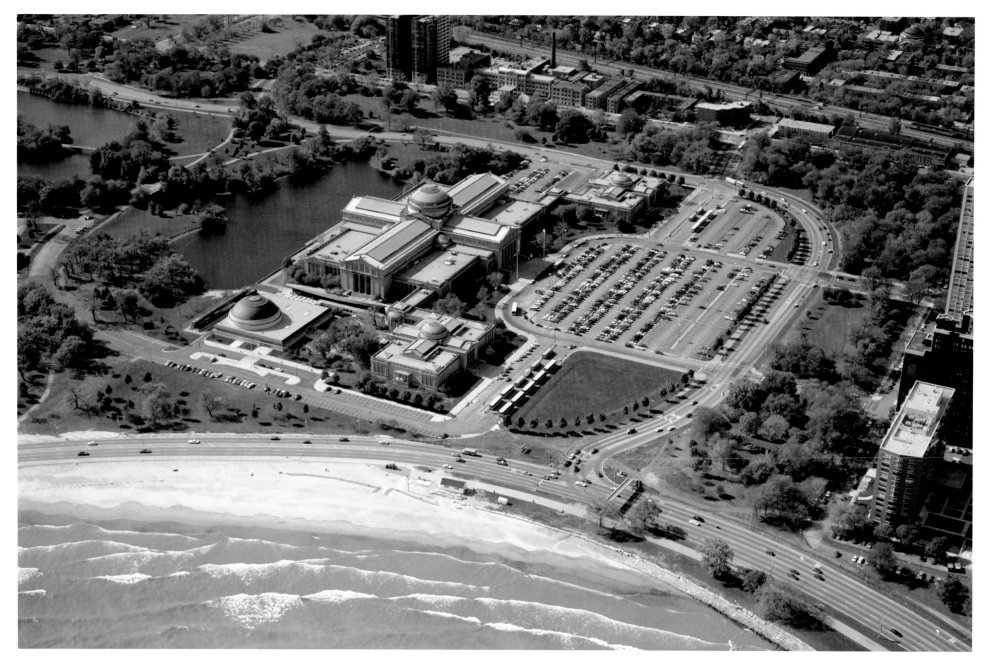

Museum of Science and Industry

Although completely reconstructed of durable materials in the
1930s, the building housing the Museum of Science and Industry
dates from the World's Columbian Exhibition of 1893. From
the close of the fair until 1920, it was the home of the Field
Columbian Museum, precursor to the Field Museum of Natural
History. Julius Rosenwald (of Sears Roebuck & Co.) contributed
more than $5 million toward the realization of the Museum of
Science and Industry but declined impassioned entreaties to
have it named in his honor.

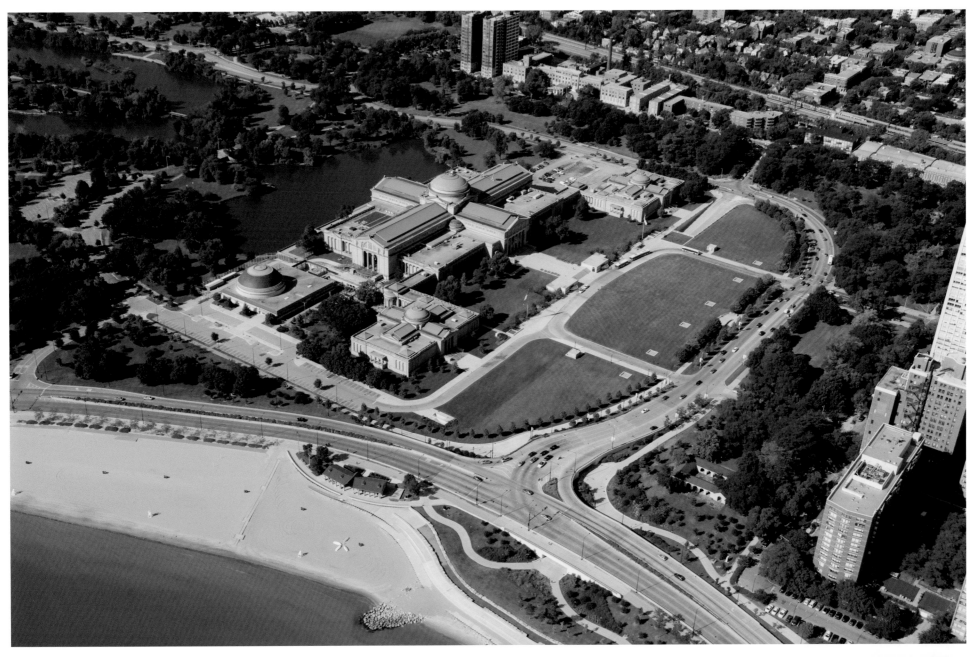

October 18, 1991
The Henry Crown Space Center (dark dome, at left) opened in 1986, a significant departure from the classical symmetry of the overall site plan. The open parking lot, which steadily expanded from the 1940s until 1958, consumed several acres of open park space, which would be restored by the end of the century. The U-505 submarine was located at the east portico until 2005.

August 27, 2010
The 1998 improvement created an underground parking facility, along with additional exhibition space. In 2005, the U-505 submarine was relocated to the underground McCormick Tribune Foundation Exhibition Hall. Five decades of Chicago weather had caused considerable damage to this extremely popular exhibit.

Field Columbian Museum
After the museum's collection was relocated to the new Field Museum in 1920, its former location, the Palace of Fine Arts (built for the Columbian Exposition of 1893), deteriorated rapidly.

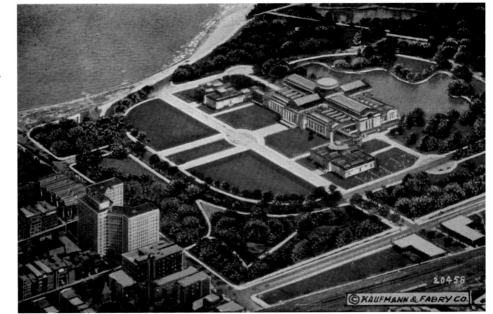

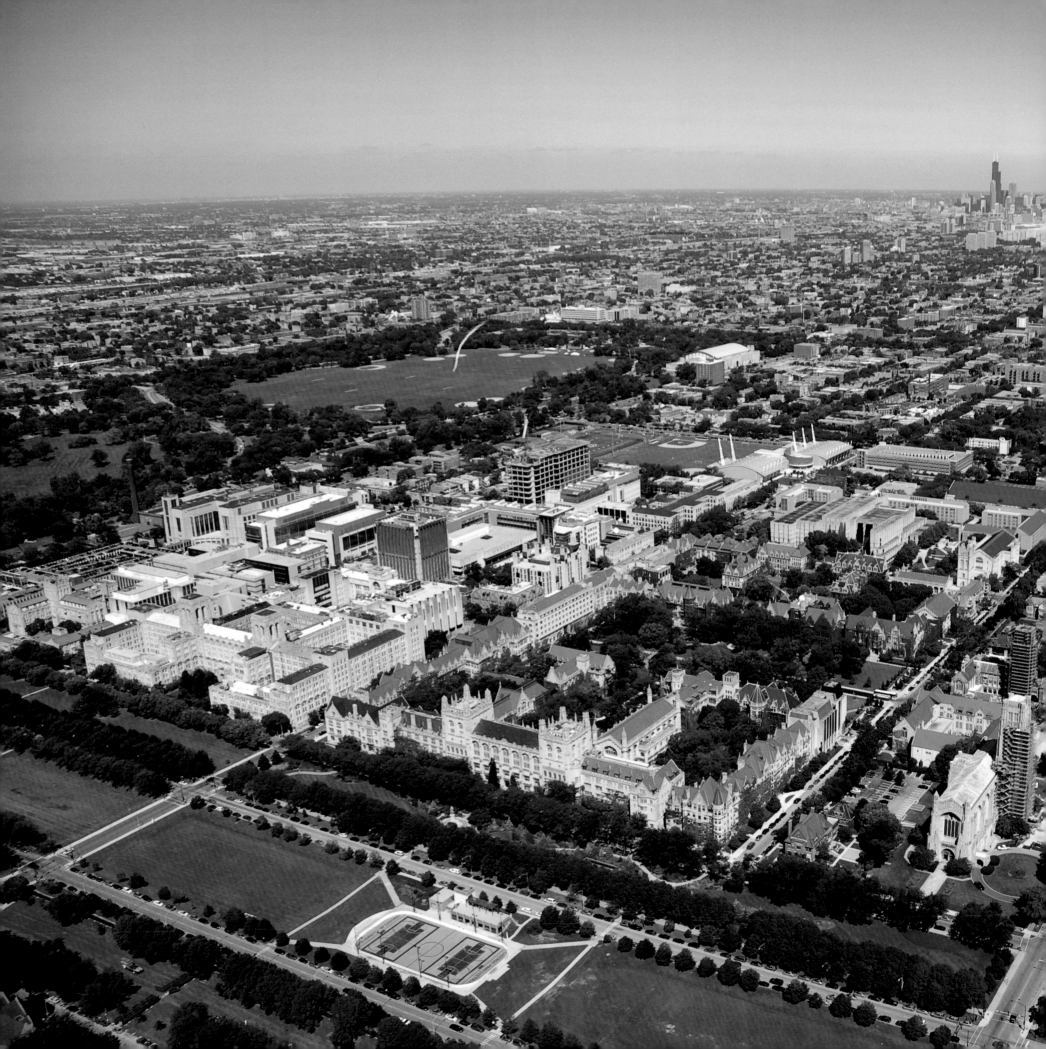

University of Chicago

Incorporated in 1892 by the American Baptist Education Society and its benefactor, John D. Rockefeller, the University of Chicago has been affiliated with 85 Nobel laureates. The original quadrangles follow the master plan laid out by architect Henry Ives Cobb (1859-1931). Rockefeller Memorial Chapel, its steeple sheathed in scaffolding, is in the foreground. It was designed by Bertram Grosvenor Goodhue Associates and constructed in 1925-28.

August 31, 2007

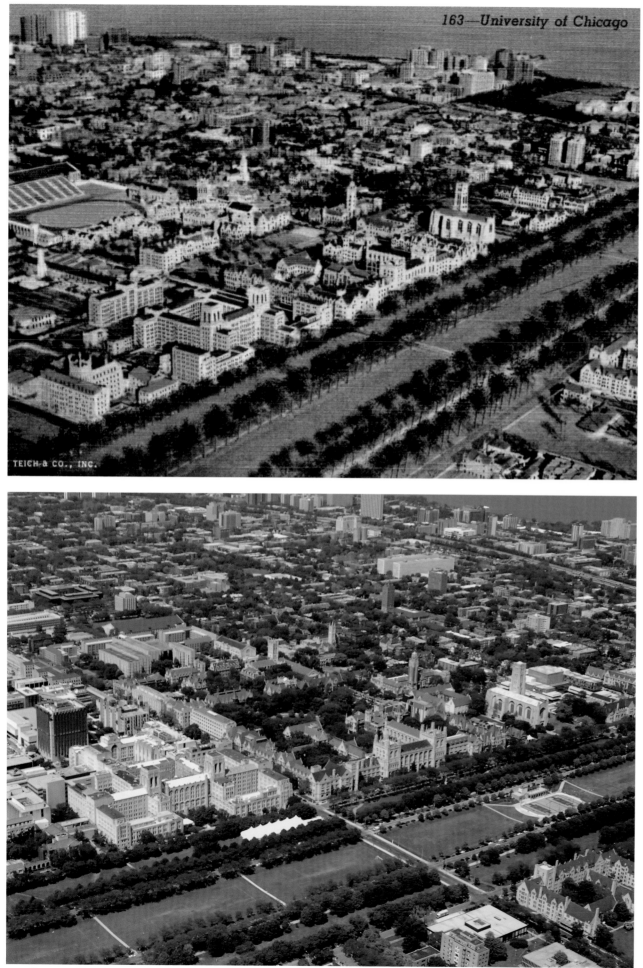

Stagg Field, circa 1941
The university dropped
its football program in
1939, shortly before it
withdrew from the Big Ten
Conference. The atomic
age was initiated beneath
the stands of the old Stagg
Field, visible at left in this
postcard image.

June 8, 2006
The Regenstein Library
stands on the former site
of Stagg Field.

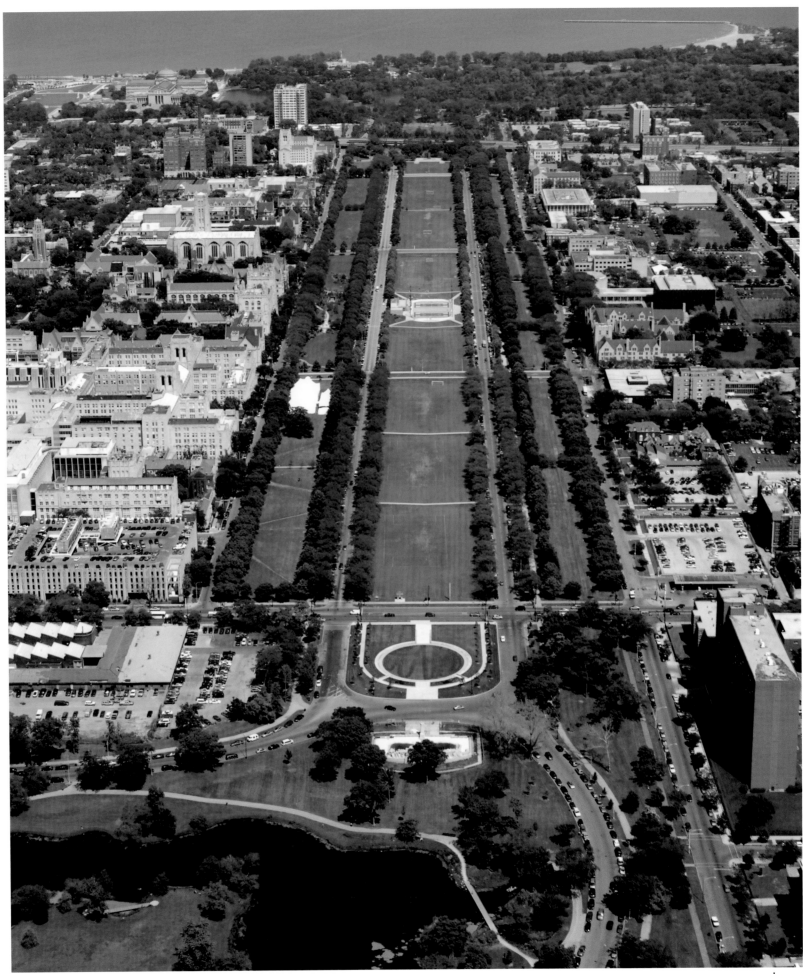

June 8, 2006
Midway Plaisance
(view facing east) links
Washington and Jackson
Parks. Long the university's
south boundary, the
Midway Plaisance is now
flanked on both sides
by university facilities.
The word "midway"
comes from the World's
Columbian Exhibition of
1893, when carnival rides
and other diversions filled
the area.

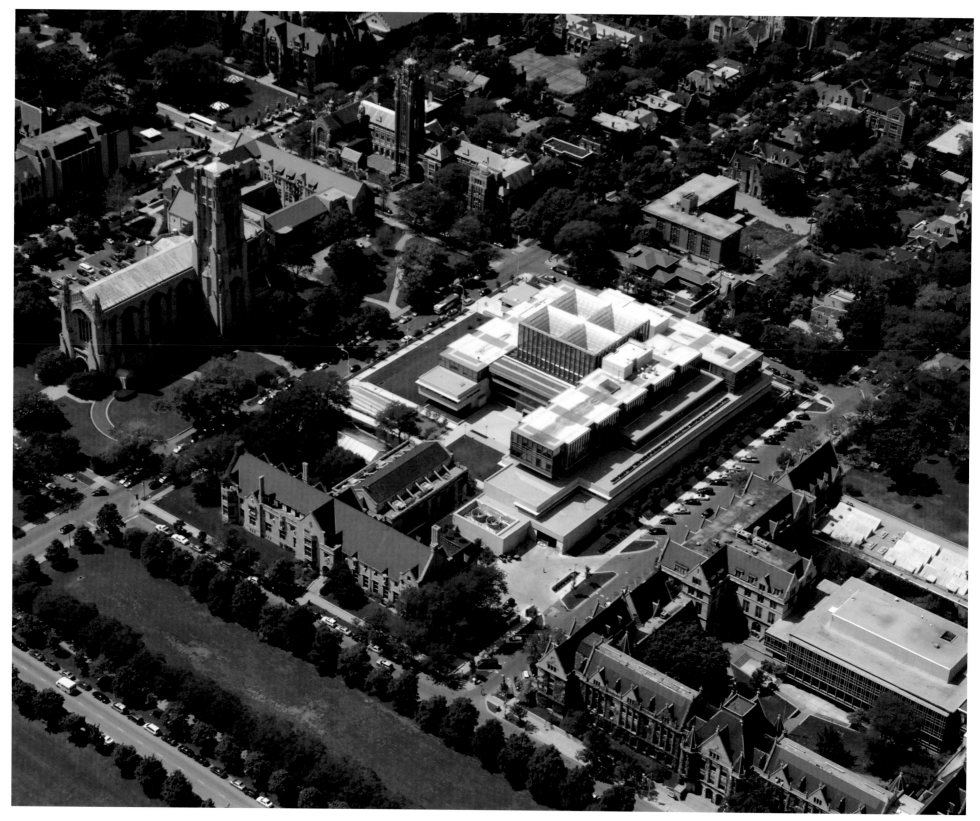

June 8, 2006
The university continues to retain prominent architects as it continues to grow. The new Charles M. Harper Center, completed in 2004, houses the business school. It is the work of the Uruguayan born, New York-based architect Rafael Viñoly.

July 30, 2007
The Regenstein Library designed by Walter Netsch, Jr. (1920-2008) of Skidmore, Owings & Merrill opened in 1970 on the former site of Stagg Field. Its collection includes more than 4.4 million volumes.

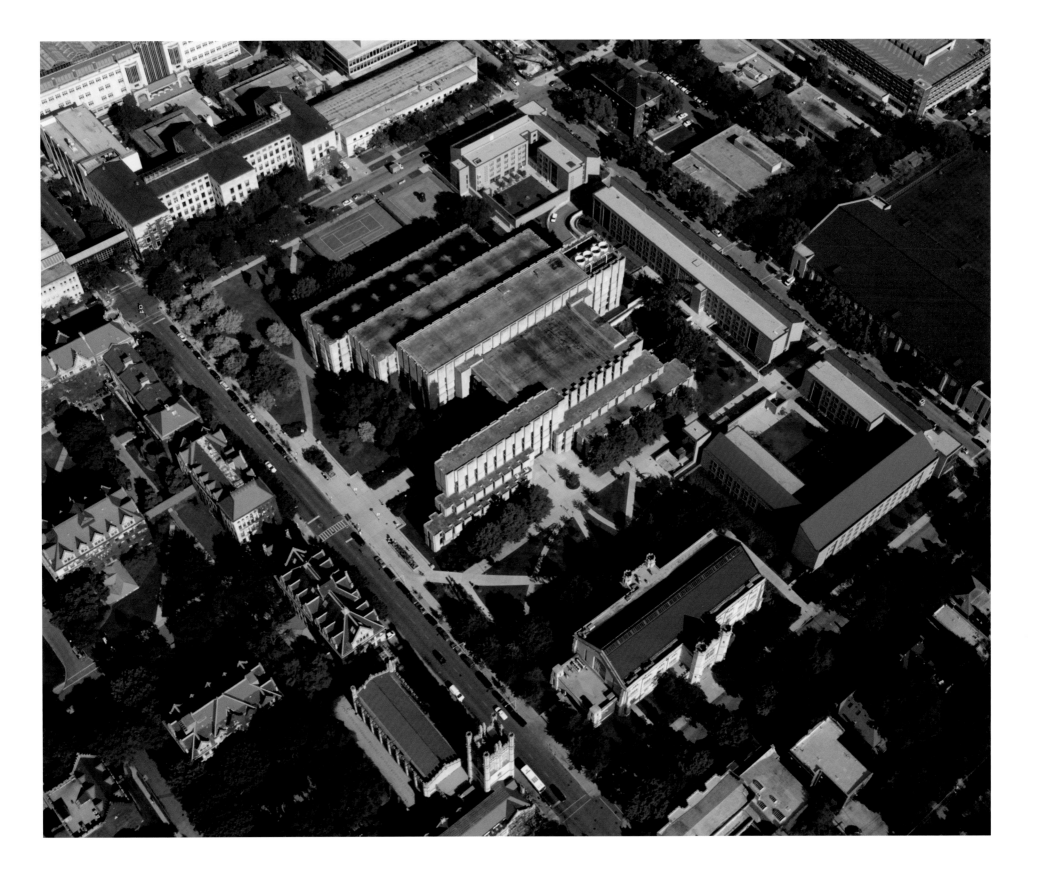

Robert Taylor Homes

The South Side experienced far reaching change in 1962 with the completion of both Robert Taylor Homes and the Dan Ryan Expressway. At its opening, Robert Taylor became the largest public housing complex in the United States. Extending from 39th Street to 54th Street, it included 28 sixteen-story buildings with 4,321 apartments. Designed for a population of 11,000, the project, at peak, had 27,000 residents.

September 19, 1996
Residential displacement related to the land acquisition required for the Dan Ryan Expressway and Robert Taylor Homes contributed to a mass migration from the South Side to the West Side of the city beginning in the mid 1950's.

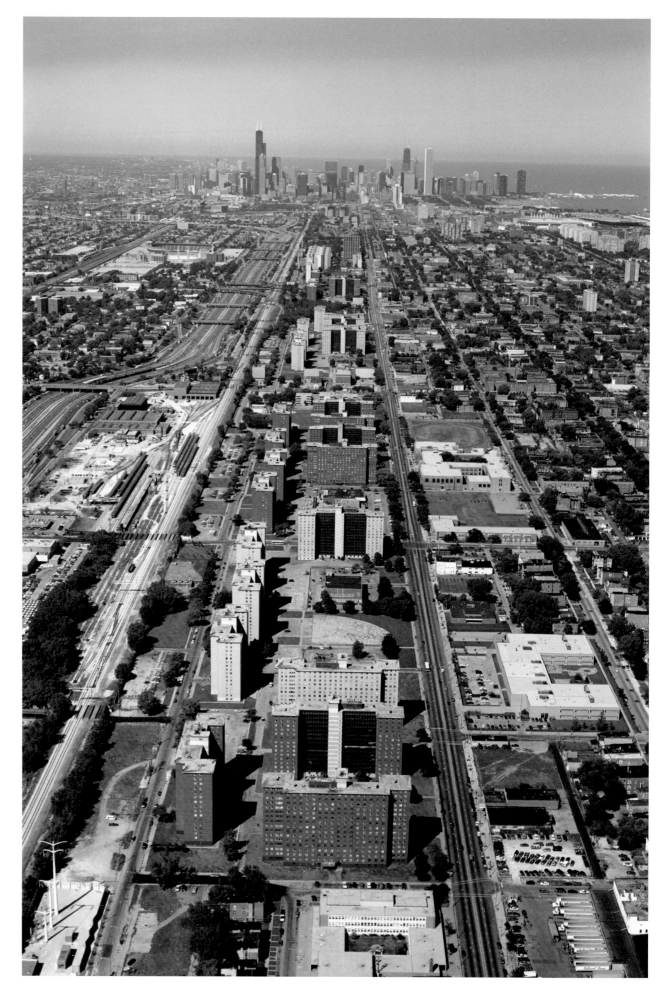

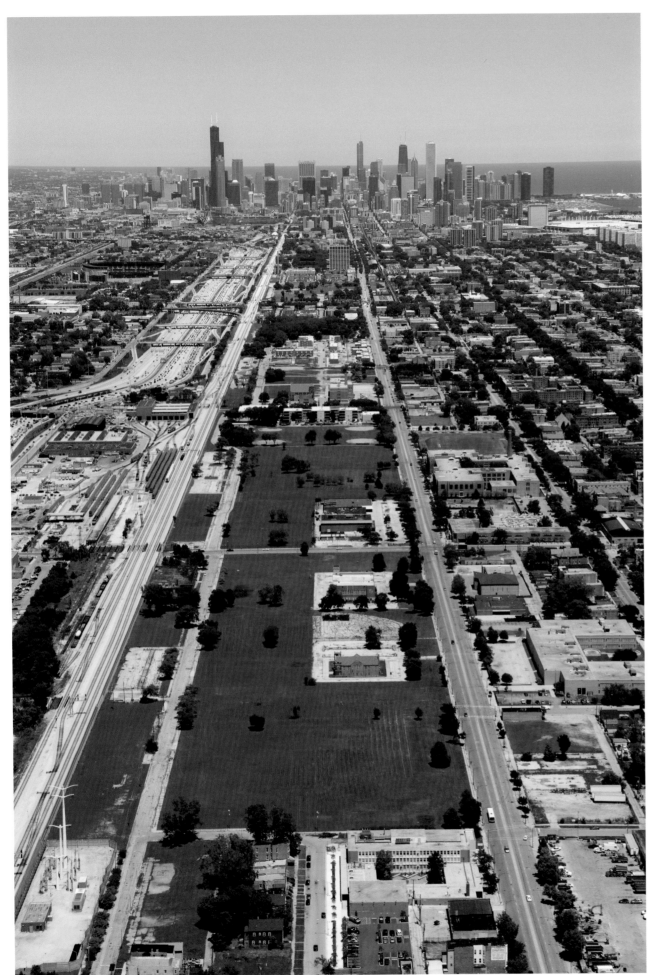

July 1, 2010
By the end of 2005, the
last residents of Robert
Taylor had been relocated.
The final building was
demolished in March of
2007. Only a few private
buildings, including
several churches, remain.
Under the HUD Hope VI
program, 2,300 low-rise
housing units are to be
developed on the site.

Pullman

Industrialist George Pullman and architect Solon Beman
created what they imagined to be the perfect workers' town.
The violent strike of 1894 put an end to the dream just 14 years
after construction began, but much of the community survives
to the present day and is an official landmark district. Under the
master plan, higher quality executives' homes fronted on Pullman
Park, with workers' accommodations at increasing distances from
the park, based on occupational status.

August 17, 1989
View to north. The
Florence Hotel, named
for Pullman's daughter,
is situated between the
highly formal Pullman
Park (center left) and the
former administration
building on E. 111th
Street (top edge
center). A fire gutted
the administration
building in 1998, more
than 100 years after its
completion.

July 1, 2010
The steel frame of the
second market square
building is visible at
center right, it, too, having
been gutted by a fire. The
curving arcades of the
Colonnade Apartments,
which frame Market
Square, appear in the
opening scene of the
1989 movie *The Package,*
filmed entirely on location
in Chicago, though
pretending to be Berlin.

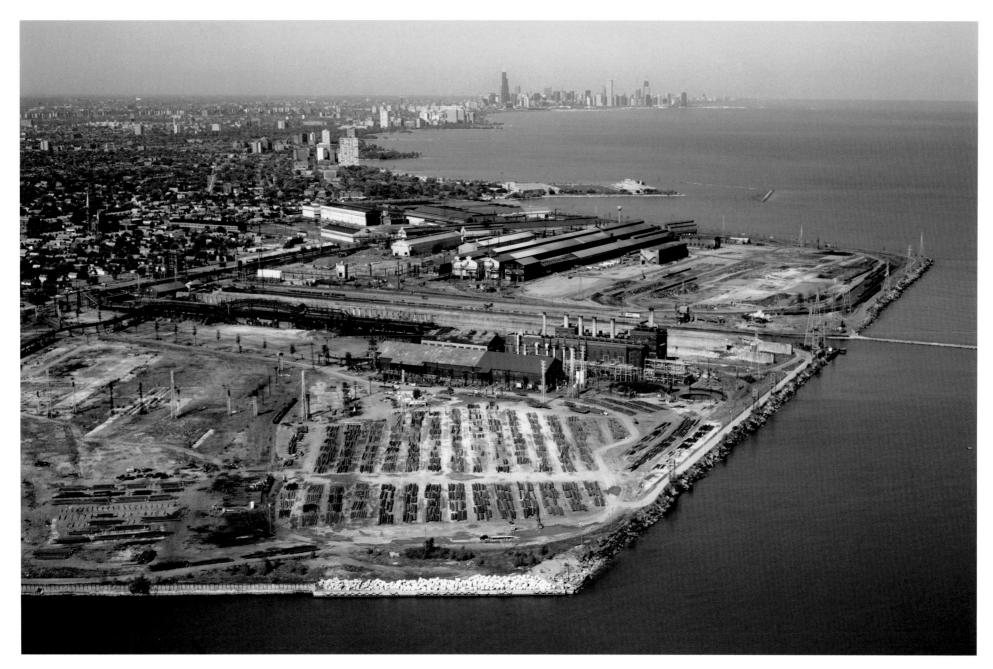

USX

Steel has been made on this Far South Side site since 1882. At its peak, the US Steel Corporation employed 70,000 workers. Much of the plant's product is embedded in the steel structures of the city's high-rise office buildings. US Steel became USX in 1991. The complex closed permanently in 1992 and the remaining 700 workers lost their jobs. The Chicago Plan Commission approved a redevelopment plan for the 573-acre site in April 2010.

October 7, 1991
By the time this picture had been taken, substantial site clearance had already occurred. The decision to close the plant occurred in 1983, when 3,900 workers were still employed at the site.

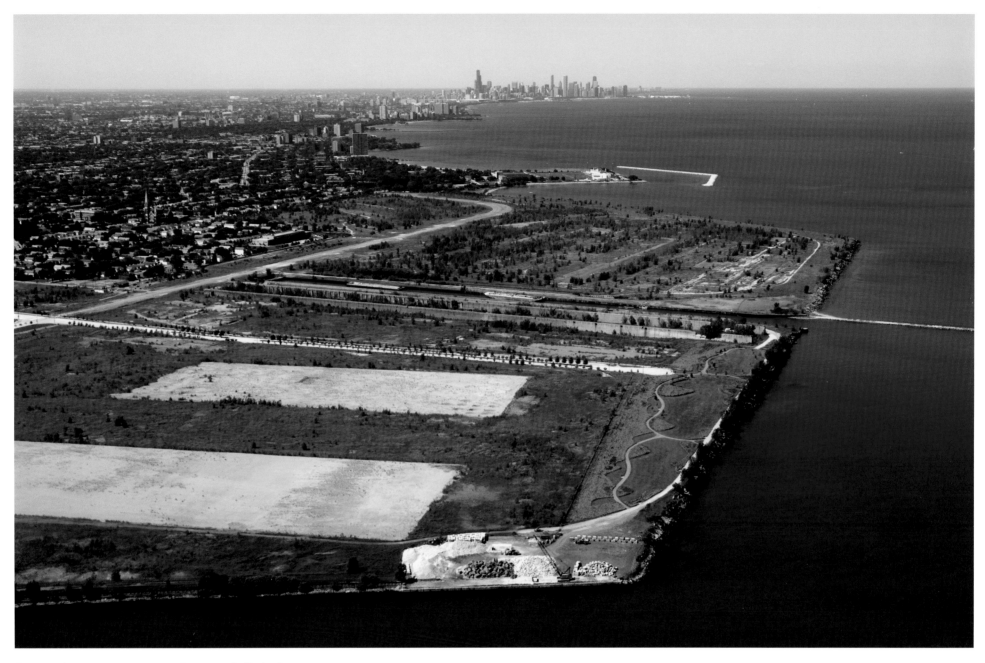

August 16, 2010
Since most of the USX site was created as a landfill, largely composed of molten slag refuse, plant life could not be supported. The newly landscaped area on the lakeshore just south of the central slip is the product of a topsoil creation project, which began in April 2004, when the first of 105,000 tons of sediment was transported by barge from a dredge site in Lake Peoria, 168 miles to the south.

Bughouse Square (Washington Square Park)

Washington Square Park, aka Bughouse Square, served as the city's center of soapbox oratory during the first half of the 20th century. A committee affiliated with the Newberry Library—which faces the north side of the park—sponsors an annual free speech event every year during its July book sale.

June 4, 1987
Too much parking and not enough architecture bordered the park, depriving it of physical containment. The Newberry Library building, designed by Henry Ives Cobb, opened in 1893. Nearly a century of accumulated urban grime discolors the building's exterior.

July 1, 2010
By 2010, the park had become the centerpiece of a vibrant new urban neighborhood. The library has been restored to its original color and all the blocks facing the park have been improved with new and restored buildings that together create a well-defined civic space.

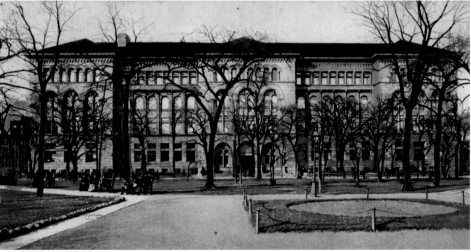

The Newberry Library, 1906

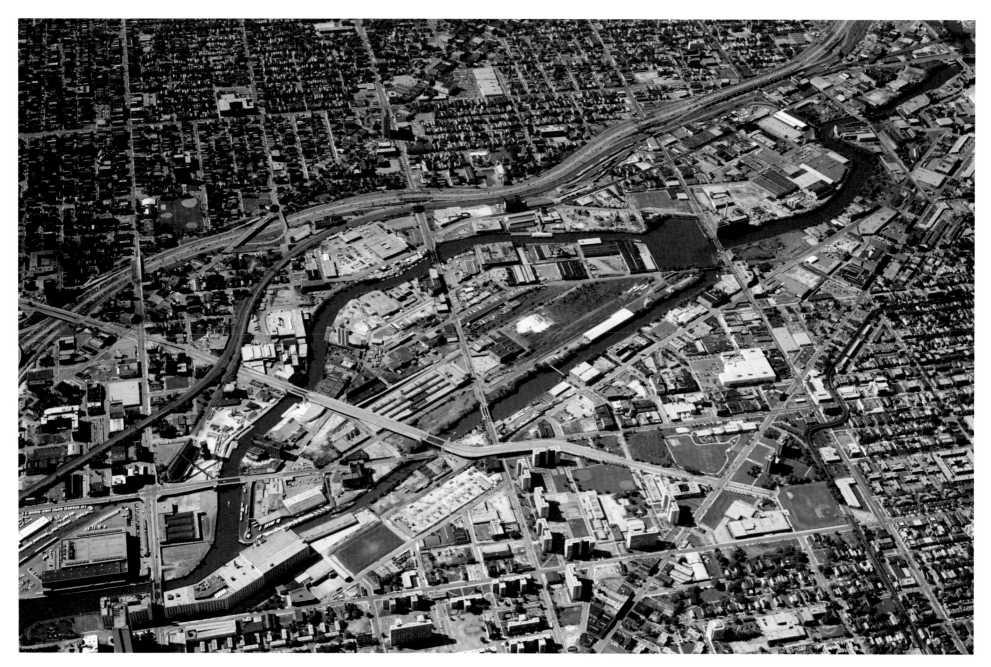

Goose Island

Mile-long, 160-acre Goose Island was created in the 1850s when the North Branch Canal (on its eastern side) was excavated. While the new waterway produced a much straighter channel than the mostly natural one to the west, the original purpose of the excavation was to extract the dense clay of the area for the fabrication of brick. The city's third Planned Manufacturing District (1994), Goose Island has long been dominated by industry. The abrupt closing of the Republic Windows & Doors plant in December 2008 made national news when the company's workers refused to leave the plant.

September 30, 1990
The old Ogden Avenue viaduct is prominent in the central part of this image. One of the city's few diagonal streets, the starting point of Ogden Avenue used to be at the intersection of Clark Street and Armitage Avenue. Its current point of origin is at the west bank of the west river channel.

September 15, 2007
New industrial facilities now blanket much of the island. The North Avenue Bridge (far right, center) is being reconstructed.

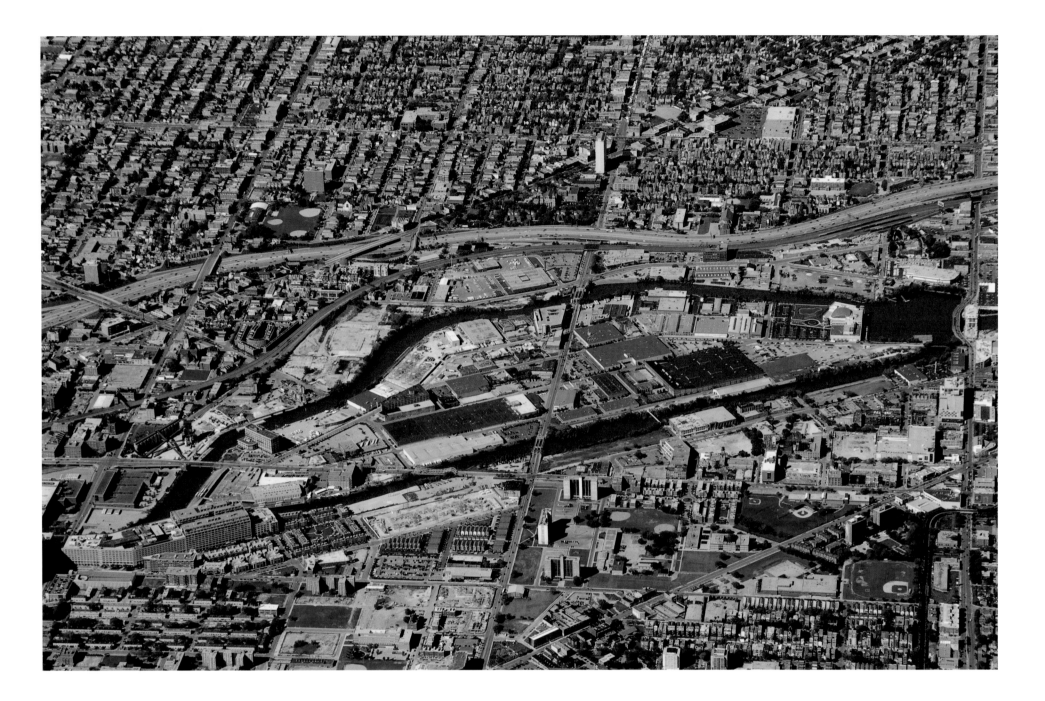

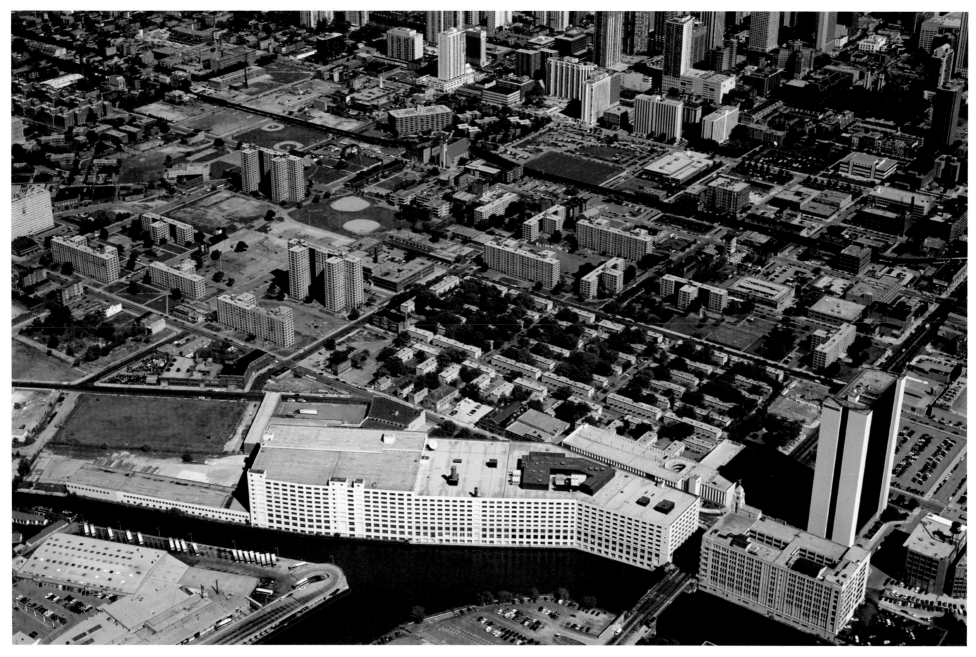

Montgomery Ward Complex

Founded in 1872, Montgomery Ward & Co. was the world's first mail order retail business. It closed permanently in 2001. Its historic Chicago Avenue properties have since been converted into residential condominiums, with retail, service and restaurant facilities. The Chicago River has become an important pedestrian and boaters' amenity for the residents of the old administration building and catalog house, both located on the river's east bank.

September 19, 1996
The Montgomery Ward complex consisted of three main buildings. The catalog house (center), constructed in 1908, has more than 2 million square feet of floor area. It was one of the first Chicago buildings with a skeletal frame of reinforced concrete.

The "old" administration building of 1930 is at right on the south side of Chicago Avenue. The high-rise building behind it is the "new" administration building, completed in 1974, and designed by Detroit-based Minoru Yamasaki, also the architect of New York's ill-fated World Trade Center.

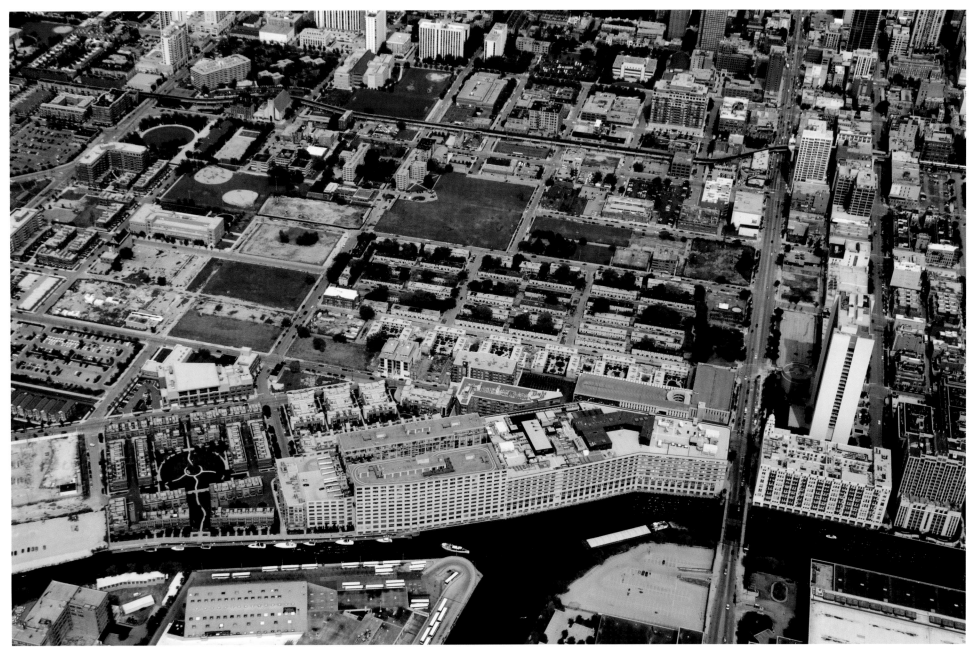

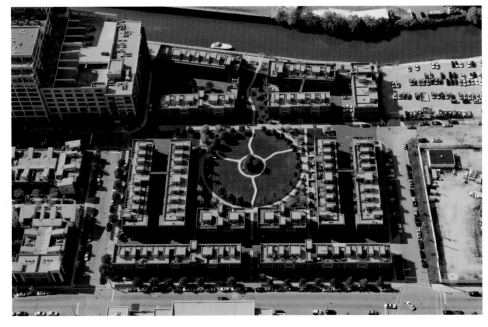

July 11, 2009 (above)
Now a thriving residential neighborhood, the old Ward properties have proved to be a magnet for new development, as the river edge townhouse project north of the catalog house (at left in photo) clearly demonstrates. The 1974 headquarters building, 26-stories high, is now called The Montgomery, a residential condominium.

October 16, 2008
Riverfront residential development would have been unthinkable prior to the completion of the Tunnel and Reservoir Plan (TARP) which prevents untreated sewage from being released into the Chicago River.

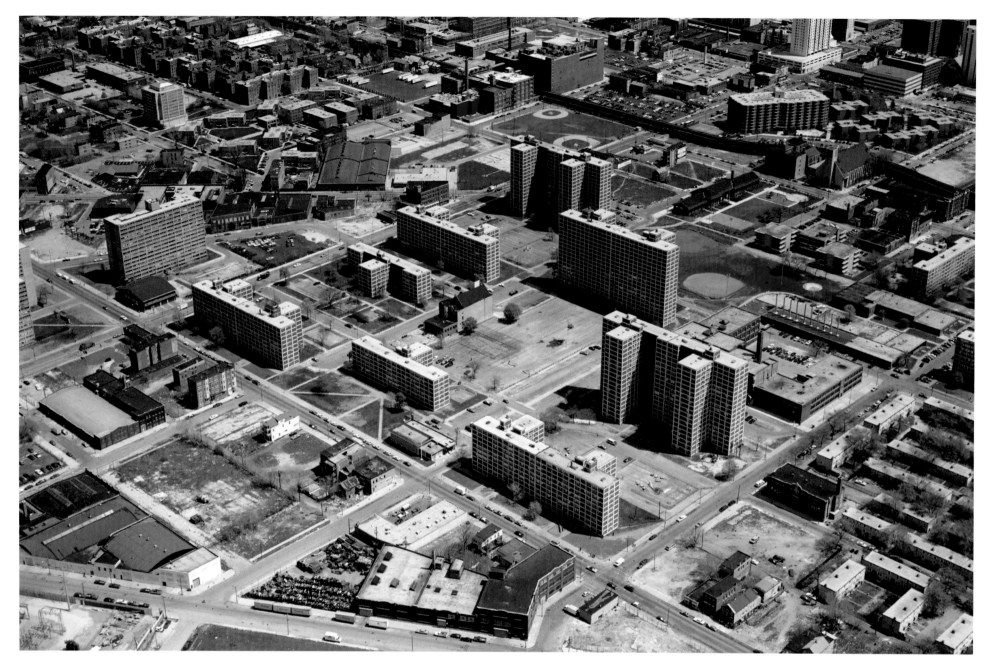

Cabrini-Green

Partly because of its proximity to the Gold Coast and partly because several very high profile crimes occurred here, Cabrini-Green had the most notorious reputation of any public housing project in Chicago. Constructed in 1958 (Cabrini high-rises) and 1962 (Green Homes), the resident population peaked at 15,000, but the project ultimately proved to be untenable due to high crime, poor maintenance, and inadequate services. Demolition of the high rises began in 1995, as the City moved to implement a new master plan for the area, known as the Near North Redevelopment Initiative. One project, the 18-acre "Parkside at Old Town," will ultimately provide 790 new mixed-income low-rise units, at a cost of $250 million.

May 5, 1992
View to northeast from Oak/Larrabee. Mayor Jane Byrne lived in one of the high-rise buildings for three weeks in 1981. In 1992, 7-year-old Dantrell Davis was killed by a sniper as he walked to school with his mother.

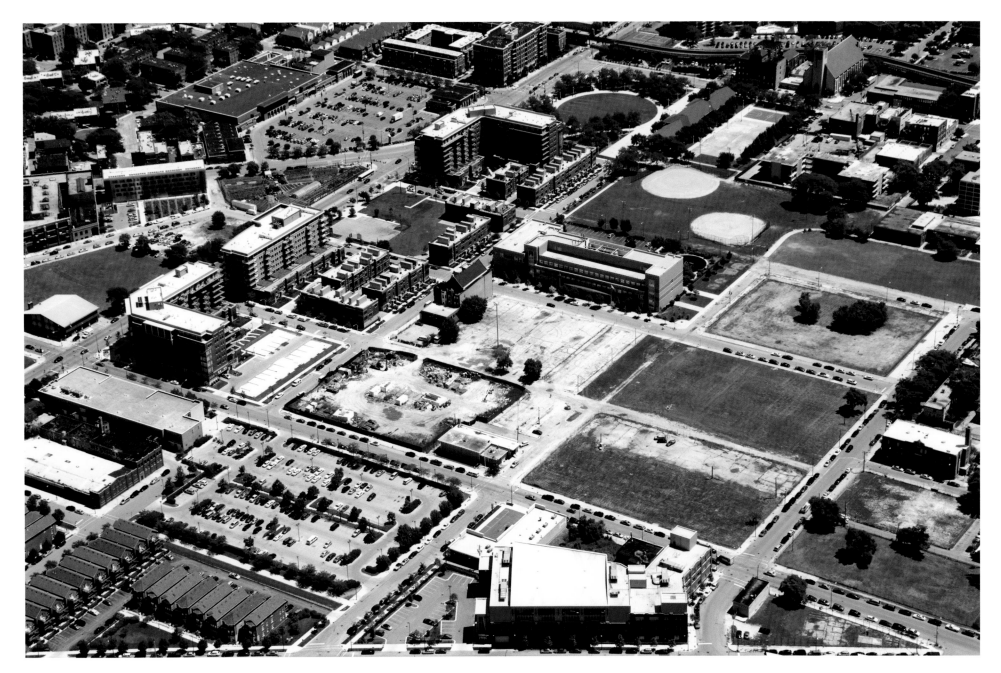

July 1, 2010

In a time of far-reaching change, the sloped-roof Wayman AME Church at 509 W. Elm Street, in the center of this image, provides a familiar point of reference. Constructed in the late 19th century, the building originally housed the First Swedish Baptist Church of Chicago. The new Edward Jenner Academy of the Arts Elementary School, completed by the Public Building Commission of Chicago in 2000, occupies an entire block along the east side of Cleveland Avenue, opposite the church.

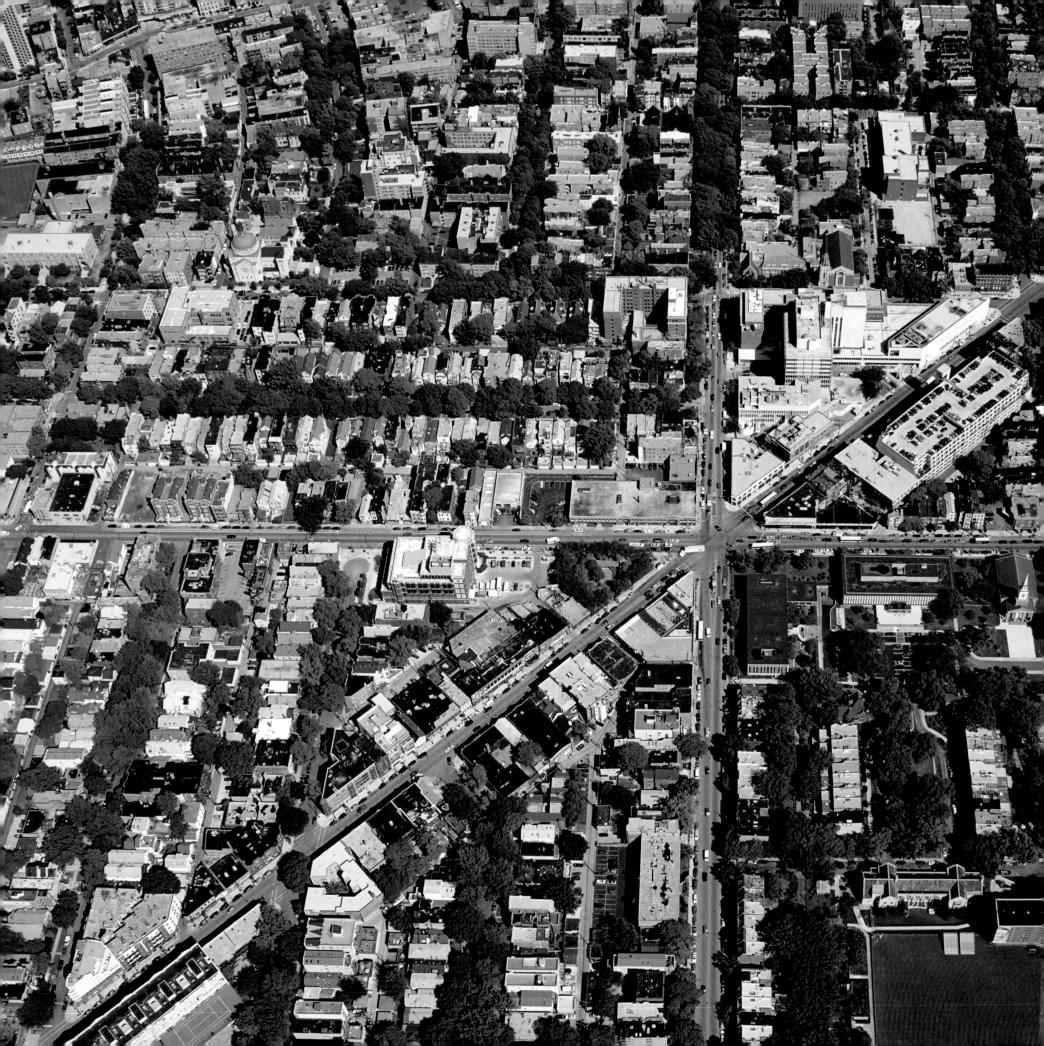

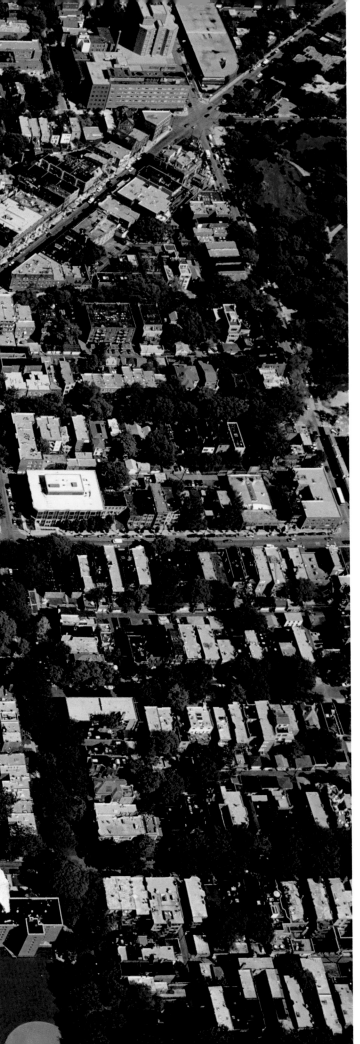

The Hospitals of Lincoln Park

Six hospitals once served the Lincoln Park community. The first to depart, Alexian Brothers (at Racine/Belden), decamped for Elk Grove Village in 1966. Roosevelt Hospital (at Wisconsin/Sedgwick) closed in 1976, to be followed by Augustana (at Armitage/Lincoln) in 1993; Columbus (at Lakeview/St. James) in 2001; and Grant (at Lincoln/Webster) in 2008. The sole survivor, Children's Memorial Hospital, is slated to close in 2012, when it relocates to its new state-of-the art facility in the Near North Streeterville neighborhood, as part of the Northwestern Memorial Hospital Campus.

August 28, 2001
View to east, centered on Fullerton Avenue. Lincoln Avenue divides the Children's Memorial Hospital campus in two, center right. The former Grant Hospital is visible in the upper right corner.

Augustana Hospital

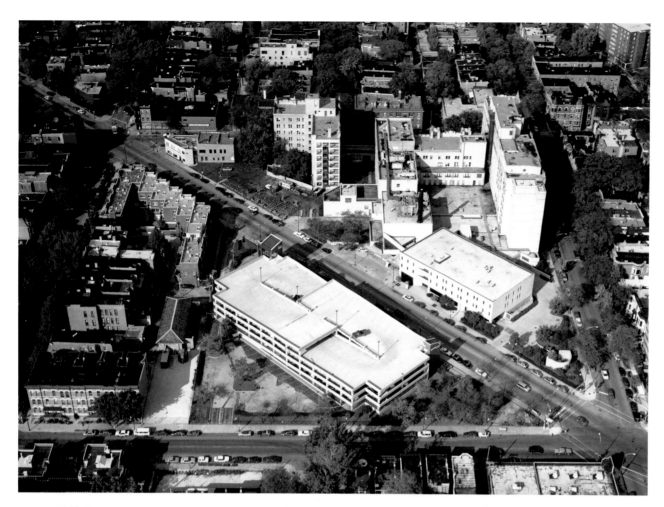

October 17, 1992
Augustana Hospital, in
its waning days. View to
the north from Armitage
Avenue.

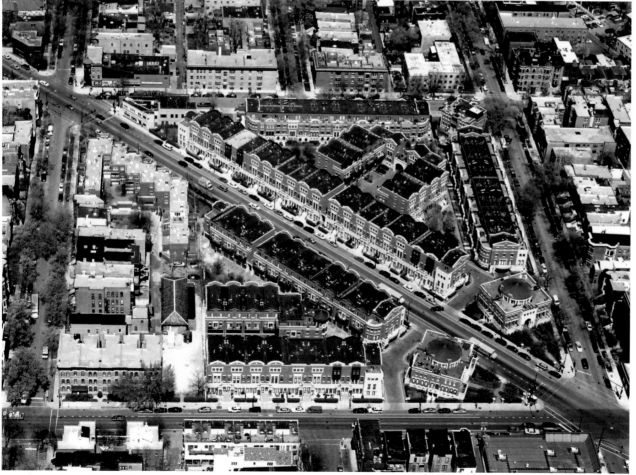

April 23, 2003
"The Pointe" townhouse
condominiums opened in
1995; architectural design
by Roy H. Kruse and
Associates.

Columbus Hospital

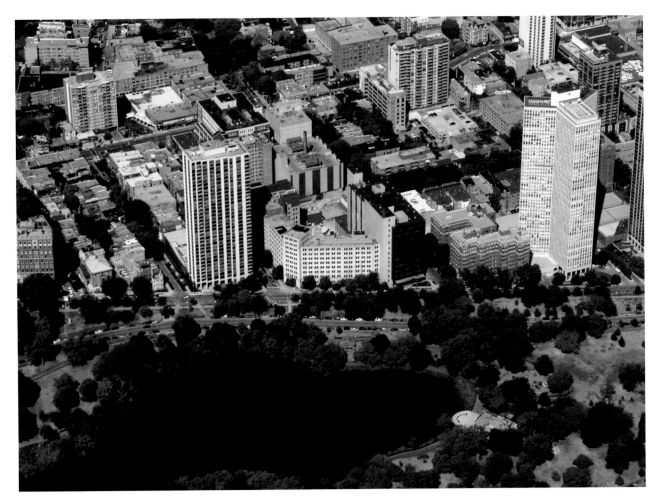

July 8, 2005
Columbus Memorial Hospital, founded in 1905 by St. Frances Xavier (Mother) Cabrini (1850-1917), originally served the Italian immigrant community.

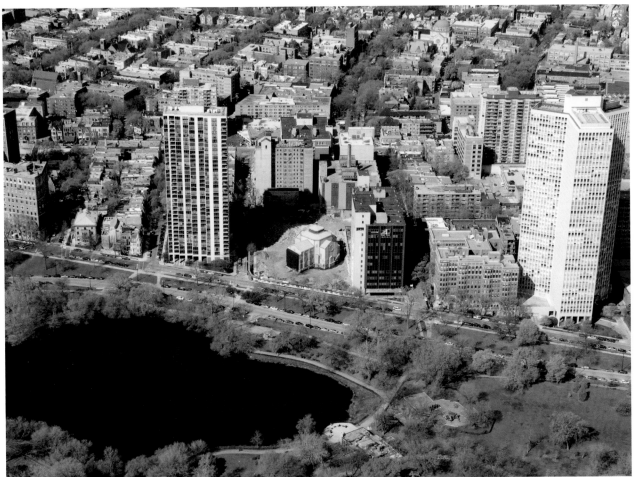

May 4, 2008
The National Shrine of St. Frances Xavier Cabrini, once concealed by the main hospital building, is to be retained as the site is redeveloped as a condominium community.

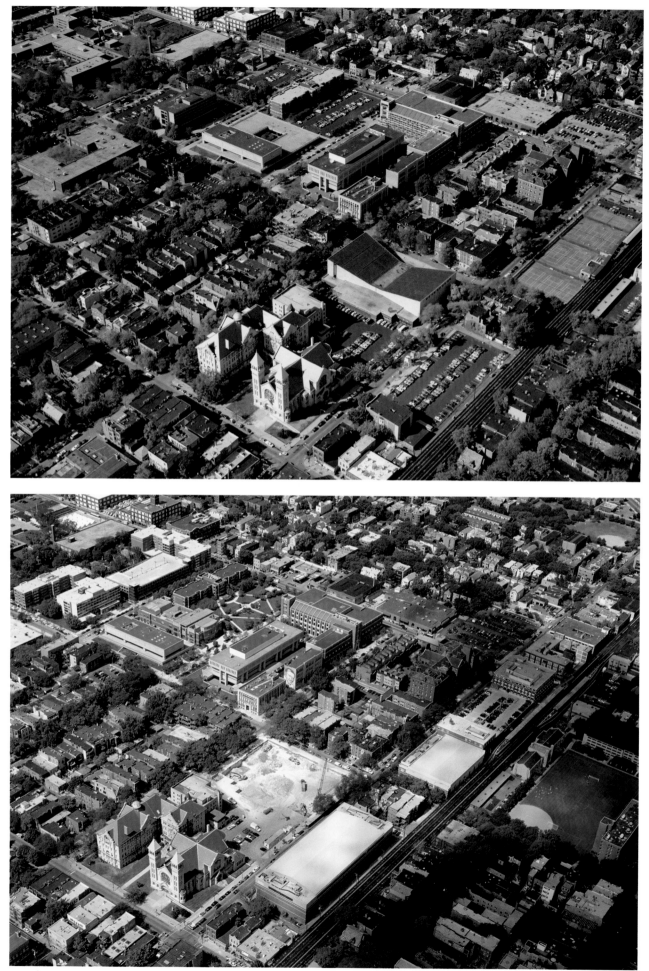

DePaul University

Founded in the Lincoln Park community in 1898 by Vincentian priests, DePaul currently maintains two campuses in the city and four in suburban communities. With an enrollment of more than 25,000, DePaul is the largest Catholic University in the United States and the largest private university in Illinois.

October 7, 1991
With its distinctive butterfly profile, Alumni Hall (center) stood at the corner of Belden and Sheffield from 1956 until its demolition in 2001. It seated 5,308 for the Blue Demons' home basketball games. The old Lincoln Park tennis club is visible at right.

September 5, 2000
By the time the site of Alumni Hall had been cleared, several new university buildings had appeared on the east side of Sheffield Avenue, including the Ray Meyer Fitness and Recreation Center (small rectangular white roof) and the Sullivan Athletic Center (larger rectangular white roof), both designed by Antunovich Associates, Architects of Chicago.

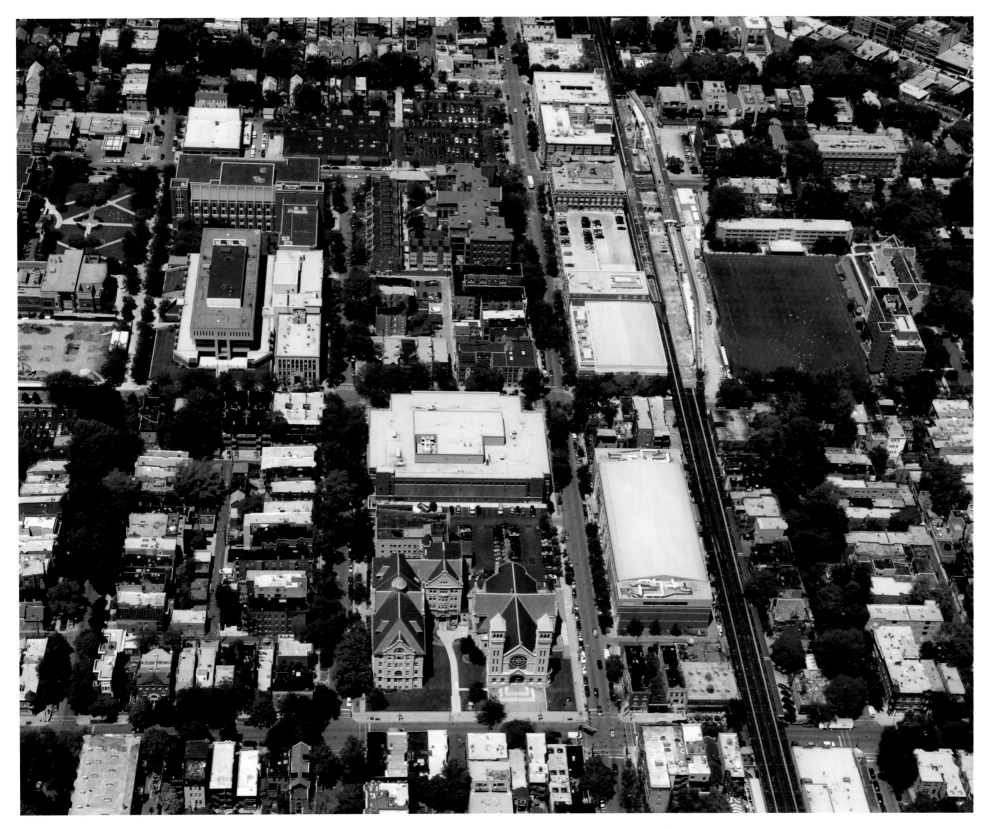

June 19, 2007
WTW Architects of
Pittsburgh designed
the new student center
on the former site of
Alumni Hall.

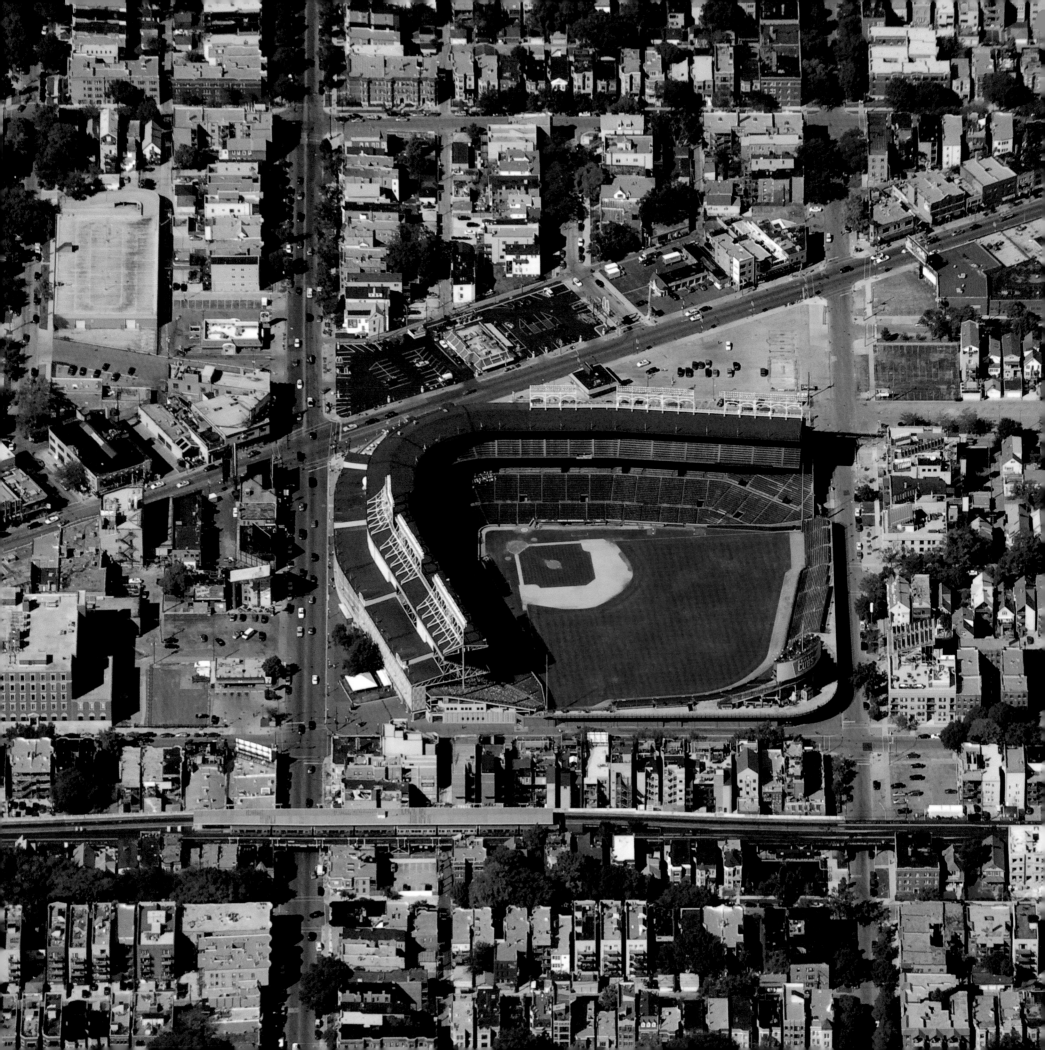

Wrigley Field

Wrigley Field has been the home of the Chicago Cubs since 1916, but it has never been the home of a World Series champion. One of the most significant changes to this historic venue may well be the profusion of rooftop seating on the buildings across the street from the outfield, although the stadium itself has undergone numerous internal upgrades as well.

September 15, 2007
Since the attacks of 9/11/01, FAA rules prohibit small aircraft from flying within three miles of stadium events.

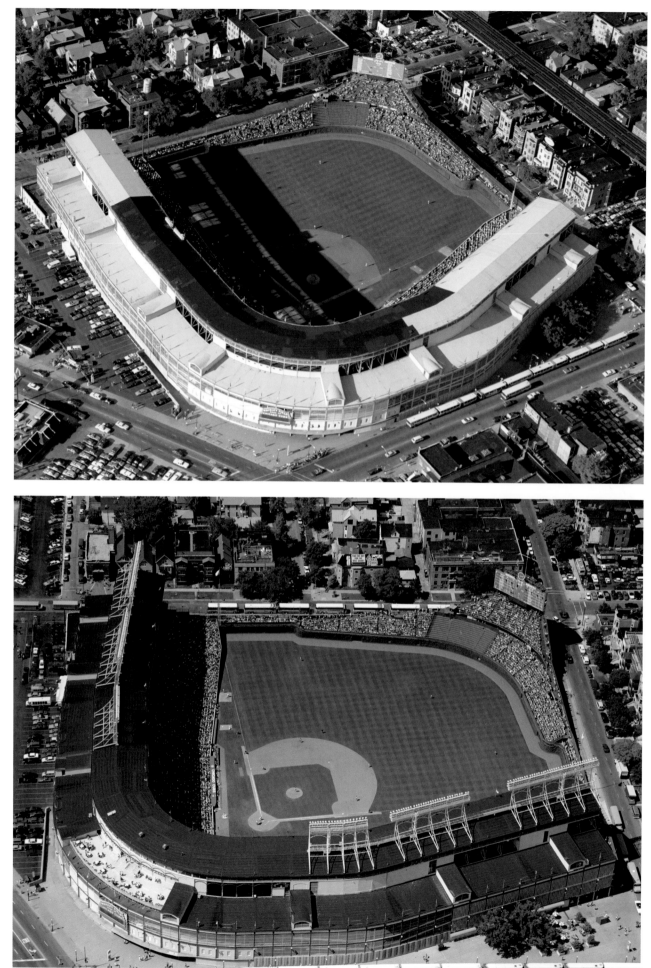

August 12, 1986 (top)
The game depicted here resulted in a 3-1 Cub victory (over the Pirates), with Dawson, Dunston, Grace and Sandberg in the line-up. Lights were not to be installed for two more years.

June 5, 1991 (left)
The second deck terrace, with views toward the city center has been established at the corner of Clark/Addison (in the lower left corner of this photo).

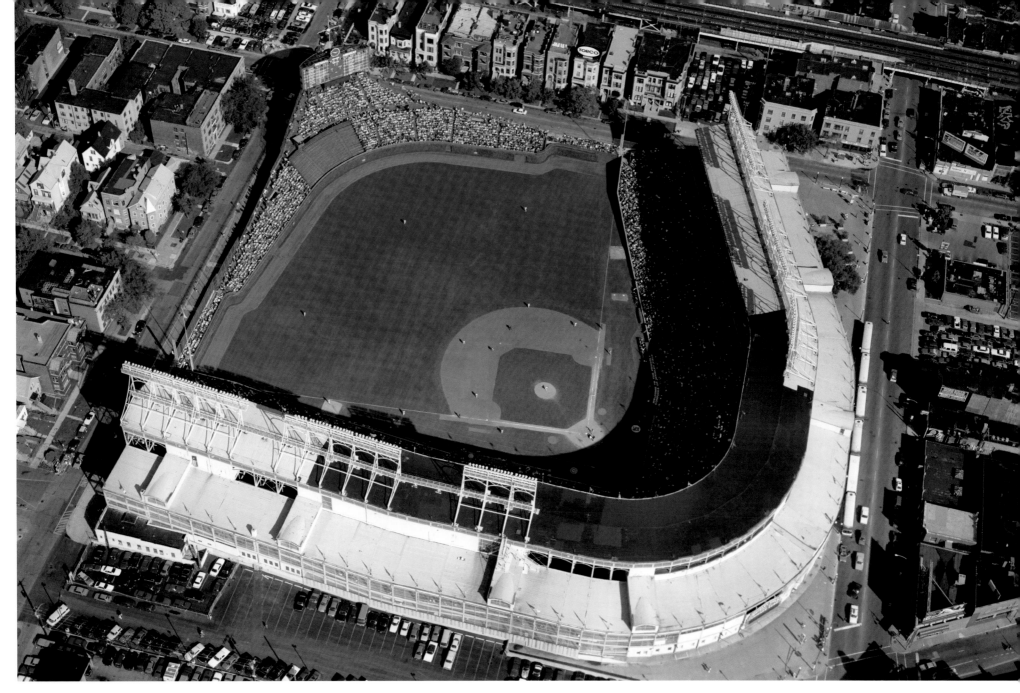

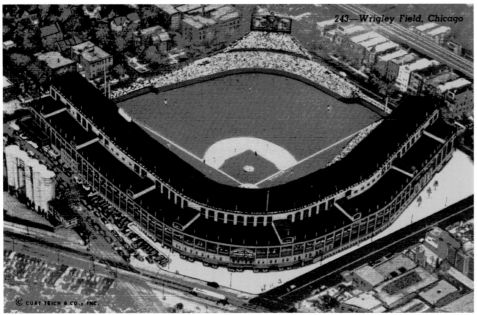

243—Wrigley Field, Chicago

October 3, 1988 (above)
The first night game, just two months earlier, on August 8, 1988, was rained out in the fourth inning. The Cubs won the next night, however, defeating the New York Mets 6-4.

Wrigley Field, circa 1950
In the 1950s, an active rail line ran between the stadium and the silos at left. In that decade, the Cubs finished last twice, seventh four times and never higher than fifth place in the National League. Total season attendance in 1955 was 959,302. In 2009, the Cubs drew 3,168,859 fans.

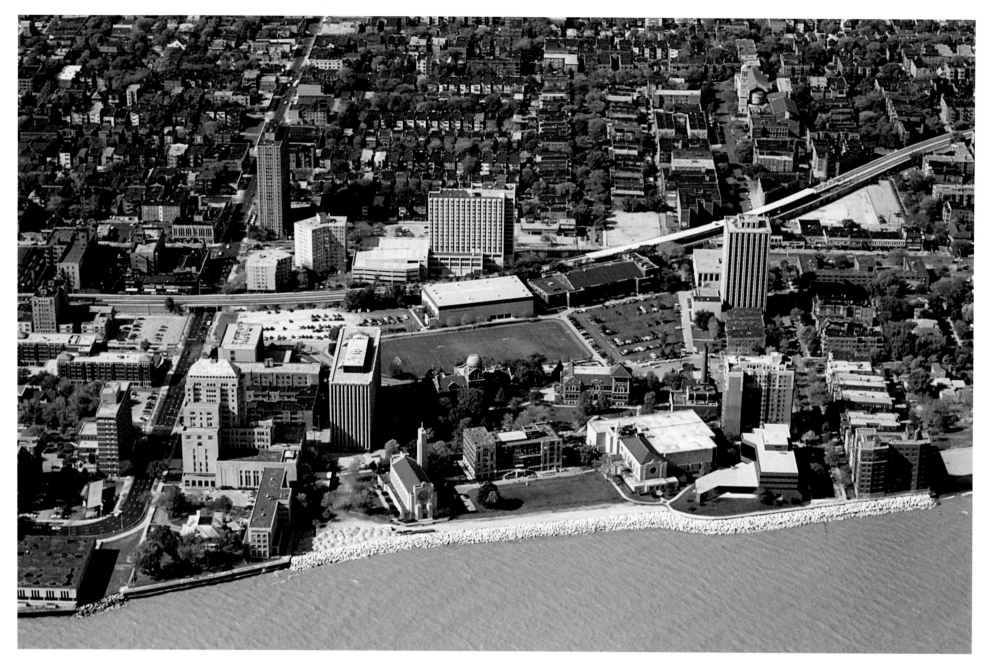

Loyola University Lake Shore Campus

Long a familiar landmark at the southern gateway to Rogers Park, Loyola University relocated from Roosevelt Road to its lakefront campus between 1912 and 1924. At 45 acres, it is the largest of the university's four campuses (one of which is in Rome). The university now owns more than 50 buildings on the campus and in the surrounding neighborhood, even as expansion continues. In September 2008, Loyola initiated a $500 million capital campaign known as "Partners: the Campaign for the Future of Loyola."

October 13, 1991
The multistory limestone building at left formerly housed Mundelein College, an all-female institution that merged with Loyola in 1991. Loyola itself has been coeducational since 1966. The Madonna della Strada Chapel on the lakeshore (left of center), designed by Andrew Rebori and completed in 1939, embodies a modernist's interpretation of the ecclesiastical architecture of the Italian Renaissance.

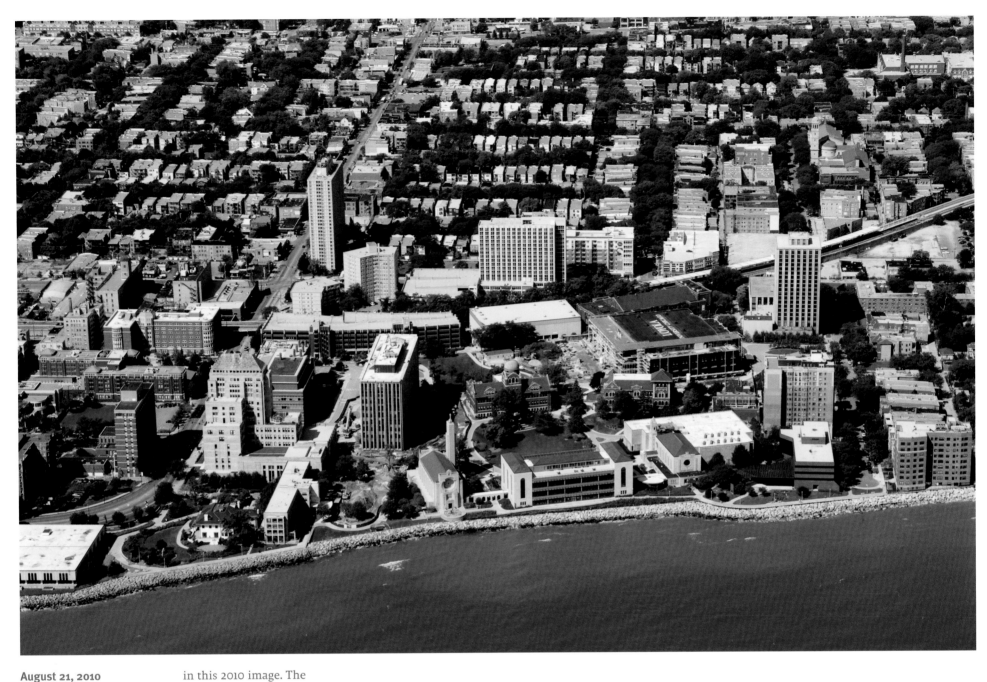

August 21, 2010
Seven of the newest buildings on the Lake Shore Campus have been designed by Chicago-based Solomon Cordwell Buenz architects, including The Richard Klarchek Information Commons on the lakeshore (center) and the Gentile Center (center right, with the rooftop logo) nearing completion in this 2010 image. The Klarchek Commons has earned silver-level certification from the Leadership in Energy and Environmental Design (LEED) Green Building Rating System, an acknowledged benchmark for the design, construction, and operation of high-performance green buildings.

Westinghouse High School

Westinghouse High School is one of more than 20 new schools developed by the Public Building Commission of Chicago (PBC) through the innovative Modern Schools Across Chicago program, announced in 2006. The PBC was created in 1956 to construct its first project, the Richard J. Daley Center, which opened in 1966. Since that time, the PBC has developed more than 700 public facilities, additions and renovations for the City of Chicago, the Chicago Public Library, the Chicago Public Schools, the Chicago Park District, and the City Colleges of Chicago.

April 12, 2003
View to northeast. The old Westinghouse High School building, constructed in 1920 as a candy factory, became a public high school in 1960.

August 23, 2009
Chicago-based DeStefano+ Partners designed Westinghouse College Preparatory High School. It opened in time for the 2009-2010 school year.

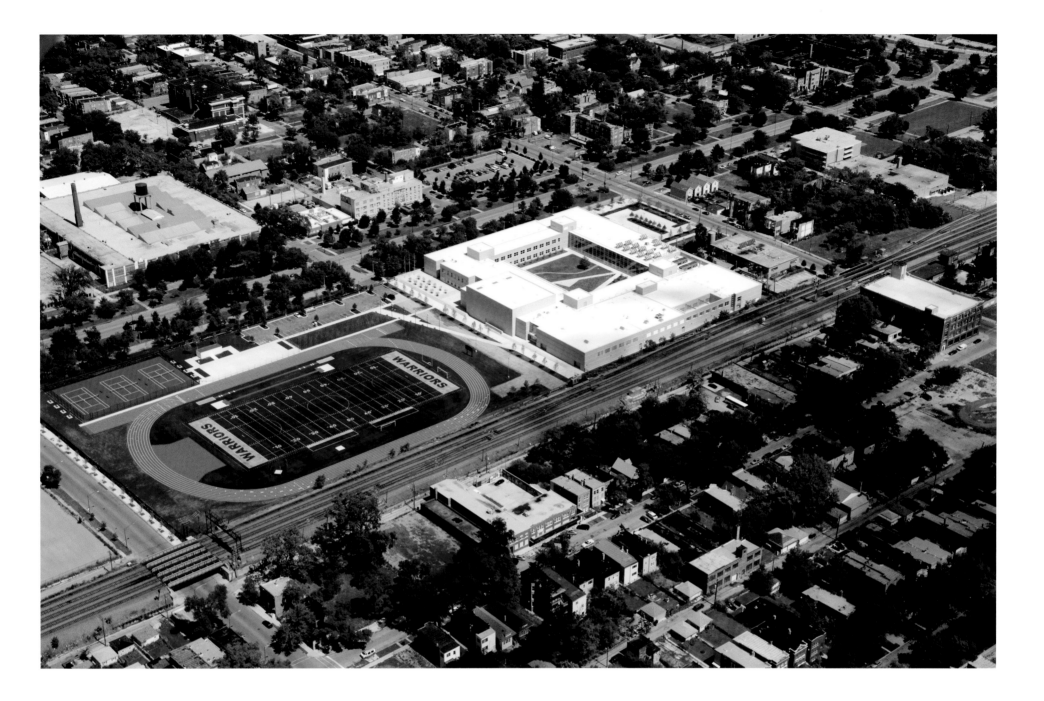

Bucktown
August 23, 2009
Until very recently an immigrant Polish community, Bucktown experienced widespread gentrification from the early 1990's onward. North Avenue is at the lower edge of this image. The CTA Blue Line runs parallel to Milwaukee Avenue at upper right.

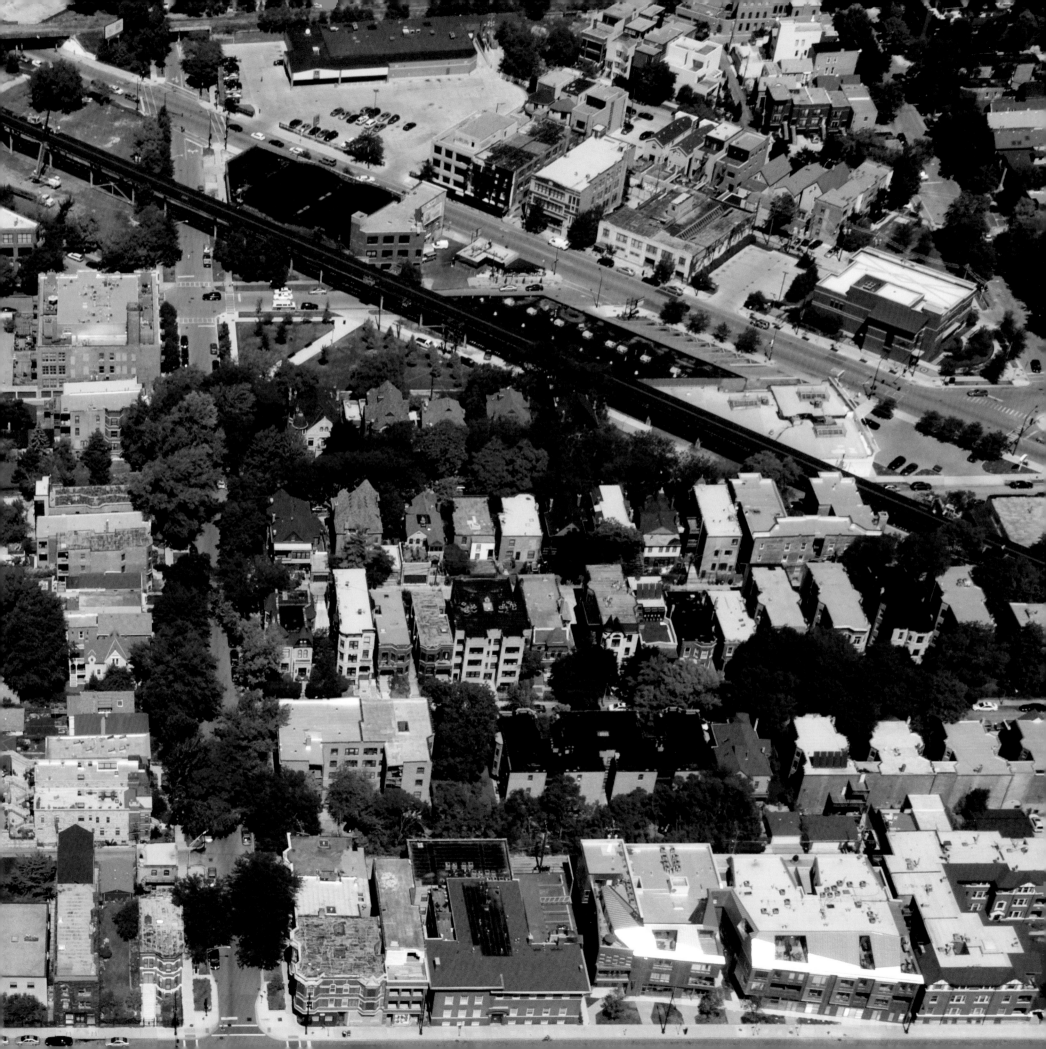

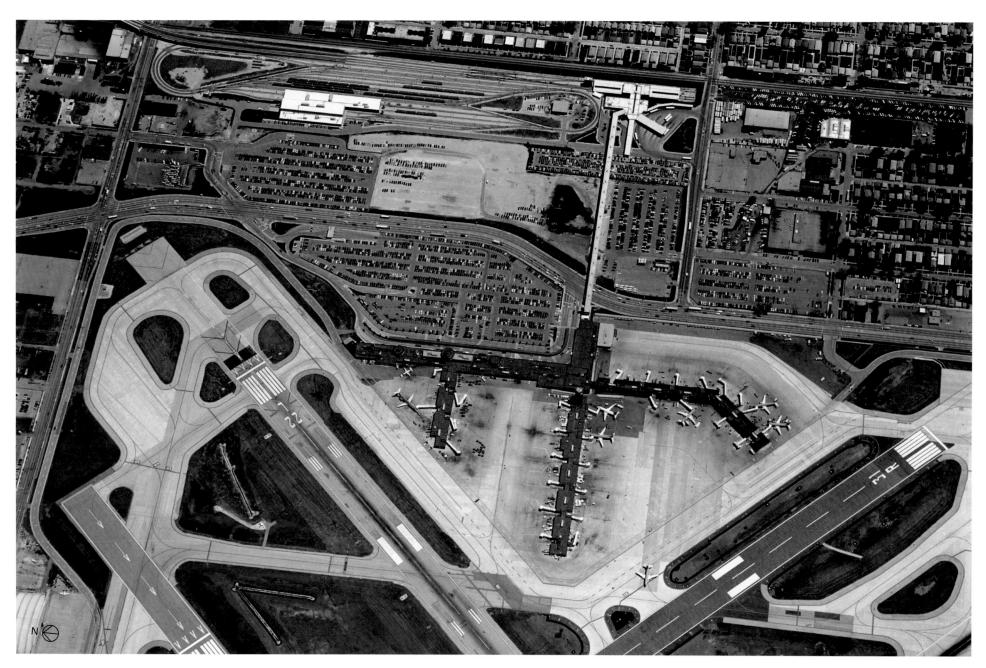

Midway Airport

Before O'Hare became the "World's Busiest Airport" in 1961, Midway held that title. Opened in 1926 and dedicated as Chicago Municipal Airport in 1927, it was renamed in 1949 to commemorate World War II Battle of Midway. The square-mile airport site, originally owned by the Chicago Board of Education, reverted to City of Chicago ownership in 1982.

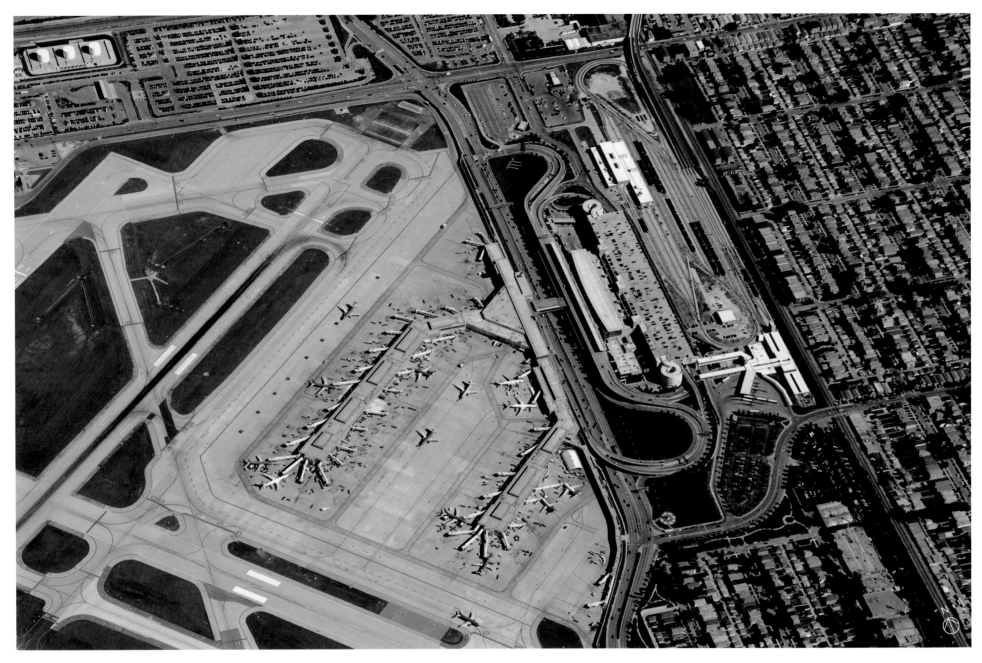

May 21, 1997
The long pedestrian bridge from the Orange Line CTA station stands out in this image. The Orange Line opened for service on October 31, 1993.

September 15, 2007
The Midway Terminal Development Program of 1997-2004 cost $793 million. A new terminal of 900,000 square feet, a parking garage with a capacity of 3,000 autos, and numerous less visible facilities, including an underground baggage handling system, utterly transformed the facility. A 6,500-car economy parking garage was added in 2005.

February 1996
(opposite, below)
The old Midway Terminal control tower, shortly before the initiation of the Midway Terminal Development Program. It was demolished in 2002.

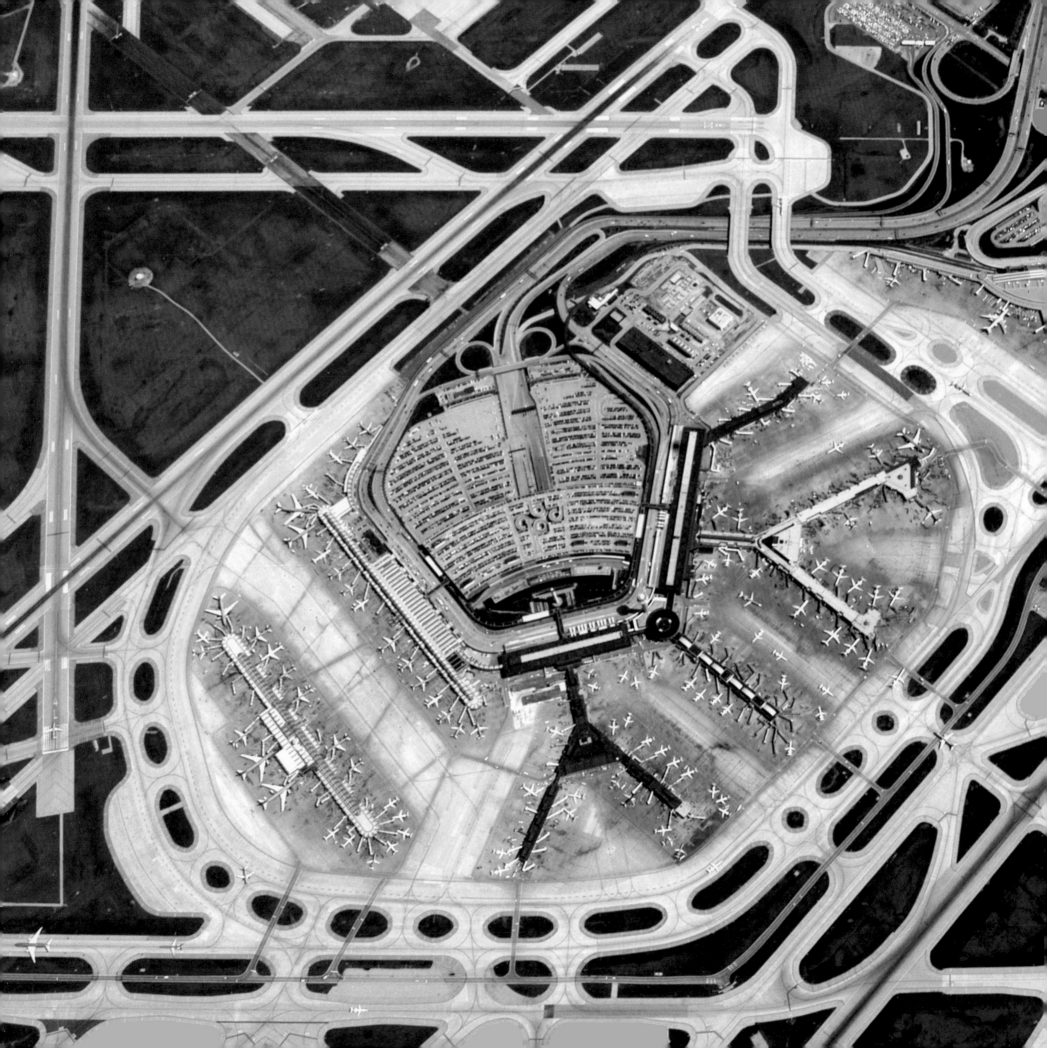

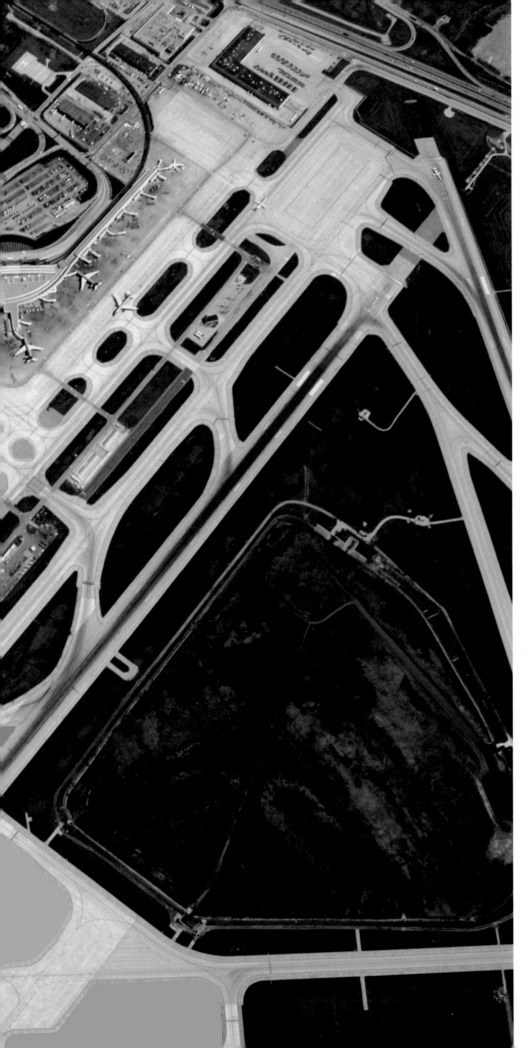

O'Hare International Airport

In 2009, O'Hare International Airport accommodated 881,566 takeoffs and landings, an average of 2,409 per day, while serving 64,397,782 passengers. Development at O'Hare has been almost continuous since its opening to commercial aviation in 1955. Some of the more prominent projects include completion of the United Airlines Terminal in 1987 and the International Terminal in 1993; and the extension of the CTA Blue Line to the terminal complex in 1984. Current projects involve extensive runway expansion and airfield reconfiguration.

April 18, 2006
The terminal complex, view to north. The geometry of the parallel concourses of the United Airlines terminal (Terminal 1), lower left, significantly departs from the radial configuration of terminals 2 and 3, which date from 1962.

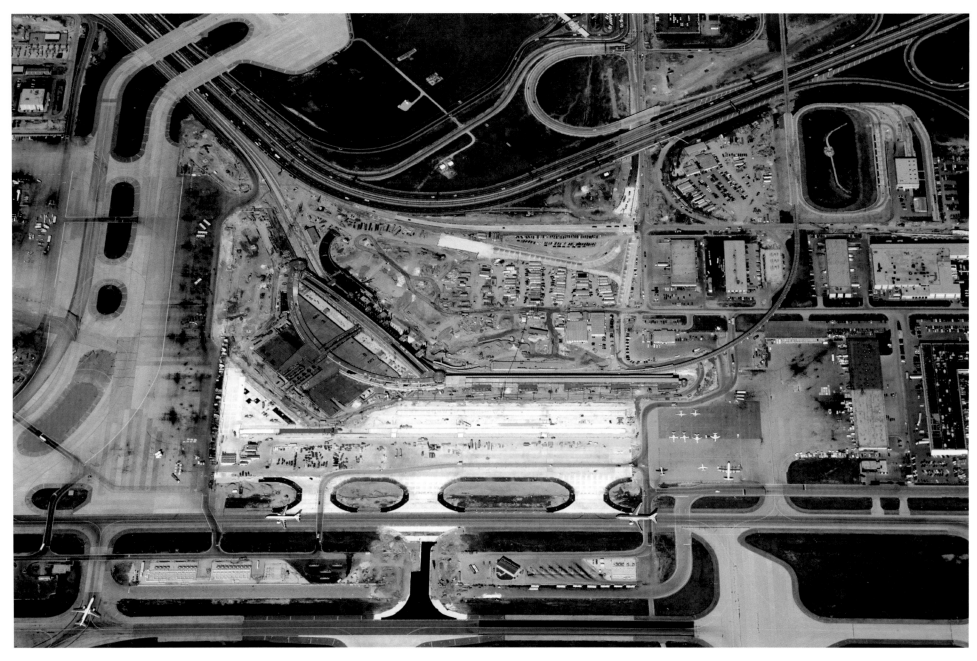

October 18, 1991
Construction of the new
International Terminal
(Terminal 5), view to
north. From 1984 until
the new terminal opened
in 1993, half the ground
floor of the main parking
garage (Terminal 4) served
international passengers.

September 15, 2007
Terminal 5, view
to southwest.
The construction budget
for the new terminal
was $330 million.
Chicago-based
Perkins+Will and
Heard and Associates,
Ltd. designed the new
building.

March 11, 2007
On final approach into
runway 27L (previously
27R). The CTA Blue Line
station at Harlem Avenue
is at right.

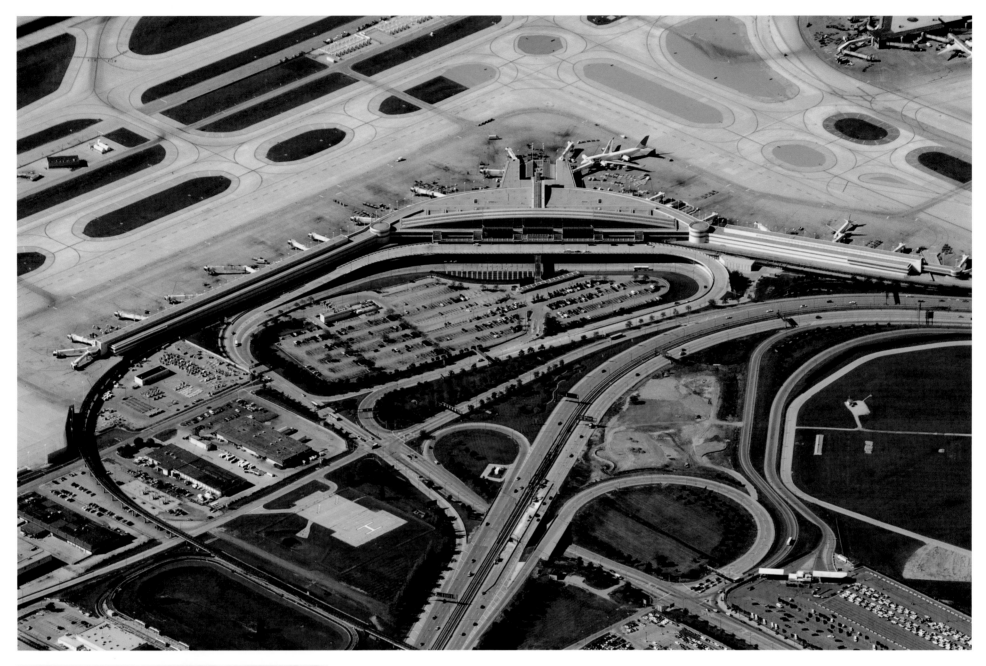

July 6, 2006
A residential subdivision in
Bartlett, in the northwest suburbs.

June 11, 2009
Veterans' Memorial
Tollway (I-355), view to the South
from the Stevenson Expressway
(I-55). Veterans' Memorial Tollway
is the southern extension of the
DuPage Tollway. The 20-mile
northern segment, between I-290
and I-55, was completed in 1989.
The 12.5-mile extension cost $729.3
million to build and opened to
traffic on November. 11, 2007.

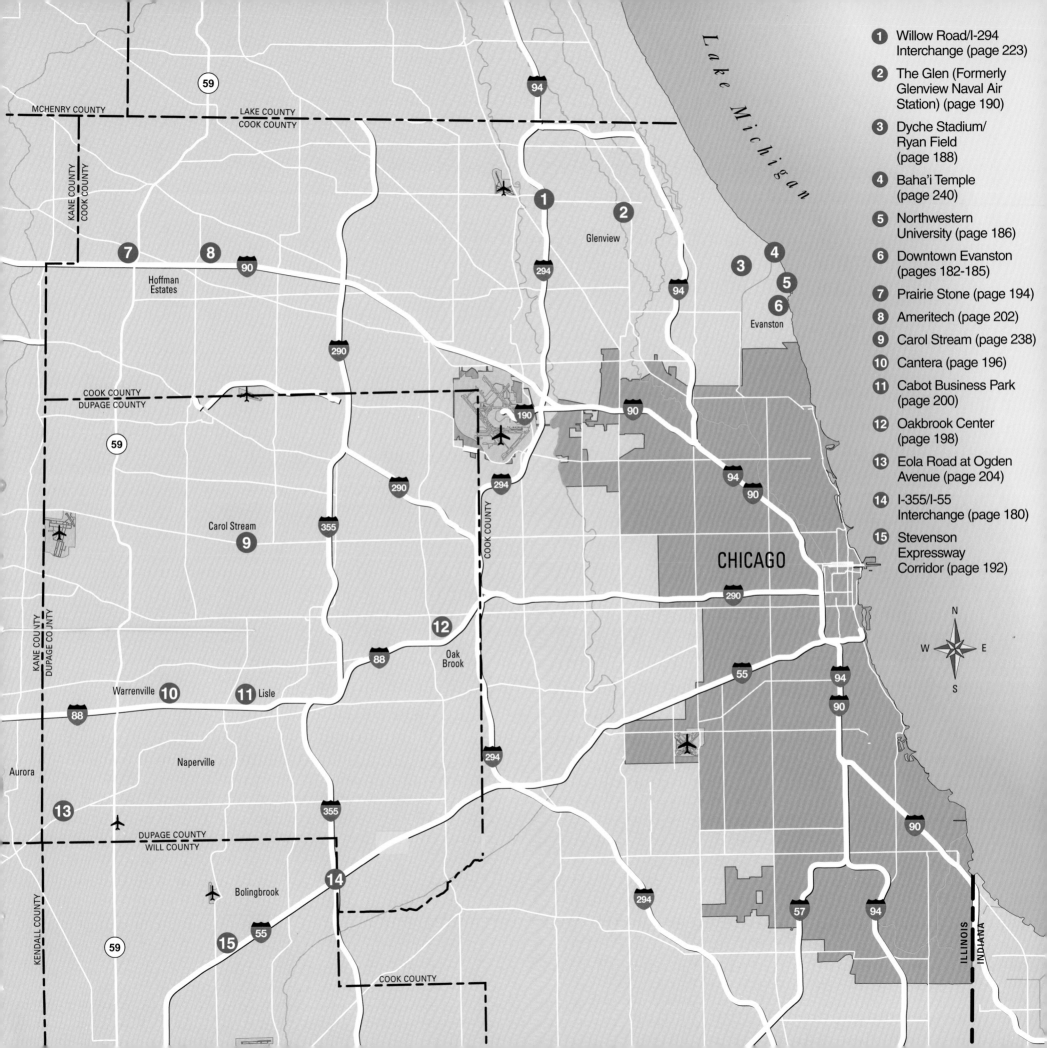

Lake Michigan

MCHENRY COUNTY
LAKE COUNTY
COOK COUNTY

KANE COUNTY
COOK COUNTY

Glenview

Hoffman Estates

COOK COUNTY
DUPAGE COUNTY

Carol Stream

Evanston

KANE COUNTY
DUPAGE COUNTY

Warrenville

Lisle

Oak Brook

COOK COUNTY

CHICAGO

Aurora

Naperville

DUPAGE COUNTY
WILL COUNTY

KENDALL COUNTY

Bolingbrook

COOK COUNTY

ILLINOIS
INDIANA

N
W E
S

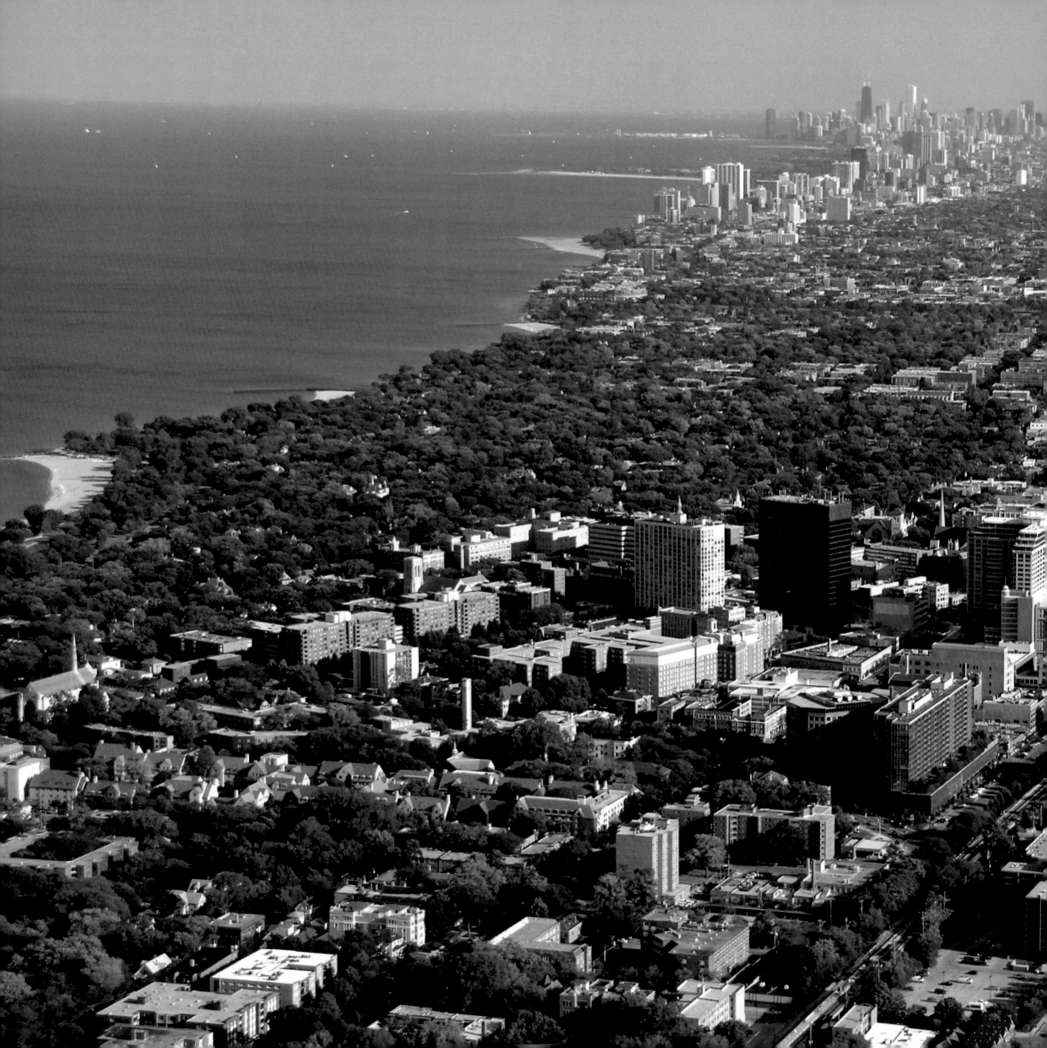

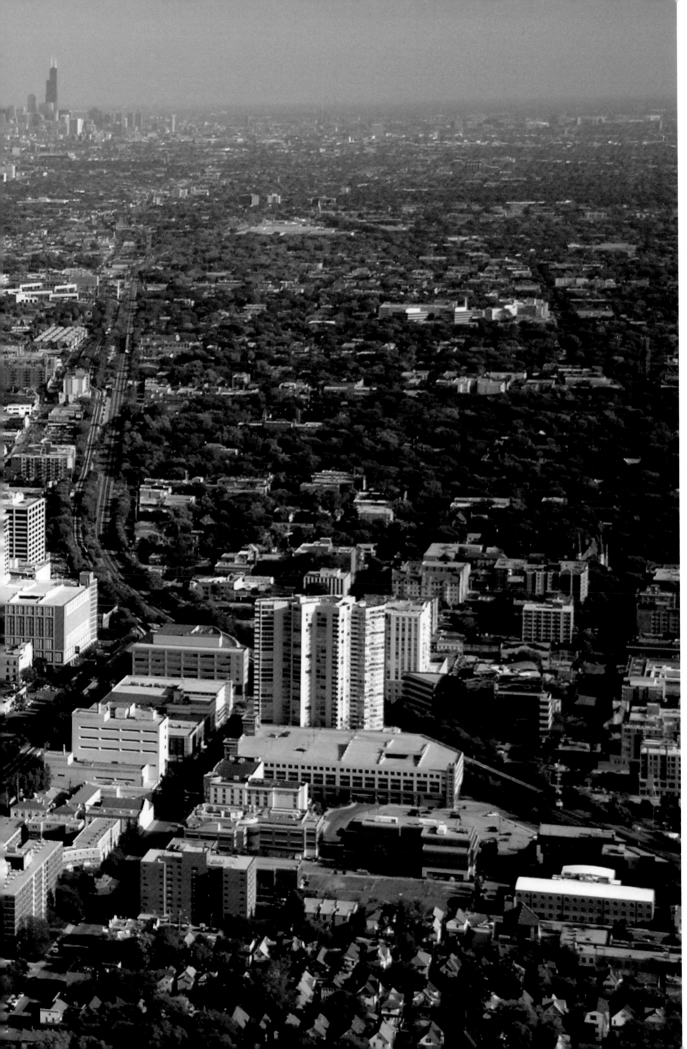

Evanston

An incorporated municipality since 1863, by the beginning of the 20th century Evanston had become enveloped by the region's explosive growth. With no open land left for new development, the city set aside its long time eight-story height limit at the end of the 1960s. Recent development has produced a highly compact, pedestrian-friendly city center, while adding more than 1,000 residential condominiums to the city's housing stock since 1997.

June 19, 2007
View to south. Evanston has always had a well-defined downtown district, which stands out prominently amid the city's leafy residential neighborhoods.

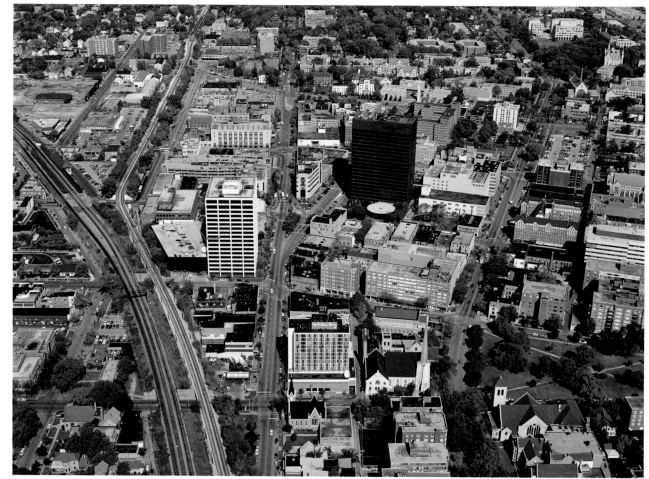

Evanston, circa 1950
The long-standing 8-story height limit reflected the limited capabilities of the city's fire fighting equipment. Fountain Square is at left.

October 1985
View to north. The elevated CTA Purple Line tracks, at left, defined the western boundary of the central business district for many years. The city's principal point of reference, Fountain Square, is at the southern tip of the acute angle block in the center of the image.

May 21, 1997
The triangular area between the CTA and Metra tracks, conceived in the early 1980's as Northwestern University/ Evanston Research Park, ultimately attracted residential, office and retail development.

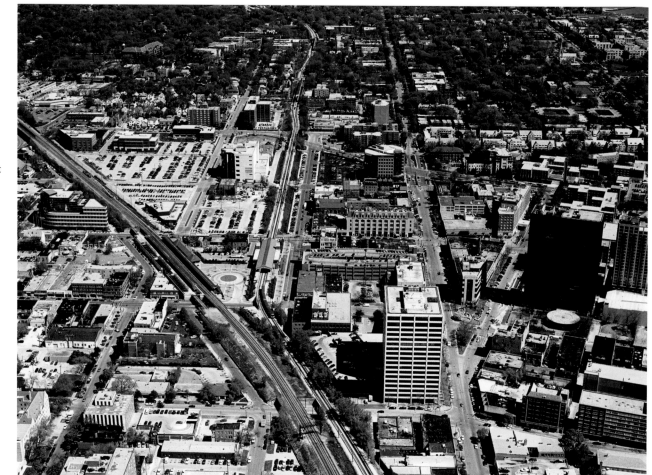

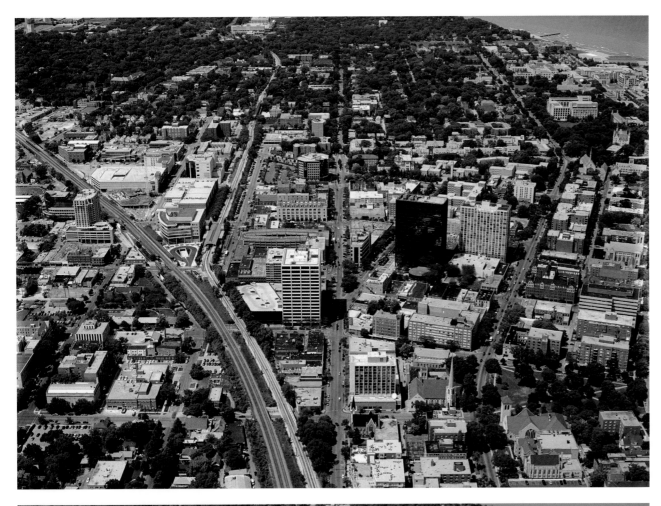

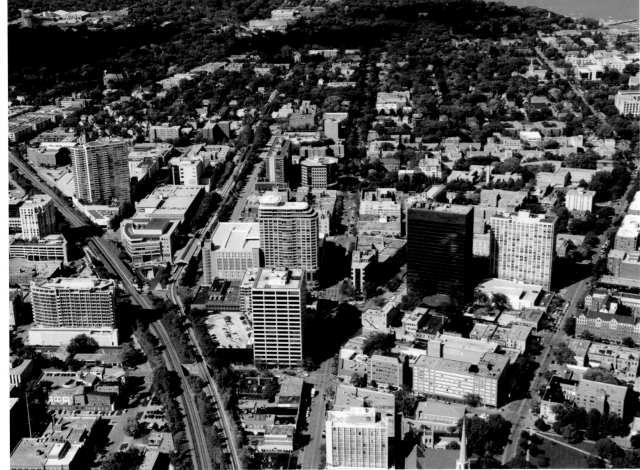

July 5, 2002
The open parking lots in the Research Park triangle have been replaced by substantial new buildings. The traditional downtown has remained largely unchanged.

September 16, 2009
Several high-rise condominium buildings appear in this image, the most consequential being Sherman Plaza, with the stepped profile (center), completed in 2006 at a cost of $190 million and located, in part, on the site of the old city parking garage.

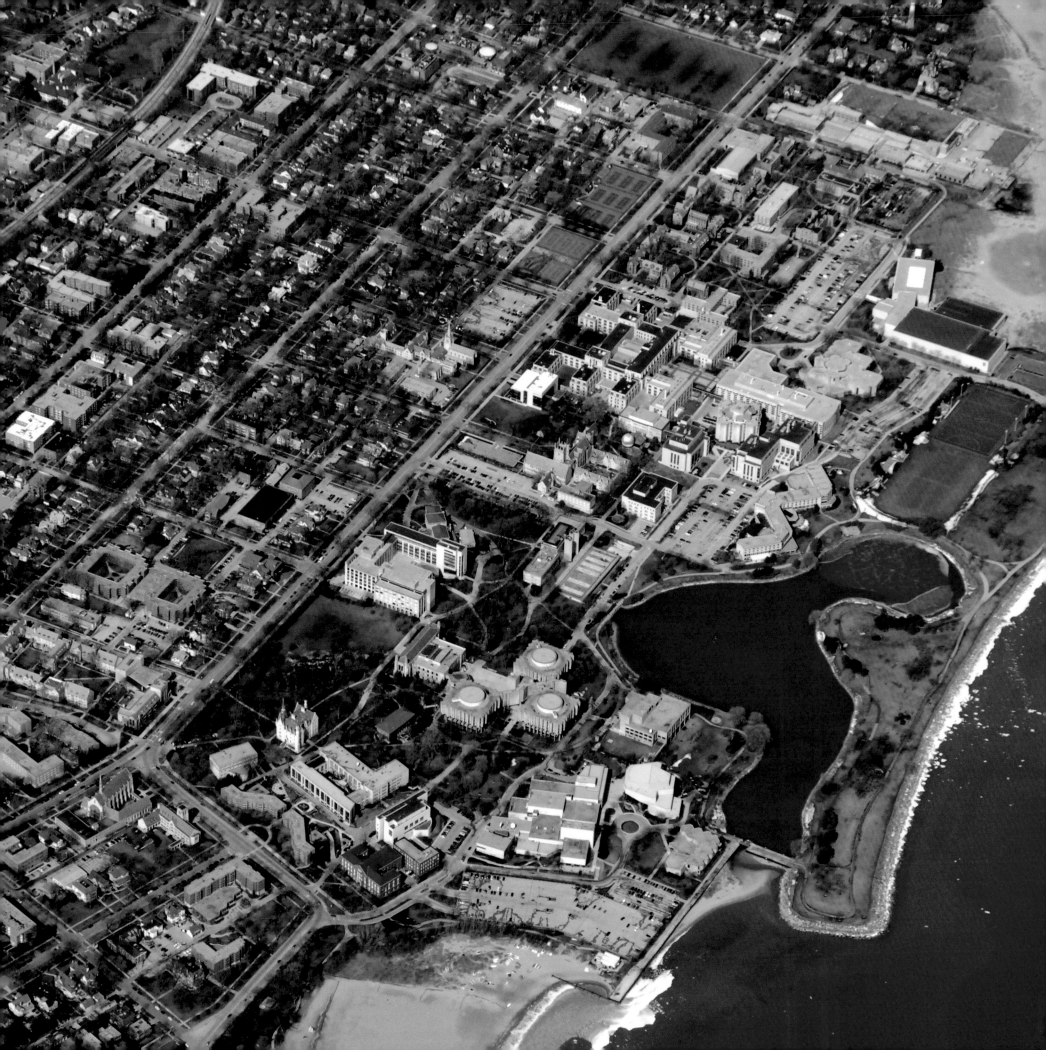

Northwestern University

The first recognized college in Illinois, Northwestern University received its charter from the state in 1851, twelve years before Evanston became an incorporated municipality. Facing a looming land shortage that threatened to constrain future growth, the university constructed a 74-acre landfill in 1962-64. With 13,790 full time students enrolled on the Evanston campus, Northwestern is, by far, the smallest of the Big Ten universities—and the only private one.

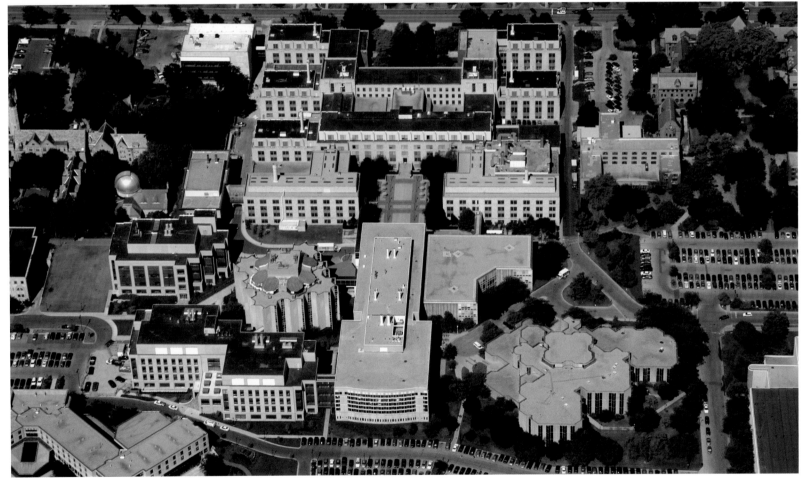

March 11, 2007
Carl Condit, in *Chicago 1930-1970, Building Planning and Urban Technology*, described the construction of the landfill: "A permanent seawall of rubble topped and flanked on the outer face by huge rectangular blocks of limestone formed a cofferdam enclosure within which sand from the Indiana dunes was deposited by clamshell buckets that lifted it from the top of decked barges."

Technological Institute, circa 1941 (top)
Holabird & Root designed the original Tech Building. This view, toward the lake, significantly predates the landfill project.

July 8, 2005
The Robert McCormick School of Engineering and Applied Sciences (aka Technological Institute) has expanded numerous times since it opened in 1942. View from the lakefront.

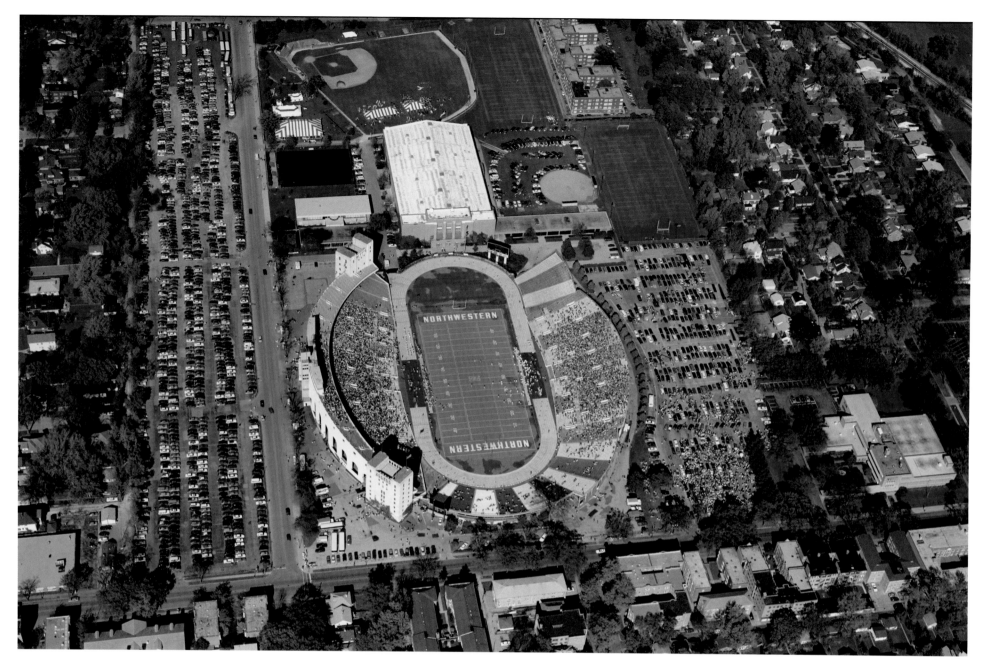

Dyche Stadium/Ryan Field

Dyche Stadium (known as Ryan Field since 1997) has been the home of Northwestern football since 1926. Prior to the memorable Rose Bowl season of 1995, the football program had endured a long period of mediocrity, having previously appeared in only one Rose Bowl, in 1949.

October 20, 1990
This photo depicts a sparsely attended game between Northwestern and Wisconsin, which Northwestern won by a score of 44-34. That year Northwestern finished with a 2-9 record, Wisconsin at 1-10. Tailgating appears to have been more popular than football watching.

August 4, 2006
The 1995 Campaign for Athletic Excellence raised $28 million for stadium renovations. The oval track was removed and the field's surface lowered five feet. Natural turf replaced the various artificial surfaces that had been in use since 1973. The new locker room, sports medicine facility and equipment room are housed in a new building just north of the north end zone (at left, with purple and white team logos on the rooftop).

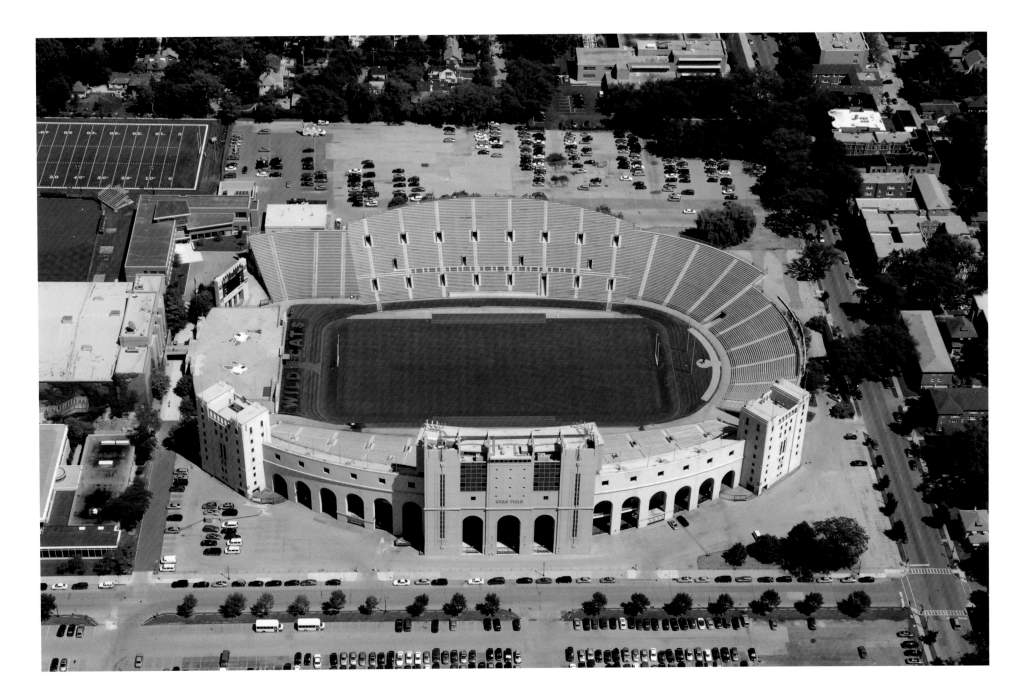

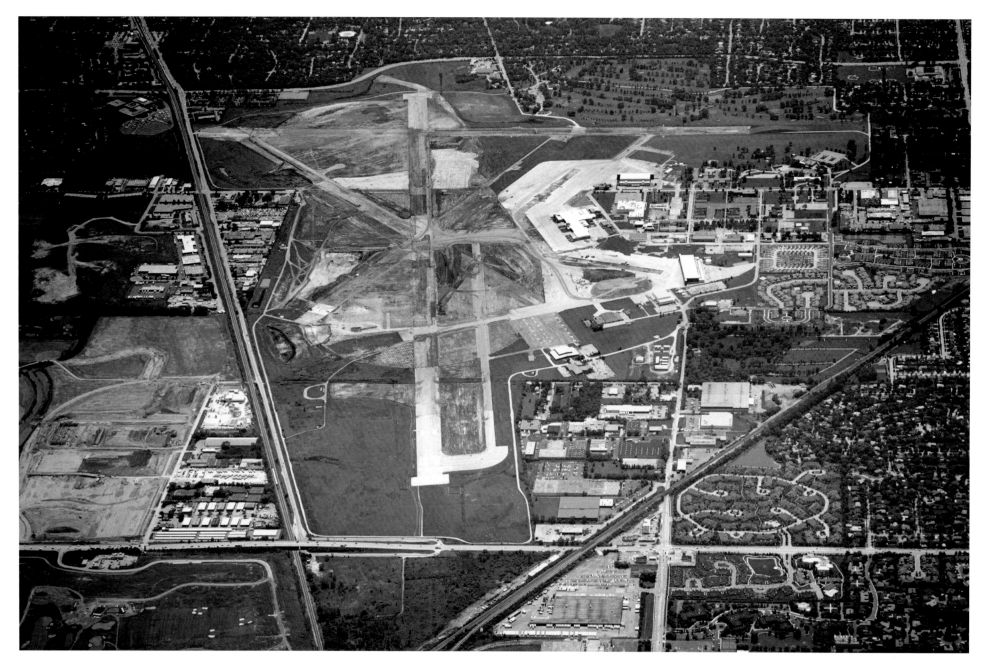

Glenview Naval Air Station

An active airfield from 1923 until 1995, Glenview Naval Air Station became the property of the United States Navy in 1940. The most famous alumni of its training programs include Neil Armstrong, Gerald Ford, and George H.W. Bush. The Department of Defense closed the field in 1993 and designated the Village of Glenview as the Local Redevelopment Authority. The 1,121-acre site has since been redeveloped as a mixed-use community known as The Glen.

June 22, 1998
View to south from Willow Road. The demolition of the facility involved the removal of one million cubic yards of concrete, the destruction of 1.5 miles of runways, and the razing of 108 Navy buildings.

August 16, 2010
145-acre Gallery Park, largely on the site of the old airfield, includes a 45-acre recreational lake that serves dual duty as a component of the site's storm water management system.

Ameritech, Hoffman Estates

The metropolitan expressway system greatly facilitated the outward movement of businesses that had historically clustered in or near the Loop. Ameritech Center, fronting on the Jane Addams Memorial (Northwest) Tollway in Hoffman Estates, is an administrative and operations complex first occupied in 1993. Designed by Chicago-based Lohan Associates, the building houses extremely flexible space. Skylit three-story atria bring abundant natural light and a sense of openness into the deep span interior.

October 1, 1987
View to northwest. The pond on the tollway frontage is a relic of a 1930's gravel quarry.

July 5, 2002
View to northwest. The building, with 1.3 million square feet of space, is flanked by parking structures with a capacity of 3,000 cars. The campus site extends over an area of 240 acres.

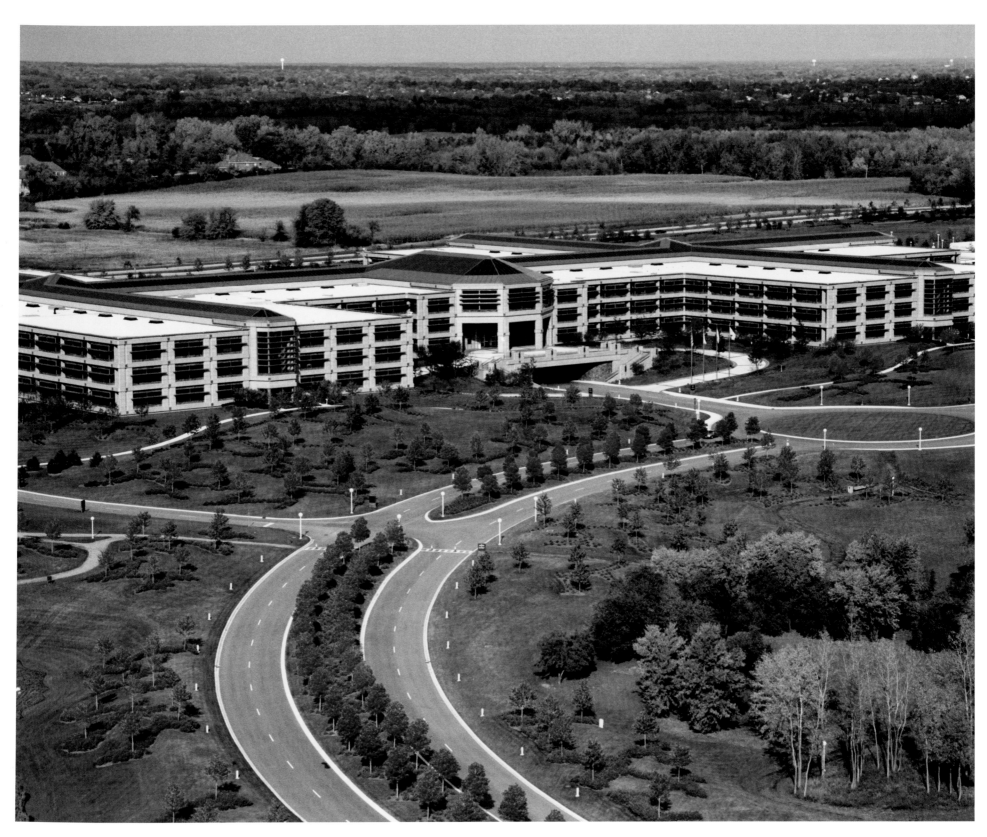

October 17, 1992

Suburban Sprawl

The great disparity between the comparatively modest growth of the region's population and its greatly expanded urbanized area will have lasting environmental consequences. The infrastructure required to support a dispersed, low-density development pattern is far costlier on a per capita basis than in the central city or the older near-in suburbs.

August 31, 2006
View to the north from Ogden Avenue at Eola Road (intersection at lower left) in Aurora. The eastward expansion of Aurora, a historic town on the Fox River, has merged with the westward expansion of Naperville. Very little open land remains in DuPage County.

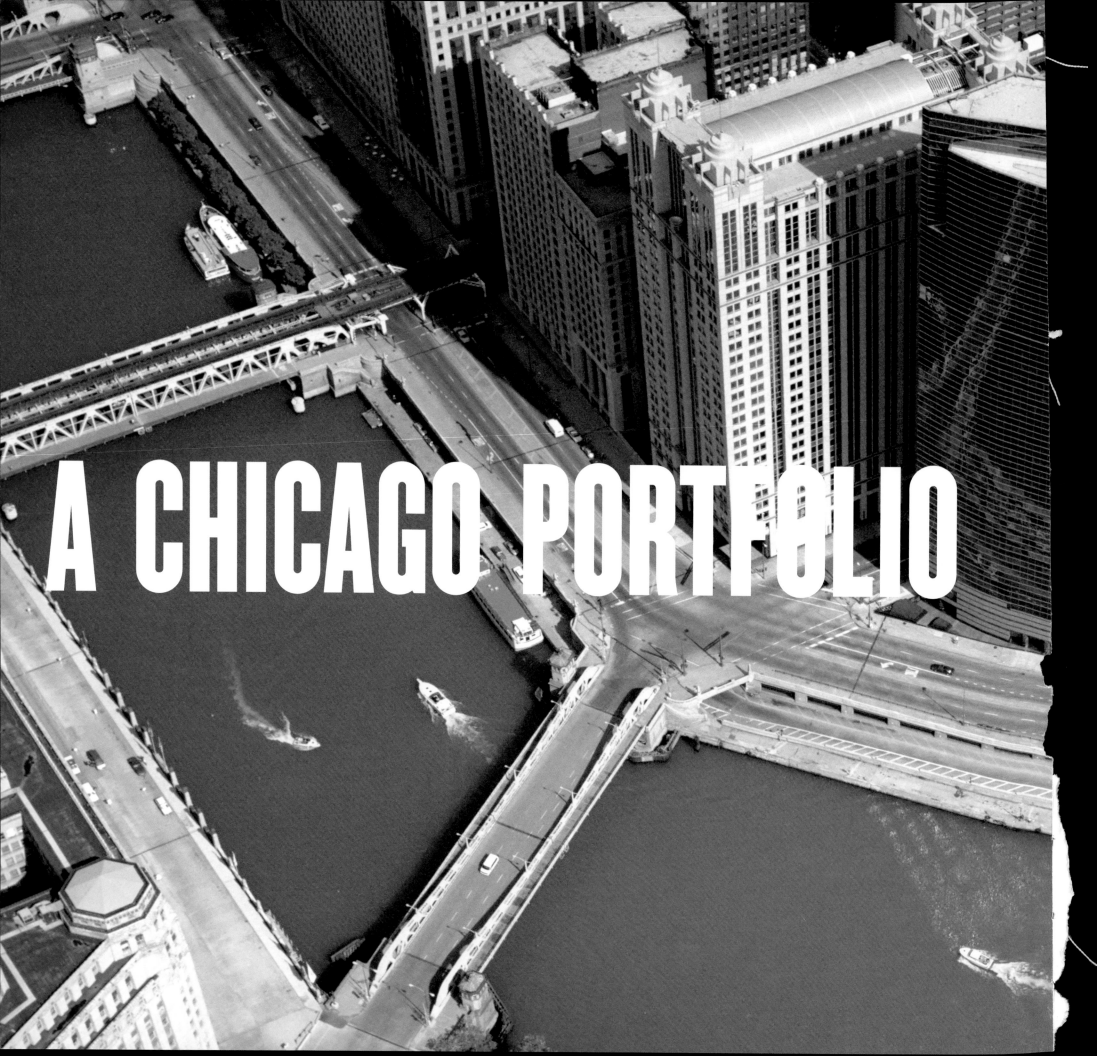

A CHICAGO PORTFOLIO

333 W. Wacker Dr.
June 7, 1992
A clearly-defined change in color immediately south of Wolf Point demarcates the convergence of contaminated water flowing south from the North Branch of the Chicago River, and uncontaminated water flowing west from Lake Michigan.

The Low Rise City
April 12, 2003
This east-facing view is a reminder that, notwithstanding its famous towers, Chicago is overwhelmingly a low-rise city. Chicago Avenue (left) provides a beeline to the lakefront.

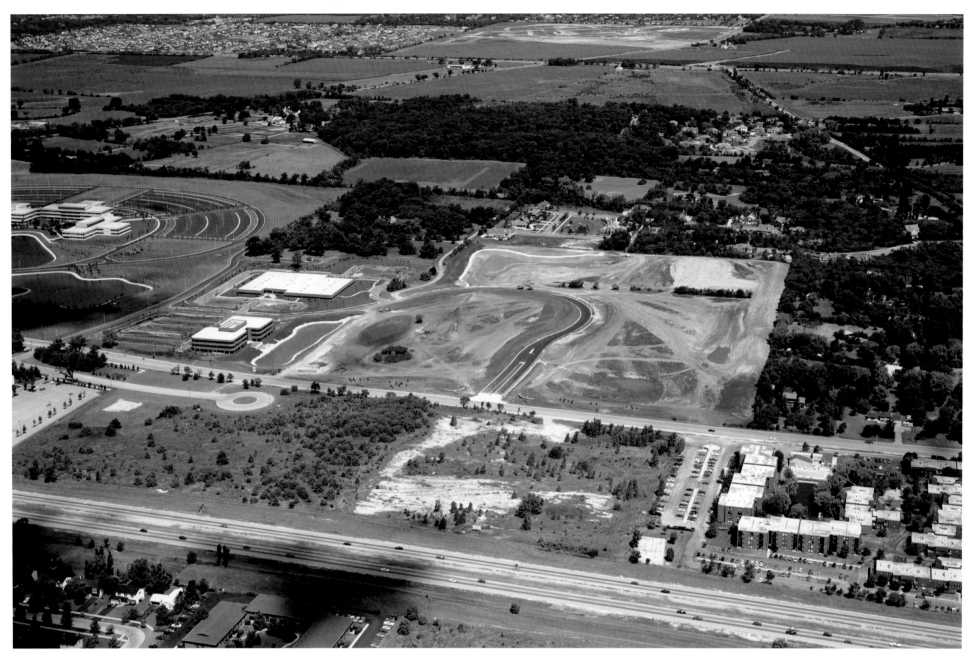

Cabot Business Park, Lisle

A stone's throw from the East-West Tollway, Cabot Business Park is emblematic of the decentralization of the region's office market. With more than 56 million square feet in place as of 2009, the I-88 Tollway corridor now supports as much contemporary office space as downtown Dallas and Denver—combined. The metropolitan expressway system was originally designed to provide access to and from the city. The construction of full interchanges facilitated the establishment of outlying business centers—and even more distant residential communities for their employees.

August 30, 1986
Cabot Business Park is just east of the Naperville Road interchange on the East-West Tollway (I-88), approximately 25 miles west of the Loop. In 1986 the Tollway had only two through lanes in each direction in this segment.

August 31, 2006
Extensive paving of formerly open land led to a profusion of artificial retention ponds to control storm water runoff (while inadvertently providing way stations for migrating waterfowl). By the time this picture was taken, I-88 had three through lanes in each direction. It has since been widened to four.

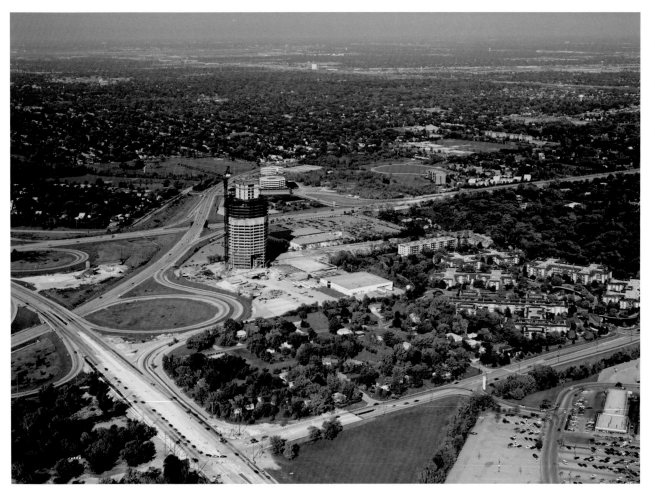

October 19, 1989
Construction of Oakbrook Terrace Tower. Designed by Murphy/Jahn Architects, and completed in 1990, the 418-foot building is the tallest in the Chicago suburbs.

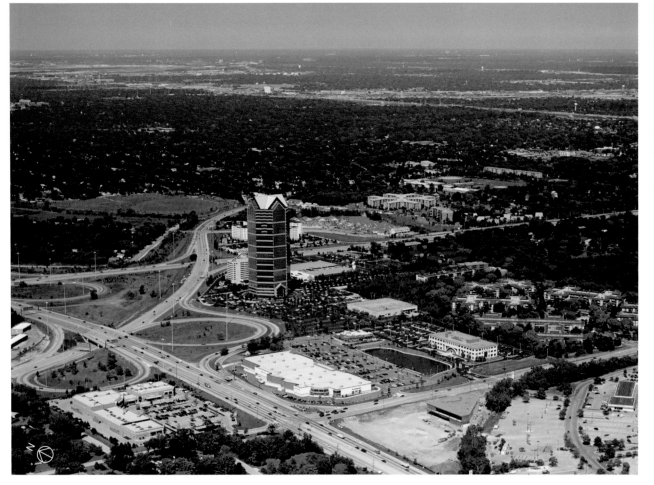

September 1, 1995
The success of the shopping center had a significant impact on the value of surrounding property. The retail and office complex at the northeast corner of Route 83 and 16th Street (in the center of this image) had been a sleepy suburban subdivision just a few short years earlier. The northwest corner of the Oakbrook Center is at lower right.

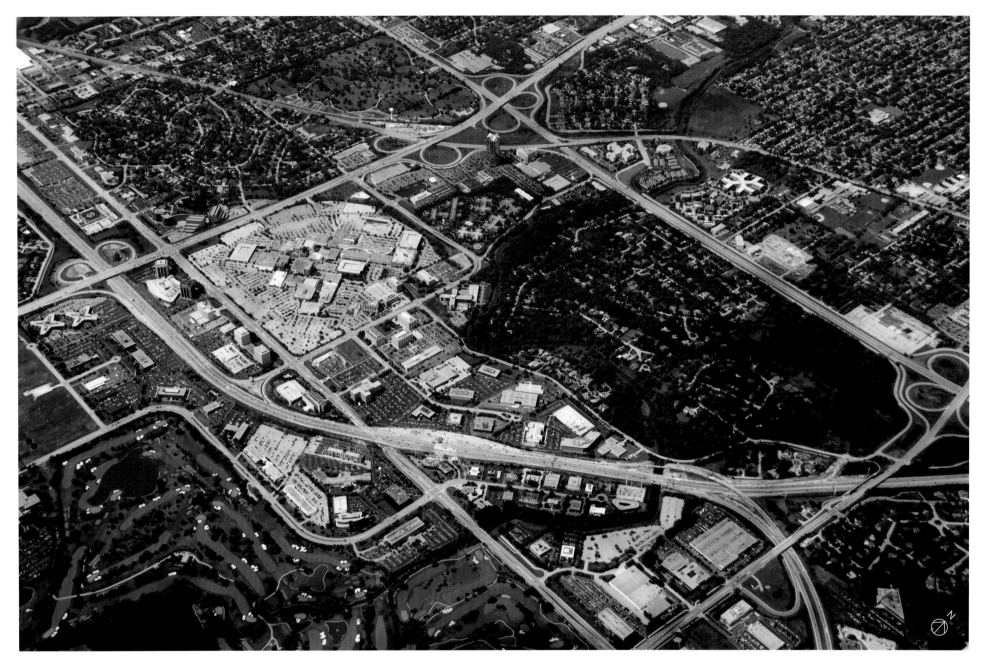

Oakbrook Center

The construction of expressways and suburban business centers greatly diminished the dominance of traditional city centers. Advantageously situated just west of the interchange of the Tri-State (I-294) and Reagan (I-88) Tollways, Oakbrook Center (in the west suburban Village of Oak Brook) was developed by Chicago-based Urban Investment and Development Corporation in 1962. With more than 2 million square feet of retail space, it is the largest open-air shopping center in the United States.

August 13, 2007
Oakbrook Center has proven to be a powerful magnet for further retail and office development. The 31-story Oakbrook Terrace Tower is visible next to the interchange in the upper portion of this image.

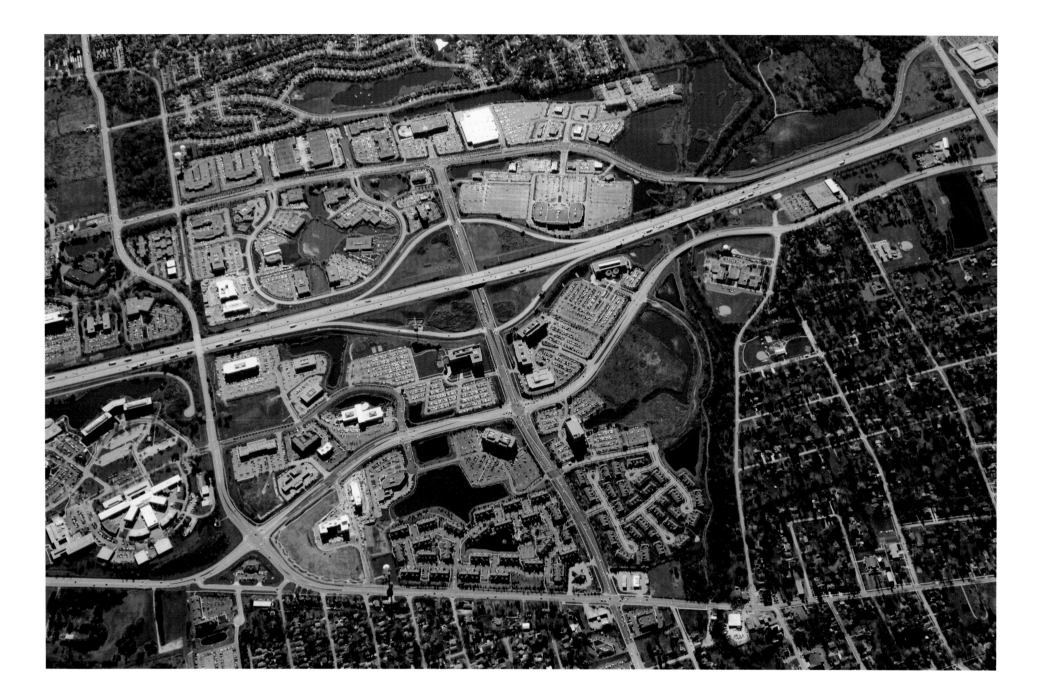

Prairie Stone, Hoffman Estates

The inefficiencies of vertical operations compelled Sears to relocate its consolidated headquarters facilities from the Sears Tower to suburban Hoffman Estates in 1993-1995. Generous public subsidies for land (from the Village of Hoffman Estates) and infrastructure (from the State of Illinois) were granted to Sears to maintain the company's presence in metropolitan Chicago. Originally planned as an office park, the 786-acre site supports numerous corporate, commercial, service and retail uses. Much of the site is given over to natural prairie vegetation and wetland habitats.

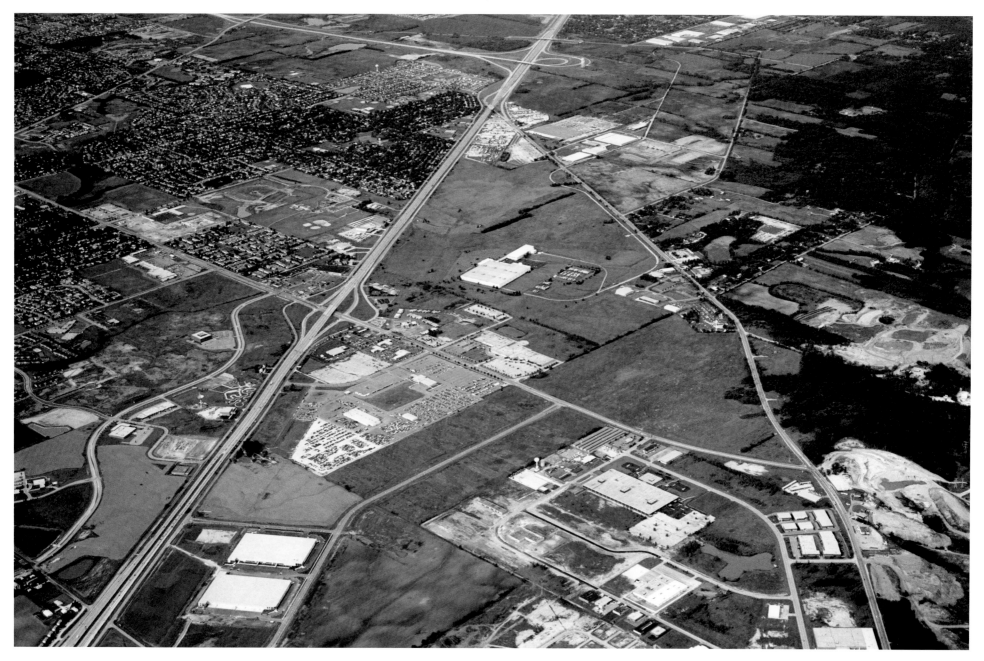

Stevenson Expressway Corridor, Will County

From farmland to big boxes in less than a generation, the corridor of the Stevenson Expressway (I-55) saw its inventory of single story distribution facilities grow from 2.1 million square feet in 12 buildings to 40.6 million square feet in 193 buildings in the decade between 1999 and 2009. Nearly all of the new growth has occurred in Will County, between I-355 on the east and I-80 on the west. Developers have greatly benefited from the real estate tax differential between their locus of operations (Will County) and the primary market their facilities serve (Cook County). Both views are to the northeast, toward Chicago.

July 1, 1990
From 1975 to 1986, the paved parcel in the southwest quadrant of the interchange at Bolingbrook Road (left center) was the site of Old Chicago, a failed effort to put an amusement park and shopping center together under one roof.

November 3, 2009
The construction of Veterans Memorial Tollway (I-355) greatly facilitated the expansive growth of the area. The segment north of I-55 (upper left) opened in 1989. The 12.5 mile extension south to I-80 (upper right) opened in 2007.

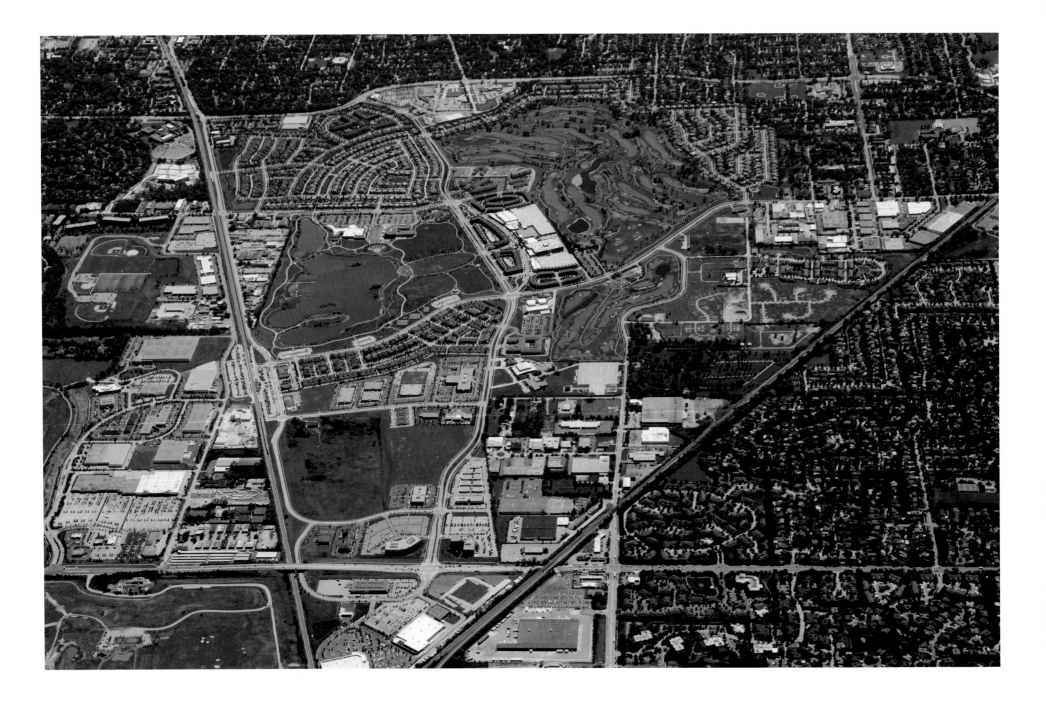

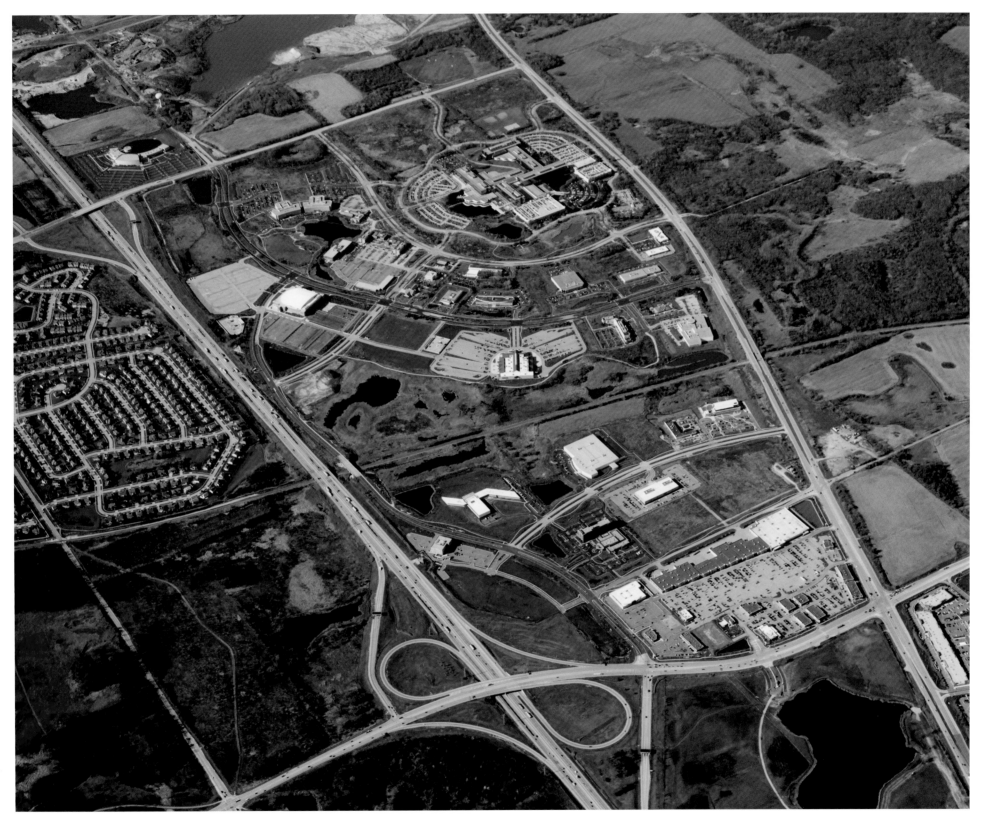

**June 29, 1989
(opposite, top)**
Poplar Creek Music
Theater (1980-1994) could
accommodate 20,000
concertgoers (view to
northwest, Illinois
Route 59 in foreground).

**October 14, 1996
(opposite, bottom)**
Prairie Stone's road and
utilities infrastructure
also facilitated the
development of nearby
properties.

November 3, 2009
The russet wetlands
flanking the old EJ&E
rail line stand out in this
mid-autumn view. Sears
headquarters is at the top.

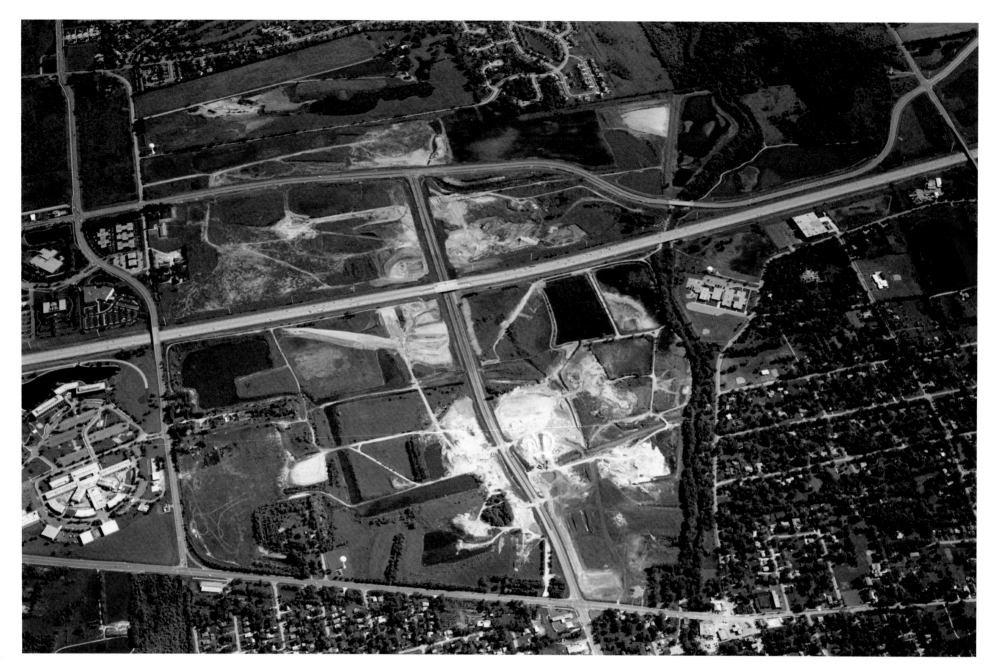

Cantera, Warrenville

For more than a century prior to its redevelopment, the 650-acre site of Cantera served as a gravel quarry. (Cantera is the Spanish word for quarry.) Straddling the Ronald Reagan Tollway (I-88), Cantera is located in west suburban Warrenville. Prior to the Cantera project, Warrenville's tax base was almost entirely residential. Since 1996, more than 7 million square feet of hotel, office, residential and retail space has been completed. Prominent Cantera companies include BP, Exelon Nuclear, Navistar, Paychex, and the headquarters of the International Brotherhood of Electrical Workers (IBEW).

May 30, 1993
View to south. In order to prepare the old quarry for redevelopment, 7-8 million cubic yards of clean fill had to be transported to the site before extensive regrading could begin. Winfield Road, crossing beneath the Tollway, was constructed in 1992, but the full interchange would not be realized until 1994.

November 3, 2009
View to south. The residential development at the north end of the property (foreground) established continuity with the pre-existing residential communities of Warrenville. The 30-screen AMC movie theater complex, in the southwest quadrant of the interchange (upper right) is one of the largest of its type.

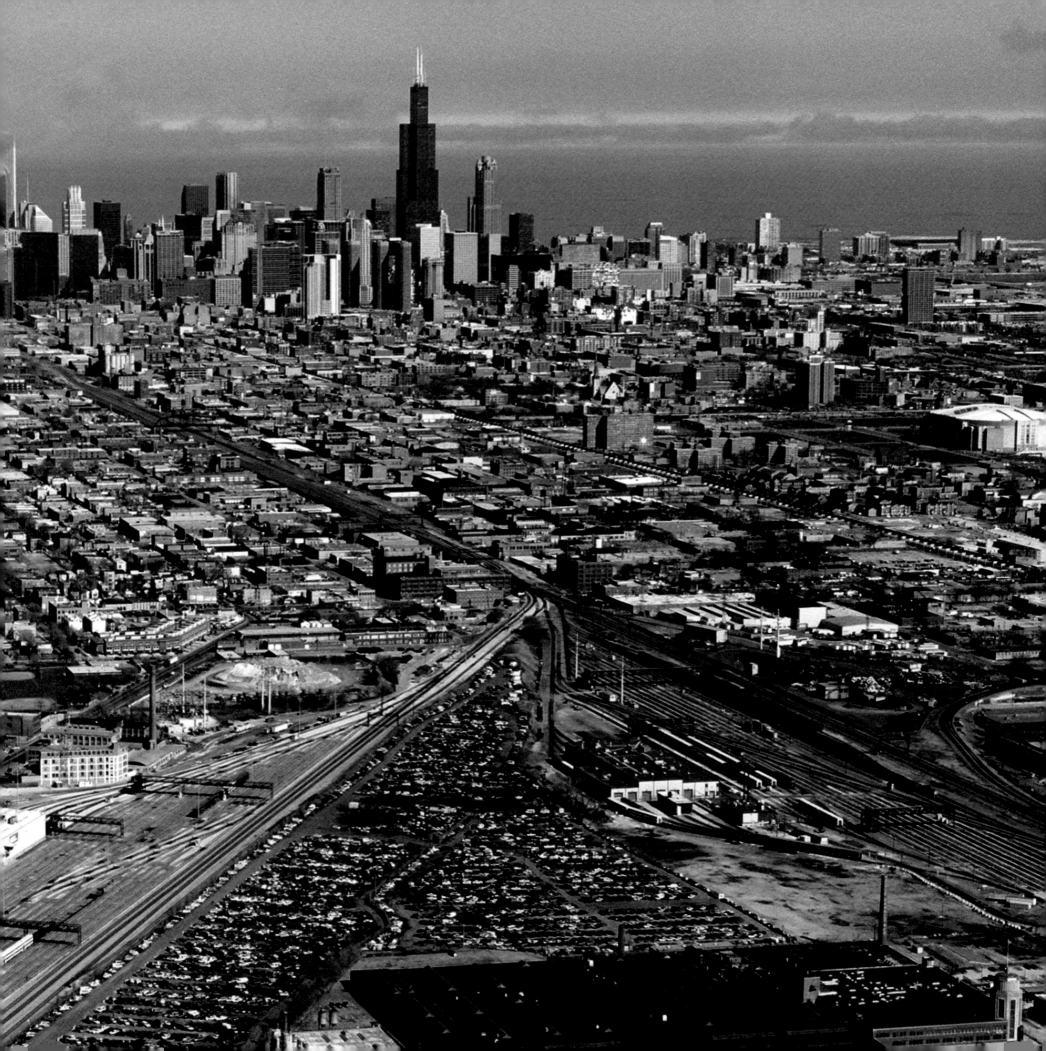

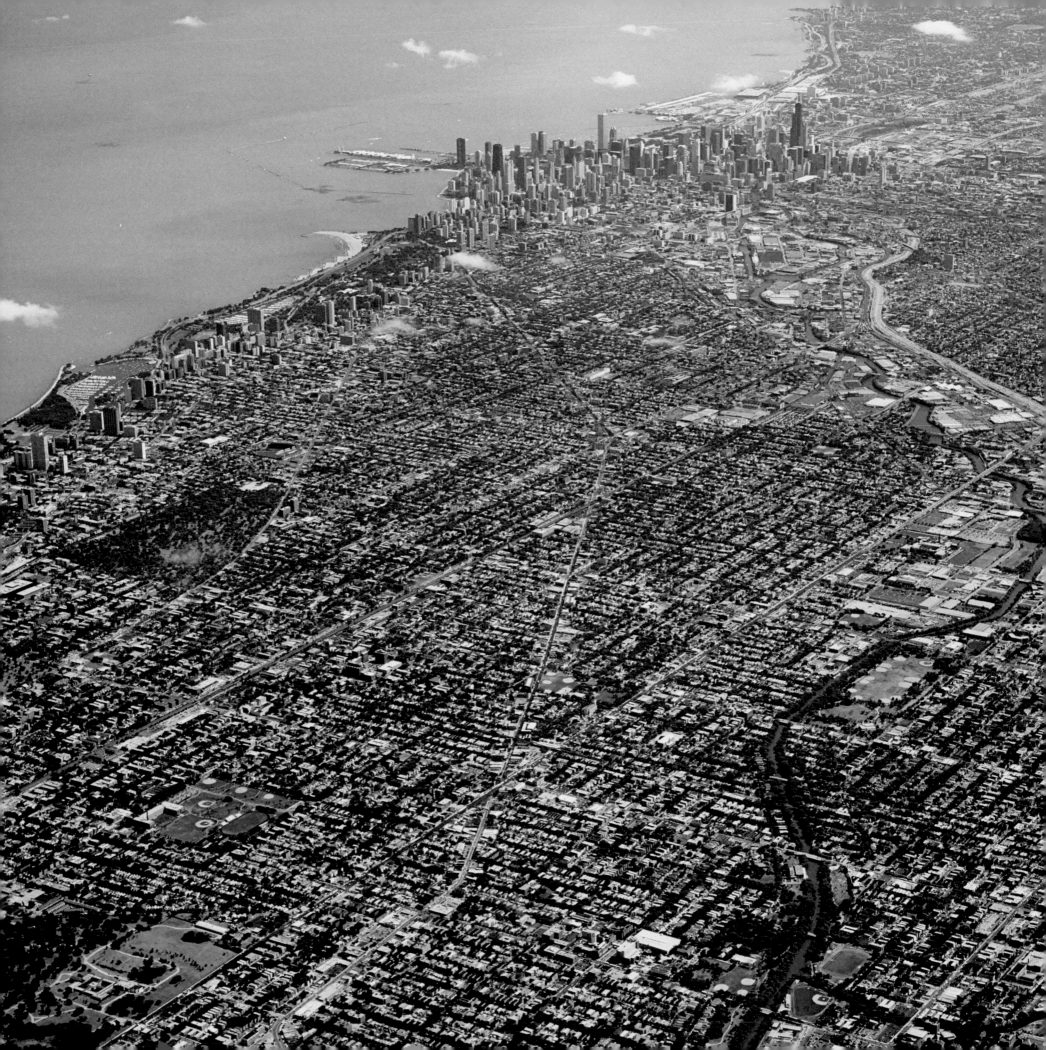

The City from 10,000 Feet

August 6, 2002

The North Shore Channel merges with the North Branch of the Chicago River in the center of the lower edge of this picture. The geometrical curves and linear segments that characterize the river as it flows toward the Loop are attributable to a number of channelization projects that eliminated the natural meanderings of the waterway. Milwaukee Avenue (at right, parallel to the Kennedy Expressway), Lincoln Avenue (several blocks to the left of the river), and Clark Street (bordering Graceland Cemetery at left), descendants of ancient Indian trails, do not conform to the dominant man-made street grid.

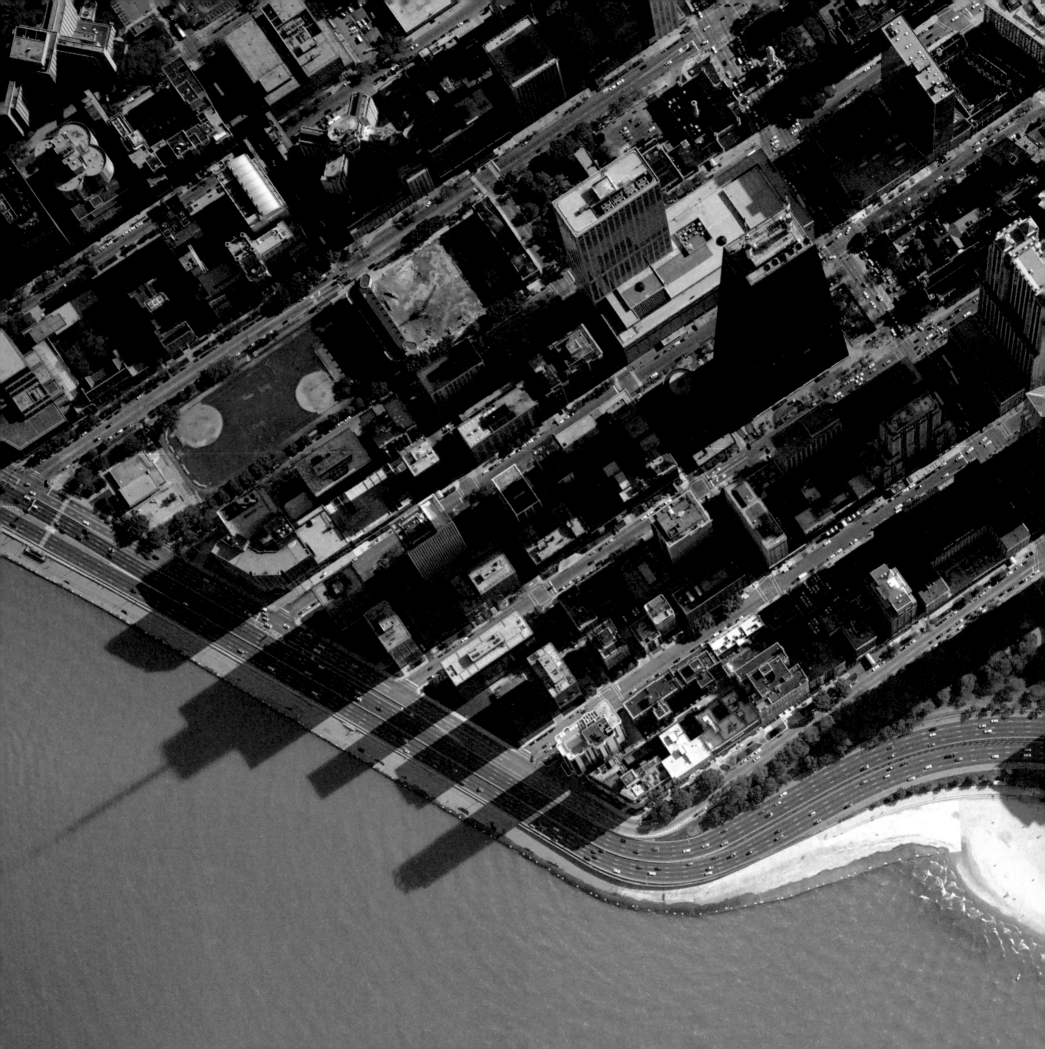

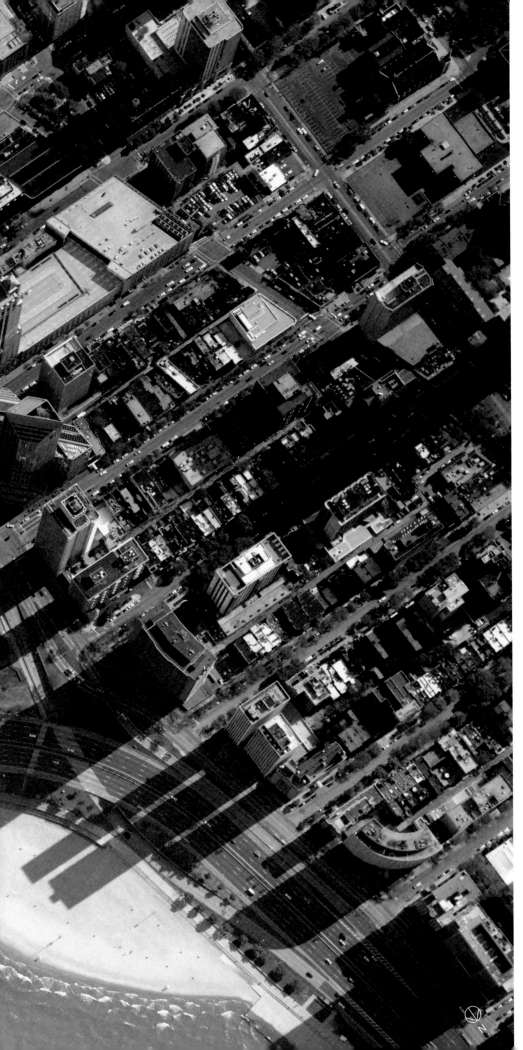

Chicago's Street Grid

May 30, 1993

The sunlit canyons among the high-rise towers of this late afternoon view are attributable to the city's rectilinear street grid. The National Guard Armory, undergoing demolition, is visible at upper left. Oak Street Beach is at lower right.

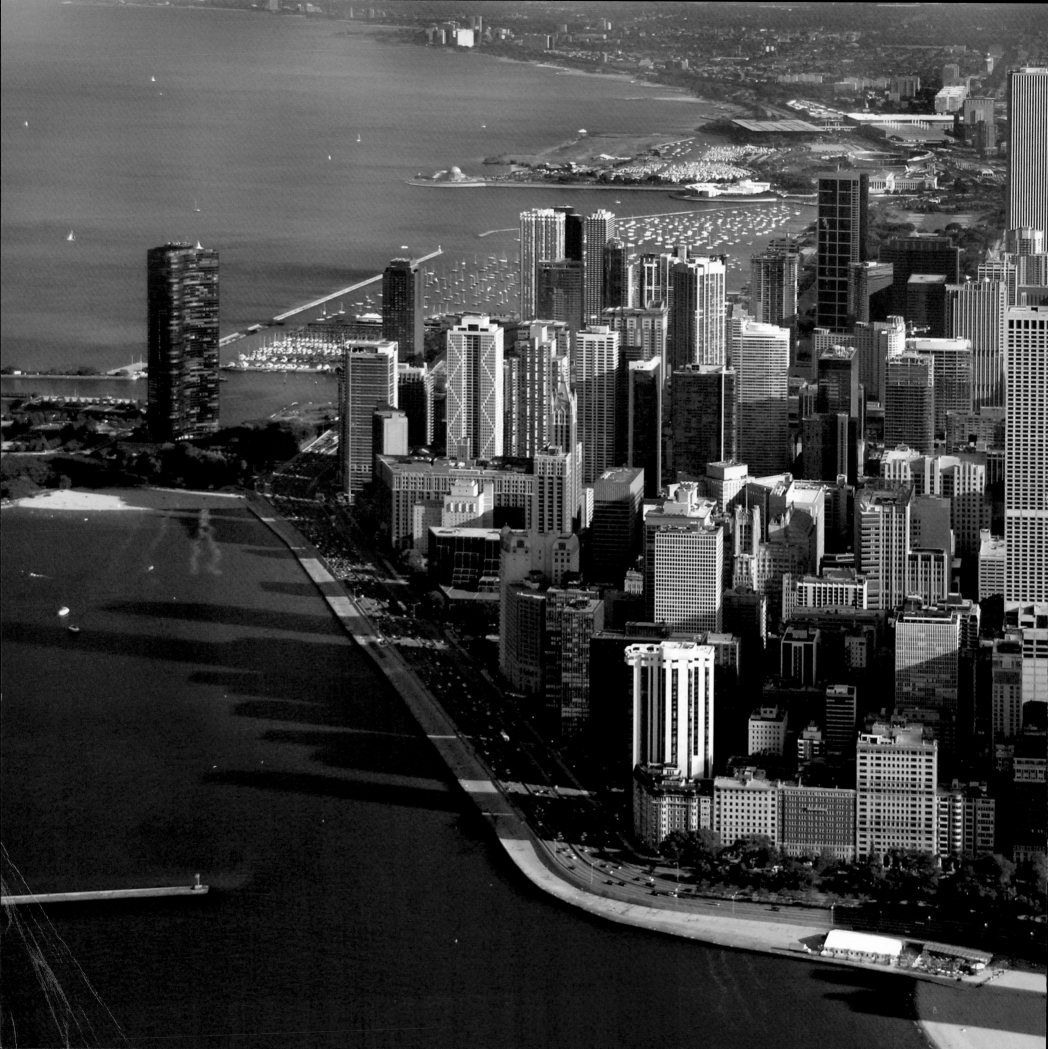

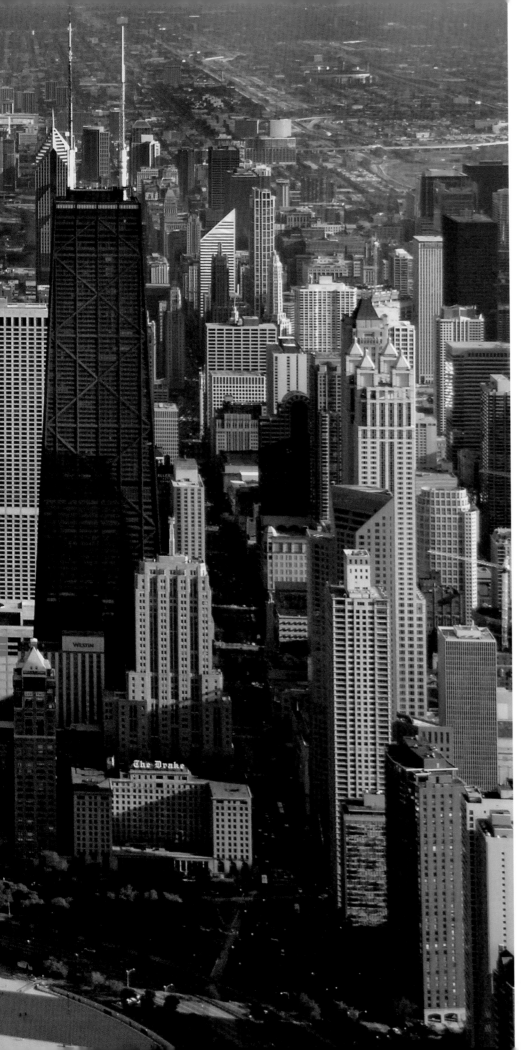

East Lake Shore Drive

June 19, 2007

View to south. Perhaps the city's most elegant residential address, East Lake Shore Drive realized its present form in 1929, with the completion of Benjamin Marshall's Drake Tower Apartments (foreground, immediately east [left] of the Drake Hotel). All eight buildings on East Lake Shore Drive were designed by Marshall & Fox or by Fugard & Knapp. The City designated the block a landmark district in 1985.

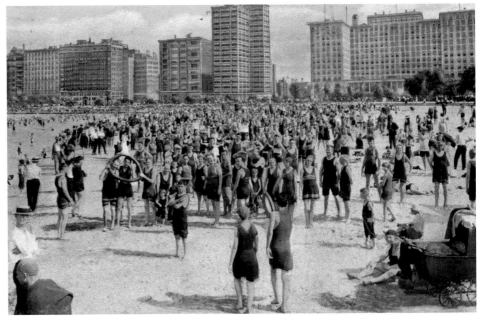

Oak Street Beach, circa 1925

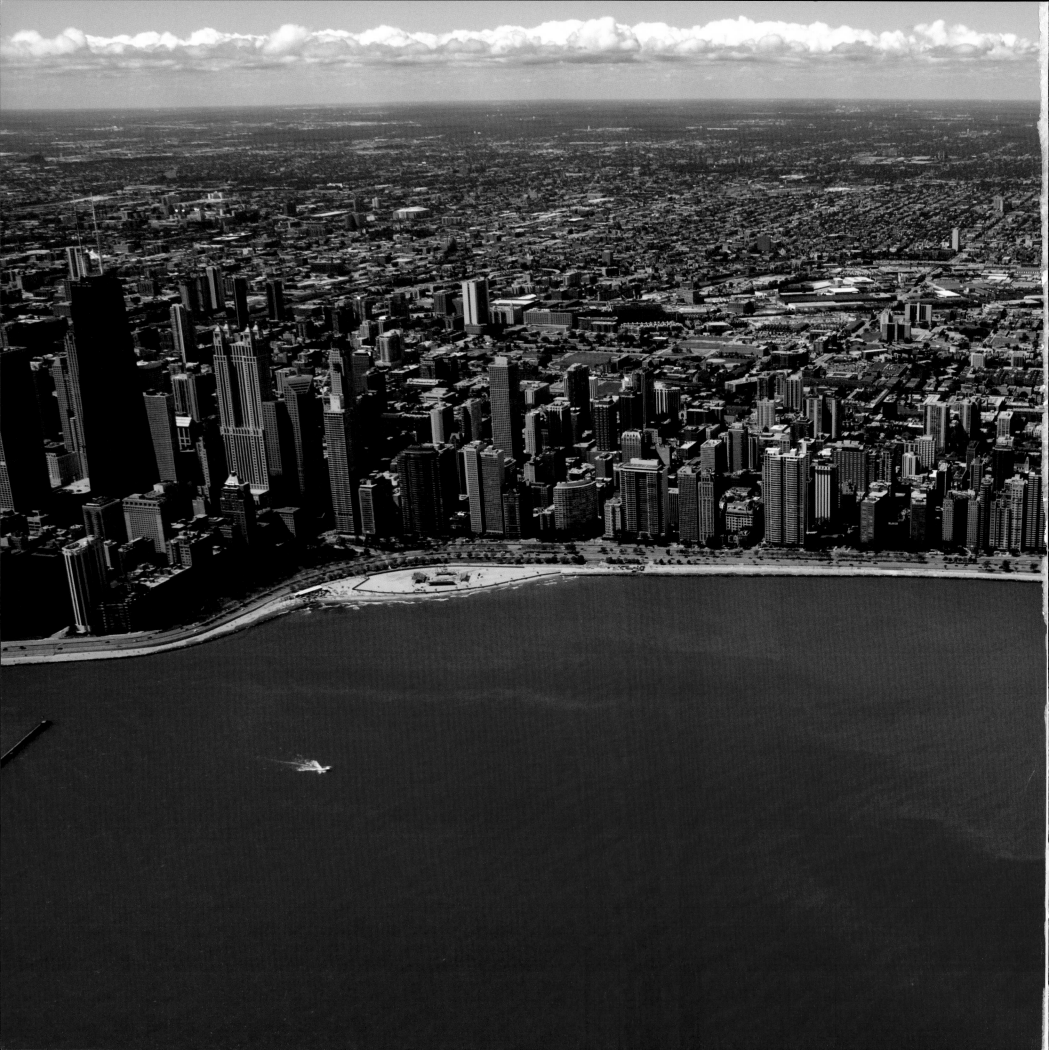

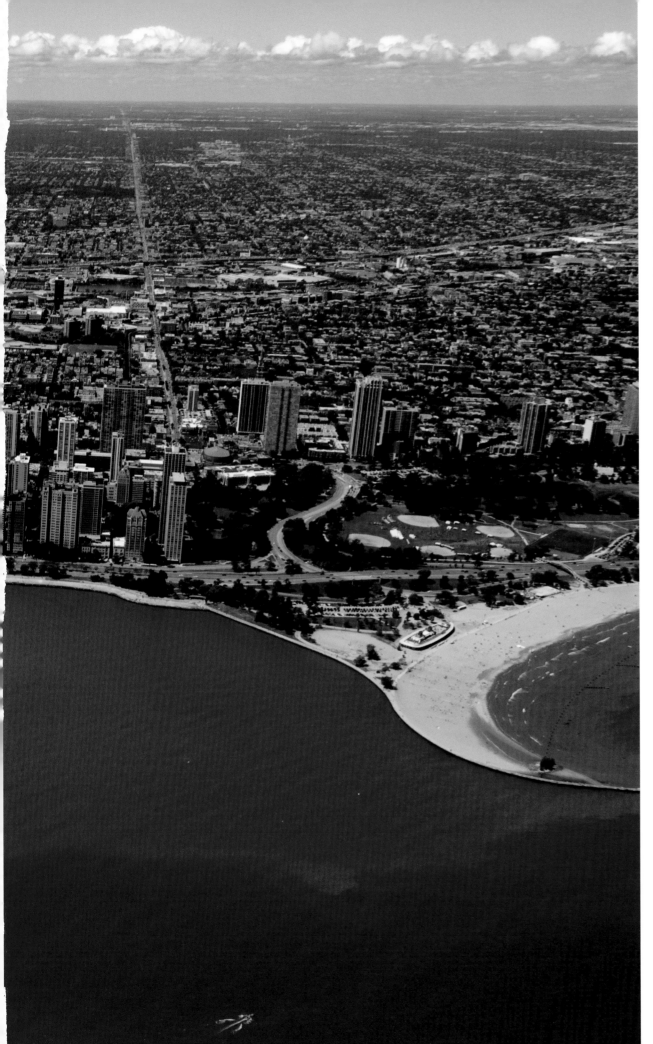

Gold Coast
August 23, 2009

The three-quarter mile segment of the Lake Michigan shoreline from Oak Street Beach on the south (left) to North Avenue Beach on the north (right) encompasses most of one of the wealthiest census tracts in the United States. The Gold Coast's rise to prominence began in 1882, when Potter Palmer completed his Gothic mansion at 1350 N. Lake Shore Drive. Its replacement by a high-rise apartment building in 1951 signaled the beginning of a transformation that would continue into the early 1970's, when the area assumed its current form.

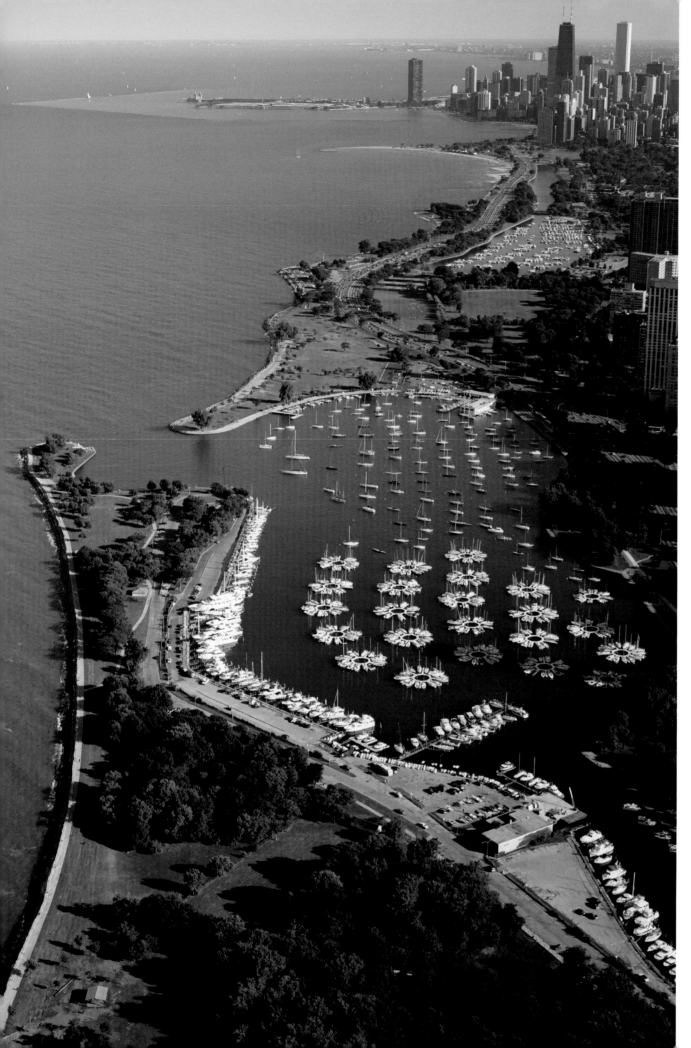

Belmont Harbor

August 12, 1986

The city acquired the original site of Lincoln Park, between North and Fullerton avenues, in 1864. A series of landfill projects initiated in 1906 added 234 acres to the park and extended it north to Belmont Avenue by 1910. By 1929, the park had reached Foster Avenue, and included new harbors at Belmont and Montrose avenues. The final extension to Hollywood Avenue was completed in 1957. The floating docks in the center of this image have since been replaced by linear structures extending from the shoreline.

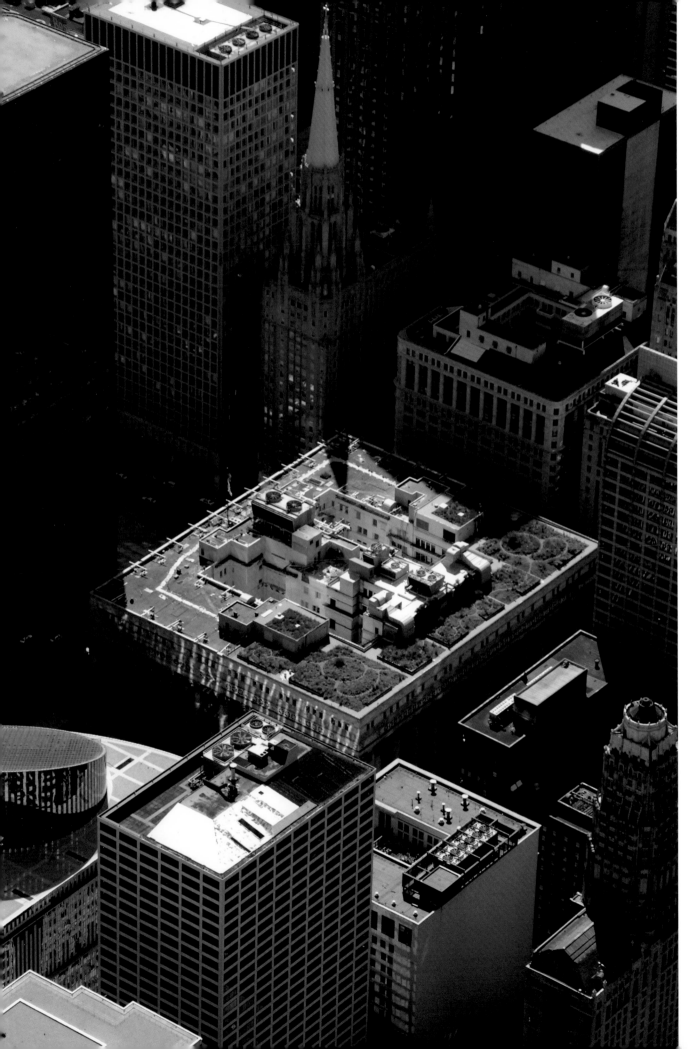

City Hall

August 31, 2006

The green roof on Chicago's City Hall covers 20,300 square feet of surface area and includes 20,000 plants representing 100 species native to the region. The technology is intended to mitigate the urban heat island effect, a problem caused by heat-absorbing surfaces such as black tar roofs. The Comprehensive Zoning Amendment of 2004 awards FAR (Floor Area Ratio) bonuses for new buildings with green roofs.

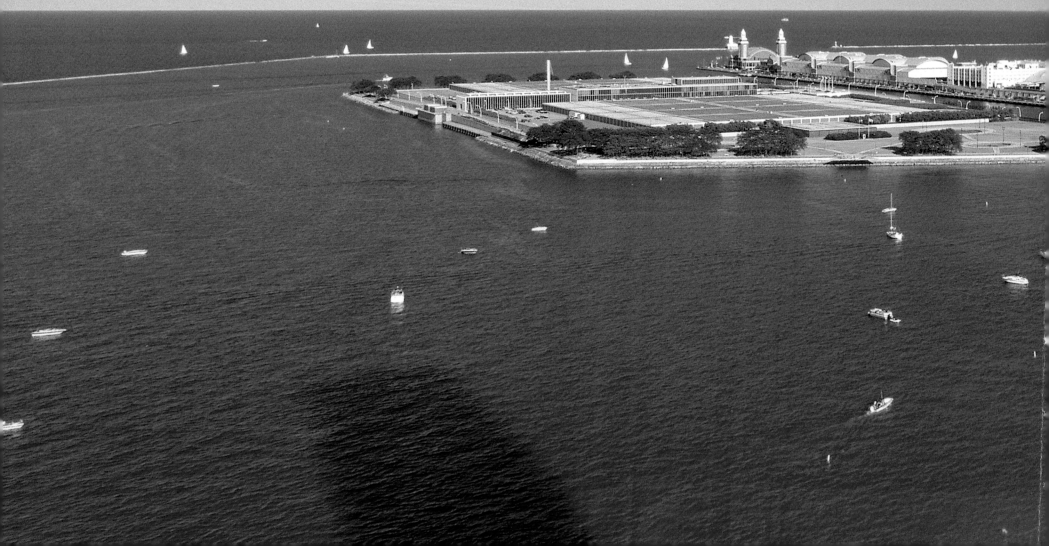

The Water Filtration Plant and Navy Pier
August 5, 1999
Recreational boaters are attracted to the
protected waters along the Streeterville
lakefront.

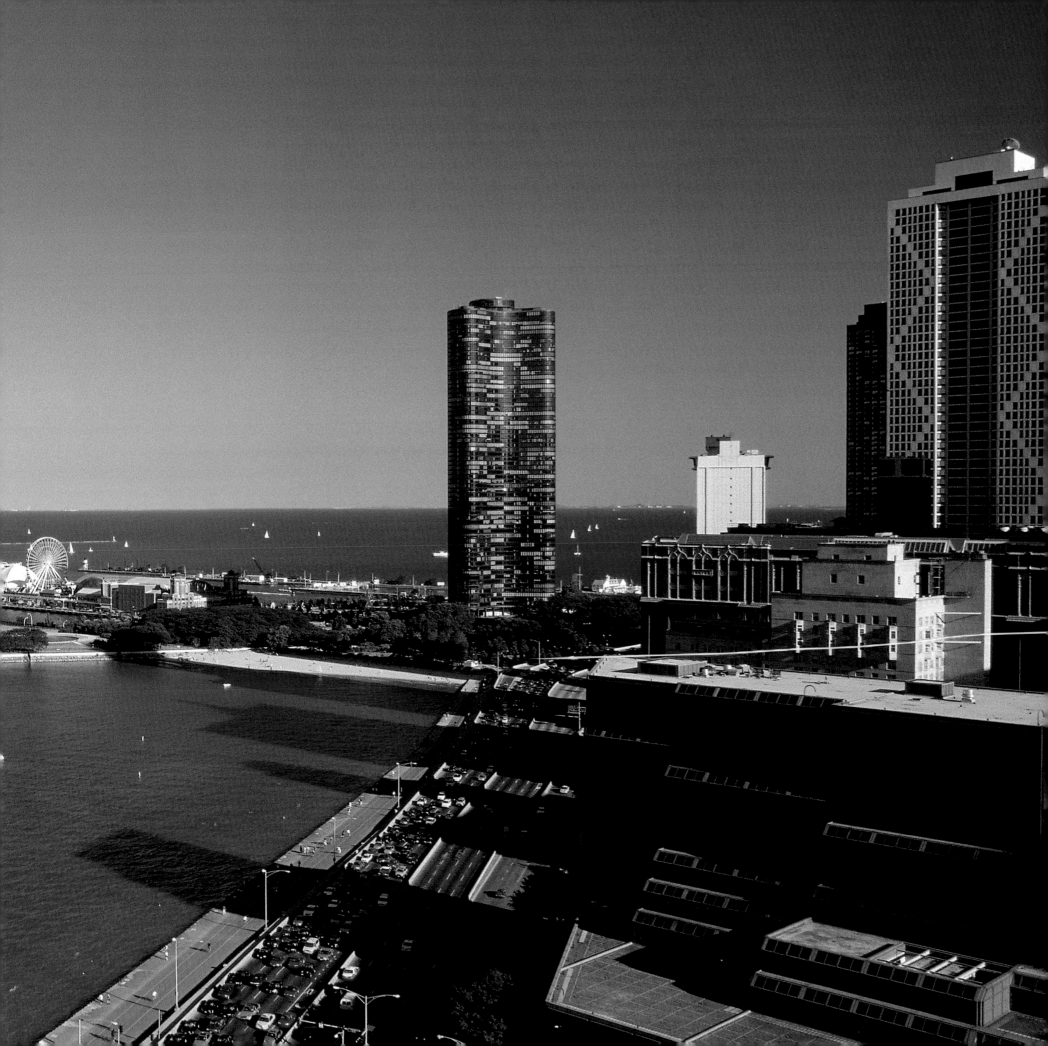

Little Village
August 18, 1998
Little Village's
26th Street, the
center line of
this image, is the
main business
district of the city's
Mexican-American
community.

Tri-State Tollway
September 29, 2004

The interchange at Willow Road in north suburban Northbrook is part of the 78-mile long Tri-State Tollway (I-294/94), the nearest expressway bypass around Chicago (14 miles west of the city center at its closest point). The industrial building in the center of this image (Culligan) has since been demolished. The interchange was reconstructed in 2009 to accommodate increasing traffic demand. The Willow Road bridge, originally five lanes in width, has been widened to accommodate ten lanes.

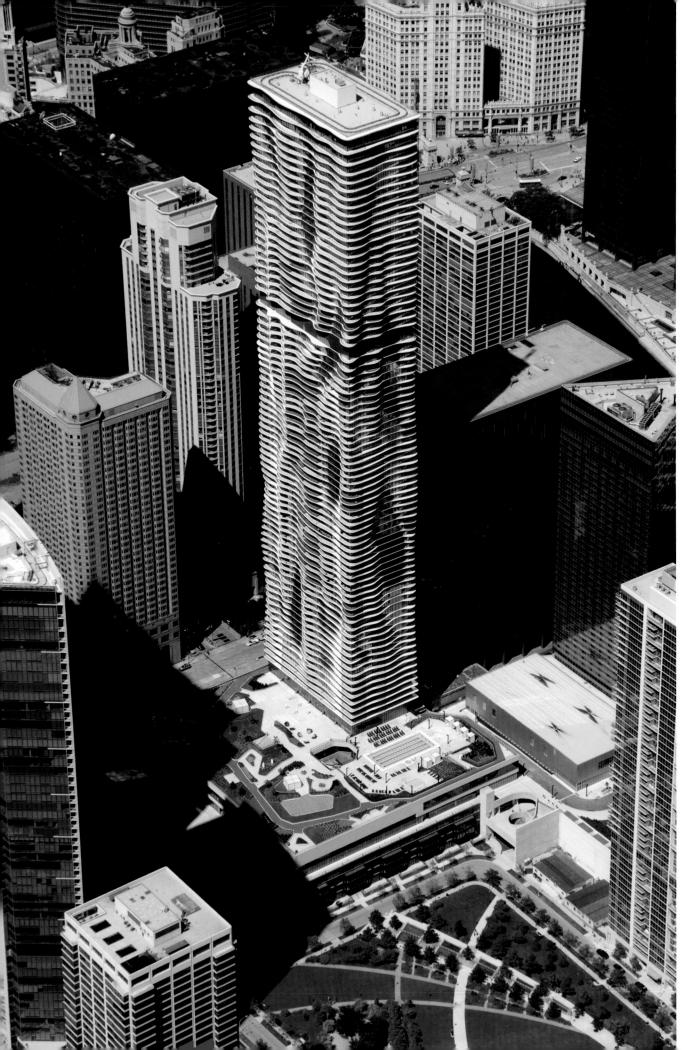

Aqua
August 23, 2009

The critically-acclaimed Aqua, designed by Chicago-based Studio Gang Architects, contains 474 rental units, 274 condominium units and an 18-story hotel. The undulating elevations derive their distinctive profiles from the highly varied curvature of the concrete floor slabs, each unique. The Park at Lakeshore East (foreground) was designed by the Office of James Barnett, with Ernest Wong.

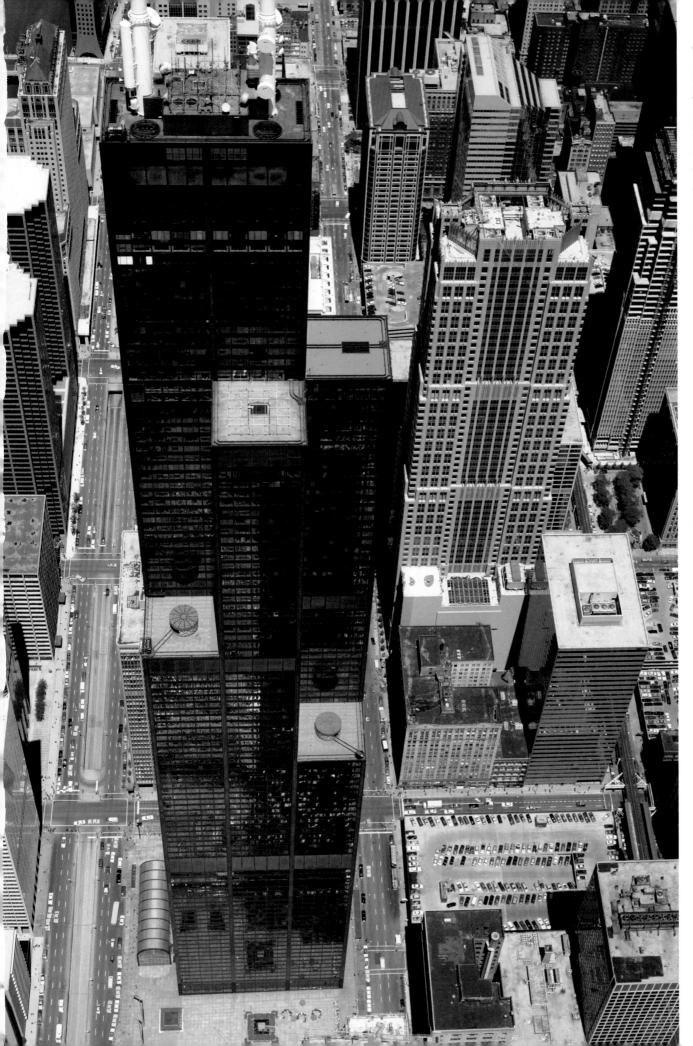

Willis Tower
(formerly Sears Tower)
June 29, 1989

Completed in 1974 and designed by
Skidmore Owings & Merrill, the "bundled
tube" structural system of the tower,
which stiffens the building against lateral
wind loads, was devised by the firm's
chief structural engineer, Fazlur Khan
(1929-1982).

Circle Interchange

August 25, 2008

View to the north
from the Congress
Expressway (I-290).
While the lake is
generally thought
to be to the east of
the city, it is visible
across the entire
horizon of this due-
north view. The line
of Halsted Street, to
the left (west) of the
Circle Interchange,
reaches the lake
at about Foster
Avenue.

Illinois Institute of Technology

May 3, 2004

Established in 1940 through the merger of Armour Institute and Lewis Institute, IIT has strongly influenced the direction of modern architecture in the United States, both in its curriculum and in the design of its own facilities. Rem Koolhaas's Campus Center (foreground) and Murphy/Jahn's State Street Residences (both completed in 2003) align with the CTA elevated tracks.

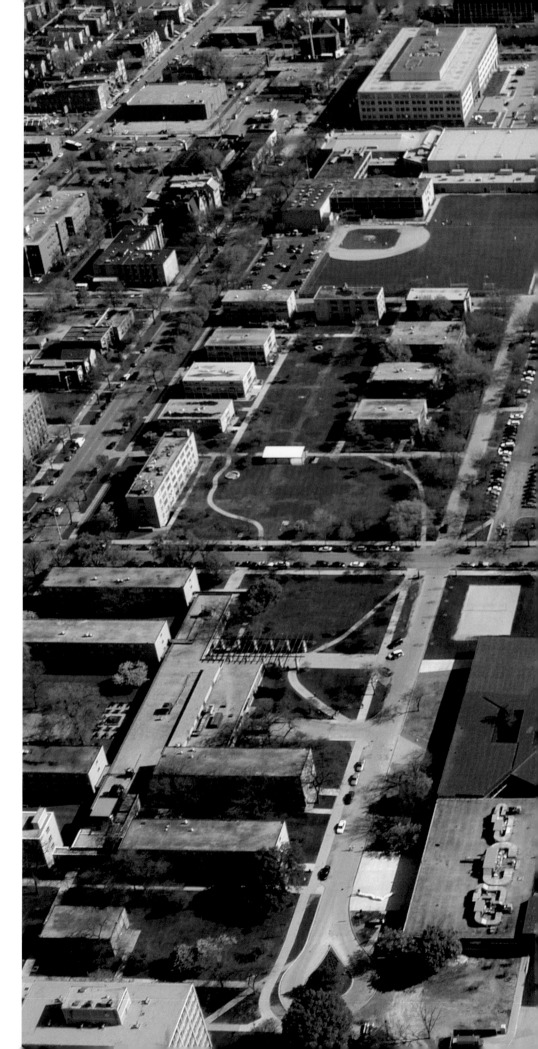

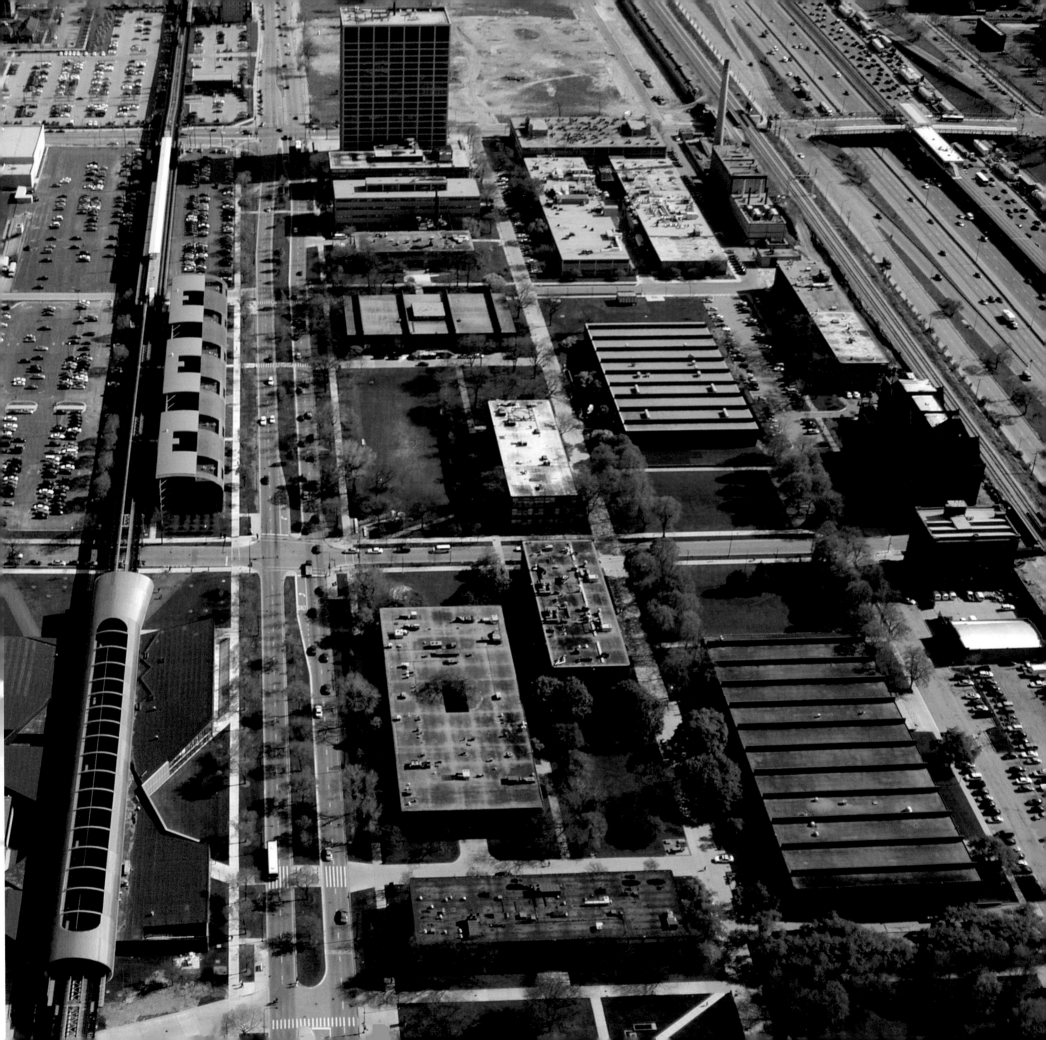

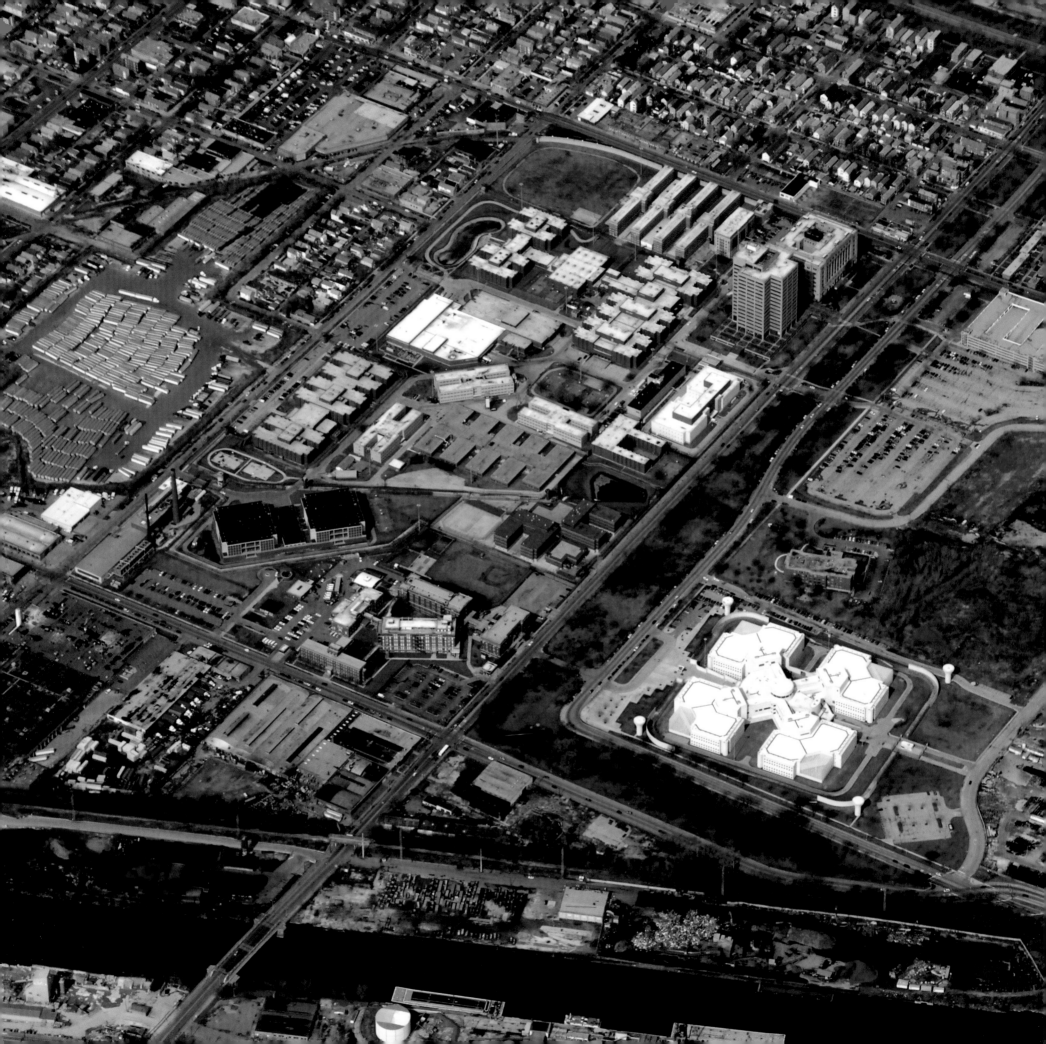

Cook County Jail

March 11, 2007

The Cook County Criminal Courts and Jail complex occupies 96 acres, roughly the rectangle divided by California Boulevard in the center of this image. Cook County Jail, with 11 divisions (cell blocks) is the largest pre-detention facility in the United States, housing some 9,000 inmates. The white cruciform building at the center is Division XI, which opened in 1995. Planned to incarcerate approximately 1,600 male inmates, the 685,000-square foot maximum security facility was designed by Roula Alakiotou, of Chicago-based Roula Associates Architects, Chtd.

Chicago Skyway
August 25, 2008
View to east. Running diagonally from upper right to lower left in this image, the Chicago Skyway opened to traffic on April 16, 1958, connecting Chicago to northwest Indiana. Officially, the Skyway is a toll bridge rather than a toll road because at the time of its construction, the city did not have the legal authority to construct toll roads. In 2005, the City of Chicago signed a 99-year operating lease with private investors, in exchange for $1.83 billion. Average daily traffic volume is approximately 47,700 vehicles.

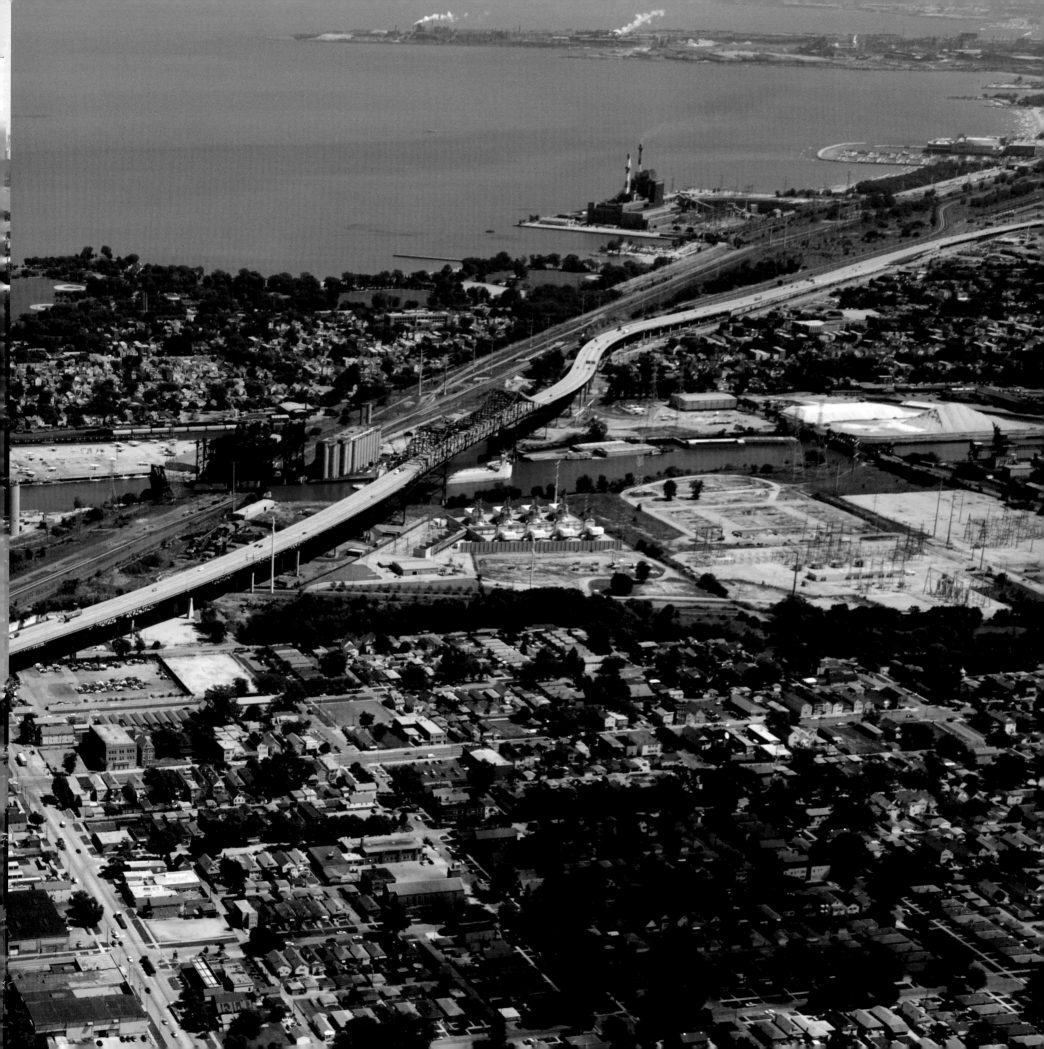

Langston Hughes Elementary School

August 23, 2009

A project of the Public Building Commission of Chicago, white-roofed Langston Hughes Elementary School is located at 240 W. 104th Street, twelve miles south of the Chicago Loop. It was designed by the Chicago-based architectural firm Schroeder Murchie Niemiec Gazda-Auskalanis.

Circle Drive
June 29, 1989

If any neighborhood in the city defies the rectilinear street grid, it must surely be Norwood Park's Circle Drive, on the Northwest Side. Bounded by the triangle formed by the Kennedy Expressway (lower right), Northwest Highway (top), and Harlem Avenue (left), Circle Drive is erroneously reputed to follow the course of an old race track. The Norwood Land and Building Association created the curvilinear subdivision in 1869. Chicago annexed the Village of Norwood Park in 1893.

August 28, 2008
From Carol Stream, a distance of 25 miles, the Chicago Central
Business District (horizon line, right of center) provides the only
vertical relief from the seemingly endless surrounding plain.
Illinois Route 64 (North Avenue) bisects the image.

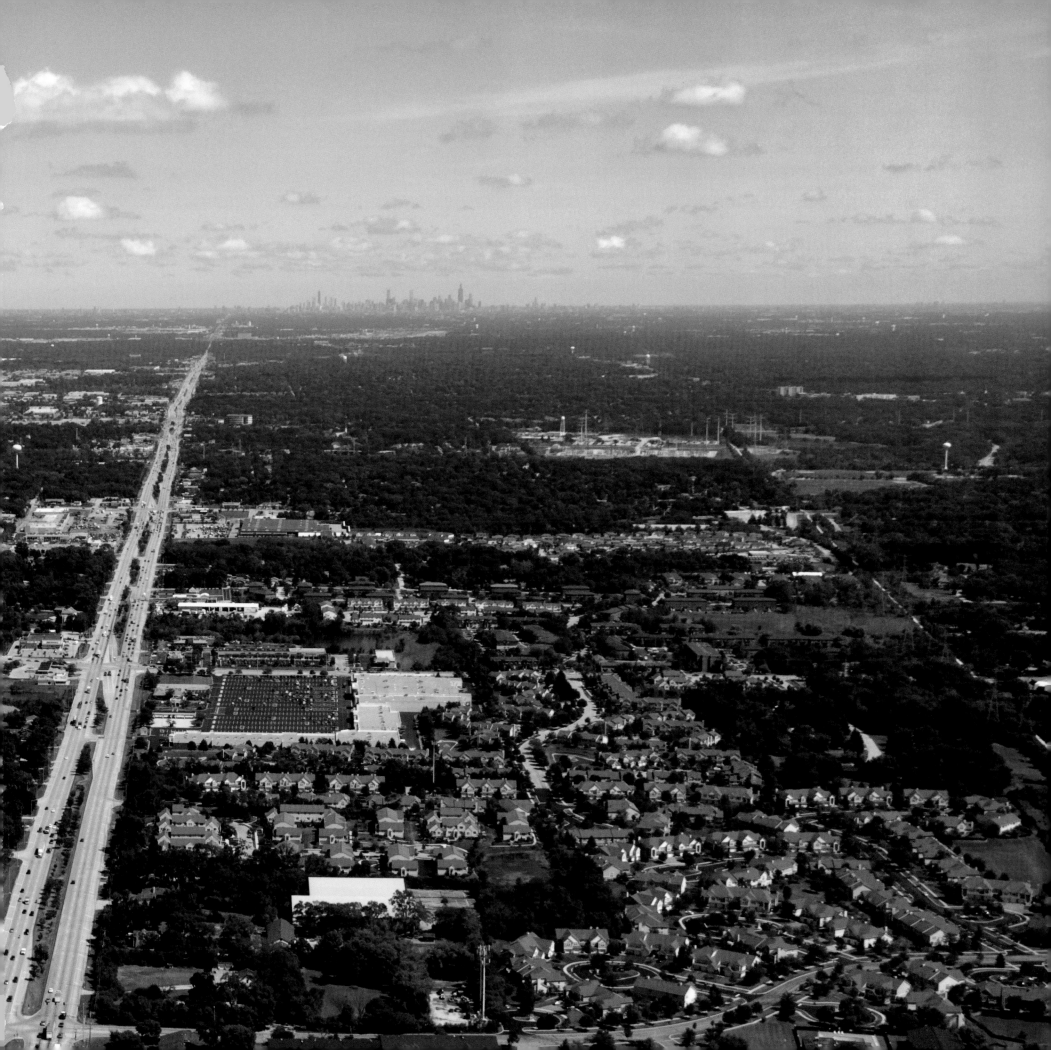

Baha'i Temple

August 31, 1993

The elaborate lattice work of Wilmette's Baha'i Temple is an extreme expression of the plasticity of concrete as a building material. The temple opened to the public in 1953 long after the death of its architect, Louis Bourgeois (1856-1930). The temple's serene presence evokes the unity of the world's great religions, a cornerstone of the Baha'i faith.

The locks beneath the Sheridan Road Bridge control the intake of lake waters into the North Shore Channel, visible at right, a significant component of the Metropolitan Water Reclamation District wastewater treatment system. Completed in 1908, the eight-mile-long channel flows into the Chicago River just south of Foster Avenue.

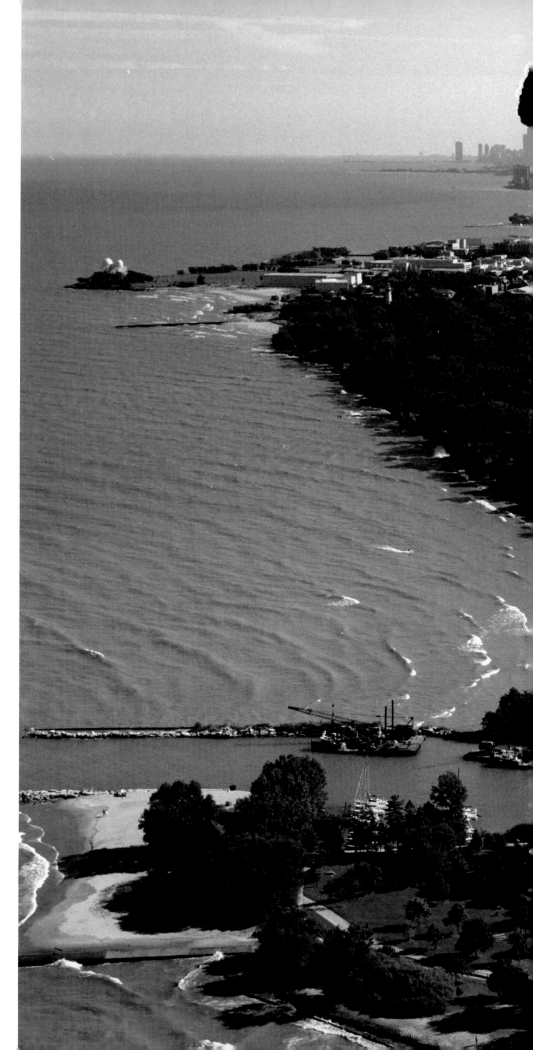

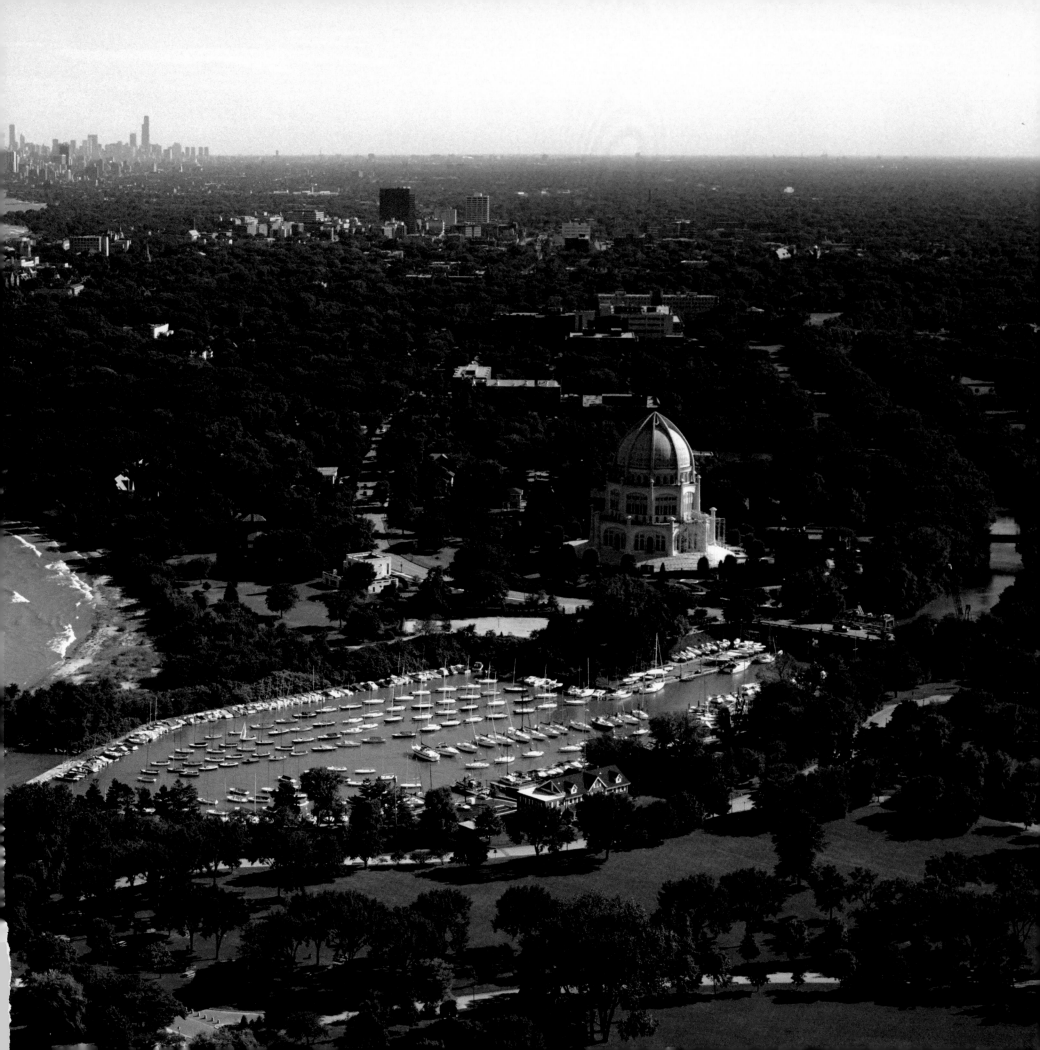

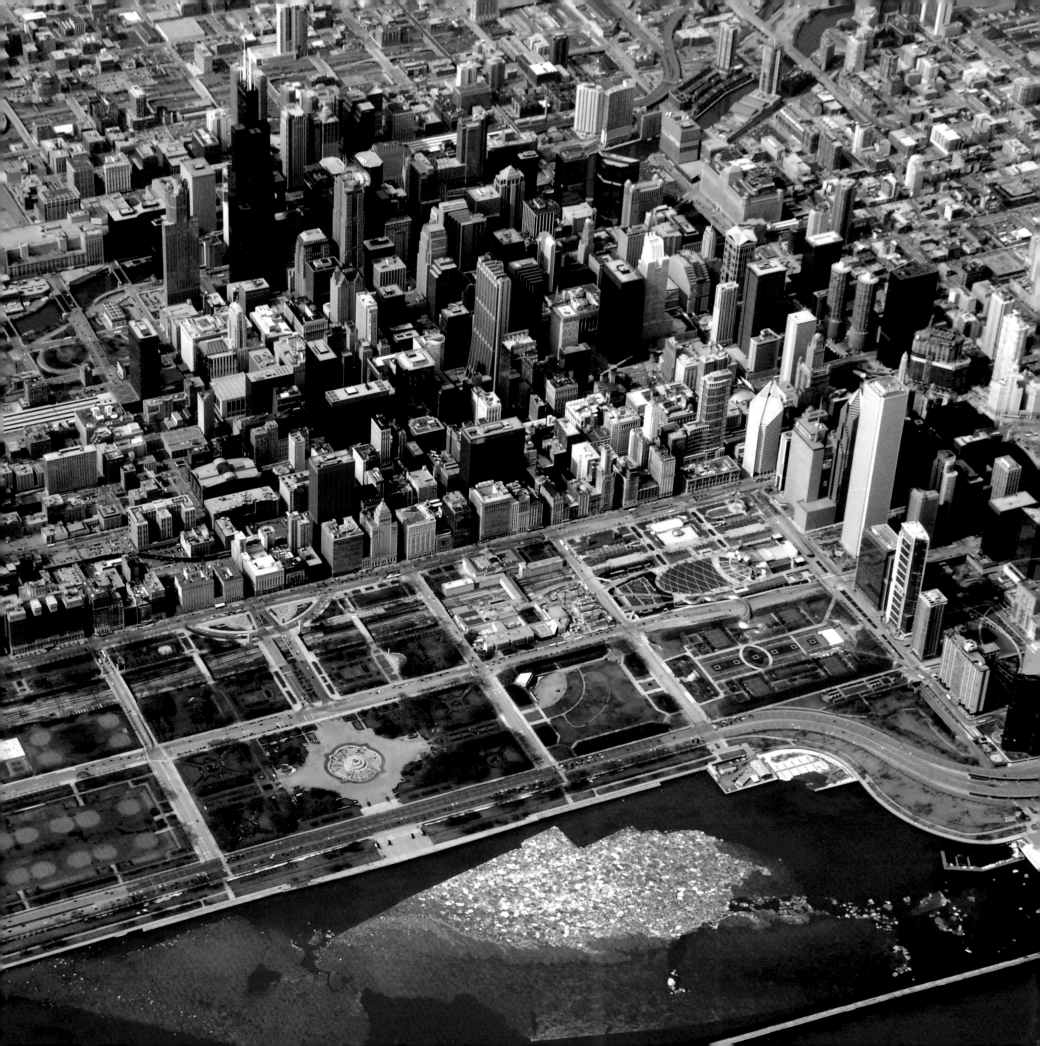

A FINAL NOTE

This collection of aerial photographs is taken from the archive of more than 25,000 images that I have captured on film and in electronic format since 1985. As much as I enjoy exploring the city from the air, I do not think of myself primarily as an aerial photographer, but as an urban planner, a field in which I have been engaged since joining the planning staff of the Chicago architectural firm, Skidmore, Owing & Merrill (SOM), in 1970. During my SOM years and during the first few years of my independent practice, beginning in 1979, I relied on third party sources to obtain aerial photography when needed.

In the early 1980's I was retained as an expert planning witness in a case involving the construction of an industrial storage facility. Believing that the planning and zoning issues involved could best be summarized if the proposal were to be presented, at least in part, from an aerial perspective, I asked the client organization if they had any aerial photography of the facility. Though they did not, they did offer to take me—and my camera—up in a Cessna 172. That experience changed everything. I snapped the shots I needed and discovered another service I could offer, one which I found to be creative, engaging, and—as I soon discovered—thoroughly in harmony with my interest in the history of urban development.

Although the overwhelming majority of the photographs in this book were taken from airplanes and helicopters, in the interest of full disclosure, it should be noted that a few of the images were captured from rooftops or the upper floors of high-rise buildings.

This book is part photo album and part pictorial history. I originally conceived it as a record of the far-reaching physical change that has occurred in Chicago and the surrounding region in the span of a single generation. Though many subjects are addressed, this work is not intended to be comprehensive, mainly because of the limitations of my archive. Indeed, the idea of making a book out of my photographs is of relatively recent origin. Had I planned from the beginning to do this, I am sure my collection would have turned out differently. Nevertheless, having completed nearly 200 photo flights over the years, I have gathered a unique record of perhaps the most prolific era in the history of development in the Chicago region.

Though the city of Chicago is the main subject of this book, I have included substantial coverage of surrounding and nearby suburban and exurban areas. More people reside in the suburbs of Chicago than in the city proper, substantial business is transacted there and, during the period covered in this book, more land beyond the city limits has become urbanized than during any comparable period in history.

Since the content of this book is a highly personal record, some subjects get more coverage than they probably deserve, others, unfortunately, less. I apologize for any disappointment. Still, it is my hope that much, if not most, of the content will resonate. Chicago is a wonderful place in which to live and work, a wonderful place to take pictures, and a subject of enduring interest and, frequently, sheer delight.

March 11, 2007
The spring thaw begins as an ice floe detaches from the Lake Michigan shoreline.